Reading Maya Art

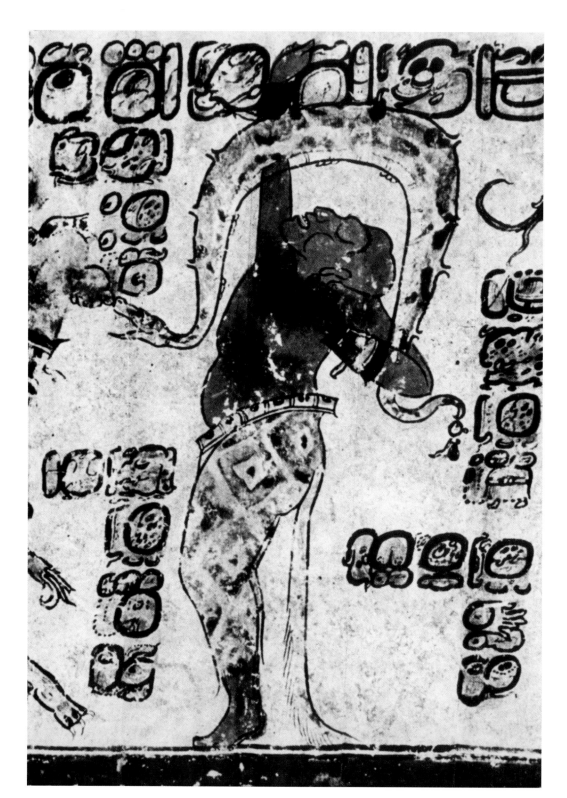

Reading Maya Art

A Hieroglyphic Guide to Ancient Maya Painting and Sculpture

Andrea Stone and Marc Zender

with 535 illustrations

READER'S GUIDE

Although inspired by Richard H. Wilkinson's admirable *Reading Egyptian Art*, the presentation of this book is largely of our own devising.[1] The Introduction is significantly longer and, as a result, able to effectively highlight and delve more deeply into major themes of interest, which would otherwise be scattered in different sections of the book. Equipped with its own illustrations, but also with ample cross-references to images and ideas in the Catalog, the Introduction is intended to provide a suitable point of departure for general reader and specialist alike.

Our visual Contents list is neither as authoritative nor as exhaustive as Alan Gardiner's famous list of Egyptian signs[2] – this for the simple reason that the decipherment of Maya writing is still very much in progress. So the organization of our list is a thematic convenience rather than an attempt to set a new standard. Nonetheless, we hope that it will serve as an intuitive guide to the one hundred topics – each encapsulated in one or more hieroglyphs – that we have chosen to illustrate the extraordinary interdependence of Maya art and writing in all time periods.

These topics are explored in detail in the Catalog: the heart of the book. In addition to an entry number and illustration of the hieroglyph(s) in question (in the upper right corner of every text page), each entry is also accompanied by its own illustrations (on the facing, left-hand page), several of which make use of a second color to pick out details of relevance to the illustrated sign(s). These illustrations are referenced within the entry by parenthetical citations – e.g., "ill. 1." Cross-references direct the reader to relevant illustrations and discussions in other entries. Image cross-references are of the form "*see* 2.3," where the first number indicates the entry, the second the relevant illustration. This cross-referencing system is employed throughout the Introduction, Glossary and Notes. The reader need merely flip through the upper right corners of the page openings to find the cited entry number. Textual cross-references are indicated by the placement of an asterisk (*) after key terms in the text. These terms are then listed, with their entry numbers, in the lower right margin. Unfamiliar technical terms are defined in the Glossary, and may be tracked using the Index. Each hieroglyph has its own entry in the index, which gathers the cross-references in one place, and highlights the page numbers of main entries in bold. Thus, although the book is designed to be read from cover to cover, we hope that the cross-references and index will facilitate its use as a reference work on Maya hieroglyphs and iconography.

Scholarship is cumulative and collaborative, and we have been blessed in equal measure with brilliant forebears and generous, insightful contemporaries. We have documented their outstanding contributions to decipherment, iconographic exegesis and archaeological discovery in the Notes, keyed to sources listed in the Bibliography. (Notes in the Introduction are indicated by superscript numbers, those in the Catalog are grouped together by entry number.) Several colleagues also loaned us their drawings, for which we make grateful acknowledgment here and in the Sources of Illustrations.

A word about orthography: we follow widespread conventions in representing Nahuatl and Mayan words.[3] Thus, the Nahuatl glottal stop is indicated by an *h* (e.g., *ahtlatl* "spearthrower," Ehecatl "Wind God"). The Maya convention is to mark such sounds with an apostrophe ('), while glottalized consonants are likewise followed by an apostrophe. These markers should not be confused with the acute (´) and grave (`) accents marking high and low tone, respectively, in Yucatec Maya. Several of these markers – initial glottalization, high tone and intervocalic glottal stop – can be seen in the Yucatec word *ch'é'en* "cave". Classic Mayan contrasted "hard" (velar) and "soft" (glottal) variants of "h," written *j* and *h*, respectively. Thus *huun* "book" is distinct from *juun* "one," the initial consonant of the latter being pronounced farther back in the mouth. Long vowels are indicated in Mayan by doubling the vowel in question (*kaan* "snake") and in Nahuatl by the use of the macron (*cōātl* "snake"). Both languages follow the sixteenth-century Spanish convention of using *x* for the sound "sh." Mayan *yax* "blue/green" therefore rhymes with English "gosh," and the first syllable of the Nahuatl name Xochipilli is pronounced like English "show." But whereas Nahuatl retains the older *hu-* and *qu-* to indicate "w" and "k" (e.g., Huitzilopochtli, *quetzalli*) Mayan now uses *w* and *k*. Note that some traditional god names (Ek Chuah, Huitzilopochtli) are given in an older, less precise orthography. Stress is unmarked in these languages, as Mayan words are generally accented on the final syllable, Nahuatl on the penultimate.

We adhere to long-standing and logical epigraphic conventions in transcribing Maya word signs in bold uppercase (**BAHLAM**) and phonetic signs in bold lowercase (**ba-la-ma**).[4] All Mayan words are indicated in italics, whether cited from modern languages (e.g., Yucatec *báalam*) or transliterated from hieroglyphic inscriptions (Classic Mayan *bahlam*). See the Introduction (pp. 11–12) for additional details on the Maya writing system, and the Glossary for definitions of some of the technical vocabulary.

First published in 2011 in hardcover in the United States of America by Thames & Hudson Inc., 500 Fifth Avenue, New York, New York 10110

thamesandhudsonusa.com

Library of Congress Catalog Card Number 2010932491

ISBN 978-0-500-05168-9

Printed and bound in China by Toppan Leefung

Frontispiece: A *wahy* demon reaches up into a dedicatory glyphic text. Painted vase from Altar de Sacrificios, Guatemala. Late Classic. Photo Ian Graham (courtesy Corpus of Maya Hieroglyphic Inscriptions, Peabody Museum, Harvard University).

CONTENTS

50. Canoe	51. Road	52. Cave	53. Cenote / Watery Cave	54. Earth	55. Mountain	56. Ocean / Sea
JUKUUB	**bi**	**CH'EEN**	**WAAY?**	**KAB**	**WITZ**	**POLAW**

57. Cloud	58. Darkness / Night	59. Moon	60. Sky	61. Star / Planet / Constellation	62. Sun	63. Censer / Offering Bowl
MUYAL	**AK'AB**	**UH**	**CHAN**	**EK'**	**K'IN**	**EL**

64. Fire	65. Spark	66. Torch	67. Rain	68. Rubber Ball	69. *Spondylus* Shell	70. Stone	71. Tree / Wood	72. Water and Pool
K'AHK'	**TOK**	**TAAJ**	**HA'AL**	**CH'ICH'?**	**?**	**TUUN**	**TE'**	**HA'** and **NAHB**

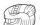 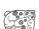

73. Wind / Breath	74. Bat	75. Centipede	76. Coati	77. Crocodile	78. Deer	79. Dog	80. Firefly	81. Fish
IK'	**SUUTZ'**	**CHAPAHT**	**TZ'UTZ'IH**	**AHIIN**	**CHIJ**	**TZ'I' / OOK**	**KUHKAY?**	**KAY**

82. Gopher	83. Jaguar	84. Monkey	85. Rabbit	86. Serpent	87. Shark	88. Tail	89. Turtle
BAAH	**BAHLAM**	**MAAX**	**T'UHL**	**KAAN**	**XOOK**	**NEH**	**AHK**

90. Hummingbird	91. Macaw	92. Owl	93. Quetzal	94. Turkey	95. Cacao / Chocolate	96. Cattail Reed	97. Flower
TZ'UNUN	**MO'**	**O' / KUY**	**K'UK'**	**AK'AACH**	**KAKAW**	**PUH**	**NIK**

98. Maize	99. Square-nosed Serpent	100. Tamale
NAL	**?**	**WAAJ / OHL**

INTRODUCTION

It should come as no surprise that two of the world's best-loved archaeological cultures, the ancient Maya and the Egyptians, have each left exceptionally rich artistic legacies, a fact accounting in no small measure for their enormous popularity with the general public. A great deal of credit must be given to their magnificent objects and buildings, infused with uniquely pictorial forms of hieroglyphic writing, for allowing people in the twenty-first century not just to admire ancient handiwork, but even, to a surprising degree, to understand the tastes, beliefs and politicking of people from civilizations long-vanished for over a thousand years. Egyptian art can claim an especially long track record as an object of fascination in the West. Greeks and Romans aside, it kept steady pace after the Napoleonic era, and movie classics, such as *The Mummy* (1932), are but one nostalgic reminder of twentieth-century Egyptomania, which has continued to inspire art, architecture, and popular culture into the twenty-first century. What is all the more remarkable, the Western passion for ancient Egypt shows no sign of abating. On the other hand, it is really only in the past few decades that the ancient Maya have enjoyed anything approaching Egypt's broad public appeal, but this has gained noticeable momentum, spawning hieroglyphic work-shops, popular books, high-profile exhibitions and even a few Hollywood movies. In order to understand this growing interest in the ancient Maya, we must turn to their remarkable artistic heritage and examine it in terms of a rather technical subject: the signs and symbols at the heart of its formal structure and communicative mission. Symbols populate Maya art with an intensity and flair not seen in any other art tradition; and this is precisely why their art is so compelling and worthy of our attention. Lavishly distributed in elite material culture, symbols were inscribed onto almost any kind of visually attractive object they produced, from tiny beads, bones, shells and chips of obsidian, to exquis-itely painted ceramics, tomb and cave walls, to towering carved stone monuments and stucco-encrusted building façades.

Well before Maya art came to serious notice in the West, in the early twentieth century, its symbolic complexity drew the attention of antiquarians. Among the earliest and most astute was the American explorer John Lloyd Stephens,[1] whose popular travel accounts, published in the mid-nineteenth century, first introduced Maya civilization to a wide audience. In one book, Stephens recorded his reac-tion to a Classic Maya sculpture, a stela from Copan, Honduras, in the following

words: "…silent and solemn, strange in design, rich in ornament, different from the works of any other people," only to lament in the very next breath, speaking of the cryptic hieroglyphic symbols, "Often the imagination was pained in gazing at them." We might explain Stephens' "pain" by considering that in the 1840s he truly *was* contemplating something inexplicable. Yet a similar reaction to the perplexing beauty of Maya art would not be out of place, even by today's standards. Stephens' mixed feelings of awe and puzzlement are instructive as they remind us that Maya art can be appreciated at face value by almost anyone, certainly for its elegant line, sumptuous detail and relative naturalism among indigenous American art styles. However, understanding what its enigmatic pictorial inventions actually *mean*, something that must be confronted if we wish to go beyond subjective impressions, is another matter entirely. While much progress has been made since Stephens' day, comprehending the symbolism of Maya art still remains a challenge, yet not an insurmountable one. For those willing to take the plunge, this book will hopefully ease the pain of Maya art appreciation by explaining the meaning of a large portion of its symbolic vocabulary, as well as the rules that govern how artists could forge these symbols into fantastically complex pictures.

SETTING AND BACKGROUND

The setting of the art and writing discussed in this book is the tropical lowlands of southeastern Mexico and the countries of Guatemala and Belize, as well as portions of northwestern Honduras. This region is conventionally referred to as the "Maya Lowlands" because most of it lies on a relatively flat limestone shelf embracing the Yucatan Peninsula. At the margins, however, Maya civilization spilled into the surrounding highlands, and some "lowland" sites, such as Copan and Tonina, are really in moderately mountainous terrain. Lowland Maya civilization began to coalesce around 2500 BC when the inhabitants of the Central American rain forest started to settle into a village way of life founded upon maize agriculture. Evidence for the earliest stages of maize cultivation is indirect, however, and the first documented farming communities date from a much later period, roughly 1200 BC. While seemingly isolated, these tropical farmers had long-distance trading contacts with other parts of Mesoamerica that had already achieved political complexity, such as the Gulf Coast Olmec and the Pacific Coast cultures of Chiapas and Guatemala. The Olmec, considered by many Mesoamerica's "mother culture," were already constructing large architectural complexes, monumental sculpture and refined artworks by 1100 BC. By the Middle Preclassic period (1000–400 BC), the Lowland Maya were on the way to an equivalent level of complexity and began building large stone platforms by at least 800 BC. The following centuries saw the rise of an increasingly powerful and well-organized elite class who commanded extensive labor. Indeed, some of the most massive architectural projects ever undertaken in ancient Mesoamerica can be credited to the Late Preclassic Lowland Maya (400 BC – AD 250). With

one or two possible exceptions, the tombs of the rulers who orchestrated these great Preclassic constructions have yet to be found, and the precise political organization of these societies remains in question. Nevertheless, in light of the impressive architectural and artistic evidence, scholars no longer view the Preclassic as a warm-up for the Classic flowering that followed, but rather as a distinct pinnacle in Lowland Maya history.

The symbol systems long in use by the precocious Gulf and Pacific Coast cultures provided the foundation for the Lowland Maya symbol system. These earlier cultures contributed the idea of using symbols to convey ideological messages, and also lent a ready-made vocabulary of symbols, for instance, of the sun, moon, maize, certain gods and animals and a number of others. The Lowland Maya began to deploy these symbols, frequently modifying them, as well as adding others of their own invention. This occurred with unprecedented intensity during the Late Preclassic period, which witnessed an explosion of symbolic and artistic expression. Symbols began to adorn not just small-scale objects of jade, bone and pottery but also large-scale constructions, such as stone reliefs, associated especially with a so-called "stela cult" apparently borrowed from earlier Gulf and Pacific Coast cultures. Late Preclassic architectural façades were fashioned into enormous stucco heads of monstrous deities elaborated through symbolic details. Indeed, one stucco mask from Late Preclassic Uaxactun, Guatemala, even displays the name glyph of Tikal's dynastic founder, Yax Ehb Xook (see 47.1),[2] indicating that glyphic writing was already integrated into the art of this period. Perhaps most revealing of the state of the symbol system at this time is the stunning mural from San Bartolo, Guatemala (c. 150 BC), the earliest full-blown narrative and display of complex imagery known in ancient Maya art (see 52.1).[3] The mural teems with delicate figures and symbols that together relate an ancient origin myth; it also boasts a number of intriguing glyphic captions and at least two relatively lengthy texts. Thanks largely to the discovery of this mural, we now know that the symbol system of Maya art had not merely taken root during the Late Preclassic, but was already quite sophisticated.

During the ensuing Classic period (AD 250–900), Lowland Maya civilization realized its greatest artistic achievements as well as its maximum demographic expansion. Hundreds of semi-autonomous towns and cities, built of finely-cut stone and led by lords (ajaw) and lesser nobility (sajal), sprang up along river systems and wetlands, resulting in burgeoning populations. The largest and most powerful kingdoms – centered at Calakmul, Copan, Dzibanche, Palenque, Tikal and Tonina, among others – can rightfully be called city-states during this period. They were led by hereditary divine kings (k'uhul ajaw) and clearly held sway over vast hinterland regions, as well as the affairs of other city-states. These powerful kingdoms consolidated their position by providing smaller clients with protection from enemies, prestigious affiliations and a share in the spoils of war.[4] In exchange, they were probably able to amass considerable political and economic power through the extortion of tribute. Sumptuary items such as jade, chocolate and feathers, as well as crucial staples such as maize and salt, were the life-blood of these tribute economies, and endless canoe-loads of these

commodities threaded the waterways and jungle paths of the Maya world. Diplomatic relations and interdynastic marriage kept client states in thrall and eased tension between the larger kingdoms. Interpolity marriage, interdynastic kinship ties, competitive feasting and a traditional elite culture also created common ground, while a conventional written language, likely based on the pan-regional prestige language, Classic Ch'olti'an, facilitated the development of a widespread political charter and religious ideology.[5] Though city-states worshipped different patron gods, they shared a core pantheon and certain basic ideological assumptions regarding, for instance, the creation of the world, the resurrection of the Maize God and the underworld origins of humanity, all of which ensured some measure of interregional solidarity.

Alongside the religion promulgated by an ever-growing retinue of priests (*ajk'uhuun*, *yajawk'ahk'*) and scribes (*ajtz'ihb*), art and writing played equally crucial roles in maintaining the cohesion of Classic Maya society and in supporting the power of the divine kings. In this manner, the Lowlands witnessed a dynamic political and artistic climate that peaked during the Late Classic period (AD 600–900) and whose intensity was never again duplicated. Even the modern population density of the Maya Lowlands has yet to regain its Late Classic height, a blessing, perhaps, considering the tenuous balance between environmental conservation and economic development in this ecologically sensitive region. In fact, the seeds of doom were sown into the very success of Classic economic and political expansion. The Classic population explosion triggered environmental degradation, which was further exacerbated by severe droughts. Added to incessant warfare waged by a crowded arena of ambitious rulers, all of these factors led to the downfall of the Classic cities.[6] This so-called "Classic Maya collapse," largely a ninth-century phenomenon, was experienced differentially throughout the Lowlands.[7] Indeed, the northern Yucatan Peninsula, or Northern Lowlands, showed much more resilience to its effects and even experienced a kind of renaissance during the succeeding Terminal Classic/Postclassic periods (AD 900–1530). This era gave us the great architectural treasures of Chichen Itza and Mayapan, rich hybrids of Classic heritage and Central Mexican Toltec influences.

MAYA WRITING

Although clearly present in earlier times, as the dramatic San Bartolo murals and architectural masks of the Late Preclassic amply illustrate, it was during the artistically fertile Classic period that Maya writing truly came into its own, not merely on par but in synch with the pictorial arts. During the transition between the Late Preclassic and Early Classic periods (*c.* AD 200), Maya hieroglyphs assumed their characteristic *calculiform* or "pebble-like" shapes, not seen in either the Isthmian, Highland Guatemalan or Late Preclassic Lowland writing systems which were precursors in some other ways to the Classic Maya script. The rounded shape and three-dimensional modeling (when sculpted) of Maya glyphs were part of a trend toward stylistic parallelism between text and image,

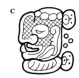

a b c d e f

something which was important for the development of both. Once in aesthetic harmony, text and image had tremendous potential for interaction, including on a basic level the back and forth borrowing of pictorial and symbolic elements.

Maya writing and art have much in common to begin with, since most of the signs that make up the writing system have evident pictorial origins. Maya hieroglyphic writing is composed of two major sign categories: syllabographs and logographs.[8] Syllabographs, literally "syllable signs," are entirely phonetic, conveying the sound of a conjoined consonant and vowel, such as **pa** (ill. 1a). Employed together with other syllabographs, these signs can spell out entire words. For instance, the word *pakal* "shield" can be spelled with the sequence of syllabographs **pa-ka-la** (ill. 1b) in which context the final *a* of **la** is essentially ignored. In other spellings the final vowel can be kept, indicating that these signs are indeed syllabographs rather than consonants proper. All Mayan signs have several variant forms, or *allographs*, and **pa**, **ka** and **la** are no exception. In some spellings of "shield," therefore, the simple net-like **pa** sign can be replaced by a humorous large-nosed creature that also reads **pa** (ill. 1c). In yet others, the simple comb-like **ka** sign, really a fish fin, can be replaced by a whole fish (ill. 1d). It is obvious to those familiar with Mayan languages that the simple **pa** sign likely derives from *paah* "net" whereas the animated **pa** derives from *pa'* "clown." Similarly, both the simple and animated **ka** signs certainly derive from *kay* "fish." While all syllabographs probably had a similar pictorial basis, most became heavily conventionalized and their sources are now obscure, as with the letters of our own Latin alphabet.

This is less true of the second class of signs, logographs, literally "word signs," which represent an entire word, such as the logograph **PAKAL** (ill. 1e). The sign depicts precisely what it denotes: a small hand-shield. It is important to note, however, that there is still a profound phonetic character to such signs, since this sign always reads **PAKAL**, and never any other word for "shield." A few signs are bivalent and function as both logographs and syllabographs, but these are exceptional cases and seem to be the result of complex historical developments. For instance, the **BAAH** "gopher" sign became a syllabograph for **ba** in very late inscriptions, though only after the vowel length and final -*h* of the word for "gopher" began to be lost in the spoken language.[9] In any case, logographs are usually more or less accurate depictions of objects or actions, albeit formatted to fit within the regimen of the rounded glyph block. They most often represented things pictographically (i.e., in an iconic or literal way), as when a realistic jaguar head stands for the logograph **BAHLAM** "jaguar." Equally pictorial, implements were frequently employed to convey the verbal actions undertaken with them, such as the depiction of an axe for **CH'AK** "to chop," a hammer for **BAJ** "to

1a syllable **pa**.

1b syllables **pa-ka-la** spelling *pakal*.

1c *pakal* spelled with 'clown' allograph of **pa**.

1d *pakal* spelled with 'fish' allograph of **ka**.

1e logograph **PAKAL**.

1f logograph **PAKAL** with phonetic complement **-la**.

pound" and steps for **T'AB** "to ascend." Others may have operated somewhat metaphorically, such as the probable origin of **AK'AB** "darkness, night" in a stylized depiction of snake scales.[10] In this way, logographs served the purposes of both writing and art.

Most Maya texts consist of combinations of syllabographs and logographs. For instance, as just discussed, the most typical spelling of the word for "shield" was the logograph **PAKAL**, itself the depiction of a shield. However, this sign was conventionally associated with the syllabograph **la** (ill. 1f). In conjoined form, the syllabograph serves as a redundant phonetic complement, reinforcing the logograph's final consonant (-*l*). In Maya writing, signs are frequently fused together in this manner to form compounds or *glyph blocks*. Typically, glyph blocks correlate with individual words and even with parts of speech (e.g., verb, object noun, subject noun), but they are not restricted to such usage. In practice they can combine several distinct words or, more rarely, represent entire sentences. The writing system's approach to sign formation in glyph blocks and other conglomerations is frequently echoed in the organization of symbols into clustered units in pictorial art.

The shared inventory of logographic signs and iconographic symbols, coupled with shared approaches to sign combination, permitted a free flow of pictorial elements between Maya art and writing. As a result, Maya art is frequently comprised of embedded logographs, and otherwise straightforward depictions of individuals and objects in pictorial art are often identical to expanded forms of logographs. Further consolidating this relationship is the fact that Maya priests (*ajk'uhuun*), the producers and curators of both art and writing, were apparently trained in both glyphic and symbolic communication. In other words, the same individuals were both artists and scribes, putting them in a commanding position to innovate new forms of text–image interaction.[11]

Because of these shared contours of Maya art and writing, one particularly effective way of making sense of its alien appearance is to examine it from the point of view of logographs, which constitute a major portion of its symbolic vocabulary. In the following pages we offer a catalog of one hundred logographs, explaining their individual meanings, phonetic values and pictorial origins, and exemplifying the various ways in which these signs related to contemporary pictorial art. We also describe the logographs in some detail since their appearances in iconography can be difficult for the novice viewer to comprehend at first glance. The catalog also includes a few syllabographs which have remained faithful to their pictorial sources and are therefore easily recognized in iconography. We nevertheless hasten to point out that the organization of the catalog does not follow any previous cataloging system of Maya hieroglyphs. We make no claims whatsoever about the wider applicability of this cataloging system, and base our organization on a list of thematic headings chosen solely to highlight the close interaction of glyphs and art. In the remainder of this Introduction we offer some further observations on the nature of Maya art in regard to symbolic representation. We hope that this information, along with the catalog, will help students acquire the iconographic literacy necessary to read Maya art.

One general characteristic of ancient American art is a facility to alternate between realistic and conceptual modes of representation. Maya art is the supreme exemplar of this pan-American artistic tradition. Motifs could appear in one of several guises ranging from naturalistic depictions to those using abstract abbreviations and symbols. Artists chose one approach over the other based on the compositional format, space limitations, and the nature of the subject matter. The conceptual renderings are what interest us here. They seem opaque for those who expect pictures to look like snapshots of the visible world, which modern artists make more comprehensible through perspective, foreshortening and light and shadow. Though Maya artists only rarely used these techniques, they were nevertheless acutely interested in accurately rendering the visible world. This is especially obvious in Late Classic art, when artists rejected the stiff, cluttered style of the Early Classic in favor of greater naturalism. Lifelike depictions of Late Classic rulers, complete with signature characteristics of portraiture as broadly construed, clearly demonstrate that realism was well within their capabilities.[12] Given this interest, Late Classic artists did employ certain illusionistic tricks, such as foreshortening, overlapping and the use of architectural cues to suggest a shallow three-dimensional space. Yet other content-driven techniques were far more important and were derived from an already extant and well-developed symbolic system: hieroglyphic writing.

Property Qualifiers

For a variety of reasons – including the close ties between writing and art in all phases of Maya history – Maya artists represented many aspects of the visible, olfactory and audible worlds in a unique and interesting way. For instance, while the illusionistic painters of seventeenth-century Europe excelled at capturing the surface appearance of things, the Maya conveyed the properties of materials through the use of embedded hieroglyphic symbols that we might call "property qualifiers." One subset of these qualifiers indicated the constituent material of a given object. For instance, wooden objects such as canoes, trees and axe-handles regularly bore the distinctive markings of the logograph **TE'**, a general sign for "wood" ultimately derived from the depiction of a tree branch (*see* tree/wood (71)). Stone objects, such as mountains, altars and axe-blades, are likewise identified by **TUUN** "stone" markings (*see* stone (70)). Even bright, shiny objects like mirrors, obsidian knives and jade jewelry forgo photographic faithfulness of depiction in favor of incorporated symbolism. In these cases a sign which otherwise functions as the logograph for a ceremonial celt – itself a bright, shiny object – serves to connote the inherent qualities of these materials (*see* jade celt (21)). It has long been recognized that gods are frequently labeled with this device, marking them as brilliant heavenly beings.[13] Bone is another material marked by a property qualifier: a wavy line representing the suture lines on bone, the critical diagnostic of the logograph **BAAK** "bone" (*see* bone (13)). Having a coded way to mark bone allowed the Maya artist not only to easily distinguish

the living from the dead in cases where this might not otherwise be obvious, but also to indicate connections with the powerful Underworld.

A second type of qualifier might be thought of more narrowly as a color label. Maya artists regularly indicated colors symbolically, an advantage in text and art largely carved in stone or etched in wood, and to which the Maya only sparingly added paints. For this reason, hieroglyphic signs for colors were employed as the iconographic equivalent of paint. Thus, fields of cross-hatched lines – diagnostic of the logograph **IHK'** "black" – are regularly employed to mark spotted jaguar pelts, balls of rubber, swirls of smoke and the dark pupils of the eyes (*see* black (46)).[14] These characteristic markings also define shrouded nighttime imagery in both art and writing. By contrast, yellow or pale-colored objects such as turtle carapaces, canoe paddles, gopher fur and brightly-dyed fabrics incorporate an infixed cross shape, the hieroglyph **K'AN** "yellow," "pale" or "ripe" (*see* yellow (49), gopher (82) and turtle (89)). Other signs served to bring out hidden properties. For instance, an **AK'AB** "darkness, night" sign appearing on ceramic vessels apparently indicates the color of the material hidden inside, often rainwater or dark alcoholic beverages (*see* darkness/night (58) and ocean/sea (56)). Similarly, a band marked by cross-hatching characteristic of the **IHK'** "black" logograph appears on bones, probably indicating the color of the bone marrow hidden within (*see* bone throne (33)).

Another type of qualifier is more conceptual in nature, serving to classify an object or entity into categories that the Maya employed for organizing their world. One such category, only recently recognized, is that of nocturnal or crepuscular animals. In Mayan languages, such creatures are frequently described by the term *ak'ab* "darkness, night" and – when functioning as an adjective – "nocturnal." By way of example, the Yucatec term *áak'ab máax* literally means "nocturnal monkey" but refers specifically to the kinkajou or *mico de noche*. Similarly, the Itzaj term *ak'ä' ch'üch'* means "nocturnal bird," but is widely employed as a label for various owls, the quintessential nocturnal bird. As a final example, *pehpem* is the Ch'olan term for "butterfly," whereas *ak'ab pehpem* is "moth." Intriguingly, Nahuatl shares the same feature, where *pāpālōtl* is "butterfly" and *yohualpāpālōtl* (literally "night butterfly") means "moth." Most importantly for our present purposes, the Maya adapted this principle of their language and cognition into a conceptual label in art and writing. Thus nocturnal animals are routinely labeled by the **AK'AB** "darkness, night" sign throughout Maya art (*see* bat (74), firefly (80) and jaguar (83)). The same is true of Maya writing, where syllabographic and logographic signs derived from portraits of nocturnal animals consistently take the **AK'AB** marker to label them as such. What is most intriguing about this feature is that the **AK'AB** label is clearly not meant to be read. Rather, it makes a silent, extralinguistic contribution to our understanding of the sign, its origins and its wider semantic compass.[15]

Finally, symbolism embedded in artwork could even evoke sound and smell. Musical instruments – including trumpets, drums, hanging shells, jade ornaments and rattles of all kinds – were regularly tagged with the logograph **IK'** "wind," evoking the sounds they must have made (*see* wind (73)). Even the human

voice could on occasion be tagged with this sign or its corre-late, a thin ribbon of visible sound that modern scholars have dubbed a speech scroll (*see* 52.2; 92.2; 96.3). Disembodied examples of the speech scroll, seen pictorially marking the sound of bouncing balls (*see* 39.2) and heavy blows (*see* 14.2), make clear that the sign was conceived of more broadly as the symbolic indication of sound itself. A spiral element marked strong musky odors (*see* deer (78)), while sweet scents and soothing sounds were indicated by the presence of flowers (*see* 30.1; 90.3).[16]

The foregoing may seem like an overly analytical approach to art appreciation. Yet, it is increasingly apparent that much of the remarkable detail in Maya art is there to supply such densely encoded information. In spite of the analytical demands on interpretation, there can be little doubt that these compositions evoked strong emotional responses in the literate Maya viewer, who would have negotiated such symbols with ease and reveled in seeing a familiar world writ large in clever pictures. For Maya scribes and artists, the marriage of symbol-ism and narrative pictography was even more faithfully representative of their environment than the work of the illu-sionists alluded to above. Beyond the mere surface appearance of objects, Maya iconography was a tour de force that could represent composition, color, quality, texture and even sounds and smells in a detailed visual and symbolic language that cor-related closely with speech.

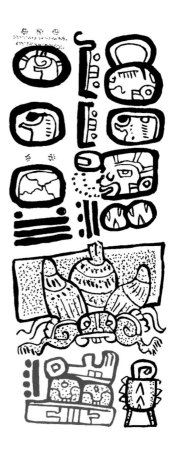

2 Scene from beekeeping almanac. Madrid Codex, page 106b. Late Postclassic.

Art and Spoken Language

In the language of the hieroglyphs, the noun *tz'ihb* refers to "writing" as well as "painting" in its broader artistic meaning. Paralleling this, images often served as mnemonic devices for oral recitations, and in this sense were probably read like texts. This is certainly the case with the Late Postclassic screenfold books, which were used by priests as agricultural almanacs and for recalling the timing and liturgy of the ritual cycles of the ceremonial calendar. In practice, juxtaposed texts and pictures were quite possibly read aloud, as the pictures incorporate lin-guistic cues in the form of embedded logographs for precisely that purpose. For example, a scene of an offering of nine maize tamales in the Madrid Codex is expressed in purely glyphic terms, showing the numeral for "nine" (obviating the need to repeat the object nine times), next to two tamales rendered as the logo-graph **WAAJ** "tamale," above which is the logograph **TE'** spelling the common numeral classifier *te'* (ill. 2). Hence, the picture faithfully translates the verbaliza-tion *baluun-te'-waaj* "nine tamales," which was probably read aloud by the priest.

In a similar vein, the interaction of text and imagery on a Late Classic painted polychrome vessel from northern Guatemala literally provides the viewer with an invitation to read the scene aloud (ill. 3). The associated text begins with

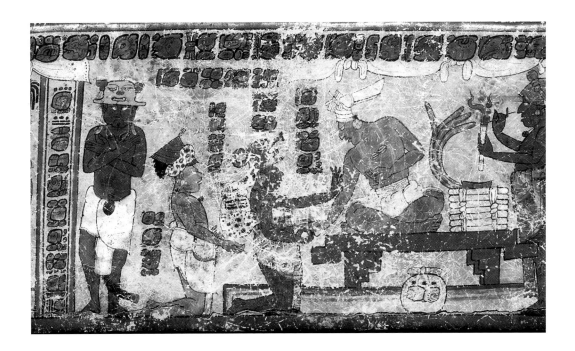

3 Emissary from
Calakmul visits the
king of Tikal.
Rollout photograph
of unprovenanced
painted vase. Late
Classic.

descriptions of the participants in a tribute scene: the kneeling figure, K'ahk'
Hix Muut, is said to be a messenger (*ebeet*) of the king of Calakmul, Yuknoom
Yich'aak K'ahk' II.[17] The event takes place in AD 691, suggesting that the seated
figure is none other than the contemporary king of Tikal, Jasaw Chan K'awiil
I.[18] Following these introductions, however, the text fails to record the actual
events of the scene, ending instead with the enigmatic verbal phrase **u-ti-ya** or
uht-iiy "it happened." At this point, we may perhaps be forgiven for asking what,
precisely, happened. The answer is that we are surely meant to read directly from
the last line of this text to the associated scene itself, which depicts not only the
actual meeting of the two protagonists described in the text, but also the tribute
evidently brought by the messenger of Calakmul to the king of Tikal: precious
textiles, quetzal feathers and a large, cloth-wrapped bundle. While perhaps not
quite worth a thousand words, the picture obviously supplies the remainder of
the narrative, both contextualizing and expanding the information provided by
the hieroglyphs. Additional hieroglyphs are employed throughout the scene as
name captions for lower-ranking participants and as qualifiers for the items
depicted in the scene itself. Note especially the glyphic label on the tribute
bundle, clarifying its invisible contents as 3-**PIK**, *uhx pihk* or 24,000 (i.e., 3 ×
8,000) cacao beans. Such uses of glyphs and narrative pictography highlight the
complex interweaving of text and imagery throughout Maya art.

Contour Outlines

The formal character of Maya art in its conceptual mode is in lock step with the
writing system. Many of the rules governing the combination of hieroglyphs
into compounds also applied to the composition of elements in pictures. Because

Maya art and writing are essentially linear, outline plays a dominant role in defining components of a picture, to the virtual exclusion of other descriptive techniques, such as modeling and color, although the latter is of more importance in murals and painted ceramics. Understanding how outline contours work is therefore a prerequisite for discerning the different elements that make up a scene.

In Maya art, contours and the shapes they describe are relatively flexible, as are the outlines of glyphs on account of their rounded edges; as mentioned earlier, Maya hieroglyphs have been characterized as *calculiform*, or pebble-shaped. But they could just as easily be described as amoeba-like, for their outlines are less codified than is apparent at first glance and display a striking readiness to compress, bend, stretch and distort. Such adjustable contours allowed signs of radically different shape to combine into a single glyph block. Coupled with the visual abbreviation of sign-elements, this also allowed texts to fit into any available space. Indeed, it is no exaggeration to say that sign clustering, the basic technique of glyph formation, could not easily have been achieved without recourse to such fluidity of shape and outline, or to the abbreviation of sign components. Given that contours and shapes were so adjustable, both iconographic and glyphic distinctions relied heavily on diagnostic markings within contour boundaries. Discriminating signs in this manner freed the artist from adherence to rigid outlines and encouraged the organic, free-flowing calligraphy for which the Maya are so famous. Egyptian art and hieroglyphs might be seen as having diametrically opposed characteristics, since they emphasize rigid, precise, standardized contours guided by naturalistic canons of proportion. We might compare Egyptian and Maya art in another way. The style of Egyptian art has been characterized as one of disarticulation, that is, seeking to separate elements in order to preserve their individual identity, whereas the style of Maya art emphasizes articulation, ways of joining, blending and fusing elements. In Egyptian art, naturalistic shapes of depicted objects were rarely violated, whereas obliterating normal shapes for the sake of composition and sign clustering presented little obstacle to Maya artists and scribes. Even the human body was not exempt from this, but could be readily distorted and even amputated, with various integral body parts – such as a jaw, forehead, eye or leg – replaced by other symbolic elements.

Incorporation of Logographs into Pictorial Art
Current evidence suggests that all Maya signs were ultimately derived from pictorial art. That some logographs *appear* to be abstract is the result of processes of scribal standardization and the evolution of sign-forms through time and of processes of abstraction and convergence inherent in sign invention. What is meant by sign convergence can be understood by comparing the logographs for drum (30), cushion throne (34) and book (41) (ill. 4).

These signs follow the same formal template, one apparently reserved for objects covered in jaguar skin. All three signs share an identical rounded cartouche, the top half of which shows a piece of jaguar pelt with its scalloped edges

a

b

c

4a logograph for drum (?).

4b logograph for cushion throne (**TZ'AM**).

4c logograph for book (**HUUN**).

referencing the results of stretching fresh hide. The signs are discriminated in their lower parts by unique symbols: an **IK'** or "wind" sign for the drum, a dimple for the cushion and a series of lines representing pages, as well as a corresponding "back cover" of jaguar skin, for the book. Many logographs follow such formulaic models and seem less concerned with the true appearance of an object than with rules of abstraction governing the depiction of objects of a particular type or shape. Yet, even after being subjected to extreme conventionalization, logographs reentered the pictorial arena as imagery, bringing with them the model of the template. Thus, an initial phase of glyphic codification partly accounts for the obtuse appearance of at least certain elements of Maya iconography. Put another way, imagery codified through logography had a license to function, as it were, conceptually in art. As such, the image of a scribe's hand holding a brush, which seems to have become a rare logograph for "writing" (**TZ'IHB**), also appears as an autonomous glyph-like element in pictorial compositions (*see* writing (43)).

Maya art readily embeds logographs into scenes that are otherwise depicted quite naturalistically. For instance, on the limestone tablet from Temple XIV at Palenque (*see* 67.2), the logographic signs **HA'** "water" and **IK'** "wind" are incorporated – along with a stream of stylized bubbles, leaves, cut shells and other aqueous imagery – into a ritualistic scene of dance and ancestral veneration, textually identified as having taken place in an important local cave. In Maya thought, caves were the abode of deities responsible for both winds and rain, elegantly explaining the artistic incorporation of these signs into the scene.

As alluded to above, even logographs lacking an obvious resemblance to their referent were fair game for incorporation into pictorial art. This is illustrated in a scene from the Madrid Codex featuring a Death God burning sweet-smelling incense (ill. 5). Sitting in the brazier, however, is not a straightforward depiction of burning incense, but rather the logograph **CH'AAJ**. Although its pictorial basis is obscure, this sign clearly refers to incense in the form of drops of liquid resin (e.g., *ch'aaj* "drops" and *ch'ajal te'* "resin," literally "drops of a tree"). While incense is normally portrayed as clusters of small balls, the artist here chose to represent this substance in a guise drawn directly from the writing system. What may have motivated this choice is a desire to differentiate liquid incense from the hardened variety. This would have been difficult in a realistic rendering, as both forms are effectively droplets. Yet in Maya ritual the distinction was important, and the use of a logograph may have been intended to avoid ambiguity.

As should be obvious from the preceding examples, logographs were regularly incorporated wholesale into pictorial art. It is important to note, however, that there is no

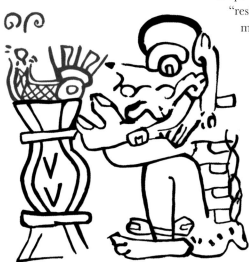

5 Death God offers liquid incense. Madrid Codex, page 50a. Late Postclassic.

corresponding relationship between syllabographs and art, which seem to have been both functionally and conceptually set apart. As units of sound rather than meaning, syllabographs were not well adapted to signification within the medium of art. Rare exceptions appear largely restricted to the domain of personal names, discussed below, which are by their very nature more closely related to spoken language than to art. This underscores an important difference with logographs, which apparently maintained much closer linkages to the objects from which their standardized forms were drawn. The perennial utility of logographs in art, coupled with the aesthetic concerns of ancient calligraphers, may partly explain why syllabic writing never developed to the exclusion of logographs in Maya script.

The incorporation of meaningful portions of logographs into art could involve a subtle allusion to glyphic features, or, on the other hand, their obvious assimilation. The latter is well illustrated on the famous sarcophagus lid of K'inich Janaab Pakal I, the well-known 7th-century king of Palenque. Here, the king is portrayed at the precise moment of his resurrection and apotheosis as a deity (*see* 21.3). His posture, in particular, is what interests us here. Legs bent, head thrown back and arms held limply before his chest, the king's body is intentionally posed like the logograph for "baby," **UNEN** (*see* baby (1)).[19] Similarly, the burning axe-head emanating from his forehead evokes the logograph **K'AWIIL**, a well-known lightning deity. Taken together, these hieroglyphs qualify the king as the deity *Unen K'awiil* or "Baby K'awiil," a prominent local god with maize associations whose images also decorate the piers of the king's funerary temple (*see* pyramid (38)).

Somewhat more subtly, elaborate poses and gestures characteristic of logographic signs could also be incorporated into figural art in order to lend their significance to the larger composition. This can be observed in the striking similarities between a logographic sign for misfortune or woe, known largely from the codices and a few occurrences in Classic writing, and the poses of grief-stricken figures in Maya art.[20] On one Early Classic incised vessel, a group of mourners effectively mimic the diagnostics of this sign as they hold their hands up to their eyes while wiping away tears at the death of their king (ill. 6). A parallel scene occurs on a Late Classic incised bone from Tikal, where the Maize God is depicted in this selfsame grief-stricken posture as he is metaphorically taken to the land of the dead in a canoe peopled by animals and other supernaturals (*see* 50.2). Maya art features numerous other poses either derived from or codified in writing, and we discuss baby (1), front (15), sit (17) and throw (20) in much more detail in the following Catalog. The incorporation of logographs into figural art was a pervasive practice, and the importance of these conventions to a fuller appreciation of Maya art cannot be overstated.

Abbreviations

Abbreviated representation was one of the main strategies adopted by Maya artists and scribes for innovating formal solutions to pictorial and textual composition. Various types of abbreviations were employed for logographs and their

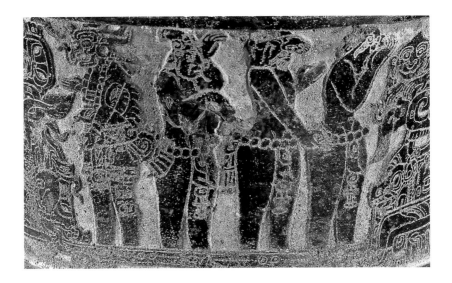

6 Carved vessel with mourning scene. Berlin Tripod. Early Classic.

corresponding pictorial symbols. In general, depictions of objects were reduced to their most diagnostic features, and those that were not required for correct identification were simply omitted. Particularly characteristic traits were usually emphasized. Further, symbols could be compressed through distortion, shown in partial view by cutting off some detail or represented by one element of a more complex array. This latter technique is known as the *pars pro toto* principle, or as *synecdoche*. Both terms refer to a situation in which an entity is represented by a prominent or representative part of the whole. Maya artists and scribes had a wealth of these shorthand substitutions at their disposal, and they added to a whole arsenal of options for altering the composition and details of conventional subject matter. Through such formal variation, the imagery never lost interest because of thematic repetition.

Certain conventional symbols are abbreviations of larger entities. One of these is the **HA'AL** "rain" sign (*see* rain (67)).[21] This strange-looking motif is visually derived from the spiral end of a conch shell. The spire was stylized as a stack of increasingly smaller rectangles, and this became a shorthand notation for the whole shell, which in turn symbolized water and, presumably through extension, rain. The **HA'AL** sign was itself subject to extreme stylization, including the attenuation and separation of the rectangles, making its pictorial source very difficult to recognize. Interestingly, in the art of Teotihuacan, an important central Mexican city, the same conch shell tended to be abbreviated by the convoluted section *below* the spire, and this despite the fact that it also seems to have symbolized rain in that tradition. However, the stylized spire with its flat bottom worked well for the Maya, who could invert it to suggest falling rain, the ultimate origin of the **HA'AL** "rain" sign (*see* rain (67) and 57.2). Scribes could also string a long line of these symbols out like so many tiny floating boats to create an implied surface of water: rippling, undulating and occasionally spraying, not unlike rain itself (*see* 71.1, 50.2–3).

Another type of abbreviation concerns the use of specific body parts as signifiers. In the hieroglyphs, whenever a body part, such as a hand, head or torso, was used as an autonomous sign, it usually bore a circle with a tiny interior dot placed at the location(s) where that body part would have connected to other parts of the body (see, for example, penis (16), skull (18), sit (17) and throw (20)). This circle, which we call a "partitive disk," is itself a sign, albeit a non-linguistic one, associating the body part in question with a complete, living entity, rather than simply a severed head or hand.[22] The distinction is important, for body parts actually intended as severed were marked with serrated edges and droplets of blood. For the Maya, who decapitated their enemies, these differences probably necessitated ready disambiguation, and a head cited apart from its host body was distinct from a head severed from that body.

a

b

c

7a tamale. Madrid 35b.

7b iguana tamale. Madrid 107a.

7c iguana scutes. Madrid 106a.

Conflation

Some interesting abbreviations are found in the pictorial scenes of the codices. Because they were tools of educated priests and each scene had restricted space, their imagery tends to be especially economical and conceptual, freely combining glyphic and descriptive representations, often in shorthand forms. For instance, one typical offering consists of a bowl containing a maize tamale represented by two different logographs, both reading **WAAJ** "tamale" (ill. 7a). A variant on this theme shows an iguana resting on the tamale logograph (ill. 7b). While this configuration might simply refer to a tamale incorporating iguana meat, it is also possible that it references a type of ritual tamale made into an iguana-shaped loaf; such elaborate tamales are still prepared for special occasions in Yucatan. In another scene from the Madrid Codex the tamale, now bearing dorsal scutes and an arching spine, has fused with the iguana (ill. 7c). This type of abbreviated representation is called *conflation*, a basic feature of the writing system whereby the details of different glyphs are consolidated into one. Conflation was an option for the Maya artist, and it offered tremendous latitude in varying pictorial representation, as well as reducing the size of an image.

Head Variants and Personification

Writing and art also relied on another kind of referencing system called *personification*, seen above in the discussion of animated variants of the **pa** and **ka** syllabographs. A particularly common type is the so-called "head variant." In a written text, animate beings such as humans, animals and gods are often indicated by their portraits only, though so-called "full-figure" forms were occasionally employed for more spectacular effect (*see* 70.4). Not only is a portrait head conveniently small for insertion in a glyph compound, but its compact shape also articulates well with other rounded glyphs. Head variants were so popular that they even served as alternate ways of writing abstract concepts, such as numbers (*see* 58.3; 45.4). The number four, *chan*, could be written as the head of the Sun God (elsewhere read **K'IN** "sun"), and two numbers were personified by the head of the Maize God, the number one, *juun*, by the Tonsured Maize God (elsewhere read **IXIM** "maize") and the number eight, *waxak*, by the

Foliated Maize God (elsewhere read **AJAN** "corn cob"). Many phonetic and log-ographic signs are also personified. As an example of the extraordinary variation that could be encompassed within any single syllabograph, consider the **pa** sign again, whose most simple form is a cartouche with an inset net. Variant forms include both a long-nosed, thick-lipped head variant (the portrait of the Maya *pa'* or "clown") and a grotesquely humorous full-figure form (*see* clown (2)). Although the diagnostic cross-hatching is maintained in all three per-mutations of the sign, this seems little consolation given the overwhelming number of details present in full-figure examples. Such remarkable variation reveals a passion for personification. Indeed, so strong was this tendency that all hieroglyphs – regardless of their ultimate origins or how abstract they might have become – could on occasion sprout a vestigial mouth, nose and eyes. In extreme cases they could even grow a trunk, arms and legs.[23]

Personification is equally widespread in Maya art, where its characteristic forms and contextual variations echo the use of head variants in the writing system. Jewelry, thrones and clothing are frequently personified with the attach-ment of a conventional zoomorphic face. Ritual paraphernalia, such as eccentric flints, obsidian blades and stingray spines, are also given faces. Nearly all plants had personified versions, whether an ear of corn, a leaf, a flower or a tree. The monstrous, chimerical personification of trees – involving a jaguar ear, missing lower jaw and streams of blood – was frequently stuck into the base of trees in art, and regularly appeared in the script as the head variant of the logo-graph **TE'** "tree" or "wood" (*see* tree/wood (71)). Underlying the extensive personifications in Maya art and writing is the view that all things in the universe are living and vitally interconnected. One could compare this to Native American art of the Northwest Coast which also makes use of small conven-tional heads, eyes and ears inserted at various points on larger figures to suggest the presence of a vital force shared among all living things. We will return to this concept below in our consideration of the motivations for the inclusion of glyphic labels and captions in pictorial art.

Metaphors

Both Maya art and writing relied heavily for its expressive content on visual metaphors. A visual metaphor is a depiction of something wholly different from what it represents, but of which it is nevertheless suggestive in some associational or symbolic sense. Symbols for water, mentioned earlier, such as the water lily (**HA'** "water") and shell (**HA'AL** "rain"), illustrate the metaphorical nature of Maya iconography, where things are not always portrayed in a 1:1 fashion but are occasionally labeled with associated objects or ideas. This kind of oblique referencing is a powerful tool of communication as much in the visual arts as it is in spoken language. By using widely understood metaphors, even for such a basic constituent in a scene as water, the Maya could not only convey the idea behind the metaphor but also portray that idea in more vivid and semantically layered terms. As symbols go, metaphors are perhaps the most stimulating to the imagination. By representing water as a flowering plant, as the Maya did with

the water lily sign (*see* water/pool (72)), the artist has introduced the pleasant sensory associations of flowers. Metaphorical substitutions further added to the arsenal of strategies for varying composition and design. However, the extensive use of metaphor requires that the viewer be educated in the Maya system of metaphorical reference in order to grasp the imagery on all of its levels.

To understand how this works we might look at the Resurrection Plate (*see* 89.3). On a basic level, this shows the birth of maize from the earth, related to a story involving the rebirth of the Maize God. The scene is constituted largely of metaphorical references. The earth itself is represented as a turtle carapace, aptly symbolizing the earth as a flat plate surrounded by the primordial sea. The water on which the turtle floats is shown under the turtle's belly as a water lily, with flower to the left and pad to the right. Below this is a dotted water scroll – a shell-like device also signifying water – and the aforementioned water stacks symbol for rain. Repetition of aqueous symbolism in three distinct guises not only enhances visual interest, but also dispels ambiguity of content since the shared connotations of the **HA'** "water", **HA'AL** "rain" and the still enigmatic water scroll sign are invoked, rather than each sign's unique denotations. While the artist was perfectly capable of showing a turtle floating in water in a more realistic fashion, he chose to reduce the painted elements to symbols and to cluster them like glyphs. Choosing between naturalistic and symbolic references was part of the creative process, seemingly dictated both by convention and individual design solutions.

The image of maize bursting out of the earth entails other metaphors. The maize sprouts from a seed, shown as a skull buried deep in the turtle's back. This imagery reflects a widely shared mythological theme in Mesoamerica whereby new life springs forth from old bones, much as new maize grows from old maize seed. An Aztec creation myth tells of Quetzalcoatl letting blood on a pile of bones to create human life. In the Colonial K'iche' Maya document called the *Popol Vuh*, a skull impregnates a woman by spitting into her hand.[24] A bone – hard and inert but redolent with life force – is an apt metaphor for a seed, and a number of Mayan languages metaphorically refer to seeds as bones, indicating that the visual pun had strong correlates in speech.

Finally, the sprouting maize is shown as a smoking torch. This is a more obscure but nevertheless intriguing symbolic reference that seems to have both a formal and semantic basis. The bundle of sticks and smoke scrolls vaguely recall a stalk and sprouting leaves. That such an equation might be made is suggested by the general practice of stylization and standardization in Maya writing and art, wherein simple but unambiguous graphic forms were often innovated at the cost of an easily recognizable relationship between a sign and its denotation. This is perhaps best illustrated by the "scroll" sign, which could have at least four standardized meanings, including smoke/flames, maize foliage, scent (including breath and flatulence) and liquids like water and blood. Motivating this extreme degree of sign standardization, perhaps, was an underlying conceptual interrelationship of the denoted items as actual or metaphorical "sustenance." One might reasonably ask what smoke and/or flames might have to do with this

concept. Produced through ritual burning of sacrificial offerings, smoke was believed to provide divine sustenance, just as blood and the scent of flowers or burning incense sustained the gods, and as maize sustained humans. Because of these symmetries, and because of the pressure of sign standardization, an initially diverse set of scroll signs with somewhat distinct formal features and wholly different denotations – smoke/flames, maize, scent, etc. – developed in time into a standardized scroll that invoked the shared theme of the entire set: actual and metaphorical food.[25] On the Resurrection Plate, the metaphorical substitution of a flaming torch for maize foliation, though initially incongruous to our eyes, signaled to the ancient Maya that these larger themes were in play. It should come as no surprise, then, that the sprouting maize plant is shown in yet another metaphorical guise: the youthful Maize God emerging from the crack in the back of the turtle.[26]

Glyphic Captions and the Interaction of Text and Image

Maya art's love of oblique referencing, through metaphor and shorthand notations, introduced a degree of ambiguity into the reading of pictures. However, this was countered by a system of labeling, so that the names of actors and places in a scene had unerring accuracy. Name and place glyph notations – the latter also referred to as *toponyms* – represent one of the most ancient, widespread and enduring uses of writing around the world. Indeed, it is likely that phonetic writing itself actually evolved precisely in order to provide such unambiguous, language-linked labels.[27] Thus, some of the earliest writing in Mesopotamia and Egypt provides the royal names of rulers and the designations of the objects owned by them. Similarly, borrowed scripts, such as Runic and Etruscan, see their first uses in labeling objects. Mesoamerican art traditions are no exception to this general pattern, and numerous Mesoamerican cultures, from the Aztec to the Zapotec, devised ways of assimilating name and place glyphs into iconography. A protagonist's name was frequently converted into details of headdress or other costume elements. Thus, actors in a scene literally wore their names, quickly allowing viewers to grasp their identities and move on to the content of the narrative.[28] Similarly, place names were regularly introduced into pictorial compositions by the use of topographic symbols, such as **CH'EEN** "cave" or **WITZ** "hill, mountain." These could in turn be conjoined with specific logographs, so that a sign for "jaguar" (**HIX**) could be combined with **WITZ** to make **HIX-WITZ**, *Hix Witz* "Jaguar Hill." This is precisely how the writing system works, of course, though with the important difference that actors could actually stand on these symbols in art, thereby situating themselves and their actions within specific locations.[29]

Maya art offers some of the most elaborate and ingenious examples from anywhere in the world of the pictorial assimilation of name and place glyphs. Stela 31 from Tikal illustrates at least four

8 Portrait of Maya king embeds hieroglyphic names. Tikal Stela 31. Early Classic.

ways that this was accomplished for name glyphs, each having a somewhat different visual effect (ill. 8). This Early Classic stela, densely packed with imagery, features the 5th-century Tikal ruler Sihyaj Chan K'awiil II. His right hand holds aloft a headdress that commemorates his grandfather, Spearthrower Owl. This connection is made explicit by a small cartouche placed above the headdress that bears an iconic rendering of his grandfather's name (a spear-bearing owl). Read as a textual label, the glyph is affixed directly to the object, in this case labeling it as an heirloom that had once belonged to Spearthrower Owl. More than just an heirloom, however, the associated text tells us that Spearthrower Owl was actually present in some way at the katun jubilee depicted on the stela's face. The labeling of this important ceremonial item was thus more than just a "name tag." Rather, it served to highlight a profound personal connection between this item and its erstwhile owner, such that the one apparently presupposed the other.

Important figures in Maya art often bore name tags which maintained their integrity as pure text. But glyphic labels just as often blurred the boundaries between text and imagery. Sihyaj Chan K'awiil II, for example, carries his own hieroglyphic name on top of his headdress, seen as the head and arms of the god **K'AWIIL** emerging in a baby-like posture (**SIHYAJ**) from the cleft in a sky glyph (**CHAN**). The king's name meant "Heavenly K'awiil is born." The lack of a frame and the dynamic propulsion of the glyph make it appear like any other iconographic motif projecting from the headdress; it is completely assimilated into the iconography. This is also true of another glyphic tag resting just above the earflare, naming Tikal's dynastic founder, Yax Ehb Xook.[30] The elements of his name – a lashed wooden ladder and a shark head with a **YAX** glyph at the tip of its nose – merge seamlessly with other iconographic details of the headdress. At the very pinnacle of the scene, the down-peering head of the Sun God (**K'INICH**) represents the king's deceased father, the previous ruler Yax Nuun Ahiin I. In yet another variation, his headdress *is* his hieroglyphic name, consisting of a crocodile head (**AHIIN**), a **YAX** glyph and a knot (**NUUN**?). Since many headdresses of Maya rulers were zoomorphic, the crocodile head was easily adapted to the helmet portion of the headdress. The **YAX** glyph sits on the end of its nose, and the knot sits on top of its head.

Personal names of rulers also became part of imagery by being transformed into seats or thrones, an iconographic ploy especially favored by sculptors at Copan. Altar Q of Copan is far and away the most spectacular example of the hieroglyphic name as throne. Wrapping around this box-shaped sculpture is a sequence of sixteen rulers, representing the king list of a single dynasty spanning some 350 years (ill. 9). Fourteen of the rulers occupy thrones spelling out their names in logographs. One of two exceptions is the dynastic founder K'inich Yax K'uk' Mo' who actually wears his name in his headdress. It consists of a bird combining both macaw (**MO'**) and quetzal (**K'UK'**) features, as well as **YAX** and **K'IN** glyphs.[31] The founding monarch sits on a glyph merely reading **AJAW** "lord." Yax Pasaj Chan Yopaat, the sixteenth-century ruler of Copan, not only commissioned Altar Q but may well have used it as a throne himself, thereby echoing the illustrious seated forebears beneath him.

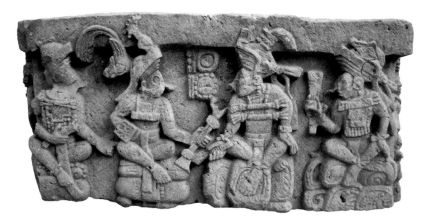

As regards the incorporation of place names into pictures, many different categories of place could be referenced. One is the so-called "emblem glyph," identified in texts by its occurrence in formulaic compounds. Although traditionally interpreted as territorial references to city-states or kingdoms, there are growing indications that emblem glyph compounds instead labeled high-ranking members of certain lineages, albeit frequently with a place name at their core.[32] On the aforementioned Stela 31 (ill. 8), the Tikal emblem glyph – possibly representing a somewhat stylized reed effigy of a crocodilian[33] – rests on the head of a jaguar god held in the crook of Sihyaj Chan K'awiil II's left arm.

Apart from the emblem glyph, kingdoms had other proper names or toponyms. Some refer not to the kingdom as a whole but to places within or near the city, including hills, caves and lakes, and other prominent topographic features. Toponyms are typically introduced into stela and altar iconography in the basal register. One important example can be found on Caracol Altar 12 (ill. 10a), where a complex glyphic compound serves as the seat of a 9th-century king of Ucanal and provides two separate toponyms: [**K'AN**]**WITZ-NAL-la**, *K'an Witz Nal* "Yellow Mountain Place" and [**UHX**]**WITZ**, *Uhx Witz* "Three Mountains." The first of these forms is usually written as **K'AN-wi-WITZ-NAL** (ill. 10b) or even **K'AN-na-WITZ-NAL**, the ancient place name of Ucanal, appearing frequently in the inscriptions of that site and nearby Caracol and Naranjo. The second form, "Three Mountains," is an important Caracol place name. It proceeds from the floral headband worn by the mountain sign: an icon of the Wind God (*see* 73.4) and well-known equivalent of the number 3.[34] Considered together, the conflated toponym registers the Ucanal lord's dominion over both regions.

Apart from people and places, the Maya also frequently labeled objects, being particularly fond of inserting texts into spherical objects, such as bundles, balls and vessels as though responding opportunistically to a ready-made cartouche of the type usually enclosing glyphs. Bundles are frequently tagged with phonetic spellings referencing their unseen contents, such as *kakaw* "chocolate," *ihkaatz* "jade" and *bu'ul* "beans," among others.[35] Rubber balls of the type used in the ballgame were often tagged with similar labels indicating their size, typically, *baluun-nahb* "nine handspans." That these are more than just size labels is apparent from other contexts, however, where such designations are referred to as the

actual "names" (*k'aba'*) of the ball. Occasionally, balls were labeled with yet other names, perhaps personal designations, such as the ball depicted in the Great Ballcourt at Chichen Itza, and tagged with the hieroglyphic label *k'ahk' (u)jol* "Fire (is its) Skull" (*see* 18.1). Such names underscore the animate quality and personal nature of such objects in Maya thought, indicating their close kinship with the name captions accorded to kings.

Written captions are familiar in the Western pictorial tradition. Protagonists on Greek pottery, Etruscan mirrors and Byzantine murals are frequently named in adjacent texts, for example, as are Egyptian pharaohs in carved temple reliefs. However, these texts are usually not extensions of the imagery, whereas Maya name tags were, in the sense that they were conceptualized to be as much a part of the picture's fabric as the figures. On Yaxchilan Lintel 5, the glyphic term **i-ka-tzi** (for *ihkaatz* "jade") labels a bundle cradled in the arms of one of Bird Jaguar IV's wives (*see* 48.1). Yet the glyphs are obscured both by her arm and by the knot tying the bundle, making the name tag barely discernible. These glyphs clearly form part of the pictorial field, subject to the same rules of overlapping as any other objects depicted.

10a Ucanal ruler sits on stylized place name. Caracol Altar 12.

10b Ucanal place name from painted vase. Late Classic.

In addition to the label-like affixation of texts to depicted objects, text–image interaction also involves a technique we might call "pointing." In this convention, certain details of a picture – often arrow-like elements such as the feathers in a headdress or a spear in the hand – point toward or even contact a glyph within an adjacent text. This device was typically used to associate a figure with a particular passage of text, thereby identifying the individual represented.[36] Depicted objects were also occasionally brought into contact with their glyphic referents as though to answer the question, "what is this?" On a mundane level, pointing helped sort out which figure in a crowded pictorial narrative "did what to whom and when," this information being contained in the targeted text. When done with extra flourish, however, such text–image contact provided aesthetic pleasure of its own.

Such aesthetic text–image interaction is accomplished nowhere more skillfully than on a painted ceramic cylinder from Altar de Sacrificios (ill. 11).[37] Here, a complex pictorial scene of six *wahy* demons intrudes into the dedicatory text in three separate places. At one spot, a seated figure obscures large portions of two glyph blocks providing the name of the vessel's owner, a nobleman named Chak El Chan ?-K'uh Huk Chapaht Tz'ikin K'inich (Ajaw). Unfortunately, pictorial overlapping (and some misguided repainting) precludes a full reading of this name, and were it not for parallel formulations elsewhere even this much would be difficult to make out. In most art traditions familiar to us, such appended written information, meant to clarify content, would never be so completely sub-ordinated to the artist's aesthetic agenda as to be partially hidden by figurative elements. In another instance, the head and shoulders of a pugilistic demon obscure portions of two glyph blocks in the dedicatory text, but nevertheless leave sufficient details to confirm their reading as *utz'ihbnahal yuk'ib* "(it is) the painting of his vase," a formulaic dedicatory phrase.[38] A third example takes similar advantage of a predictable phrase, where the hand of a reaching figure jostles glyphs describing the contents of the vessel, *ixim te'el kakaw* or "maize tree chocolate." At first glance, one is tempted to read the fisted hand of the figure as

a glyphic prefix, but the text merely carries on around it, as if ignoring the hand rudely thrust into its midst. In an opposite maneuver, where text intrudes into imagery, the scribe has labeled the large vessel and stony weapon held by the upper figures with **AK'AB** "darkness" symbols, playfully suggesting their contents and associations. The large vessel is also subtly integrated with the rim text by appearing to hold one of the glyphs. Here, the picture readily incorporates textual elements even as the text stalwartly refuses to integrate invading elements of the pictorial scene. For the painter of the Altar Vase, the pleasure of such visual play took precedence over the dutiful recitation of textual content, revealing a sophistication and wit that we often think reserved for recent Western art.

While not every facet of Maya art is integrated with the writing system, the preceding discussion demonstrates that a great deal of it is. Reading Maya art appropriately requires an intimate appreciation of this relationship. The influence of writing on Maya art goes beyond the mere incorporation of hieroglyphs into pictures and accounts for numerous other idiosyncrasies, including clustered compositions resembling glyphic compounds and standard ways of stylizing, abbreviating and personifying pictorial imagery. Maya scribes/artists embraced this relationship and fully exploited its power of signification, which could be deployed within limited spatial formats. Although the influence of writing, which gained momentum throughout the Classic period, made Maya art more conceptual and obtuse to the uninitiated, the same artists were simultaneously exploring the possibilities of naturalism and achieved extraordinary heights of realism in the realm of portraiture. Maya artists' true genius lies in their masterful solutions to combining the two approaches. Late Classic Maya art is the perfect marriage of the conceptual and naturalistic, and for this remarkable achievement is most deserving of Stephens' previously quoted assessment: "…different from the works of any other people."

11 Rollout photograph of painted vase from Altar de Sacrificios. *Wahy* demons intrude into rim text. Late Classic.

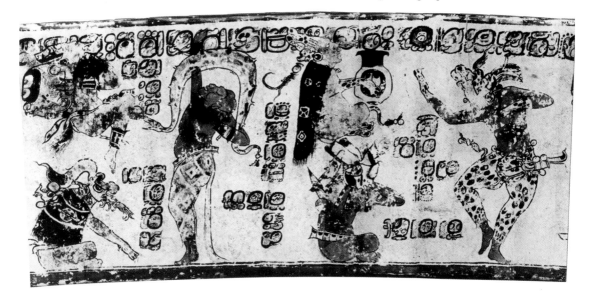

CATALOG

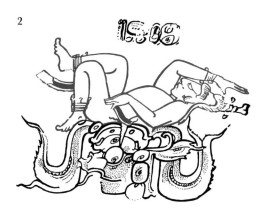

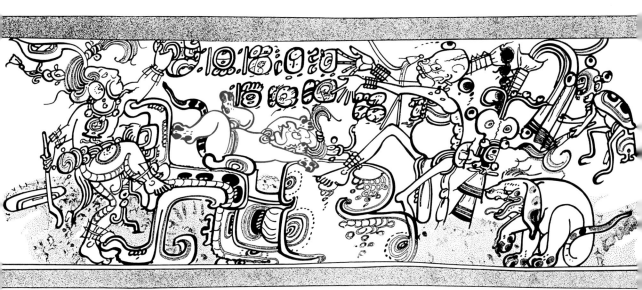

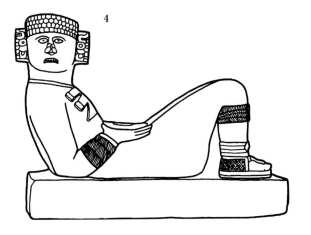

1 **UNEN** and **BAHLAM** signs on the belt of Sihyaj Chan K'awiil II. Stela 31, Tikal. Early Classic.

2 Birth of the Maize God. Codex-style vase. Late Classic.

3 Sacrificial scene on the Metropolitan Vase. Late Classic.

4 Chacmool from the Temple of the Warriors, Chichen Itza. Terminal Classic.

Unen means "baby" in Ch'olan languages, and the **UNEN** glyph depicts a reclining infant with its limbs flexed and head held up in a typical pose of young children. Curious about the world around them, but still somewhat lacking in muscular coordination, the unpracticed, ineffectual movements of babies are at once key symbols of renewal and of comparative helplessness.

UNEN

A fairly straightforward example of the sign's usage can be found in a portrait of the Tikal king Sihyaj Chan K'awiil II (r. AD 411–456). Conspicuously, the king wears **UNEN** and **BAHLAM** (jaguar*) glyphs on his rear belt-ornament, most likely in acknowledgement of the shadowy 12th ruler of Tikal, his probable ancestor (ill. 1; *see* Introduction, ill. 8, for the full scene).

However, the sign is not always so denotative, and it frequently appears in contexts connoting birth, infancy or themes of renewal. Thus, in similar scenes from at least two codex-style vessels, the youthful Maize* God adopts an infant's pose as he is reborn from a seed (ill. 2). Such scenes are directly paralleled by that on the carved sarcophagus lid of the Palenque king, K'inich Janaab Pakal I (r. 615–683). Here, the king is portrayed at the precise moment of his resurrection and apotheosis, and likewise assumes the Classic pose of infancy (*see* 21.3). These traits, coupled with the burning K'awiil* torch piercing his cranium, inform us that the king has been reborn as the deity *Unen K'awiil* or "Baby K'awiil." This prominent local divinity has overt maize associations – also reflected in the king's jade adornments, skirt and tonsured hair – and his images adorn the king's funerary pyramid.

Of all of the images associated with the **UNEN** sign, however, those of child sacrifice are by far the most powerful. Thought of as "exchanges" or "substitutes" (*k'ex*) offered to the Underworld for new life or recovery from illness, such sacrifices have a long history in Mesoamerica and span a period from Olmec times (*c.* 1000 BC) to at least the time of the Conquest (AD 1521). Fantastic scenes of the sacrifice of babies with jaguar characteristics provided a sacred paradigm for actual infanticide (ill. 3; *see* 53.3; 14.2). Although rarely depicted, scenes of actual sacrifice show children either as burnt offerings – lying supine in bowls or braziers – or as the victims of heart-extraction (*see* 63.1).

Interestingly, it is this last connection which explains the enigmatic Chacmool, at base a warrior posed as a sacrificial child (ill. 4). Often, Chacmools display carved tear-drops on the sides of their noses or on their upper cheeks, and some are decorated with images of Tlaloc, a Central Mexican rain and thunder deity. Chacmools were multivocal sacrificial victims cast in stone: on one hand, they evoked the captured warrior and the concomitant glory due his captor; on the other, they evoked an ancient custom of child sacrifice predicated on a pan-Mesoamerican association of raindrops and tears through the linking metaphor of sympathetic magic.

* K'AWIIL 10
JAGUAR 83
MAIZE 98

1

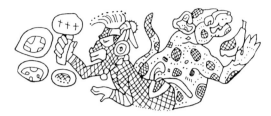

1 A *pa'* clown and jaguar in festival scene. Incised Peccary Skull, Tomb 1, Copan. Late Classic.

2 A *pa'* clown and jaguar in drunken dance. Painted vase. Late Classic.

3

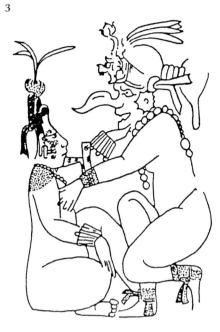

2

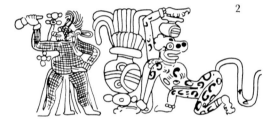

3 A clown accosts a young woman. Painted vase. Late Classic.

4 One of two large clown sculptures holds a rattle, marking Copan's west plaza "reviewing stand" as a place of performance. Late Classic.

4

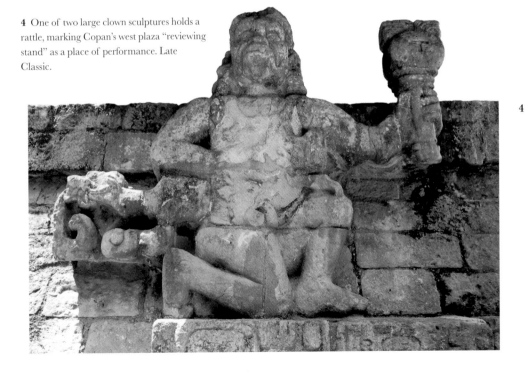

In Lowland Mayan languages *pa'* means "ritual clown" or "buffoon," and comparison with the playful images of clowns in art shows that the head-variant of the **pa** syllable is a realistic portrait of these characters. Not only does it display the characteristic bulbous nose and thick lips of the clown, but it also wears the same black* body suit of coarse cloth covering everything except feet, hands, eyes and mouth. Another diagnostic trait of the **pa** sign is the long loop of cloth drawn through the earlobes, a feature also seen on some Classic clowns (ills. 2, 4).

Ritual clowning, excessive drinking and ribald humor were important features of ancient Maya ceremonialism, marking key periods of transition in the solar and agricultural year. In one Early Classic scene (ill. 1) a ritual clown appears alongside a smiling jaguar* in festivities associated with the period-ending 8.17.0.0.0 (October 21, AD 376). While the clown shakes a rattle, the jaguar character holds out an enema syringe. In a similar scene (ill. 2), the clown smokes a cigarette and shakes his rattle while dancing. The jaguar dances alongside him, holding a large urn (marked with maguey leaves) in one paw and balancing a flask on his head. The urn, the cut-gourd enema syringe and the flask are probably all filled with alcohol, effectively explaining the antics of the clown and his companion. Staggering about in drunken abandon, the pair would no doubt have elicited much laughter from crowds gathered for the New Year's festivities. In a related scene from a Late Classic polychrome vessel (ill. 3), the drunken clown makes rude and fumbling sexual advances to a young woman, fondling one of her breasts even as she reaches up to stroke his chin. These and other scenes seem to depict actual festival performances, poking fun at traditional courtship practices and occasionally even simulating copulation between young women and patently unsuitable mates, including clowns, monkeys* and even insects. Such absurd and antisocial antics served to highlight the difference between moral and immoral behavior in ancient Maya society. The very capacity of such behavior to shock and provoke laughter in the festival setting underscored its inappropriateness in daily life.

In modern Maya festivals, clowns satirize established authority and serve as catalysts for social commentary, and this may explain why Classic clowns wore the traditional headbands of lords* (ill. 1–3). The periodic farces of clowns provided a safe climate for the populace to laugh at their rulers, which in turn allowed for the cathartic release of social pressures. Far from undermining authority, then, ritual clowning helped to foster a temporary but crucial feeling of community solidarity, and smart rulers probably encouraged these activities. Indeed, the presence of two large clown sculptures in the west court of Copan's acropolis (ill. 4), perhaps the location of festival performances and ritual clowning, strongly intimates that ritual clowning had state sponsorship and sanction. Large stone effigies of conch shell trumpets* also adorned this "reviewing stand," and the *pa'* clowns each brandished a rattle.

pa

* LORD 4
TRUMPET 31
BLACK 46
JAGUAR 83
MONKEY 84

1 The Maize God's head forms part of a glyph modeled in stucco. Templo Olvidado, Palenque. Late Classic.

2 A noblewoman witnesses the coronation of Yo'nal Ahk III. Stela 14, Piedras Negras. Late Classic.

3 Regal woman. Jaina-style figurine. Late Classic.

4 Feminized portrait of a noblewoman from Tikal. Painted vase. Late Classic.

5 Queen of El Peru. Cleveland Stela. Late Classic.

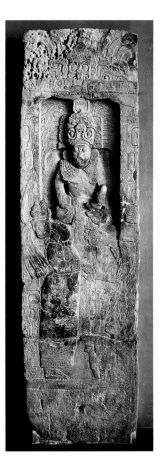

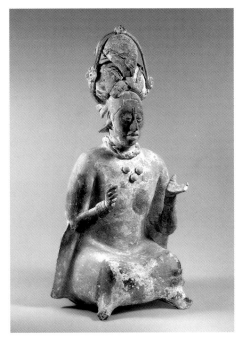

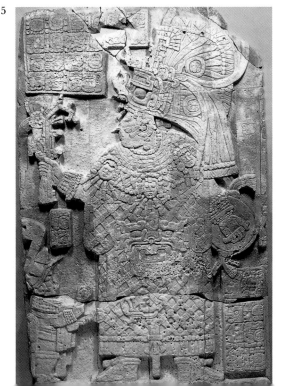

In Maya writing, female names are prefaced by a logograph consisting of a profile head, read **IX** or **IXIK**, introducing the name as "Lady so-and-so." This sign satisfies obligatory gender marking of names and titles that has no male counterpart, a pattern mirrored in the spoken language. The femaleness of the head is signaled by a hairdo evoking the wispy ringlets, ponytails and wound tresses of elegant women. The logograph shows this as rolled hair in the upper corner with a few strands dangling across the jaw and a forelock, often reduced to a dark disk. Another diagnostic is face paint resembling the letters IL (ill. 1). These facial markings, associated with youthful beauty, also adorn Adonis-like male gods, notably the Maize* and Wind* Gods (*see* 25.2), and certain baby* gods. The young Moon* Goddess's head also resembles the **IXIK** logograph.

Women are prominently featured in Maya art, especially during the Late Classic as the dynastic basis of political power became firmly entrenched. Although rulers were typically male, their legitimacy rested on a royal bloodline reckoned through male *and* female kin. Indeed, a king's mother or wife could be the daughter of a great monarch from an allied city. Women of this rank, as well as daughters of local kings who had no male heir, had tremendous prestige; some acted as regents or, rarely, reigned over cities as a *k'uhul ajaw "divine ruler."* Kings depicted themselves next to important women who validated their authority. In ill. 2, the accession of the eighth-century Piedras Negras ruler Yo'nal Ahk III is witnessed by a noblewoman proffering quetzal* feathers.

Mundane women performing domestic duties, such as weaving, child-rearing, and corn-grinding, are the subject of ceramic figurines. Yet these also depict elegant women of high status. A Jaina figurine represents a refined woman with intricate coiffure and forehead jewels recalling the **IXIK** logograph (ill. 3). Women's physical charms are most explicit on painted ceramics, seen, for instance, in a highly feminized portrait of a noblewoman from Tikal whose intricate face paint and bouncy hairdo, especially the diagnostic forelock, echo the **IXIK** logograph (ill. 4). Also standard code of femininity are her intricately woven garb with scooped neckline, wide girth, breasts visible beneath her clothes, curved hands and swirling hemline. Even the posing of a hand near her chin is a feminized gesture. The scooped neckline garment is a hallmark of beautiful women in Maya art and on the figurine is delineated by paint (ill. 3).

Women depicted on public monuments, on the other hand, are less feminized and even assume masculine trappings. On the Cleveland Stela, a queen of El Peru grasps a shield, while in her headdress glyphic medallions register her associations with Calakmul. In the accompanying text, her name phrase boasts an impressive *kaloomte'* title, usually reserved for kings (ill. 5). Contrary to ills. 3 and 4, her neckline is smothered under jade ornaments. Yet, this matronly queen still has womanly features, such as a forelock, floral earflares and wide girth. Rather than appealing to feminine beauty, however, the portrait of this aristocratic woman acknowledges the prestige, wealth and power befitting her station.

* BABY 1
MOON 59
WIND 73
QUETZAL 93
MAIZE 98

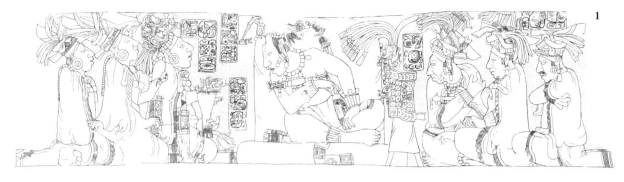

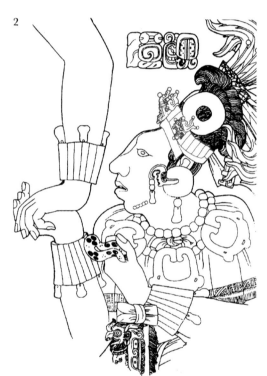

1 The accession of K'inich Ahkal Mo' Nahb III.
Temple XIX bench, Palenque. Late Classic.

2 Yok Ch'ich' Tal, the Fire Priest. Temple XIX
stone panel, Palenque. Late Classic.

3 The parents of Yiban, the *ajk'uhuun*.
Alabaster vessel. Late Classic.

4 Jade Jester God diadem excavated at Aguateca.
Late Classic.

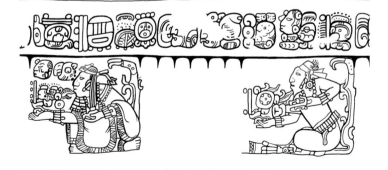

Unlike the logographic sign for lady*, which essentially depicts a generic young noblewoman, that for "lord" is specifically a portrait of Juun Ajaw, one of the Hero Twins*. Thus, although the **AJAW** sign sports the dark cheek spot characteristic of Juun Ajaw (*see* 71.3; 89.3) and a common marker of mammals (*see* 22.2; 59.3; 84.2), this device is never seen on more mundane lords. Nevertheless, as the son of the Maize* God and the first earthly prince, Juun Ajaw was the veritable model of lordship. His filial piety (*see* 89.3) and physical prowess (*see* 67.1; 71.3) are recurrent themes in the artistic treatment of this god, and it therefore seems likely that he was revered as the ideal young lord upon whom Classic courtiers modeled their own behavior. It is for these reasons that he wears the characteristic paper headband of lordship.

In monumental art, elaborate headdresses and helmets frequently obscure the plain paper headbands which were themselves key symbols of authority. Yet clear indications of the importance of these elements emerge in accession scenes. Thus, on the remarkable stone bench of Temple XIX at Palenque (ill. 1), K'inich Ahkal Mo' Nahb III (r. AD 721–*c*. 736) is handed a paper headband and Jester God diadem by his cousin, Janaab Ajaw, on the day of his coronation. Intriguingly, associated inscriptions tell us that this accession was also the reenactment of a sacred mythical event, for the king's cousin impersonates Itzamnaaj*, the king of the gods, while the king impersonates the local Palenque patron god GI. Just as Itzamnaaj installed GI into office before the beginning of the present era, so too does that event provide supernatural justification for K'inich Ahkal Mo' Nahb III's own accession.

Yet the headband of lordship was not confined to kings and high nobility (*see* 5.3; 70.6), nor even to males. Elsewhere in Temple XIX, the high-ranking cleric Yok Ch'ich' Tal is also portrayed with not only the characteristic Tlaloc-miter of the *yajawk'ahk'* fire priests, but also with the Jester God headband of lordship (ill. 2). Similarly, on a Late Classic incised vessel from the collections of Dumbarton Oaks (ill. 3), both the father and mother of another priest, Yiban the *ajk'uhuun*, also wear Jester God headbands.

Thus, while the Jester God diadem recently discovered in a burnt palace at Aguateca (ill. 4) is without doubt an extraordinary and interesting find, its discoverers have been quick to point out that it need not necessarily have been the crown of a king. Rather, headbands and diadems seem to have been the province of a broader spectrum of nobility than previously thought and suggest that the model of comportment provided by Juun Ajaw applied to all of the nobility. It also suggests that the headbands and Jester God crowns worn by ritual buffoons (*see* 2.1–3) may have been intended to spoof the noble class as a whole, rather than being narrowly focused on the exploits of the king.

AJAW

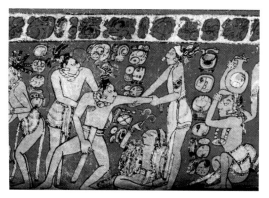

1 Akan vomits while holding an enema syringe. Painted vase. Late Classic.

2 Akan decapitates himself. Painted vase. Late Classic.

3 Akan smokes a cigar. Incised cache vessel. Early Classic.

4 Scene of drunken abandon. Painted vase. Late Classic.

4

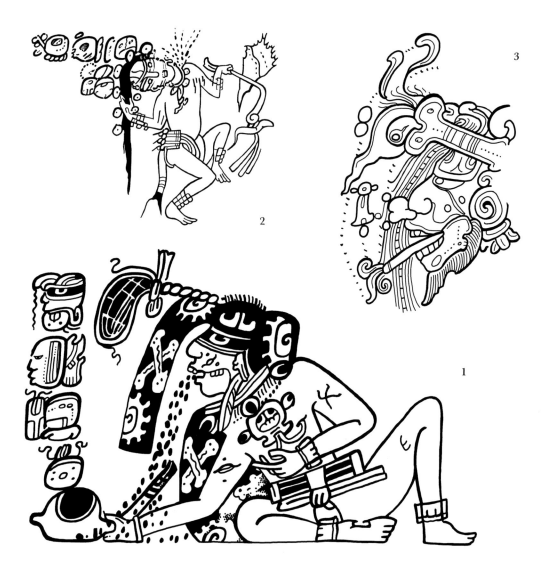

3

2

1

Akan is an anthropomorphic entity with pronounced insect characteristics, including the so-called "percentage sign" labeling his face and body, a skeletal lower jaw and an **AK'AB** "darkness"* sign on his forehead (ills. 1–3). Occasionally he also wears a long bone* in his hair, probably a human femur (ill. 3; *see* 58.4). These grisly traits, coupled with occasional scenes of the god engaged in self-decapitation (ill. 2), have long led scholars to associate Akan with the gods of death*. But *akan* is a widespread word for "wasp" in Mayan languages, handily explaining both the death imagery (a common characteristic of insects in Maya art) and Akan's blackened eyes (evocative of wasps). One early Maya dictionary further names Akan as "god of wine," a deity of ritual intoxication whom sixteenth-century friars compared to Bacchus.

Thus Akan is occasionally depicted sprawling on the floor and vomiting (ill. 1), smoking a large cigar of native tobacco (ill. 3) or carefully cradling the large, narrow-necked vessels that held alcoholic beverages (*see* 58.4). The bees buzzing around these vessels are probably an allusion to *balche'*, a native drink made from fermented honey and the bark of the balche' tree (*Lonchocarpus longistylus*). Another common alcoholic beverage was called *chih* (or "pulque"), and was made from the fermented sap of the maguey plant. Since the long central stalk of the maguey plant had to be cut in order to leech sap from the plant, it may be that Akan's frequent acts of self-decapitation (ill. 2) reference the harvesting of maguey. In any case, a number of hieroglyphic texts at Copan describe the ritual consumption of *chih* by kings impersonating Akan during festivals. In his sixteenth-century account of the Yucatec Maya, Diego de Landa describes the following bacchanalian scene:

"The Indios were extremely uninhibited when drinking or drunk, which had many ill effects; it led them, for example, to kill one another…They made wine from honey, water, and the root of a certain tree which they grew for this purpose, which made the wine strong and foul smelling. They would dance, make merry, and eat in pairs or groups of four. After they had eaten, their cupbearers, who as a rule did not get drunk, brought out large tubs for them to drink from, which led in the end to a general uproar."

Similar scenes of abandon are known from Maya art. On one Late Classic polychrome (ill. 4), one fellow props up a large clay jug (labeled with the **chi** glyph), another smokes a cigarette, and a third is so inebriated that he needs to be helped to his feet by his comrades. Yet Maya beverages contained only relatively small amounts of alcohol, and great quantities would need to be drunk in order to produce high levels of intoxication. For this reason, enema funnels were used to introduce alcohol into the body more rapidly. A number of enema administration scenes are known from Classic times, and Akan himself is occasionally depicted with just such a device (ill. 1).

AKAN

* DEATH 7
ＢONE 13
DARKNESS 58

1

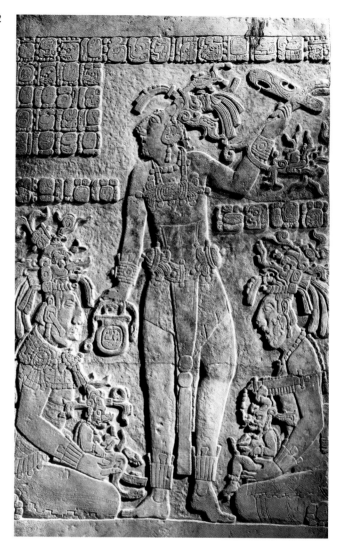

2

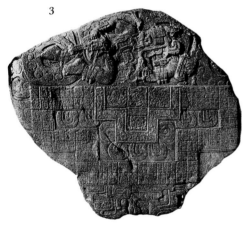

3

4

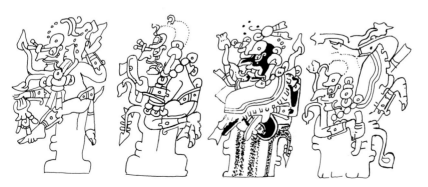

1 Chahk with standard attributes and pose. Painted vase. Late Classic.

2 K'an Joy Chitam II dances as Chahk in the company of his parents. Dumbarton Oaks Panel 2, Palenque. Late Classic.

3 Chahk dances before a symbolic mountain containing maize. Altar of Zoomorph O, Quirigua. Late Classic.

4 Chahk of the four directions. Dresden Codex, pages 30–31. Late Postclassic.

Unlike people of the ancient Andes, where irrigation was widely practiced, Mesoamericans largely relied on rainfall agriculture. Consequently, gods of rain* were critically important and appear early in Mesoamerican art. Equally for the Maya, their Rain God, Chahk (God B), a word meaning "thunder," was a central and enduring figure in their pantheon. Still venerated in Yucatan, Chahk enjoys a longevity of over two thousand years. Chahk's portrait glyph incorporates a large spiral eye and convoluted forehead (both derived from cloud iconography), *Spondylus* shell* earflare, fish barbels and shark* tooth, indicative of Chahk's piscine nature and aquatic domain. Chahk is depicted standing in water, fishing or calling down rain (*see* 81.1).

Chahk's composite makeup is illustrated in full-length portraits. Ill. 1 shows his anthropomorphic body combined with snakeskin patterns and a split fish tail. Other attributes include a shell diadem, upswept ponytail or mounded hair, water scroll body markings, knotted waist ornament, and an inverted **AK'AB**-vase pendant (*see* 58). Chahk assumes a standard attack pose, axe drawn back ready to strike (*see* 12.2). His axe was conceived as an ophidian lightning bolt, and the handle sometimes blossoms into a serpent* (ill. 2). Associated with rain, clouds* and lightning, serpents are Chahk's primary zoomorphic alter-ego, the fish* being another. Chahk's axe-in-hand pose refers to his heroic role as "splitter," which he manifested through dance. In one myth, Chahk splits open a mountain* containing maize* (or the Maize God), thus bringing sustenance to humans. This theme is the subject of a relief from Quirigua (ill. 3). Entwined in cloud scrolls, Chahk dances before a mountain filled with maize seeds. Axe-wielding Chahk was the archetypal executioner, using his magic weapon to decapitate victims. He is frequently shown on painted pottery about to chop a hapless baby* jaguar* (*see* 1.3).

Chahk's dual persona, part macho aggression, part fertility bearer, made him a superb model for Classic Maya kings, who frequently took his name or impersonated him. Chahk's visage was worn on headdresses and as face masks. Rulers dressed as Chahk and also reenacted his heroic deeds. On Dumbarton Oaks Panel 2, the Palenque ruler K'an Joy Chitam II (r. AD 702–711) memorialized himself performing Chahk's axe-wielding dance (ill. 2).

Like other Mesoamerican rain gods, Chahk had manifold aspects, reflected in different titles and attributes, and could appear in multiples, usually of four. Destructive and nurturing, Chahk's aspects were associated with different world directions, colors and eco-niches. These are explicit in the Late Postclassic art of the Northern Maya Lowlands where, by this late date, Chahk's primary attribute was a long, downturned snout. Chahk's mercurial personality is especially evident in the "Chahk pages" of the Dresden Codex (ill. 4). Permeating the natural world, he inhabits realms as diverse as sky*, earth*, cenote* and pool* of water. As master of rain and the fate of the corn crop, Chahk had universal popularity. His cult was as dear to kings as to peasants, none of whom could escape the whims of the Rain God.

CHAHK

* BABY 1
CENOTE 53
EARTH 54
MOUNTAIN 55
CLOUD 57
SKY 60
RAIN 67
SPONDYLUS SHELL 69
POOL 72
FISH 81
JAGUAR 83
SERPENT 86
SHARK 87
MAIZE 98

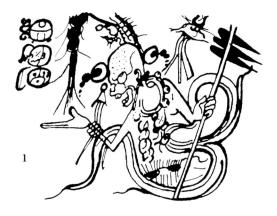

1 "Fire-heart snuff death". Codex-style vase. Late Classic.

2 "Gluttony death". Codex-style vase. Late Classic.

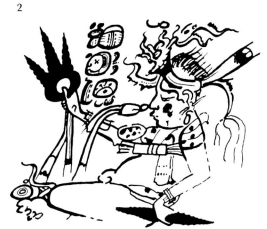

3 "One-foot snuff death". Codex-style vase. Late Classic.

4 "Turtle-foot death". Stucco façade, Tonina. Late Classic.

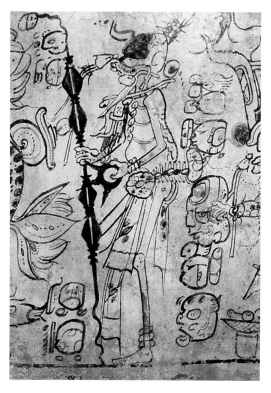

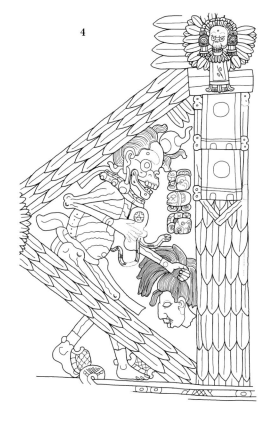

The glyph for "death" is obviously affiliated with those for bone*, skull* and tomb*, yet is also distinct enough to merit its own category. Unlike the skull sign, which is essentially a naturalistic depiction of the human skull (minus its mandible), the **CHAM** sign strikes one as a somewhat more malevolent entity. Its narrowed eyes, grinning jaws and eclectic jewelry, including a disembodied eye sported as a diadem, suggest kinship with Underworld beings. Indeed, the **CHAM** sign probably represents a portrait of the Death God himself (*see* 13.1, 2; 33.1). A cackling, gleefully capering bundle of bones, the Death God appears throughout Maya art as the recipient of sacrificial offerings, especially the recently deceased (*see* 1.3; 27.2; 81.2). His iconography is rich and varied, including a complex back rack fashioned of bones and a shield* of stretched human facial skin with disembodied eyes (*see* 1.3).

Like humans everywhere, the Maya were concerned with explaining life, aging and the inevitability of death. The mythology of the Death Gods and their contest with the Hero Twins* provided one such avenue of explanation, establishing a contract for the human soul that likely had specific terms, conditions and reciprocal obligations. Because nourishment was a universal requirement for life, the Maya accepted killing and sacrifice as necessary adjuncts, and therefore made "exchange sacrifices" (*k'ex*) to ward off disease and other misfortunes. But diseases obviously had some source or explanation of their own. Unaware of either germs or the role of heredity in disease, the Maya saw diseases as the semipersonified dark forces wielded by sorcerers and witches.

In the *Chilam Balam of Kaua*, a Colonial Yucatec Maya manuscript, we read of a monstrous creature called "spider snake* macaw* wind*," a personified illness associated with seizures. Similarly horrific hybrid entities have long been known in Maya art: the *wahy* creatures. Although traditionally identified with concepts of "animal companion spirits," there is now good reason to see *wahy* as the malevolent personifications of sorcerous spells, manifested as various diseases and misfortunes. This category would include the "yellow gopher* rat" (*see* 82.1, 2), "fire*-tailed coati"* (*see* 76.2, 3), "striking spark star* jaguar*" (*see* 61.4) and "white bone carapace centipede"* (*see* 75.2), among numerous others. Two fairly straightforward examples are *k'ahk'* "fever" (*see* 64.1) and the aptly named *mok chih* or "pulque sickness" (*see* 58.4). Mortal illnesses were also featured. Thus, *k'ahk' ohl may chamiiy* "fire-heart snuff death" (ill. 1) may reference some heart or lung ailment, whereas *sitz' chamiiy* "gluttony death" (ill. 2) perhaps cues death by overindulgence. *Tahn bihil chamiiy* "middle-road death" was represented by a venomous snake coiled around a raptorial bird (*see* 86.4). Two additional mortal illnesses were *juun ook may chamiiy* "one-legged snuff death" (ill. 3) and *ahk ook chamiiy* "turtle-foot death" (ill. 4). Both remain rather enigmatic, to say the least.

CHAM

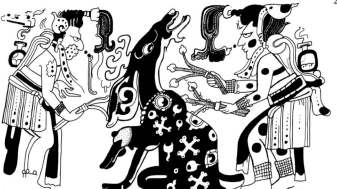

1 The Hero Twins and the Monster Bird Chan Mo' Nal. Stela 2, Izapa. Protoclassic.

2 The Hero Twins hunt a large deer. Painted vase. Late Classic.

3 The Hero Twins in conversation. Drawing 87, Naj Tunich. Late Classic.

4 The Hero Twins at the court of Itzamnaaj. Incised vessel. Late Classic.

Long referred to in the literature as the "young lords" or the "headband twins," it is now clear that the Classic period Juun Ajaw and Yax Baluun can be equated with the Hero Twins, Junahpu and Xbalanque, known from the *Popol Vuh*. They can also be related to a number of other trickster gods known from Ch'ol, Mopan and Q'eqchi' Maya mythology. Taken together, such accounts speak of a pair of twins who vied for parental attention with their half-brothers (whom they eventually turned into monkeys*), fought monstrous beasts and contested the lords of death* in order to avenge and resurrect their father.

The hieroglyphs for Juun Ajaw and Yax Baluun are clearly portraits of these important gods. Both are depicted as young men, and they often wear the paper headbands of lords*. Yet the Hero Twins are also distinguished from one another by specific bodily markings and other iconographic traits (ills. 2–4). Thus, Juun Ajaw is characterized by prominent spots on his cheek and body and frequently wears an **AJAW** diadem on his headband. Indeed, Juun Ajaw's portrait served as the model for the **AJAW** glyph, and it therefore seems likely that this god was revered as the ideal young lord to whose carriage and comportment Classic courtiers aspired. As for Yax Baluun, his face and body are invariably marked with jaguar pelage, and he occasionally wears a cut shell **YAX** jewel on his headband or in his hair.

The Hero Twins were expert hunters and ballplayers and frequently appear in scenes directly related to these pursuits (*see* 36.4; 90.2). As huntsmen, the Hero Twins vanquish all sorts of mythical beasts and monsters in order to make the world a safer place for humans. Most important among their conquests was Chan Mo' Nal (ill. 1; *see* 91.1), the monstrous macaw* who pretended to lordship over the heavens and who managed to tear off one of Juun Ajaw's arms before their task was done. In another poorly understood scene, the twins hunt a large deer marked with cave* symbolism (ill. 2). With respect to their ballplaying, the *Popol Vuh* relates that it was a series of ballgames with the Death Gods that ultimately decided the fate of their father. In Classic times, he was identified with the young Maize* God, Juun Ixim (*see* 95), and the Hero Twins are often depicted in attendance at his resurrection (*see* 89.3).

Numerous depictions of the Hero Twins show them in conversation with one another (ill. 3), or at the court of the Creator God Itzamnaaj* (ill. 4; *see* 94.2), to whom they evidently pay fealty or bring offerings. Yet in other scenes, Juun Ajaw is shown firing his blowgun at Itzamnaaj's avian avatar (*see* 67.1; 71.3). The reasons behind these diverse interactions remain somewhat unclear, but such scenes probably refer to the despoiling of the jade celt* and other riches with which the monster bird was endowed.

JUUN AJAW
and
YAX BALUUN

* LORD 4
DEATH 7
ITZAMNAAJ 9
JADE CELT 21
CAVE 52
MONKEY 84
MACAW 91
MAIZE 98

1

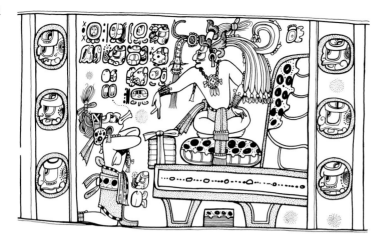

1 Itzamnaaj receives a Wind God in his mountain court. Painted vase. Late Classic.

2

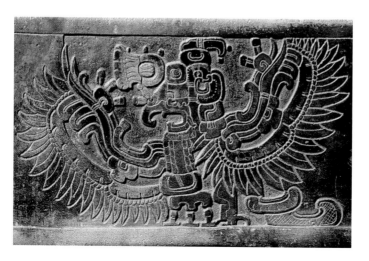

2 Itzamnaaj receives a winged messenger. Sculpted throne back, Museo Amparo, Puebla. Late Classic.

3

3 Itzamnaaj in his avian aspect. Incised tripod. Early Classic.

Known as God D after early tabulations of deities depicted in the codices, there is no longer any question that this god was cognate with the creator deity *Itzamna* known from Postconquest Yucatan. That said, there has been a great deal of confusion about his relationship to another deity, labeled God N, and a full reading of his name remains elusive. In fact, the God D glyph is itself a conflation of the portrait glyph of the almond-eyed old God N (**ITZAM**) with that of a large-eyed supernatural avian dubbed the Principal Bird Deity (still of unknown reading). Additionally, Itzamnaaj's earspool occasionally bears a striking resemblance to a partitive disk, perhaps indicating conflation with the penis* sign (**AAT**).

ITZAM-?

Itzamnaaj is one of the most frequently depicted gods in the Maya pantheon and is, without doubt, the most important. Stela C from Quirigua reveals that he had a hand in the setting up of various bone thrones* at the turn of the last baktun in 3114 BC, and a new bench text from Palenque Temple XIX reveals that he oversaw the accession to kingship of Palenque's local patron god almost two hundred years earlier. Such direct parallels with the political machinations of Maya kings reminds us that earthly authority replicated a higher, divine order, and that it was Itzamnaaj who provided the model of divine rule. This dual role of Itzamnaaj as creator god and overlord is amply attested in art, where he is often shown seated directly in the sky* (*see* 100.3) or on sumptuous cushion thrones* bedecked with jaguar skins (ill. 1; *see* 90.1; 93.2). In some scenes (ills. 1, 2), his court is identified by associated hieroglyphs and iconography as a great mountain* cave*, from which he rules in Olympian splendor. Whether in the sky or in his mountain hall, he frequently receives visitors or guests before his throne. Some mythological animals, like the coati* and various winged messengers, apparently relay information to Itzamnaaj. Others, like the deer* and hummingbird*, come to receive their antlers and wings in Classic Mayan versions of "just so" stories still told today (*see* 100.3). Other minor gods, such as the Hero Twins* (*see* 94.2) and a duck-billed Wind* God (ill. 1), come to pay homage and bring tribute in the form of books*, jade celts*, quetzal* birds, tamales*, weavings* and other valuable offerings.

Itzamnaaj's avian counterpart is occasionally shown alone (ill. 3; *see* 21.3; 60.1), and such depictions make it clear that the blue-green* diadem jewel, forehead darkness* mirror* and large jade celt pectoral are attributes of the Principle Bird Deity rather than God N. Indeed, it has recently been suggested that they represent the bird's great wealth, recalling the shiny metallic teeth which were the pride and joy of Seven Macaw* in the *Popol Vuh*. Thus, when the Hero Twins shoot the monster bird (*see* 67.1; 71.3), this may reference the despoiling of his wealth and finery, an event obviously paralleling the comeuppance of God L, the Merchant God of the Underworld (*see* 92; 95).

1

1 K'awiil, in typical guise, holds a torch. Painted vase. Late Classic.

2 A burning ceremony manifests K'awiil from the mouth of a serpent. Painted vase. Late Classic.

3 K'awiil scepter held in the hand of K'ahk' Tiliw Chan Yopaat. Sandstone monument. Zoomorph P, Quirigua. Late Classic.

2

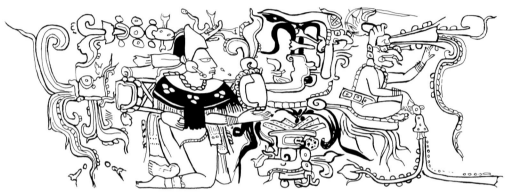

4 Stucco-covered wooden manikins of K'awiil. Burial 195, Tikal. Early Classic.

5 Postclassic form of God K. Dresden Codex, page 26. Late Postclassic.

5

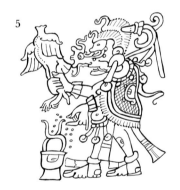

3

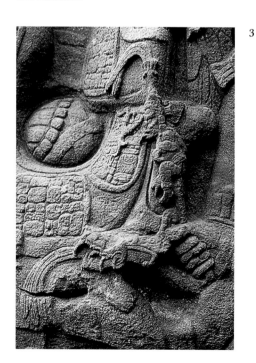

4

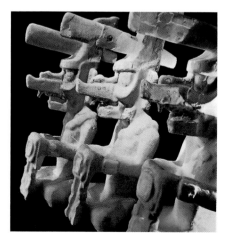

Ironically, the most ubiquitous god in Classic Maya art, K'awiil (God K), is also the most enigmatic, because of his proclivity to blend with other gods and his multifarious associations, among them transformation rites, agricultural fertility and royal rituals in general. Fortunately, he is easy to identify. K'awiil has a zoomorphic head with large eyes, long, upturned snout and attenuated serpent tooth. His prominent forehead bears a reflection cartouche penetrated either by a torch*, stone celt, or cigar, typically emitting two plumes of smoke. A head with these features comprises K'awiil's hieroglyph. However, the smoking forehead was his essence and could by itself represent him; indeed, impersonating K'awiil merely required donning his forehead torch. The K'awiil portrait glyph was adopted in the names of many rulers who also wore headdresses bearing his visage.

K'awiil's physique is anthropomorphic but one leg mysteriously transforms into a serpent* (ill. 1). The serpent leg is revealing of K'awiil's identification with a flaming lightning axe, a role accounting for his unique symbolism, such as the burning forehead device, the analog of an axe-head, and the serpent leg, the analog of the axe-handle. In Mesoamerica, lightning was conceived as a burning ophidian axe, the Storm God's preferred weapon (see 6.2). Chahk is but one god associated with K'awiil; in their Classic guises both have bodies covered in serpent skin. Another is the Maize* God, who sometimes displays K'awiil's forehead device. Like the Maize God, K'awiil played a role in agricultural fertility. These two gods are the principal divinities appearing on painted capstones from the Northern Maya Lowlands (see 34.5). The transforming power of lightning, which burns on contact, also made K'awiil an embodiment of metaphysical transformation, in the sense of engendering supernaturals into the earthly realm, a process facilitated by burning rituals. K'awiil presided over such propitiatory acts as bloodletting intended to invoke spirits who traveled on a serpent pathway and emerged through its portal-like jaws. K'awiil himself was manifested in this way. In ill. 2, smoke rising from a censer* has induced K'awiil's birth via the serpent. Rulers donned K'awiil's burning forehead device or brandished images of K'awiil when overseeing the ritual birthing of gods.

K'awiil's serpent leg served as a handle for an effigy dubbed the "Manikin Scepter." Appearing on countless relief sculptures, the Manikin Scepter was a royal scepter brandished like an axe (ill. 3). While probably fashioned from wood, several carved in durable stone have survived, as have remarkable chipped flint portraits of K'awiil. Seated wooden K'awiil effigies, a kind of object actually depicted on stone panels (see 6.2), were found at Tikal. Although the wood had decayed, a shell of painted plaster was intact, permitting their restoration (ill. 4).

Like Chahk, K'awiil's attributes became simplified in Postclassic art. Rarely seen are his forehead torch and serpent leg, while dramatic emphasis was placed on an upturned, ornate snout (ill. 5). His constellation of Classic roles also diminished. Less a patron of dynastic rituals, K'awiil's role in agricultural fertility came to dominate his Postclassic persona.

10

K'AWIIL

K'AWIIL

* CENSER 63
TORCH 66
SERPENT 86
MAIZE 98

1 Paddler Gods emerge from the maws of a two-headed serpent. Carved cache vessel, Tikal. Early Classic.

2 Jaguar Paddler. Stela 2, Ixlu. Terminal Classic.

3 Stingray Spine Paddler. Stela 2, Ixlu. Terminal Classic.

A pair of gods known as the Paddlers get their name from their role paddling a dugout canoe*. The Paddlers fall into the aged class of Maya gods, as do beneficent creator and ancestor deities. For the Paddlers, age reflects the maturity and wisdom needed to guide canoes and stage-manage acts of creation. Their hieroglyphs are anthropomorphic heads wizened by age, toothless, with pointed chin, prominent nose and wrinkles. While they share these features, they contrast in others and are essentially dualistic. The Stingray Spine* Paddler wears a bloodletter through his nose, either a stingray spine or sharpened bone. The Jaguar* Paddler's portrait glyph is distinguished by a jaguar ear. In pictorial renditions, the Jaguar Paddler can appear as a full-fledged jaguar with paws (ill. 1). The Paddlers occasionally wear zoomorphic headdresses specific to their roles. The basis of their opposition is the solar cycle, since the **K'IN** glyph, referring to the daytime sun*, is emblematic of the Stingray Spine Paddler, while the Jaguar Paddler's insignia is the **AK'AB** glyph, meaning darkness/night*, associated with the sun's nocturnal aspect. Jaguars have solar associations, while the Stingray Spine Paddler's square eyes and cranial reflection recall the Sun God.

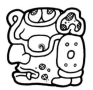

?

The deeper meaning of the Paddler Gods revolves around transformational acts that affect states of being, particularly birth and death. Their transformational role is mirrored in their dualism, which implies changes of state couched as a solar metaphor. The Paddlers' canoeing is transformational since it involves crossing cosmic realms, a service they provided for the recently deceased or those about to enter the world of the living. The Paddlers are best known from a series of canoe scenes inscribed on bones found in Burial 116 at Tikal. On one, the Jaguar Paddler guides the bow and his companion, the stern (see 50.2). They transport the deceased Maize* God through the watery Underworld, an allegory of the death journey of the interred king, Jasaw Chan K'awiil I (r. AD 682–734). The Paddlers can be thought of as the Maya version of Charon who, in ancient Greek lore, was an old ferryman who brought the dead to the Underworld. In a more complex fashion, however, the Paddlers directed the Maize God's water journey to his place of resurrection (see 50.4). The Paddler Gods made fitting ushers given their solar nature and the sun's importance in establishing cosmic order. In textual accounts of world creation, the Paddlers are among the privileged divinities to have set up one of the three stones* of the cosmic hearth that formed the center of the universe.

Another of the Paddlers' transformational feats occurred on period-endings. In these contexts the Paddlers are portrayed on stelae riding cloud* scrolls above the head of the ruler whose sacrificial burning has engendered them (ills. 2, 3). This process was conceived on one level as the ruler giving birth to the Paddlers. On another level, texts often refer to the Paddlers' "bathing" (yatij), perhaps an indication that they blessed the ceremony with a downpour. Evidence of the Paddler bathing ritual occurs very late in the Classic period and may have been a response to prevailing drought conditions.

1 The day sign Ajaw. Stela 63, Copan. Early Classic.

2 Chahk attacks two dwarfish creatures and a deer. Painted vase. Late Classic.

3 An iguana consumes three gods. Painted vessel, Becan, Campeche. Early Classic.

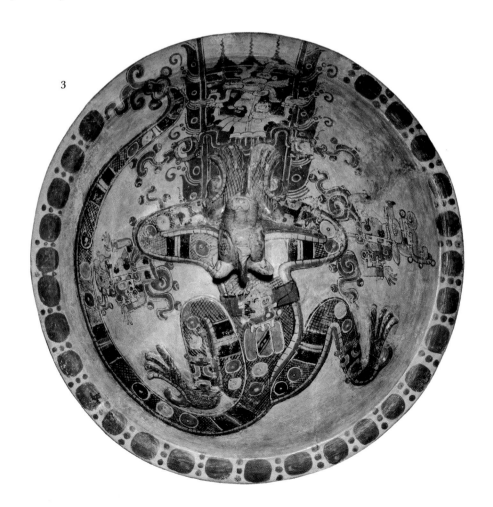

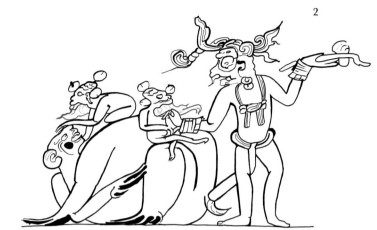

Although more common in the Early Classic period, blood-related iconography occasionally recurs in later imagery and continued to be reflected in the blood glyph, which appears with some frequency in Late Classic texts. In these contexts, it typically refers to the sacrificial aftermath of battles, when "skulls pile up (and) blood pools" (*witz-iij u-jol-ool nahb-iij u-ch'ich'-el*). Yet the sign has its clearest antecedents in Late Preclassic and Early Classic texts, where day signs from the 260-day calendar are typically swathed in bloody cartouches (ill. 1). Early day signs usually represented the heads of animals or gods (as here), and the bloody scrolls arguably represent their decapitation. This concept is probably reflected in the red day sign cartouches of Late Classic Maya murals and polychrome vessels, and in the red and occasionally serrated necks of day signs in the Late Postclassic Aztec and Mixtec codices.

A particularly clear example of Late Classic blood iconography comes from Stair Block 1 of the west façade of Copan's Temple 16 (*see* 18.3). Here, a large trilobed scroll pours from the agnathic visage of the Central Mexican Storm God Tlaloc. The conformation of the scrolls, coupled with the infixed dots and semicircle of the central element, leave little doubt that this represents a gush of blood (*see* 23.5 for related iconography). Even more graphically, one Late Classic polychrome vessel shows the Maya Rain God Chahk* with raised axe (ill. 2). Having just torn the mandibles from two dwarfish creatures (who obligingly gush volutes of blood), he prepares to chop* the fat deer* on which they ride. The scene is a unique one, but its sacrificial and militaristic significance is nonetheless clear. Diego de Landa wrote that sixteenth-century Yucatec Maya warriors removed the mandibles of vanquished enemies as trophies of war. As patrons of war and sacrifice in addition to their more agricultural roles as makers of rain*, mythological narratives of Chahk and Tlaloc likely provided part of the underlying rationale for the taking of mandibles, bones* and skulls* as military trophies.

Blood iconography is also prevalent in scenes of death and dismemberment. Although uncommon, two recent discoveries make possible a fresh engagement with such scenes. The first is a remarkable Early Classic lidded dish uncovered in Becan, Campeche (ill. 3). Part painting and part three-dimensional lid handle, this shows a large and fearsome iguana devouring the lower bodies of three individuals. Probably gods, the three figures wear their names in their headdresses (one seems associated with an early deity from El Mirador), and their closed eyes and helpless postures indicate that they have been killed. Similar scenes are known from a diminutive stela and a large but fragmentary altar, both Early Classic in date and unfortunately unprovenanced. An explanation for these scenes comes from Palenque's Temple XIX bench, which recounts a bloody contest between the local patron god GI and a supernatural crocodilian*. The crocodilian was eventually beheaded, and the earth and sky were likely fashioned from his corpse. The sacrifices of these gods therefore preceded the making of the world.

CH'ICH'?

* CHAHK 6
BONE 13
CHOP 14
SKULL 18
RAIN 67
CROCODILE 77
DEER 78

1

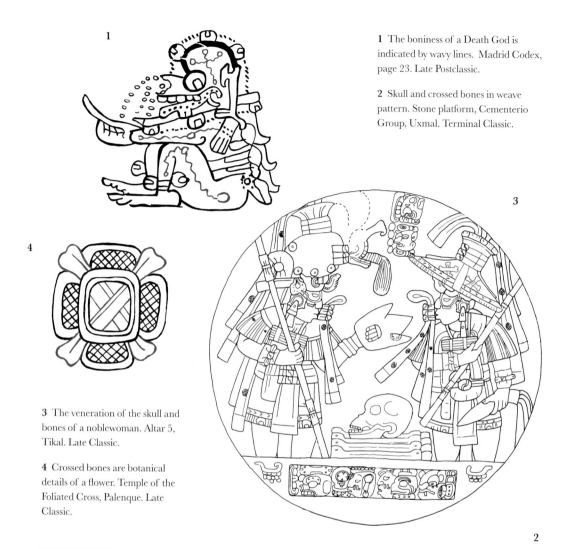

1 The boniness of a Death God is indicated by wavy lines. Madrid Codex, page 23. Late Postclassic.

2 Skull and crossed bones in weave pattern. Stone platform, Cementerio Group, Uxmal. Terminal Classic.

3

4

3 The veneration of the skull and bones of a noblewoman. Altar 5, Tikal. Late Classic.

4 Crossed bones are botanical details of a flower. Temple of the Foliated Cross, Palenque. Late Classic.

2

Because death* and the Underworld loomed large to the ancient Maya, they devised clever ways of representing skeletalized body parts, including skulls*, long bones, and the vertebral column. The word for "bone," *baak*, was represented by several logographs. The one discussed here derives not from its shape but rather a surface feature: the wavy suture lines that develop during growth. That such a subtle trait could serve as an independent logograph underscores the Maya's fascination with surface properties. The signifying power of the suture line was such that it implied skeletalization even when bones were themselves absent. For instance, in the Madrid Codex suture lines on a Death God stand in lieu of his skeletal body parts (ill. 1). In the logograph, the suture line floats between two dotted ellipses representing bony plates, an optional detail that reinforced the glyph's meaning. The bone logograph was the main sign of the Palenque emblem glyph, which, perhaps because of its western location – where the sun entered the Underworld – was called the "kingdom of bone." However, *baak* has other meanings, one of which is "captive," and this rebus is the typical linguistic reference of the bone logograph in Maya writing. This textual reading must have been tempered, however, by mental play between the notion of captives and death as suggested by the bone.

BAAK

The suture line appears on the long bones, skulls and mandibles of skeletal figures and their bone-laden costumes (*see* 1.3). Crossed long bones and eyeballs decorate skirts, capes, and bat* wings in Classic Maya art (*see* 5.1). By AD 900 crossed bones begin to appear juxtaposed to a skull. On a stone platform from Uxmal (ill. 2), crossed bones flanking the skull of a Death God form an unusual interlace pattern suggestive of woven cloth, symbolism relating to an old goddess who patronized weaving*. The skull and crossed bones of European pirate flags and poison bottles are likely of Maya origin.

In Mesoamerica, it was not customary to leave the bones of the departed in eternal peace. Human bones played an active role in the world of the living. Bones were displayed as war trophies, intricately carved, or inlaid with precious stones. Rituals of death – ancestor worship, hunting rituals and captive sacrifice – often involved the manipulation of bones. Bones were defleshed, disarticulated and sorted into piles for veneration, a practice attested in caves containing piles of skulls and long bones. Altar 5 from Tikal shows the veneration of the sorted bones and skull of a noblewoman (ill. 3). One attendant wears a hat decorated with crossed bones.

In Mesoamerican thought, bones were viewed as the seeds of future life. Conceived as having regenerative potential, they often merge with life-affirming symbols, such as flowers* and jewels. The idea of a regenerative bone seed was expressed in depictions of vibrant flowers partly composed of bone (ill. 4). Bones were not dusty, forgotten relics but rather formed a vital bridge between generations.

* DEATH 7
SKULL 18
WEAVING 26
BAT 74
FLOWER 97

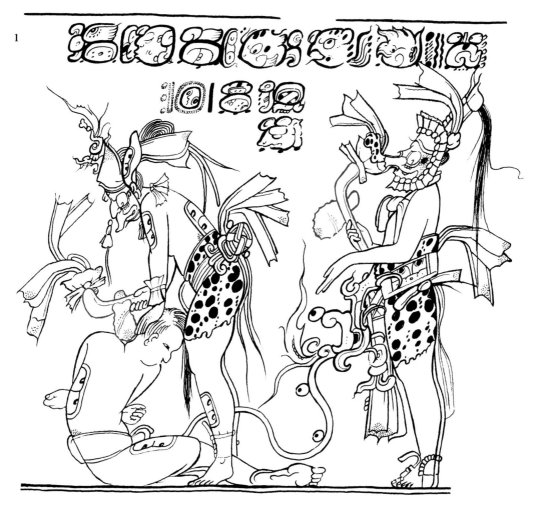

1 The Hero Twins behead an Underworld god, on the Princeton Vase. Late Classic.

2 A Chahk impersonator prepares to strike a Jaguar. Carved vase. Late Classic.

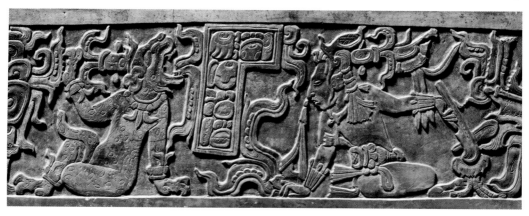

Its handle clearly marked as wood*, and its blade infixed with the characteristic markings of stone* and sturdy flint*, the **CH'AK** sign has long been recognized as the depiction of an axe. Yet despite the obvious iconic derivation, it would be incorrect to read this sign narrowly as an "axe." Rather, this glyph and others like it partake of a process whereby the instrument of an action was employed to symbolize the verbal action itself. Thus, an axe (*ch'akib* or "chopping instrument" in the language of the script) was deployed as the verb root *ch'ak* "to chop," just as a staircase – *t'abib* or "thing for climbing" – was chosen to signify the verb root *t'ab* "to climb, go up." Although the distinction may seem a minor one, it suggests that axes (and adzes) depicted in art were intended to convey the use of the tool rather than just its presence in the scene. Put another way, axes in Maya art are *in flagrante delicto*: depicted in the act of chopping.

This is perhaps best illustrated in a scene from the famous Princeton Vase (ill. 1). Masked as performers, the Hero Twins* explicitly decapitate an Underworld god with large, decorous axes. Note how closely each axe resembles the **CH'AK** sign, including the diagnostic markings of stone, flint and wood. Although offstage in this illustration (*see* 92.2), God L sits nearby in his ostentatious Underworld palace, seemingly absorbed in the task of bestowing jewels on one of his concubines. Only one of the attendant women sees what is going on outside the palace, and she surreptitiously taps her companion on the ankle to get her attention. As related in the *Popol Vuh*, this event marks the beginning of the end for God L's privileged reign.

The axe was also the weapon of choice for the Rain God Chahk*, and numerous scenes in Maya art show him wielding this deadly weapon (*see* 12.2). In some scenes, particularly when he sacrifices jaguars* (*see* 1.3), Chahk wields a heavy flint handstone in addition to a thin-handled lightning axe, its surface marked as shiny and glowing by the sign for jade celt*. This type of axe is strongly associated with K'awiil*, suggesting that the Lightning God may merely be the personification of Chahk's lightning axe. Certainly the weapon is a supernatural one, for when humans impersonate the Rain God they wield more natural-looking stone weapons. Thus, on one elegantly carved bowl in the Kimbell Art Museum (ill. 2), an impersonator wears Chahk's signature *Spondylus* shell* earflare and cut-shell diadem, and hefts a typical flint-bladed wood-handled axe in preparation for his sacrifice of the large, roaring jaguar who faces him. Similarly, on the Dumbarton Oaks panel (*see* 6.2), K'an Joy Chitam II dances in precisely the same costume, wielding a container of rainwater (*see* 58; 67) and a flint-marked axe blade with a venomous serpent* for a handle.

14

CHOP

CH'AK

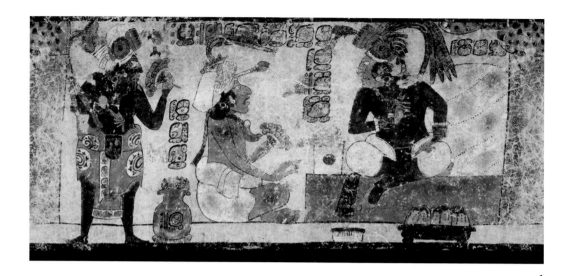

1

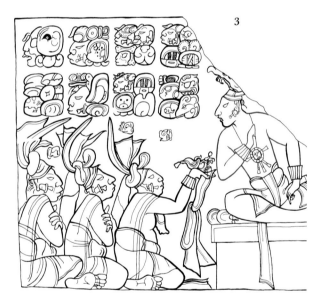

3

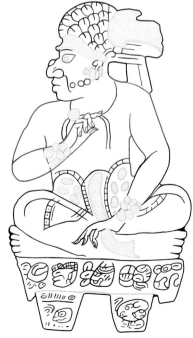

2

1 In the presence of K'awiil Chan K'inich of Dos Pilas. Painted vase. Late Classic.

2 Lordly seated figure in "presence pose." Shell plaque. Late Classic.

3 Accession scene. Sculptured Stone 4, Bonampak. Late Classic.

In several Lowland Mayan languages *ichon* (or a close cognate) means "front" and, somewhat more metaphorically, "presence." Phonetic complements and substitution patterns suggest that this concept was reflected in hieroglyphs by the frontal depiction of a human torso. Usually the neck or the lower body shows the partitive disk which identifies signs derived from human body parts in Maya writing (*see* 16–18; 20). One arm is shown, the elbow bent, the forearm angled across the torso, and the hand lightly flexed in the chest area. This is usually the left arm, but the right arm is featured in at least one instance. The arm is undoubtedly intended to draw attention to the chest area, in this way signaling the general meaning of "front."

In writing, the **ICHON** glyph is usually flanked by the phonetic signs **yi-** and **-NAL** to spell the relational noun *y-ich(o)n-al* "(in) front of" or "(in) the presence of." This term typically introduces the name of a deity or higher-ranking lord who oversaw or attended to a previously stated action. Intriguingly, this important relational noun also seems to have a visual cognate in the highly structured poses and gestures typical of Classic Maya court scenes. On one painted vase, K'awiil Chan K'inich of Dos Pilas (r. AD 741–761) is shown enthroned in his palace conversing with two of his vassals (ill. 1). Elevated above both of his subordinates and portrayed frontally (with the exception of his head), the king is clearly the focus of the scene. This foregrounding is further highlighted by the king's gesture in the form of the **ICHON** glyph, qualifying the entire scene as taking place "in front of him" or "in his presence." This gesture was evidently so recognizable that it could even appear out of the courtly context, as on a carved shell in the collections of Dumbarton Oaks (ill. 2), where a lordly seated figure strikes a solitary "presence pose."

In larger scenes, the "presence pose" of the highest-ranking figure typically overlaps with a series of well-known gestures of respect or subordination made by onlooking vassals, visitors or captives. These gestures include crossed arms, hands tucked under armpits or one hand grasping the opposite shoulder. On one sculptured panel from Bonampak (ill. 3), two vassals gesture respectfully as a third hands the headband of lordship up to his king, who sits cross-legged and makes the "presence pose." Similarly, on the south side of Palenque's Temple XIX bench (*see* 4.1), six vassals and priests gesture respectfully "in the presence of" K'inich Ahkal Mo' Nahb III on the day of his accession (for other scenes illustrating this pairing of presence and respect, *see* 34.1; 28.4; 85.4; 40.3).

Maya art features numerous poses either derived from or codified in writing. Some of the best known include baby*, sit*, throw* and the still-undeciphered term for sadness or grief (*see* Introduction, ill. 6; 50.2, 4).

ICHON

* BABY 1

SIT 17

THROW 20

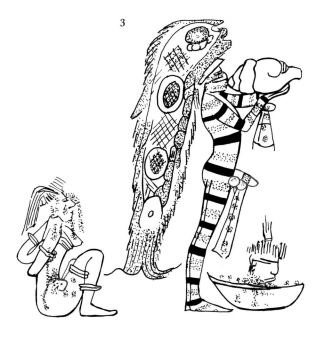

1

3

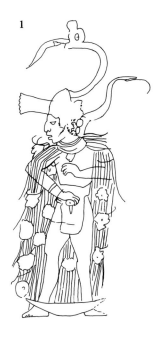

2

4

1 Phallic bloodletting viewed from the front. Painted vase, Dumbarton Oaks Collections. Late Classic.

2 A man holding an erect phallus. Drawing 20, Naj Tunich. Late Classic.

3 An ithyphallic Huk Sip impersonator with a nude captive. Painted vase. Late Classic.

4 Limestone phalli. Uxmal. Terminal Classic.

5 A figure with exposed genitals pays homage to a giant phallus. North Temple, Great Ballcourt, Chichen Itza. Terminal Classic.

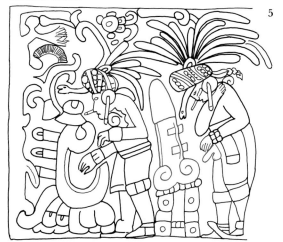

5

Only male genitalia got much "exposure" in Maya art and writing, an outgrowth of male dominance in elite ritual life and representational media. Furthermore, of all forms of blood* sacrifice, drawing blood from the penis had the most cachet. Genital bloodletting lent the penis a mystique reinforced by subtle and not-so-subtle pictorial representations of this act (*see* 24.1). The **AAT** sign, which has no female counterpart in Maya writing, is symptomatic of this androcentric attitude. It presents a flaccid penis and testicle, usually infixed with either a partitive disk characteristic of anatomical glyphs or a marker of rough or wrinkly skin (*see* 77.4; 84.2, 3; 94.3). Two short parallel marks at the top derive from the sign for red*. This may have been the perceived hue of male genitalia, but red was also associated with things hot and masculine, such as the sun*. Although superfluous to its linguistic value, the sign sometimes references bloodletting with the addition of three knots tying a sharpened bone, standard code for autosacrifice. The penis glyph is visually evocative; nevertheless, it was used mainly in nominal constructions, such as the deity name Yopaat.

AAT

Phallic bloodletting is a recurrent subject of Maya art. However, given the rules of decorum, representations of this act on public monuments tend to be veiled. This was not the case for privately viewed, small-scale objects, such as painted vases and ceramic figurines, where such depictions are overt. One vase shows penis perforation in progress from a rare frontal view (ill. 1). The privacy of the setting also encouraged greater candor. Deep in the cave Naj Tunich, Guatemala is a painting of a nude figure with large penis (ill. 2), his squatting pose characteristic of genital bloodletting. Short lines on the penis reference the **CHAK** sign for "red," comparable to the logograph.

The two primary thematic contexts for genital display appear together on a vase which features an ithyphallic ritual performer with the striped body markings and conch trumpet* of a hunting god (ill. 3). His phallus is festooned with bloody bands, and, below, blood is splattered on a bowl displaying a severed head. Behind him is a bound, nude captive. As this scene demonstrates, male nudity was associated both with heroic self-sacrifice and the ignominious treatment of captives. Disgraced captives are shown cast on the ground, with bound arms and disheveled hair, often with ungainly genitals exposed.

Although not well understood, a phallic cult was present in ancient Maya culture. Effigy phalli were fashioned from wood, stone, pottery and even cave stalactites. A few bear cut marks on the tip, suggestive of bloodletting. Effigy phalli are found sporadically across the Maya area. They were produced in the largest quantity and scale in Yucatan, beginning around the Terminal Classic period. Monumental versions are found throughout the Northern Lowlands (ill. 4). Sometimes serving as drain spouts, many adorned buildings, while others were set up stela-like in plazas. A relief in the North Temple of the Great Ballcourt at Chichen Itza depicts men – one displaying his own genitals – paying homage to a giant penis mutilated with wooden insertions, suggesting how monumental stone phalli were used in ritual (ill. 5).

* BLOOD 12

TRUMPET 31

RED 48

SUN 62

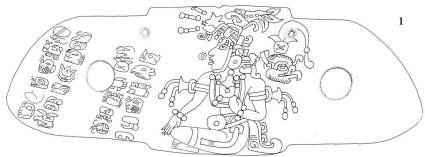

1

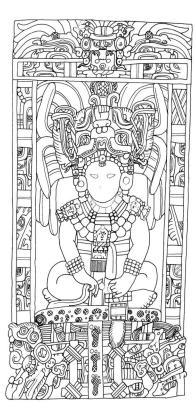

2

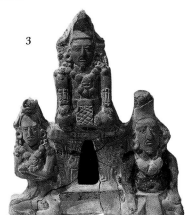

3

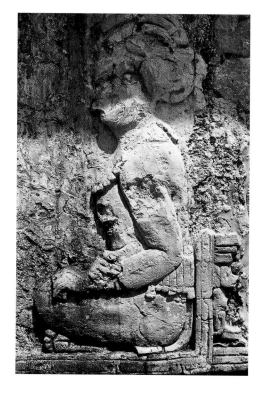

4

1 An early depiction of a ruler in a seated posture with a seating glyph in the adjacent text. Incised Olmec quartzite pectoral. Late Preclassic.

2 K'inich Yo'nal Ahk I seated at his accession. Piedras Negras, Stela 26. Late Classic.

3 Three seated figures. Jaina-style figurine. Late Classic.

4 Subordinate seated figure. Stucco relief. Pier C, House A, Palenque. Late Classic.

Among the earliest verbs known in the Maya script is a pictographic rendition of a human thigh and lower torso, shown in profile. Carved on an Olmec quartzite pectoral centuries later by Late Preclassic Maya, the verb records the action "to sit" and mirrors an accompanying picture of a person dressed in kingly attire seated cross-legged (ill. 1). The verb expresses a metaphor for assuming office through the act of sitting. Going back to the time of the Olmec, who themselves carved box-like thrones, this concept has great antiquity in Mesoamerica. Thus, it is not surprising to see the "seating verb" at the dawn of Maya writing. In this early version in ill. 1, the pictorial basis of the sign is obvious. However, as the verb evolved, it became compacted into an upper hump (the torso) resting over a flattened one (the thigh), stylizations that obscure its iconic source. Normally, on the thigh is the partitive disk marking anatomical glyphs. The profile seated posture easily adapted to the rounded contours of glyphic modification and was coined at a time when kingly figures were always shown in profile.

In Maya political symbolism, sitting on a special seat was a formal culmination of coronation rites. Textually, taking office was expressed through such phrases as "so-and-so sat," usually *chumlaj* or *chumwan*, followed by a preposition and the office, such as *ti ajawlel*, "in lordship." The same metaphorical construct was applied to the calendar in that the seating verb also stood for what numerically was the zero day of a month (*see* 26.1b). The seating or beginning of a month denoted its official "reign" over a 20-day period. Indeed, full-figure glyphs, representing numbers and calendrical periods, are usually shown seated (*see* 58.3).

Kings commissioned sculptures to commemorate their accessions to office. Some sculptures cue the accession with the image of a seated king. Accession stelae from Piedras Negras recreate a ritual in which the king walked to the position of his elevated seat. The artist used footprints to intimate the road* or path of ascent and lead the eye to the enthroned king (ill. 2; *see* 3.2).

In Classic Maya art, profile seated postures are commonplace and generally indicative of important individuals. When kings retrospectively portray ancestors, they are typically shown seated in deference to their status. Palace scenes painted on vases are replete with seated dignitaries surrounded by subordinates. As a general rule, the highest-ranking figure is seated at the highest level, typically on a throne, while subordinates may stand or sit (ill. 3). However, the seated profile posture was not limited to those of high status. Captives sometimes sit cross-legged but more often kneel, the most blatantly deferential pose. In addition, when contrasted with a front-facing figure, the profile seated figure is generally subordinate. In cases where many seated figures are shown in profile, other details, such as degree of elevation and costume, clarify relative status. Hand and arm gestures also play a role in differentiating rank. For instance, one hand grasping the opposite limb could differentiate a seated figure of lesser status from a more powerful one (ill. 4).

CHUM

* ROAD 51

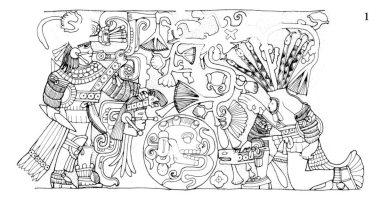

1

2

1 Ballcourt decapitation scene. West Central Panel, Great Ballcourt, Chichen Itza. Terminal Classic.

2 A boxer wearing a skeletal mask. Jaina-style figurine. Late Classic.

3 West façade of Temple 16, Copan. Late Classic.

3

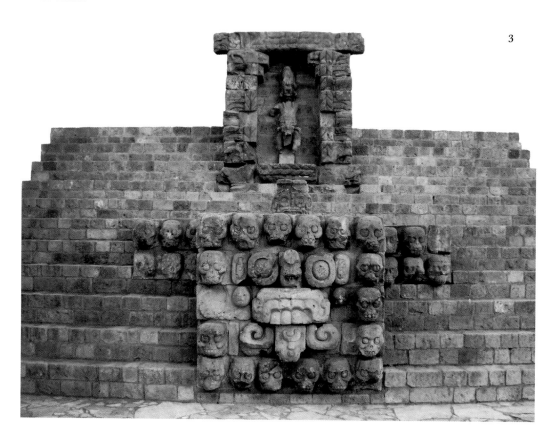

While similar to the sign for death*, that for "skull" or "head" represents a body part proper. For this reason, it takes the characteristic circular marking of signs derived from body parts. The **JOL** sign also typically lacks the articulated mandible, disembodied eyeballs, percentage sign, and topknot of hair, which characterize the Death God (*see* 1.3; 13.1, 2; 33.1).

This disambiguation of skulls-as-body-parts from the preternaturally animated head of the Death God is unlikely to have been accidental. Rather, it allowed for the representation of human skulls as objects in and of themselves, avoiding the problem of their misinterpretation as references to the mythological Underworld realm. Thus, the sign for tomb* depicts a profile skull interred beneath the stone steps* of a mortuary pyramid*, with the skull functioning as a metonymic device for the entire burial. Similarly, on Tikal Altar 5 (*see* 13.3), two individuals re-inter the remains of a deceased noblewoman, indicated by the human skull and tidy pile of long bones situated between them. Despite the imagery of crossed bones in the headdress of the rightmost figure, the scene is historical rather than mythological. Stone* markings beneath the figures indicate that she is to be buried beneath a plaza floor, and archaeologists did indeed discover the bones of an adult female beneath Altar 5.

In addition to conveying mortuary symbolism, skulls were natural symbols of decapitation sacrifice. In the Great Ballcourt at Chichen Itza, there are no fewer than six such scenes (ill. 1). Two teams of from six to seven players line up behind their captains, who face one another across a massive ballgame ball labeled with hieroglyphs reading "Fire (is its) Skull." The loser has been decapitated by the winner, who grasps his disembodied head in one hand and a large flint* knife in the other. Serpents and flowering vines gush from the loser's serrated neck, probably representing the ebbing of his breath and blood, respectively. Such ritual decapitations reenacted the mythological narrative of the Hero Twins*, who played ball with the Death Gods in order to recover the decapitated body of their father, the Maize* God. Ritual reenactments of this myth are well known in Maya art (*see* 36.4; 19.2), and one Jaina-style figurine of a boxer wearing a skull mask probably represents the "impersonation" of one of the Death Gods from this enduring myth (ill. 2).

Ballgame mythology provides much of the rationale behind the *tzompantli* or "skull rack." On the west façade of Copan Temple 16 (ill. 3), the dynastic founder K'inich Yax K'uk' Mo' is depicted ascending into paradise within an ancestral cartouche marked with sun* and centipede* symbolism. Below him is a censer* and a massive skull rack, both emblazoned with fearsome images of the Mexican storm god Tlaloc. The censer, skulls and blood* pouring from the jawless head of Tlaloc serve as reminders of the persistent linkage between sacrifice and the daily journey of the sun.

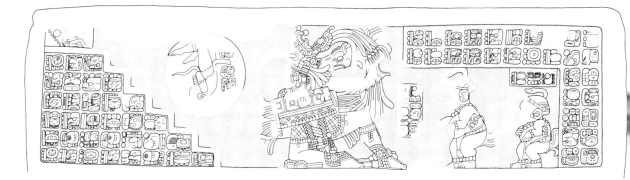

2

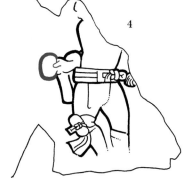

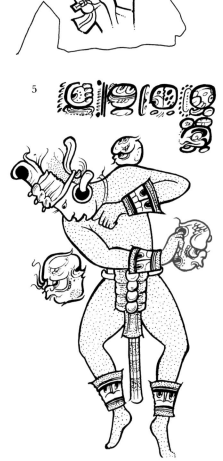

3

1

4

5

1 *Jatz'aal uk'ahk'*, "his fire is struck". Stela 21, Caracol. Late Classic.

2 Bird Jaguar IV of Yaxchilan strikes a trussed-up captive from Lakamtuun. HS2, Step 7, Yaxchilan. Late Classic.

3 A boxer clutching his handstone. Jaina figurine. Late Classic.

4 A boxer wielding a cloth-wrapped handstone. Sculptured Stone 10, Piedras Negras. Late Classic.

5 A supernatural boxer. Painted vase. Late Classic.

Violent sports such as boxing and the ballgame are prevalent themes in Maya art, and so it should come as no surprise that these activities are referenced in glyphic texts. Obviously drawing inspiration from the heavy, cudgel-like weapons held by Classic combatants (ills. 3–5), the **JATZ'** glyph represents a human hand tightly grasping a semi-spherical object. Lest there be any doubt of the material from which these objects were made, they are unfailingly marked with the diagnostic attributes of stone*. Also, it should be noted that the sign occasionally appears in fire-striking texts (ill. 1), suggesting that the stone of choice for these objects was sturdy flint*.

On Yaxchilan Hieroglyphic Stairway 2, Step 7 (ill. 2), we find the **JATZ'** glyph employed to reference the "striking" of the ball. Here, Bird Jaguar IV (r. AD 752–768) impersonates the Water Lily Serpent, a supernatural patron of the sea (*see* 56.3). He is depicted not only in the guise of this god, but also in full ballplayer apparel, including a yoke, protective hipcloth and kneepad. As dwarf servitors of the god look on, the king has just struck his captive, sending his bound body careening wildly off the ballcourt* stairs. The text compares this sacrificial act with three decapitations of supernatural beings that are said to have taken place thousands of years in the past. These references to ancient struggles between ancestral gods and the lords of the dead comprise the underlying mythical rationale of the ballgame. Bird Jaguar IV's ritual reenactment of this myth places his actions in the context of those events, and lends cosmological significance to his act of sacrifice.

While the **JATZ'** sign had varying uses in writing, its principal role in art relates to bloodsports such as boxing. Thus, boxers typically grasp stone cudgels with their right hands, and hold them out in combat readiness (ills. 3, 4) or use them to strike at opponents (ill. 5). These boxers are invariably well protected, wearing long, heavy hipcloths and yokes to protect their kidneys and other vital organs. Armbands controlled the flow of sweat (ills. 4, 5), keeping hands dry and ensuring a good grip on weapons; kneepads (ill. 4) protected joints from injury. Despite these precautions, the sport clearly resulted in grave injuries, as the battered and bloodied face of more than one Classic boxer attests (ill. 3).

There were probably elements of both sport and ritual in such contests. Frequent association of boxing scenes with ballcourts might suggest the former, while depictions of mythological characters engaged in boxing (ill. 5; *see* 61.4) reveal an important religious component, perhaps associating combative bloodletting with agricultural themes such as rainmaking or crop abundance. This may explain why Chahk* and Yopaat (*see* 65.4), the Classic gods of rain and lightning, frequently wield boxing weapons. Indeed, a number of modern Mesoamerican groups still practice highly-ritualized forms of boxing in times of drought, their aim being to let blood and thereby to stimulate rainfall through sympathetic magic.

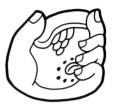

JATZ'

* CHAHK 6
FLINT 27
BALLCOURT 36
STONE 70

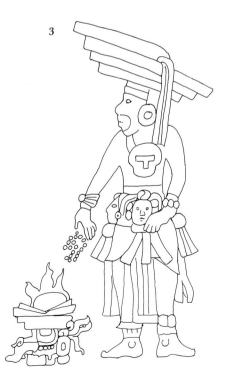

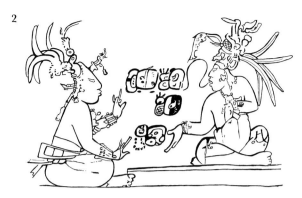

1 Planting scene. Madrid Codex, page 34. Late Postclassic.

2 The hand gesture implies "scattering." Painted vase. Late Classic.

3 A ruler tosses pellets into a burning brazier. Stela 15, Nim Li Punit. Late Classic.

4 Bird Jaguar IV drops sacred fluid on a knotted bundle. Stela 1, Yaxchilan. Late Classic.

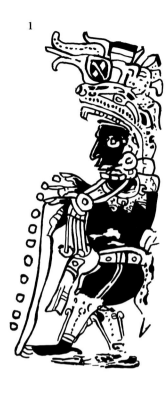

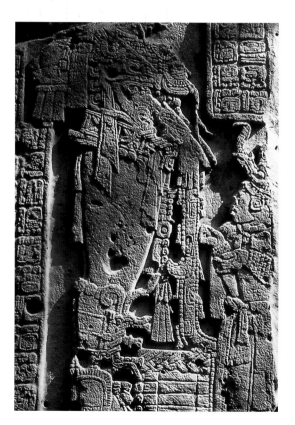

Maya writing relays conventional ritual actions through stylized hand gestures. A common one is a downward-pointing hand, palm facing inward, marked by a partitive disk. The gesture is one of gently tossing something. This hand conveys the meaning "to throw," *chok*, and was narrowly employed to cue a particular ritual act known as "scattering." The verb's direct object is often incorporated into the hand: cascading balls, called *ch'aaj*. An ongoing debate concerns the nature of the scattered material, potentially incense, blood*, water* or maize* seed, all of which were represented as tiny circles and were subject to scattering actions. Fundamentally, the scattering motion recalls the act of sowing corn seeds, which involved tossing them into a hole made by a pointed stick (ill. 1). Indeed, the visual parallel between sowing and ritual scattering – and between the maize seed itself and scattered sacrificial offerings, such as blood – infused scattering rites with generative powers. The gesture was so conventionalized in Maya art that a downturned hand could imply a scattering action even in the absence of any ejected material. On a painted vase a figure makes the throwing gesture with nothing apparently falling from his hand (ill. 2). However, this is deceptive, as the scattered material takes a written form: a logograph reads **K'UH(UL)** "god, holy," wherein lie the pellets, seen as a line of dots.

On many occasions the scattered material appears to be incense; indeed, a standard title of Maya rulers was *ch'ajoom* "incenser." At Nim Li Punit several stelae depict scenes in which pellets are thrown into a flaming brazier (ill. 3). In Colonial Yucatan a substance called *ch'ajalte'* or "tree drops," a viscous form of incense, was burned in precisely this manner. Sometimes the person doing the tossing holds a pouch (*see* 99.3). The fact that the Aztecs used an incense pouch, or *copalxiquipilli*, further suggests that the Maya pouches are incense bags.

Variations in scattering scenes, however, raise the likelihood that different kinds of materials were thrown on different ritual occasions. Another, more fluid, type of scattered substance takes the form of streaming volutes, usually edged by droplets and bearing a specific set of symbols, among them the signs for the colors yellow* and blue-green* and the *Spondylus* shell*, all of which seem to qualify the liquid as something precious and sacred; these volutes must represent a liquid substance, such as blood or water, or something more conceptual encompassing both. On stelae at Yaxchilan the ruler makes the **CHOK** hand gesture as he releases this fluid on a knotted bundle (ill. 4; *see* 47.2).

Although scattering rites varied from city to city, they were performed throughout the Classic Maya realm on period-endings, celebrated by the erection of a stela, many featuring scattering scenes. These stelae often show a ruler in the act of tossing pellets (*see* 57.1). Supernaturals, such as the Paddler Gods*, often hover above, entangled in dense scrolls. This imagery underscores an important goal of ritual scattering: to call forth spirits from the otherworld realm.

20

THROW

CHOK

* PADDLER GODS 11
 BLOOD 12
 BLUE-GREEN 47
 YELLOW 49
 SPONDYLUS SHELL 69
 WATER 72
 MAIZE 98

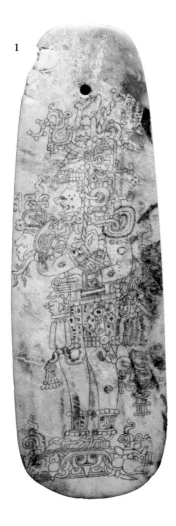

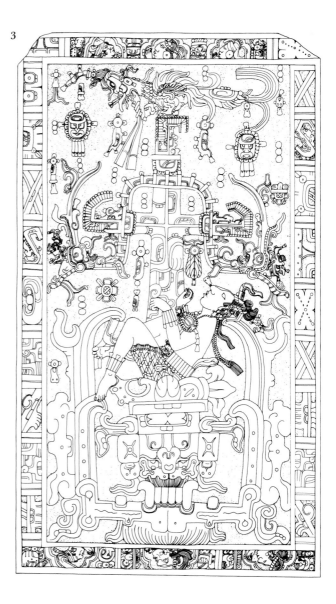

1 Incised Celt. Early Classic.

2 Tree planting scene. Codex-style vessel. Late Classic.

3 Resurrection of K'inich Janaab Pakal I of Palenque. Sarcophagus lid, Temple of the Inscriptions, Palenque. Late Classic.

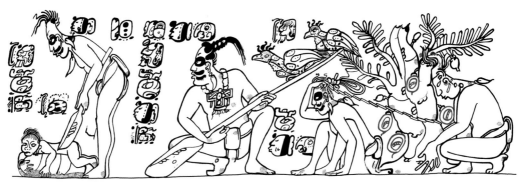

Jade was considered among the most precious of materials and was fashioned by Maya lapidary artists into a wide range of sacred and valuable objects, most notably the incised celts comprising royal regalia (ill. 1). Long termed "celts" because of their fancied resemblance to axe-heads, it is now clear that slender, tapered jade plaques such as this one were actually worn as belt pendants, suspended beneath the revered jade portraits of ancestors, and worn in dance and deity impersonation. In fact, two such belt heads and their pendant celts can even be seen on the front of this plaque, where they hang to left and right of the lord's* heavy belt. Suspended from a single drill hole alongside two or more other celts, the objects would have swung against one another with every move made by the wearer, emitting the sharp, resonant tones for which jade is so well known. That some celts were labeled *uk'ees* or "noisemaker," a term otherwise used only for shell trumpets* and drums*, indicates that the musical chimes of these objects were far from accidental to their appearance on ritual costume.

Although still undeciphered, the contexts and appearance of this sign strongly suggest that it was the Classic symbol for jade and other precious stones. Thus it appears as a logograph for jade celts and celtiform objects in the inscriptions and frequently labels jade objects in art. Yet the sign is ultimately derived from depictions of fruit in iconography. For instance, trees are occasionally depicted with large numbers of these objects hanging from lower branches (ill. 2; *see* 71.3), and the important world trees of Classic Maya cosmology partake of a significant *double entendre* in that their trunks are labeled with a symbol evoking rich crops of both jade and fruit (ill. 3). Given the evident iconic origin of the sign, it's possible that it may read **HUT**, the ancestral Ch'olan term for "fruit, seed and face," but this still requires confirmation. The sign's complex head variant, seen labeling the tree and surrounding sky-band in ill. 3, may eventually provide the solution to this enigma.

Beyond its associations with fruit and jade, the sign's most important role in Maya art and script was as a nonlinguistic marker of bright, shiny or wet objects. Thus, gods and other supernaturals are frequently labeled with this device, presumably to mark their glowing, otherworldly skin (e.g., Itzamnaaj* and the bright mirror of K'awiil*). The basic function of the sign as a label for bright objects is perhaps best shown by the Paddler Gods*, where the day paddler is always marked with the bright jade sign while the night paddler is always marked with the darkness* glyph. The same contrast is regularly seen in sky-bands, where the jade celt (usually in its head variant form) qualifies the bright daytime sky* in opposition to the **AK'AB**-marked skies of night (ill. 3; *see* 17.2; 24.5; 81.1). Elsewhere, sharks* are frequently labeled with the jade celt in probable reference to their wet, glistening surfaces, a trait apparently shared with gourds (*see* 52.1; 89.2) and toads (*see* 71.2). This practice may derive from the appearance of dew on ripe fruit, or the film of moisture on cool hard objects like jade in humid tropic environments.

HUT?

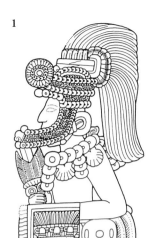

1

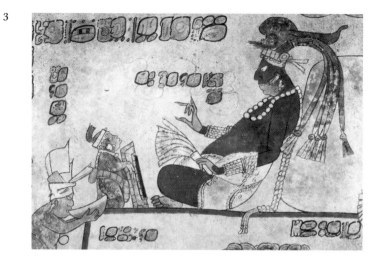

3

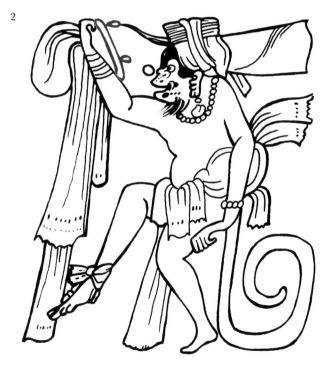

2

1 Yax Nuun Ahiin I wearing Mexican garb and back mirror. Stela 31, Tikal. Early Classic.

2 A dancing spider monkey gazes into a mirror. Painted vase. Late Classic.

3 A lord gazes into an effigy mirror-holder fashioned as a small dwarf. Painted vase. Late Classic.

4 Depictions of mirrors propped up on pillows. Painted vases. Late Classic.

4

Ground and polished stone mirrors have a long history in Mesoamerica and span a period from pre-Olmec times (*c.* 1500 BC) to the Late Postclassic era of the Aztecs (*c.* AD 1500). During the Maya Classic Period, such mirrors were usually fashioned from a mosaic of finely-fitted pieces of iron pyrite pasted onto a backing of slate, wood or other material. Often these mirrors were further incorporated into wooden, basketwork and even featherwork holders, sometimes incorporating elaborate carving and hieroglyphic texts. The **NEHN** "mirror" glyph illustrates the front view of just such an object, with fasteners of jade or bone visible to either side of a central, carved depression. The side view, while not present in writing, was the more common one in art (ills. 2–4) and allows one to imagine the intricate fastening mechanisms and backings of these exquisite objects.

NEHN

Mirrors were frequently worn as personal adornments. On the right side of Tikal Stela 31, for example, the Early Classic king Yax Nuun Ahiin I (AD 379–*c.*406) sports just such a mirror at the small of his back (ill. 1). This recalls the well-known Postclassic Aztec back mirror (*tēzcacuitlapilli*), a symbol of both warfare and fire-making ritual. This connection is enhanced by associated Highland Mexican military symbolism, including coyote tails, an *ahtlatl* (spearthrower), a Tlaloc shield* and a shell-mosaic helmet*. Burials of warriors uncovered in Early Classic Teotihuacan and Kaminaljuyu are equipped with many of these materials, including back mirrors just like those worn by Yax Nuun Ahiin I.

Mirrors also played a prominent role in religion. Concave mirrors of the type favored by the ancient Olmec both reflected and inverted images and could actually start fires. Even the only slightly concave mirrors of the Classic Maya distorted reflected images and this lent them a mysterious power. In addition, mirrors seem to have been conceptualized as openings to other worlds – much like caves* – and it was perhaps this feature more than any other that led to their role as important instruments of divinatory scrying. On one Classic Maya vase, a monkey* dances while gazing into a mirror held outstretched in his right hand (ill. 2). The mirror is illustrated from the side, its fastenings and a fine weave of hanging cloth clearly visible.

Yet mirrors held an even more prominent role in the aesthetics of the Classic Maya court, depictions of which frequently show kings gazing raptly into mirrors held by their subordinates. In one such scene, a lord gazes at an effigy mirror-bearer fashioned to resemble a diminutive dwarf (ill. 3), while in others, attendants look away as the image of their king is revealed. Even more frequently, mirrors are depicted propped up on jaguar-skin pillows or other supports alongside thrones* (ill. 4), often sitting to one side of the main scene among a group of other important courtly provisions, such as cacao* vases, pulque vessels, and plates burdened with seasoned tamales*.

* HELMET 28
SHIELD 29
THRONE 33
CAVE 52
MONKEY 84
CACAO 95
TAMALE 100

1

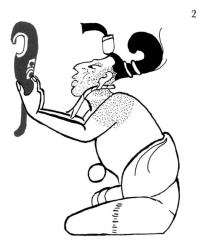

2

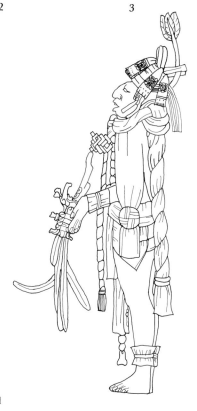

3

1 Prismatic obsidian blade. Aztec. Denver Art Museum. Late Postclassic.

2 Hooked and pointed eccentric obsidian. Painted vase. Late Classic.

3 Obsidian bloodletter with multiple prongs. Relief sculpture. Temple of the Foliated Cross, Palenque. Late Classic.

4 An earflare worn by the *ajk'uhuun* of K'inich Ahkal Mo' Nahb III has a projecting obsidian element. Temple XIX stone panel, Palenque. Late Classic.

5 A sacrificial bowl holds three bloodletters and the decapitated head of the Maize God. Incised ceramic dish. Early Classic.

4

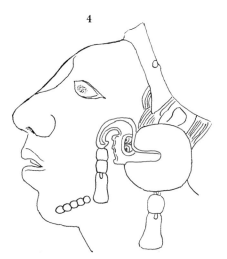

5

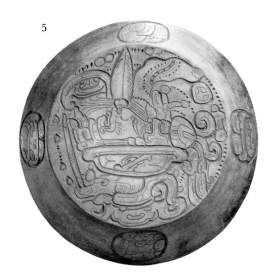

For the grim task of blood sacrifice, the Maya had no lack of imagination or tools. Quite sensibly, bloodletters were fashioned from obsidian, a siliceous volcanic glass which produced the sharpest cutting edge (ill. 1). Obsidian blades not only were admirable bloodletters but were also placed in caches, sometimes by the thousands. The fist-like hieroglyph features a rounded form – the bloodletter's base – given clarity by the pointed blade. In Maya art, points, hooks and indentations are a hallmark of obsidian artifacts, called "eccentrics" because of their irregular contours (ill. 2). The glyph is infixed with either a reflection sign – like the one marking jade celts* and other smooth-surfaced objects – or the sign for darkness/night* appropriate to dark-colored obsidian.

Textually, the obsidian bloodletter reads *ch'ahb*, a verb with complex meanings, such as "to be pious," "to do penance," "to punish" and "to create." How might these disparate ideas be relevant to an obsidian bloodletter? Bloodletting was a devotional, painful ordeal, yet one with overtly creative consequences. Blood offerings appeased the gods who controlled the natural cycles and, ultimately, human fecundity. In this sense bloodletting promoted life, and, indeed, the **CH'AHB** sign was used glyphically to express the relationship between parent and offspring. Perhaps the essence of *ch'ahb* is captured in phallic bloodletting inflicted with an obsidian blade (*see* 25.2). This act, in which men offered the stuff of life from their generative organ, was at once devotional, penitential and procreative.

As seen on several Yaxchilan lintels, the obsidian bloodletter appears in containers alongside other bloodletting equipment. On Lintel 25, a bowl, also holding a stingray spine*, is clutched by Lady K'abal Xook (*see* 46.2). The obsidian bloodletter resembles the glyph, but the blade is curved. Sharply hooked, jagged and indented contours characterize both obsidian bloodletters and weaponry, which typically bear the **AK'AB** "darkness" sign. One example, seen on a vase, has a projection at bottom that recalls a prismatic blade (ill. 2). An obsidian bloodletter bearing an **AK'AB** sign, pictured on a Palenque relief, has a crooked blade-like shaft and side extension (ill. 3). On another limestone relief at Palenque, an obsidian component of an earflare can be readily identified by a delicate hook, jagged edges and **AK'AB** infix (ill. 4).

A unique aggregation of bloodletting tools depicted on the lid of an incised ceramic cache vessel includes a stingray spine flanked by an obsidian bloodletter (at left) and a flint* blade (ill. 5). Lining the rim of the bowl (a ploy to reveal the bowl's contents), the three bloodletters are made to resemble a plant sprouting from the decapitated head of the Maize* God. The usually straight flint blade, at right, has been bent to parallel the curving obsidian bloodletter, transposing them into curling leaves, while the erect stingray spine sprouts like a growing plant. This blend of vegetal and sacrificial imagery neatly illustrates the causal logic weaving together the diverse meanings of *ch'ahb*: the devotional act of blood sacrifice ensures the continuity of the earth's creative processes.

23

OBSIDIAN
BLOODLETTER

CH'AHB

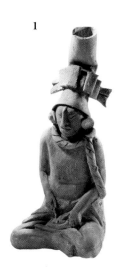

1 A man performing phallic bloodletting, his neck wrapped in rope. Jaina-style figurine. Late Classic.

2 Text framed by rope. Stela F, Copan. Late Classic.

3 A ruler draped in twisted cloth simulating rope. Temple XIX stone panel, Palenque. Late Classic.

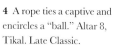

4 A rope ties a captive and encircles a "ball." Altar 8, Tikal. Late Classic.

5 A celestial scene in which twisted rope supports the heavens. Paris Codex, page 22. Late Postclassic.

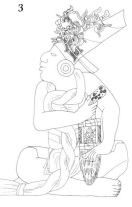

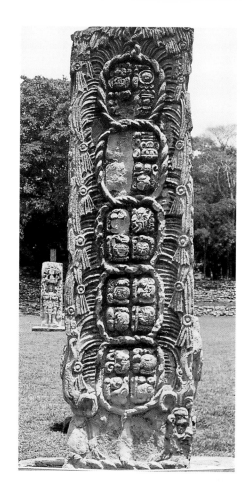

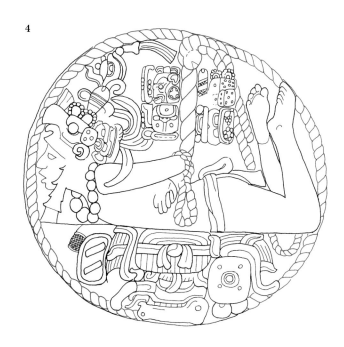

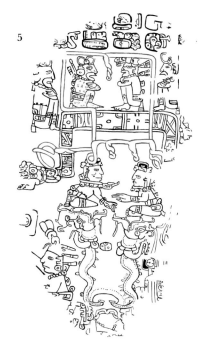

Maya art pays meticulous attention to tying and binding, whether of gods, rulers, prisoners, offerings, ritual paraphernalia or even stone monuments. Binding methods are precisely depicted and knots, symbolic of binding, are exaggerated and often shown in high stacks (*see* 20.4). Given this interest in tying, something that can be traced back to the Olmec, the basic binding material, rope, was redolent with meaning. In spite of its prolific use in Maya art, rope in its glyphic form is relatively rare. The few known examples depict the rope looped at one end or formed into a figure-eight. The twisted fibers, perhaps wrought from sisal, are simulated by short lines.

The thematic context of rope bindings fits into two broad categories: capture associated with warfare and hunting where bindings suggest humiliation and conquest; and rituals where bindings had more lofty connotations, of sacred status and, for the bound ritual performer, of restraint implying spiritual surrender, piety, humility and self-sacrifice (ill. 1). All known occurrences of the rope logograph in Maya writing concern the latter context. Indeed, the tying of ceremonial objects, ranging from small bundles to immense stone altars and stelae, some of which have ropes carved into their compositions, was a mainstay of elite ritual. Even hieroglyphic texts on stelae were sanctified through carved rope frames (ill. 2).

Certain forms of ritual binding required elites to swaddle themselves in thick knots of twisted cloth (ill. 3). Worn captive-style around the neck, these cloth bindings seem to be elegant versions of rope, evinced by the fact that the rope logograph also stands for this same twisted cloth. It may seem odd that royalty would don rope-like paraphernalia so clearly reminiscent of bound captives. However, in elite ritual, this was an expression of piety since rope bindings were broadly emblematic of sacrifice, an idea extending to those who nobly shed their own blood, as well as the hapless captives who did so unwillingly. Similarly, sacrificial offerings, such as rubber balls*, were bound in rope (*see* 68.4). Altar 8, Tikal is an intriguing variation on the theme of sacrifice and rope binding (ill. 4). The altar's circular shape and the encircling rope suggest a tied rubber ball. The captive inside the ball, a victim of Yik'in Chan K'awiil (r. AD 734–746), is likewise tied. The rope, thus, suggests an equivalence between the rubber ball and human sacrifice as two classes of bound sacrificial offerings.

The twisted form of the rope logograph is significant and has direct iconographic parallels. Evocative of an umbilical cord, twisted rope, sometimes given serpent* attributes, represented a kind of structural support for the heavens, binding it together, maintaining its integrity and even dragging celestial bodies through the sky. In historic times, the Yucatec Maya called this rope *u táab kà'anil* "cords of heaven," or *k'uxá'an sùum* "living rope." A scene from the Paris Codex depicts this twisted cord weaving around four world bearers sitting on an arched sky*-band (ill. 5). Both the twisted cord and four world bearers outline the heavens' geometry, and by doing so provide affirmation of its structural integrity and a reassuring sense of world order. In the lower right, a cord suspends the sun* shown in an eclipse phase.

CH'AJAN?

* SKY 60
SUN 62
RUBBER BALL 68
SERPENT 86

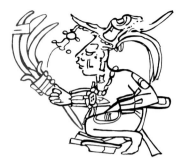

2 Young god letting blood from his penis. Huehuetenango Vase. Late Classic.

1 Stingray spine engraved with hieroglyphs. Burial 82, Piedras Negras. Late Classic.

2 Young god letting blood from his penis. Huehuetenango Vase. Late Classic.

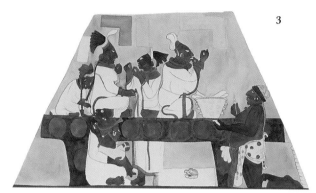

3 Noble women let blood from their tongues. Room 3 Mural, Bonampak. Late Classic.

4 Sacrificial scene. Lintel 14, Yaxchilan. Late Classic.

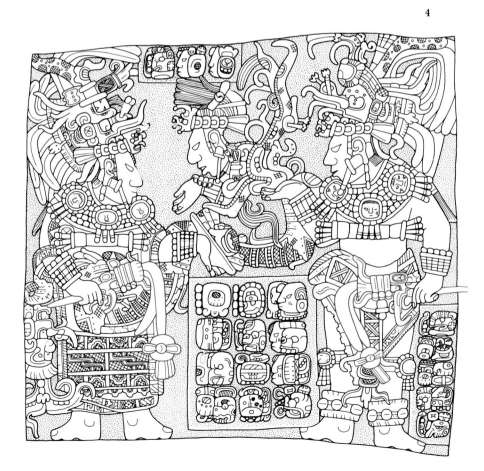

Although originally derived from a compound noun meaning "serpent's tooth," *kohkan* came to refer more narrowly to the sharp spines of the stingray, one of a group of rays of the family *Dasyatidae* common to the warm coastal waters of Mesoamerica. The **KOHKAN** glyph is a reasonably realistic depiction of a stingray spine, as can be seen by comparing it with one such spine recently recovered at Piedras Negras, Guatemala (ill. 1). Interestingly, the spine actually contains the **KOHKAN** glyph in a name-tag, which serves to identify this object as the stingray spine of a local prince.

While the stingray itself was rarely depicted in art, its spine was a matter of intense interest and importance, not least because of its role as an instrument of penitential bloodletting. Such usage has a long history in Mesoamerica, spanning from at least Olmec times (*c*. 1200 BC) to the early Colonial era. Indeed, Diego de Landa records the use of stingray spine bloodletters into at least the late sixteenth century.

The testimony of ancient art informs us that stingray spines and other sharp implements were used by male rulers to draw blood directly from the foreskin of the penis*. Thus, in a scene from the Huehuetenango Vase, a young god kneels before an offering bowl, preparing to let blood from his penis with the elaborately-decorated obsidian bloodletter* he holds in his right hand (ill. 2; *see* 24.1). By contrast, noble women let blood from their tongues. In a scene from the Bonampak murals (ill. 3), for instance, we see the wife of the king preparing to pierce her tongue as an attendant looks on, offering another bloodletter should it be needed. Beside her, another lady of the court is assisted in drawing a cord through her already pierced tongue. More detailed scenes, such as those on Yaxchilan Lintels 24 and 25 (*see* 46.2, 3) show that the cord could be studded with thorns, making it even more effective at drawing blood. Both of these scenes feature very realistic stingray spines resting in bowls alongside obsidian lancets and other sharp instruments, a widespread icon known as the Quadripartite Badge (*see* 63.4; 21.3; 23.5).

Such bloodletting rites fulfilled the Maya's debt to the gods, who created humans out of blood* and maize*. These were therefore sacred acts of creation and rebirth not unlike the modern taking of the Host in holy communion. On a Late Classic lintel from Yaxchilan, Lady Great Skull and her brother celebrate the successful birth of her son, the future Itzamnaaj Bahlam IV (AD 769–*c*.800), through deity impersonation and bloodletting in symbolic reenactment of creation (ill. 4). Both hold stingray spines set in ornate deity-head hafts crowned with quetzal plumes (ill. 2). Just such hafts, molded in the likeness of the Classic Rain God Chahk* and associated with stingray spines, have been recovered in recent excavations at Piedras Negras.

KOHKAN

* CHAHK 6
 BLOOD 12
 PENIS 16
 OBSIDIAN
 BLOODLETTER 23
 MAIZE 98

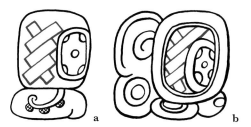

1　Glyphs for the first month, K'anjalaab ~ K'anjalaw. Late Classic. 1a **[K'AN]JAL-bu**. Cross Tablet, Palenque. 1b **CHUM-[K'AN]JAL-wa**. Hieroglyphic Stairway, Copan.

2　Tribute offering scene. Painted vase. Late Classic.

3　Textile pattern from a Late Classic painted vase.

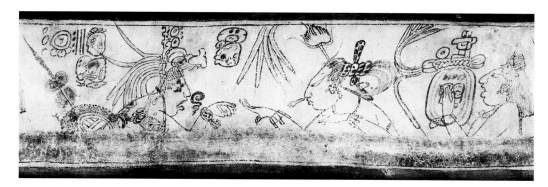

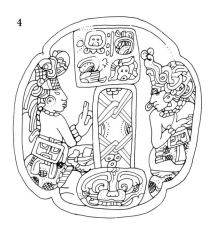

4　Two figures flank a stela and altar. Incised Peccary Skull, Tomb 1, Copan. Late Classic.

5　Front façade of Copan Structure 22-A. Late Classic.

Although often referred to as the mat sign (*pohp*), hieroglyphic inscriptions and associated art suggest that the **JAL** glyph never had this pronunciation or restricted significance. For one thing, the glyph regularly appears with the value **JAL** in the compound for the first month of the Maya year, K'anjalaab or K'anjalaw (ill. 1). For another, the **JAL** sign was far more general in application than has previously been suggested, apparently referring to all sorts of woven materials. Thus, although finely-woven textiles were one key referent, the sign seems occasionally to refer to plaited hair, twists of rope* in addition to the reed mat which was a key symbol of royalty.

There can be little question, however, that the sign's primary referent in art was to woven cloth. Thus, in tribute payment scenes from codex-style ceramics, an attendant holds a large bundle of offerings – including jade jewelry, quetzal* feathers, textiles and a bag filled with 8,000 cocoa beans (*junpihk kakaw*) – while his master parlays with a heavily-armed warrior (ill. 2). On related vessels, the attendant carries lesser or greater amounts of textiles, occasionally alongside such fineries as bone* ornaments, *Spondylus* shells* and bundles of jade*. The textiles given in tribute were probably mantles and capes of the type mentioned in Colonial sources and no doubt resembled the finely-woven garments worn by royalty. Indeed, one schematic representation of cloth from a Late Classic polychrome vessel incorporates embroidered flowers* alongside a layered weave (ill. 3), motifs duplicated in conflated form on the garments of Lady K'abal Xook and Itzamnaaj Bahlam III on certain of the Yaxchilan lintels, explicit sources for the design and elaboration of Classic period textiles (*see* 46.2, 3).

Other depictions are somewhat less clear with respect to the class of woven material referenced. In one scene from an incised peccary skull (ill. 4), two figures are seated to either side of an altar-stone and stela within a quatrefoil cartouche representing a cave*. The stela is clearly marked with the **JAL** glyph, and the associated text refers to the "wrapping" of the stela on an important period-ending (8.17.0.0.0, or October 21, AD 376). Ethnographic accounts speak of a dangerous, liminal period during which time newly-fashioned sacred objects are extremely susceptible to soul-loss. Such objects are typically wrapped in cloth to protect them until they are stronger, and perhaps that is what is referenced here.

Somewhat less clear are the occasional appearances of the **JAL** glyph in the elaborate stone mosaic façades of certain palatial buildings, such as Structure 22-A of Copan (ill. 5) or the Palace of the Governor at Uxmal. While potentially "Mat Houses" (*pohpol naah*) of the type referenced in Colonial dictionaries, it is also possible that these designs refer to textiles, perhaps highlighting the economic value of woven cloth to the residents of these fine palatial structures.

JAL

1

2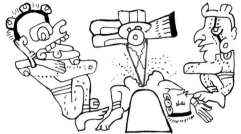

3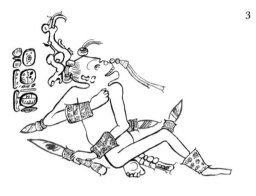

5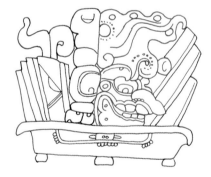

4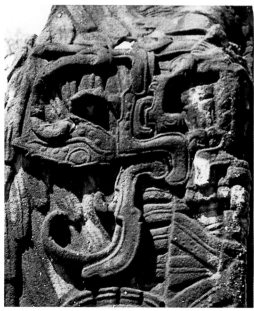

1 Chipped bifacial ovoid knife.

2 Crossed wavy lines mark a flint knife. Madrid Codex, page 76. Late Postclassic.

3 Flint knives sprout from the joints of an underworld *wahy* character. Painted vase. Late Classic.

4 A centipede with a flint blade tongue. Stela J, Quirigua. Late Classic.

5 An offering dish holds a personified flint. Altar 7, Tikal. Late Classic.

Despite lofty achievements, the Maya were essentially a Stone Age people. Until the end of the Classic period metal was neither manufactured nor imported in the Maya Lowlands. Although gold and copper appear during the Postclassic, metal was not a factor in the rise of Maya civilization. For tools and weaponry they relied on two types of stone: flint, a hard, siliceous rock, also called chert, and obsidian, or volcanic glass. Of the two, only flint was available in the Lowlands, with the largest mining center situated at Colha, Belize.

That flint was worked into so many types of artifacts accounts for the variability of its corresponding logograph. It sometimes mimics an ovoid bifacial knife (ill. 1); indeed, textually, a flint sign can allude to this weapon and more broadly to blood sacrifice, a secondary meaning of *took'*. At other times, the edges of the logograph are irregular, like an eccentric flint. The diagnostics of the sign also vary. They usually consist of black bands, corresponding to flint's natural banding, and lines bordered by dots, perhaps evoking flint's sparking action. First seen in the Late Preclassic San Bartolo murals (*see* 52.1), these linear and dotted elements comprise the earliest sign for "stone*" in Maya art, a role later assumed by the **TUUN** glyph. However, **TOOK'** and **TUUN** signs are related and sometimes merge their diagnostic elements. Another symbol for flint consists of zigzag lines crossed in an X, emulating the scalloped surface of chipped flint. This sign stood for the day Etz'nab whose equivalent in the Aztec calendar is Tecpatl, a flint knife. The wavy lines mark a flint knife in a gruesome scene in the Madrid Codex (ill. 2).

Flint blades were associated with death*. One blade-studded *wahy* ogre is a veritable slicing machine (ill. 3). Because of its use in weaponry, flint was emblematic of warfare, seen in the flint–shield* glyphic compound, a military ensign worn on rulers' costumes. In a variation on this theme, the flint blade forms the tongue of the grisly centipede*, transforming it into a living weapon (ill. 4). While the spear was the Maya's principal weapon, for ritual executions, which often entailed decapitation, the flint axe was standard (*see* 14). The Maya chipped effigy axes in their entirety – from wooden handle to blade – out of a single piece of flint.

The Maya's expertise in lithic technology is no better illustrated than in so-called "eccentric flints," ritual paraphernalia of intricate design. It may seem odd that rude flint was ever adopted as an artistic medium. Yet, Maya flint-knappers produced objects of great aesthetic merit. Eccentric flints are usually notched or multi-bladed affairs with built-in handles, as can be seen on Tikal Altar 5, where one figure holds an eccentric flint and another a flint knife (*see* 13.3). Eccentric flints are found, often in large numbers, in buried caches. Nine eccentric flints cached in the Rosalila Structure at Copan were lovingly wrapped in blue cloth. The eccentric flint was personified as though a living thing (ill. 5; *see* 29.3); most spectacular of all are chipped flint effigies, usually of the god K'awiil*.

27

FLINT

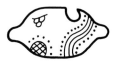

TOOK'

* DEATH 7
K'AWIIL 10
SHIELD 29
STONE 70
CENTIPEDE 75

1

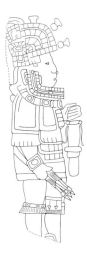

1 A mosaic helmet as part of Teotihuacan-inspired military garb. Stela 1, Tres Islas. Early Classic.

2 A Teotihuacan-style figure wears a mosaic War Serpent headdress. Painted stucco, lid of ceramic bowl, Burial 10, Tikal. Early Classic.

3 K'inich Yo'nal Ahk II wears the War Serpent headdress. Stela 7, Piedras Negras. Late Classic.

4 Lady Sak K'uk' presents a mosaic helmet to her son K'inich Janaab Pakal I. Oval Palace Tablet, Palenque. Late Classic.

5 Pillbox hat style of mosaic helmet. Jamb relief, Upper Temple of the Jaguars, Chichen Itza. Terminal Classic.

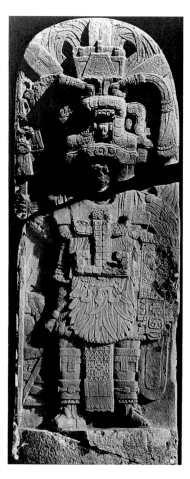

3

2

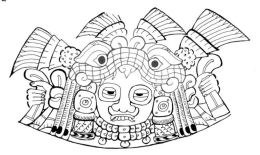

4

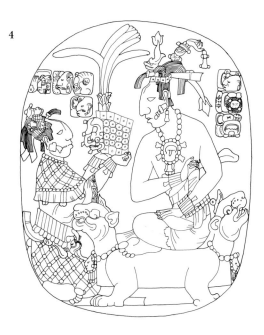

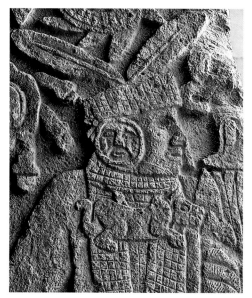

5

One of the most intriguing headdresses in Maya art is a tall war helmet covered in a mosaic of shell plaques. Piles of *Spondylus* shell* plaques excavated at Piedras Negras may be the remains of these helmets, without wooden backing, long deteriorated. While pictorial evidence indicates that the helmet had variant forms, the logograph standardizes it as a tall rounded headdress covered in scalloped plaques reflecting the shell's natural curvature. As a thing of beauty, the shell mosaic war helmet must have been dazzling but would also have been protective if worn in battle.

Although the shell mosaic war helmet was a staple of Maya military costume for 500 years, its origins lie in Teotihuacan. Centuries before the helmet, along with a constellation of other costume elements, such as paneled collars, knee bands, flat shell necklaces and back mirrors*, appeared in Lowland Maya art, they were already a standard warrior outfit at Teotihuacan. Sacrificed young men interred underneath the Temple of the Feathered Serpent at Teotihuacan, around AD 225, were actually wearing parts of this costume. Dating to the fifth century, the earliest Maya examples are closest to Teotihuacan prototypes. For instance, on a stela from Tres Islas, Peten, the protagonist, wears a helmet resembling the logograph, a paneled collar and knee bands and carries a bag and *ahtlatl* darts, all highly reminiscent of Teotihuacan models (ill. 1). By adopting these trappings, Maya warrior kings aligned themselves with what was then the most powerful political and economic center in Mesoamerica.

The mosaic helmet has a zoomorphic variant based on another Teotihuacan creation known as the War Serpent*, a creature linked to a military cult of the Feathered Serpent. An Early Classic Maya example on a painted bowl from Burial 48 at Tikal adopts both the iconography and rigid style of Teotihuacan art (ill. 2). The popularity of the zoomorphic mosaic helmet in military portraits persisted through the Late Classic period, as illustrated by Stela 7 from Piedras Negras, where the ruler's head is encased in the serpent's jaws. Teotihuacan symbols frame the helmet, whose harsh angularity, antithetical to Classic Maya design, suggests something foreign (ill. 3). While Early Classic examples of the helmet are concentrated in a zone around Tikal, during the Late Classic they are more prevalent in the Western Lowlands. In a standard coronation scene at Palenque, for instance, the ruler receives the helmet, perhaps an heirloom, from a parent. In Palenque's Oval Palace Tablet, Lady Sak K'uk' presents a helmet to her son, K'inich Janaab Pakal I (ill. 4). The Jester God head (*see* 4), quetzal* feathers and round disks, indicative of jade rather than shell mosaic, moderate the helmet's foreign flavor and make it more like a royal crown than just a war bonnet. A trimmer "pillbox" version of the helmet survived into the Terminal and Postclassic periods at Chichen Itza, well after the demise of Teotihuacan (ill. 5). The war helmet in its Postclassic guise suggested fealty to the cult of the Feathered Serpent and Tollan, a mythic "great foreign power" (*see* 96), possibly modeled on Teotihuacan, that shaped Postclassic political ideology.

28

HELMET

KO'HAW

* MIRROR 22
SPONDYLUS SHELL 69
SERPENT 86
QUETZAL 93

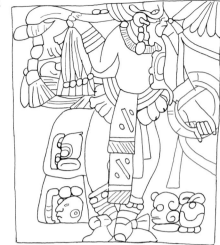

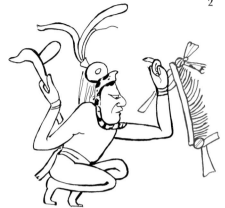

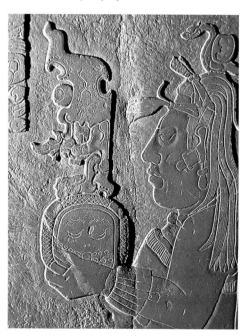

1 A shield held by straps. Carved vase. Late Classic.

2 A large shield used for protection. Painted vase. Late Classic.

3 A noblewoman holds a "flint–shield" war emblem. Tablet of the Slaves, Palenque. Late Classic.

4 A shield used as insignia on a war banner. Painted vase. Late Classic.

5 A wrist shield with the visage of the Jaguar God of the Underworld. Jade plaque. Late Classic.

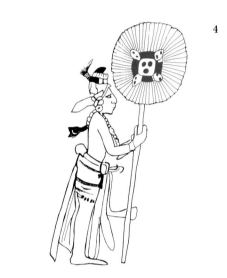

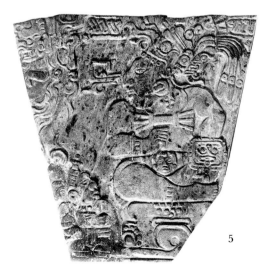

Although the ancient Maya were once viewed as peace-loving people absorbed in arcane intellectual pursuits, this stereotype was shattered by evidence of chronic warfare. In this regard, the Maya fare no better than the Aztecs, whose reputation for saber rattling is legendary. As in Aztec society, distinction in warfare was a path to glory, no less for kings whose regnal titles boasted of captives claimed to have been taken. Given this bellicose climate, instruments of war became potent symbols of power. This is certainly true for the spear and shield, which stood for war, as seen in the hieroglyphic expression *u took' u pakal* "his flint*, his shield."

The logograph for shield is conveyed by a round wrist shield featuring a cross-hatched outer band, often ringed by dots, and a narrow band of chevrons representing woven straw; these patterns are conventional textile borders and appear together, for instance, on baskets (*see* 46.3). On the shield they encircle a central field with varying insignia. At the corners, circles indicate where decorative tassels were attached. These materials were mounted on a rigid backing, possibly of wood. The lavish embellishment of shields shows that they were objects of manly pride. As pictured in ill. 1, the back of the shield was outfitted with straps for a secure grip. These small shields were most effective for quick maneuvering at close range. The Maya also used larger shields, which afforded complete body protection (ill. 2). The largest rectangular flexible shields, adopted from Teotihuacan, had wicker armatures covered in thick woven cotton decorated with tassels. Several limestone panels at Tonina are carved effigies of rectangular shields.

The design within the central field conveyed symbolic messages, some diagnostic of ethnicity. For instance, the Maya adopted war-related imagery from Teotihuacan seen in certain shield designs, such as the image of an owl*, a dripping blood* motif and the visage of the Storm God Tlaloc. However, most shield ensigns derive from the Maya pictorial tradition. One, the flayed face shield, with stretched facial features, reflects a widespread practice in Mesoamerican warfare comparable to taking scalps. Conquistadors reported that Spanish soldiers captured by the Aztecs had their faces turned into leather masks. In Maya culture, the flayed face shield was incorporated into elite ritual, as were other military objects. At Palenque flayed face shields, together with a personified flint blade, an iteration of the flint–shield war glyph, were ceremoniously displayed by women (ill. 3). Another common shield design, consisting of three circles resembling a face, may be an abstraction of the flayed face shield. On one pictorial vase a shield of this type emblazons a war banner, demonstrating that the image of a shield served as a kind of military insignia (ill. 4). This shield is clearly identifiable by the dark border and tassels at the four corners. Other shield blazons include the death*-related percentage sign, meant to intimidate enemies, and the visage of the Jaguar* God of the Underworld, a patron of war. The latter shield imagery, the most common type in formal portraits of kings (ill. 5), may have served to ward off destructive supernatural forces.

PAKAL

* DEATH 7

BLOOD 12

FLINT 27

JAGUAR 83

OWL 92

1

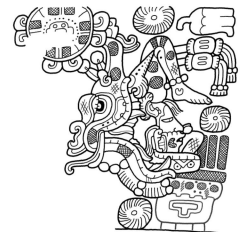

2

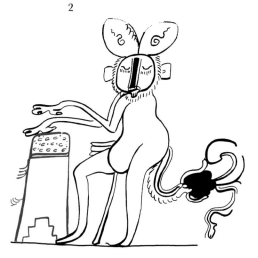

4

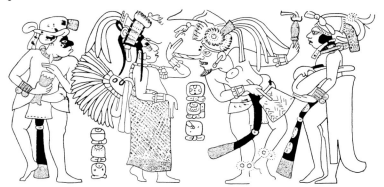

1 An acrobatic drummer on the Deletaille Tripod. Early Classic.

2 A deer plays the standing drum. Painted vase. Late Classic.

3 Various anthropomorphic animals play instruments. Chama-style vase. Late Classic.

4 A sexually-charged dance. Painted vase. Late Classic.

3

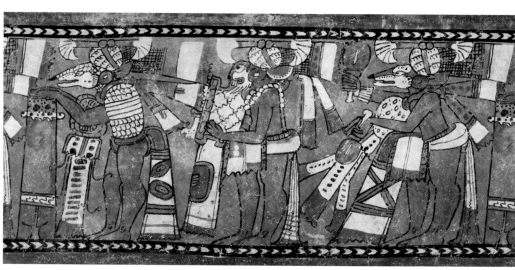

Music was the heart of Classic Maya ritual life, and few indeed are the Classic scenes of dance, performance or ballplaying without participating musicians. Like other Mesoamerican peoples, the Maya did not practice musical notation, so in order to reconstruct the nature of their music, scholars make educated guesses based on Colonial accounts, on the rich depictions of musical instruments in art, and on those precious few instruments which have been recovered archaeologically. Among the more common instruments were flutes, whistles, rattles, bone and gourd rasps, bells and trumpets*. But by far the most impressive instrument was the drum, itself coming in a variety of sizes ranging from small hand drums known as *lajab* (ill. 4) to massive, upright floor drums resembling the well-known Aztec *huēhuētl* (ills. 2, 3; *see* 89.1).

Although somewhat rare and unfortunately still undeciphered, the rich iconography of the sign illustrated above leaves little doubt that it represents a standing Maya drum. Perhaps most striking is its clear representation of a spotted jaguar* pelt drumhead. Many drums in art are supplied with precisely this kind of head (ills. 1–3), though some occasionally feature the skins of other animals, as in a probable deer-skin drum depicted at Bonampak (*see* 89.1). By convention, the pelts on these drums are shown with scalloped edges, revealing that they were stretched taut during tanning, either by stakes or on a frame. Another key feature of the drum sign is the **IK'** (wind*) motif, which frequently labels musical instruments in Maya art. In one scene from an incised Early Classic tripod (ill. 1), soothing sounds represented by iconic blossoms and buds emerge from an **IK'**-marked drum and rattles played with extraordinary dexterity by an acrobatic musician. Bearing the distinctive tapered forehead and tonsure of the young Maize* God, he partakes in a scene of verdant paradise, surrounded by flowers*, birds, acrobats and musicians (*see* 90.3 for another part of this scene, where the Wind God plays rattles alongside a singing hummingbird*). Finally, the drum sign also incorporates a marker of "hollowness" occasionally seen in signs for caves* and beehives. In this context, the reference is probably to the drum's resonating chamber.

The drum seems to have been a key staple of Maya musical performance and is usually present even when other instruments are not. Thus, in one scene from a Late Classic polychrome vessel (ill. 2), an anthropomorphic deer beats a tune on the drum while a black jaguar and monkey* merely dance. Another vessel, from the Chama region (ill. 3), is more typical in accompanying the standing drum with turtle-shell, antlers and a pair of rattles (*see* 89.1 for a similar ensemble). In one ribald scene from yet another vessel (ill. 4), two dancers wearing composite hummingbird and flower headdresses engage in a sexually charged dance as musicians play a small hand drum and gourd rasp. Feather headdress and loincloth undulating, the male wheels about like a bird, his faux phallic nose penetrating the woman's hand.

?

1

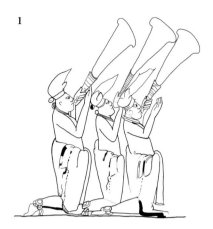

2

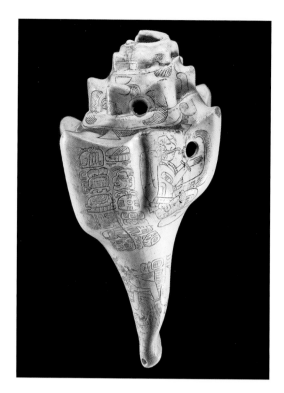

1 Three trumpeters in a court scene. Painted vase. Late Classic.

2 The Pearlman conch shell trumpet. Early Classic.

3 A lord and his retinue. Painted vase. Late Classic.

4 A lord and his retinue. Painted vase. Late Classic.

3

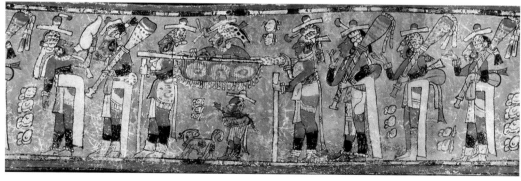

4

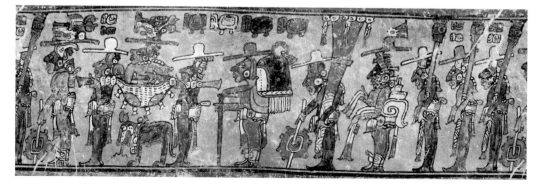

While still of uncertain reading, contextual clues in script and evidence from Mayan languages suggest the value **HUUB** "marine shell trumpet." Whether this proves the correct solution or not, the sign clearly represents a conch shell trumpet and has strong cognates in both art (ills. 3, 4) and actuality (ill. 2). Not only does it depict the characteristic whorl and conventionalized spiral of the conch shell, but it also incorporates a mark of "shininess" (*see* 21), doubtless referencing the high polish of the shell. Lest there be any further doubt, this sign actually functions as the descriptive name tag of the Early Classic conch shell trumpet illustrated here (ill. 2).

Unlike more conventional instruments such as the flute, rattle or drum*, Classic Maya conch shell trumpets also served several highly important functions in hunting, particularly as a tool for disorienting prey, for communicating with other hunters and, perhaps, for signaling their triumphant return. Thus, on one Late Classic vase (*see* 78.1), successful hunters blow diminutive conches as two of their party drag the unfortunate animals home. In other scenes, the hunting deity Huk Sip regularly plays a conch shell trumpet (*see* 78.2; 66.4), and at least one surviving conch shell trumpet is textually identified with this god (ill. 2), its owner referred to as one Huk Sip Winik or "Deer* God Man," perhaps a ritual impersonator. Note the finger-holes on the artifact and their realistic reproduction in at least one of the depictions (78.2). Although not illustrated here, the text of one conch shell trumpet in a private collection actually boasts that its owner "speared (a) deer" (*u juluw chij*) on a certain date, suggesting that conch shell trumpets may have been emblematic of hunting in general.

The role of the trumpet in hunting probably carried over into the function of heralding the arrival of state dignitaries. Thus, in four related scenes from Late Classic Chama-style vessels (ills. 3, 4; *see* 34.2; 79.1), a traveling lord is borne on a litter*, accompanied by a retinue of trumpeters, a throne-bearer and a dog*. A series of day signs on the Ratinlixul Vase (*see* 79.1) – *Imix, Ik'* and *Ak'bal* – suggests that this particular company marched for at least three days. On a vessel from the Heye Collection (ill. 3) an attendant at the front of the column sounds his conch shell trumpet, perhaps to halt the day's march or to announce their arrival. While the other scenes show no blowing of trumpets, two of the bearers carry conch shells on their backs (ill. 4; *see* 34.2) and most of the others carry the long, tubular wooden trumpets most frequently encountered in court scenes (ill. 1). Some of the trumpets seem to combine wooden tubes with hollow gourds (ill. 3), perhaps for a more resonant sound, while others are decorated with tufts of string or feathers (ill. 4; *see* 34.2), perhaps designed to wave and undulate when the instrument was played.

31

TRUMPET

HUUB?

* DRUM 30
LITTER 35
DEER 78
DOG 79

1 Three youthful deities
burn the Jaguar God of the
Underworld on an altar.
Codex-style vase. Late
Classic.

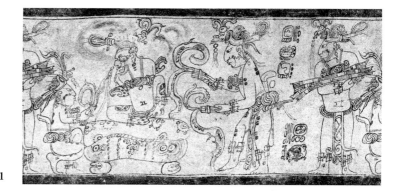

1

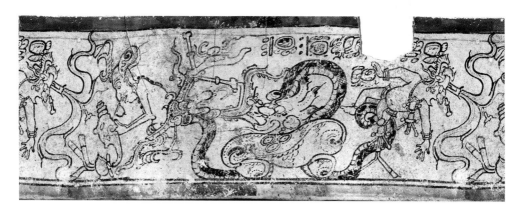

3

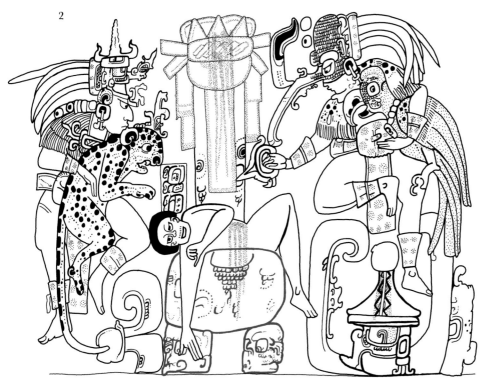

2 Man sacrificed on
altar. Painted vase. Late
Classic.

3 The "agave altar"
place. Codex-style vase.
Late Classic.

Because of its rarity and its characteristic stone markings, the undeciphered altar sign has often been confused with similar signs for stone* (**TUUN**) and mountain* (**WITZ**). One school of thought has even interpreted the sign as a throne*. Yet the sign probably represents a stone altar resting on supports, as revealed in one telling Early Classic variant from Tikal.

A strikingly similar stone altar is depicted on a codex-style vessel in a European collection (ill. 1). The theme is well known in Maya art, representing the sacrifice of the Jaguar God of the Underworld (hereafter JGU) at the hands of four humanoid supernaturals bearing torches: young lords named the Chan Te' Xib (literally "Four Males"). Importantly, this vase adds two features not seen in other versions. First, usually only one of the Chan Te' Xib burns the JGU (*see* 48.3). While this vessel clearly shows two different characters preparing to immolate him with their burning torches, a third waits in the wings with an armload of cordage with which to pile the fire high. A second important addition is the stone altar, atop which the JGU sits with his arms securely fastened behind his back. This obscure mythical event has been argued to provide a rationale for the ritual sacrifice of captives, as suggested by two historical "impersonations" of the ill-fated JGU by captured prisoners at Naranjo and Tonina.

If there remained any lingering doubt about the nature of sacrificial altars among the Classic Maya, they have been dispelled by a striking Late Classic polychrome vessel in the Dallas Museum of Art (ill. 2). The scene clearly shows a slain captive stretched across a stone altar, his chest torn open and his face depicted in a rare frontal pose, poignantly pleading with the viewer. The altar's placement before a tall, narrow object wreathed in decorations (perhaps of paper or textile) strongly suggests a stela and reminds one of the stela and altar pairs so common in Maya plazas. The lords flanking the victim are probably masked as gods, but other elements of the iconography are difficult to explain, including the jaguar* and macaw* they cradle in their arms even as they deliver the *coup de grâce* to their victim.

With two possible exceptions at Naranjo, the altar glyph tends not to appear in sacrificial texts. Rather it is usually restricted to writing the place name of "agave altar" (*see* ill. 3 for an iconographic example), a locale associated with the culture hero Foliated Ajaw. According to texts from Copan and Pusilha, this enigmatic character oversaw period-endings at "agave altar" in AD 81 and 159, while Late Classic texts from the Mirador basin credit him with an (unfortunately not able to be dated) conjuring of K'awiil*. Some scholars suggest that Foliated Ajaw was an important ruler of the Late Preclassic, and that "agave altar" may have been the ancient name of El Mirador or Nakbe, two great Maya centers of the Late Preclassic.

?

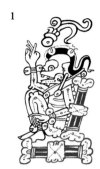

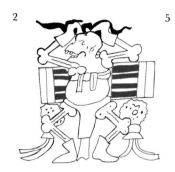

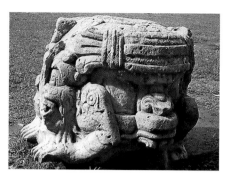

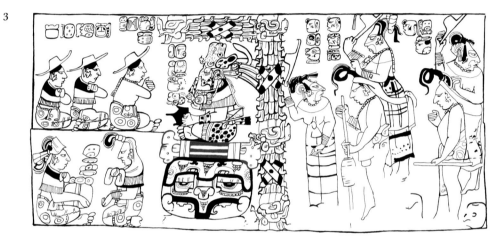

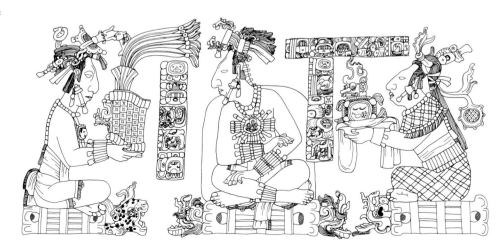

1 A Death God sits on a bone throne. Dresden Codex, page 53. Late Postclassic.

2 A bone throne is the back rack of a dancing Death God. Popol Vuh Bowl. Late Classic.

3 A god sits on a bone throne set over a cosmic mountain. Painted vase. Late Classic.

4 K'an Joy Chitam II and his parents sit on bone thrones. Palace Tablet, Palenque. Late Classic.

5 A cosmological stone seat bears the bone throne sign. Altar of Stela N, Copan. Late Classic.

For the Maya the concept of a throne was no simple matter. While some resemble functional seats, any number of objects were conceived as "thrones." The most esoteric embody cosmic domains with which the sitter wanted to be identified – for instance, in mythic thought, a sacred mountain* or, in the human realm, a stone* sculpture conceived as a sacred mountain. Indeed, a variety of sculptural forms at Maya sites served as actual thrones or symbolic ones. The exemplar of this genre of throne as otherworld realm is the so-called "bone throne," a seat evoking the power of the Underworld.

Modeled on a long bone*, possibly a human femur, the bone throne's stylizations can be observed in the throne of a Death* God, seen in ill. 1. The bone's knobby termination, or condyle, is an exaggerated trefoil repeated at both ends. The shaft bears black bands – cross-hatched in sculpted media – which visualize the internal bone marrow. Short vertical bands represent bony plates which at times seem to tie the striped bone like a bundle. This allusion was significant as sacred bundles, like bone thrones, were foci of supernatural power. The hieroglyphic sign compresses the bone's features, frequently blunting the trefoil ends. Although bone thrones sometimes adorn the costumes of Underworld figures (ill. 2) and miniature versions are proffered in ritual, their overarching function is a seat, which, on painted pottery, usually belongs to a god. In ill. 3 a god sits on a bone throne placed atop a cosmic mountain. Here it relates the god's power to his spatial domain, further emphasized by his shrine before which three pilgrims beseech him.

Usually covered in jaguar* skin (see 34), thrones were quintessential status objects. That this one is fashioned from bone points to the Maya's boundless respect for the Underworld. Indeed, the same black-banded bone is the basis of the cenote* glyph, another Underworld location. The power of place emerges in a text recounting world creation on Stela C, Quirigua. Here three bone thrones are linked to three gods, including the mighty Itzamnaaj*. The thrones establish a fixed point or seat for the setting of three stones representing a cosmic hearth, astronomically related to three stars in the constellation Orion. Additional symbols cast the thrones in one of three standard guises: jaguar, serpent* and water*.

Bone thrones linked to this creation myth are portrayed on carved limestone panels from Palenque. On the Palace Tablet, the young prince K'an Joy Chitam II and his parents occupy bone thrones embellished with death eyes, another Underworld symbol (ill. 4). Zoomorphic heads link the thrones with the familiar triad of jaguar (left), serpent (right), and water (middle, in the form of a shark*). That K'an Joy Chitam II shared such cosmological seats with his parents strongly suggests that they were real objects in the palace environment. Indeed, one such may survive in the form of a carved altar from Copan (ill. 5). The occupant would have sat directly on the bone throne glyph which tops a massive zoomorphic head. The seat is further identified as a "water throne" by a water scroll and shark head. Stone symbols on the shark suggest that this seat also embodied a sacred mountain and heavenly hearth stone.

?

1

1 Umbilicus in the form of a dimple sign. Tablet of the Slaves, Palenque. Late Classic.

2 A throne carried in procession. Chama-style vase. Late Classic.

3 A cushion is visible behind an enthroned lord. Panel 3, Piedras Negras. Late Classic.

4 An assembly of lords sit on cushions. Relief sculpture, North Temple of the Great Ballcourt, Chichen Itza. Terminal Classic.

5 A hunchback sits on cushion seats and backrest facing enthroned K'awiil. Painted capstone. Late Classic.

2

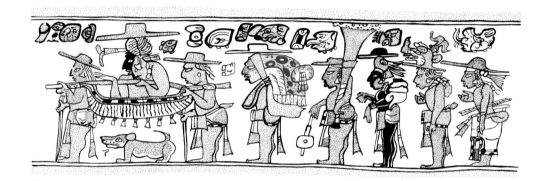

3

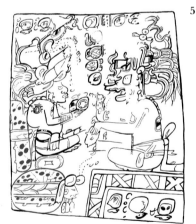

5

4

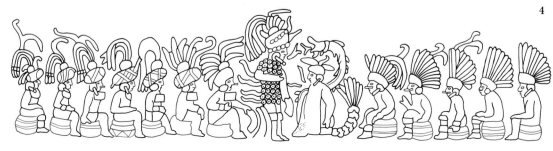

Many palace scenes in Maya art feature a lord* sitting on a plump cushion draped in jaguar* pelt often with a matching cushion as a backrest. While no remnants of these cushions have survived, they seem to have been fabricated from a pliant material like leather, stuffed with fluffy vegetable fiber. Wavy lines depicted on these cushions – typically painted brown when hue is indicated – may be the seams of leather panels stitched together to achieve a rounded shape. Read *tz'am* or "throne," the corresponding logograph shows the cushion draped in jaguar skin. In the lower half is a squarish dimple, a convention for a depression in a soft, bulging surface, used even for the belly buttons of corpulent lords (ill. 1). This dimple was the critical diagnostic of the **TZ'AM** logograph and served as an independent sign (the so-called **po** sign). In Maya hieroglyphic writing it occurs in an oft-used metaphorical compound for "lord," *ajaw* (*see* 35), proof of the cushion's importance as an insignia of kingship.

Emblematic of opulence and royal prerogative, the cushion was combined with other luxury items to form a "regalia compound," which could even be placed on its own throne (*see* 64.2). Painted vases show that the cushion was hauled on journeys to provide for a lord's comfort (ill. 2; *see* 79.1). In Classic art the cushion is usually restricted to a single dominant individual (*see* 93.2). In many palace scenes the seated king, presiding over his subordinates, is framed by the silhouette of the cushion backrest. Jaguar skin covers the example in ill. 3, part of an exquisite, although damaged, wall panel from Piedras Negras. However, a relief from Chichen Itza depicts a dozen lords given this seat of honor, reflecting the throne's less exclusive function in Postclassic cities of the Northern Maya Lowlands (ill. 4).

In Maya art, the cushion stays truest to the hieroglyph when the dimple and jaguar skin are both present; yet in practice these details were quite variable. Three versions are depicted on a painted capstone probably from Campeche, two with jaguar skin and one a plain dimple (ill. 5). The redundant inclusion of the latter may have been to provide a linguistic clue to reading the cushion as *tz'am*; however, the dimple sign by itself was used to represent a pillow or seat.

The jaguar skin draped over the cushion deserves further comment. The jaguar was a symbol of governance especially associated with royal seats. A Colonial document from Yucatan records an expression for a council leader's seat as "jaguar's mat" (*ix póop tí' báalam*). In addition to covering thrones with their pelt, the Maya painted images of jaguars on thrones and carved thrones in the form of jaguars (*see* 83.3). Palenque's Oval Palace Tablet (*see* 28.4) depicts a double-headed feline throne. This relief was originally displayed above a bench; therefore its shape was intended to resemble a cushion backrest. Jaguar skin on the cushion surely invoked the idea of a jaguar throne and, more broadly, the concept of rulership. Jaguar skin also advertised the sitter's wealth. Furthermore, since the jaguar was "king of the forest," relegating one to a seat was a stark reminder of the sitter's power.

CUSHION
THRONE

TZ'AM

* LORD 4

JAGUAR 83

1

2

1 Litter and accompanying warriors. Painted vase. Late Classic.

2 Naranjo's captured hummingbird litter. Lintel 2 of Temple IV, Tikal. Late Classic.

3 Hummingbird litter and bearers. Graffiti, Tikal Structure 5D-65. Late Classic.

3

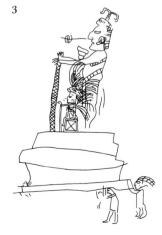

Like Aztec and Inca emperors, Maya kings did not walk when they made their royal pilgrimages or led their troops into battle; they were carried on the shoulders of their subordinates in royal litters or palanquins. Heavily decorated in vibrant quetzal* and macaw* feathers, and frequently burdened by wooden effigies of patron gods (ills. 1–3), these vehicles were far more than a mode of transportation. They were portable thrones and religious shrines, and where they traveled the entire royal court doubtless followed.

The logograph for "litter" or "palanquin" is in fact a depiction of one of these portable royal thrones. Although highly stylized, it displays the recurved edges characteristic of benches in Maya art (*see* 92.2), and contains a miniaturized **AJAW** "lord"* element which was almost certainly intended to be conceptual rather than literal. That is, it probably refers to the royal mat and pillow (these being the constituent parts of the **AJAW** sign) and suggests that such conveyances were the exclusive province of nobles. On a series of Late Classic vessels, a lord is carried in a rather simple litter, accompanied by his faithful dog* and various attendants bearing trumpets* and a cushion throne*. But most palanquins were far more elaborate affairs, such as the beautifully decorated (if equally small scale) example seen on another vase (ill. 1). Accompanied by warriors and a bearer, its seat draped in a jaguar* hide, this "parked" litter clearly shows its carrying poles, and is adorned with the image of a fearsome crouching deity.

One of the most elaborate war palanquins can be seen on a wooden lintel from Tikal's Temple IV (ill. 2). Here, the Tikal ruler Yik'in Chan K'awiil grasps a shield and the lightning axe of K'awiil* and sits upon a throne below the towering effigy of a composite solar*, fire* and jaguar deity with hummingbird* characteristics. Associated texts and iconography make it clear that this litter (called a *tz'unun piit* or "hummingbird litter"), complete with its awesome patron, had actually belonged to the rival kingdom of Naranjo, from which it was despoiled in a "star war" which took place on February 4, AD 744. Yet the lintel does not depict this battle or even its immediate aftermath, but rather a Roman-style triumph which took place some three years later, in AD 747. During this event Yik'in Chan K'awiil was paraded along the great causeways of Tikal in the captured palanquin, bearing its hostage god and the despoiled secular and sacred emblems of defeated Naranjo. A lively piece of ancient graffiti may actually depict this very moment (ill. 3) and almost certainly depicts the same palanquin, which is here clearly borne on large poles by a number of bearers.

As they were constructed of highly perishable materials like wood*, papier mâché and leather, archaeologists have yet to uncover any of these remarkable objects in their excavations. In the meantime, we are fortunate that so many rich depictions of these portable thrones and litters survive in Maya art and writing.

35

LITTER

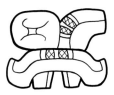

PIIT?

* LORD 4
K'AWIIL 10
TRUMPET 31
CUSHION THRONE 34
SUN 62
FIRE 64
WOOD 71
DOG 78
JAGUAR 83
HUMMINGBIRD 90
MACAW 91
QUETZAL 93

1

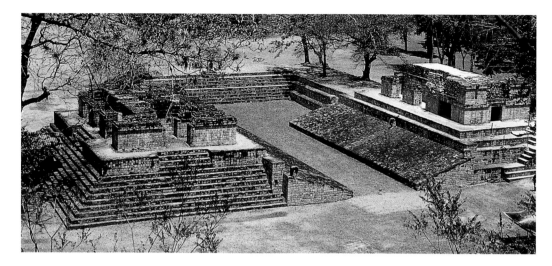

2

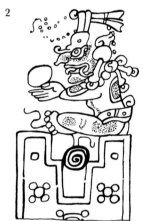

3

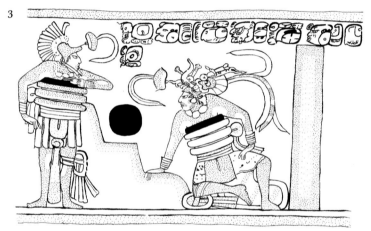

4

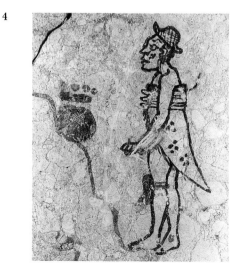

1 Ballcourt A-III, Copan. Late Classic.

2 Chahk sits over a ballcourt cradling a rubber ball. Dresden Codex, page 41. Late Postclassic.

3 Polychrome vase with a ballgame scene. Late Classic.

4 Cave painting of Hero Twin Juun Ajaw before a ballcourt. Drawing 21, Naj Tunich. Late Classic.

Like a modern sports stadium, Classic Maya ballcourts were an expected presence in the urban landscape. Most large cities boasted several, and they varied dramatically in size and design features. Some courts are extremely rudimentary, consisting of little more than two parallel platforms forming a playing lane. In the Southern Lowland version of the ballgame, players attempted to strike a rubber ball* with their heavily padded bodies, scoring points by hitting one of three flat stone markers placed along the court's centerline. However, in the Northern Lowlands the ball was aimed at stone rings mounted on the enclosure walls, looking rather like a basketball hoop turned sideways. This is how the game was played in the Great Ballcourt of Chichen Itza, the largest and most spectacular of all Mesoamerican ballcourts, thoroughly embellished with sculptures, murals and temples. Ballcourts of this kind went beyond athletic competition and set the stage for ritual theater that accompanied games, including human sacrifice.

The hieroglyphic sign for ballcourt depicts the court from the vantage point of someone looking down the central alley. The inner walls form steps which cradle the rubber ball. A half-court glyph essentially conveys the same idea. Neither version of the ballcourt glyph is entirely accurate in that a real ballcourt features a sloping base wall above which may be a few steps and, sometimes at the summit, a small building, as seen in a ballcourt at Copan (ill. 1). Rather, the ballcourt glyph is a generic architectural platform and can bear a **TE'** logograph signifying wood*. This sign occurs on other architectural logographs, including those for step* and house*, and may pertain generally to platform constructions. Yet the ballcourt glyph's basic composition – steps on one side and straight wall on the other – reasonably approximates ballcourt architecture. The ball acts as a semantic qualifier of the building's function.

The portrayal of ballcourts in Maya art follows glyphic conventions. The Dresden Codex shows Chahk* hovering over a ballcourt modeled on the full-court glyph (ill. 2). A standard type of ballcourt composition, seen in ill. 3, features a kingly player in a conventional action pose, facing the steps. Here a second player, of subordinate status, likely a foreign visitor as indicated by his brimmed traveler's hat, stands left. A cave painting from Naj Tunich portrays one of the Hero Twins*, Juun Ajaw, standing before a profile ballcourt complete with ball (ill. 4). In their basic conception, the ballcourts in ills. 3 and 4 resemble the half-court glyph.

The simplified depictions of ballcourts in Maya art belie their incredibly rich symbolism as known from mythic traditions and ballgame imagery. Most ballgame themes concern death, sacrifice and regeneration. Maya ballcourts display sculptures of tortured captives and decapitated players (*see* 18.1). In the *Popol Vuh*, a ballcourt is likened to an Underworld realm called Xibalba, where the dramatic tale of the Hero Twins unfolds. It is interesting that four paintings of ballplayers, including the one in ill. 4, are found in Naj Tunich cave. This confirms that, in Maya thought, ballcourts recreated the mythic space of the Underworld.

?

1

2

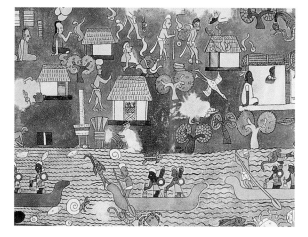

4

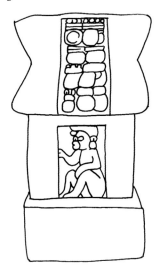

1 Thatch sign stands for the roof of a building. Madrid Codex, page 103. Late Postclassic.

2 Village scene. Reconstruction of mural, Temple of the Warriors, Chichen Itza. Terminal Classic.

3 Effigy of a house. Carved stone. Late Classic.

4 Stone slabs simulate a thatched roof. House E, Palenque. Late Classic.

5 A miniature house in a frieze over a monumental gateway. Labna. Terminal Classic.

3

5

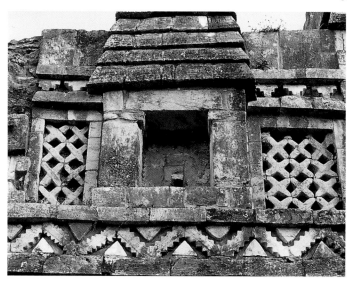

This logograph for house – Maya writing has several – implies a possessed house in the sense of a "home," the meaning of *otoot*. The **OTOOT** logograph is comprised of a stepped platform and panel bearing a weave pattern, here standing for a thatched roof, still a fixture of traditional homes in the Maya area. This weave pattern cues items made of dried palm leaves, including, in addition to thatched roofs, woven mats and baskets, and can be reduced to a simple chevron. The connection between thatched roofs and architecture was so intimate that the thatch band served as an independent sign and could convey the concept of an entire building (ill. 1). Occasionally, the flat roof characteristic of corbel-vaulted stone buildings appears in **OTOOT** logographs, as do privacy curtains. The two units of the house logograph roughly correspond to the bipartite form of Maya buildings: a superstructure, expressed by the thatch sign, and a supporting platform. In the hieroglyph, the stepped platform may be marked by the symbol for wood*, seen on many architectural logographs with terraced profiles, such as those for ballcourt* and step*.

Murals from the Temple of the Warriors at Chichen Itza preserve realistic renditions of ordinary houses with thatched roofs, whitewashed pole and daub walls and stone platforms (ill. 2). The same elements comprise miniature stone houses found at Copan that are identified hieroglyphically as *waybil* or "sleeping chambers" (ill. 3). The Maya accorded the house great respect, seeing in it the prototype of all enclosed buildings. The house served as a model for stone temples, which when named textually, were called "house," using another term, *naah*. This terminology was not just a quaint turn of phrase. Not only did stone buildings resemble houses but also, at sites like Palenque, architects adopted slanted roofs in imitation of a thatched roof. One prestigious building called the *sak nuhkul naah*, "white skin house," House E of the Palace, bears on its roof carved stone slabs imitating thatch (ill. 4). The west walls are painted white recalling the common whitewash of ordinary houses. Miniature houses with thatched roofs were also depicted in Puuc architectural friezes (ill. 5).

Because temples and palaces were termed "houses," certain royal rituals were called "house entering" (*och naah*) and "house censing" (*el naah*); house rituals also commemorated a building's completion. The elite spared no effort in drawing attention to their building projects. Yet house rituals most likely originated among the peasantry and reflect popular attitudes toward the domicile and ritual space. The Maya believed a house possessed a life force and was a microcosm of the universe, lending the house a kind of innate sanctity. The house served as a template for various kinds of sacred places, for instance the cosmic domains of gods, such as caves. In many Mayan languages, one term for "cave" is "stone house." Maya art often pictures caves as houses having a roof, side wall, and basal platform much like the **OTOOT** glyph (*see* 70.5). Houses were more than dwellings to the ancient Maya, who conceived of them as cosmic centers and archetypal containers of supernatural forces.

OTOOT

* BALLCOURT 36
STEP 39
WOOD 71

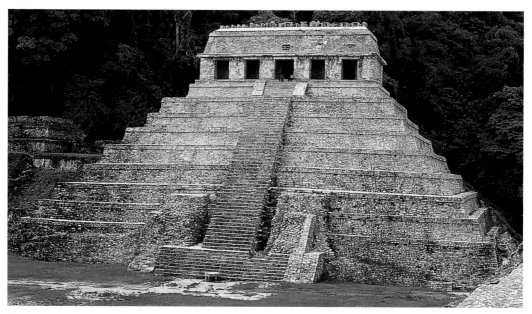

1

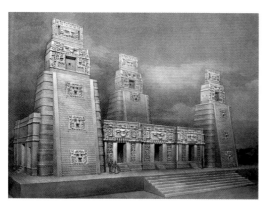

2

4

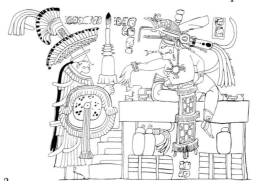

1 Temple of the Inscriptions, Palenque. Late Classic.

2 Reconstruction drawing of Structure 1, Xpuhil. Late Classic.

3 A Maya pyramid and Teotihuacan-style architecture shown together. Incised cylindrical tripod vessel. Problematical Deposit 50, Tikal. Early Classic.

4 Terraces serve as shorthand for a building. Painted vase. Late Classic.

3

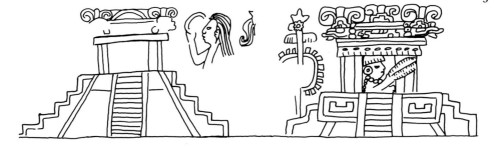

Maya pyramids have a rectangular plan and rise in diminishing stages, or terraces, which form a solid mass that served as a platform. In most cases a single staircase flanked by flat balustrades, or *alfardas*, leads to a small building or superstructure at the summit, which was the holy sanctuary. While not resembling Old World pyramids, Maya pyramids sometimes housed royal burials, as did Egyptian pyramids; but they were generally afterthoughts, made by carving out a suitable crypt from an existing pyramid. Rarely, pyramids were conceived from inception as funerary temples, the most famous case being the Temple of the Inscriptions from Palenque (ill. 1).

Although Palenque is not known for tall pyramids, most examples of the pyramid hieroglyph are found in the site's inscriptions. The pyramid sign is a schematic rendering of the platform showing two or three terraces and the central staircase. Flanking the staircase are narrow bands representing the *alfardas*. The superstructure is omitted since the high platform was what made the building truly distinct. Occasionally, the pyramid glyph qualifies a T-shaped logograph that reads **NAAH**, "house," perhaps to indicate a pyramidal structure in its entirety. This suggests that the shrine atop the platform was basically a kind of house, albeit a special one.

Because of his extensive building campaign, the Palenque king K'inich Janaab Pakal I was remembered as a great patron of architecture. His sons referred to him posthumously by the title "he of five pyramids." The first son to take office, K'inich Kan Bahlam II (r. AD 684–702), recorded a "pyramid event" on his accession monuments which took place when he was a mere lad of six, in celebration of his heir apparency. Unfortunately the event remains poorly understood, and it is not clear which building was involved. The piers of the Temple of the Inscriptions portray an adult holding a baby* aspect of the god K'awiil*. Display of this baby god from the temple summit may have been another type of pyramid event.

Given the pyramid's prestige, its form was invoked on architectural façades as a show of status. A style of architecture known as Río Bec features non-functional towers imitating pyramids with wide staircases (ill. 2). In graphic art the Maya tended to favor profile views of pyramids, which easily showed cutaways of the temple interior. However, a more unusual frontal view of a temple, resembling the pyramid sign, plus the superstructure, is seen on a carved Early Classic vase from Tikal (ill. 3). The scene juxtaposes a typical Maya pyramid with a Teotihuacan-style building, at right, featuring talud-tablero construction.

While the lofty superstructure was the most sacred and restricted part of a pyramid, the staircases and terraces were the settings for ritual events of a more public nature. Steps*, such as those seen in the pyramid glyph, also in the glyphs for ballcourt* and house*, had recognized cultural importance and served as shorthand notation for "architecture." A painted vase depicts a ruler hoarding his tribute bundles under a dais (ill. 4). Steps at left supply the scene's architectural setting, doubtless a grandiose palace.

?

* BABY 1
 K'AWIIL 10
 BALLCOURT 36
 HOUSE 37
 STEP 39

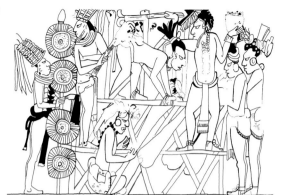

3

1 Tribute-bearers ascend steps to the king. Painted vessel. Late Classic.

2 Ballgame viewed from the sideline. Painted vessel. Late Classic.

3 Scaffold sacrifice. Painted vessel. Late Classic.

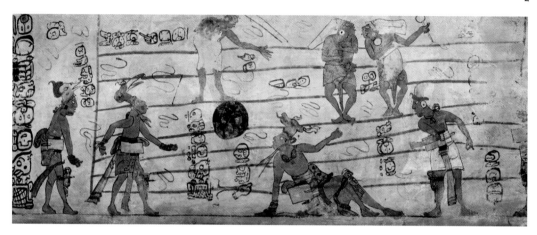

1

In Mayan languages, *ehb* means both "step" and "ladder," and this probably explains the two distinct forms of the **EHB** sign in Maya writing. The first is clearly a profile view of a staircase, a form frequently encountered in art. The second represents a lattice of lashed-together wooden* poles seen from a frontal view.

Steps and staircases are omnipresent in Maya art, which frequently features architectural forms as a backdrop to courtly dramas enacted in palaces. Pyramids* frequently sport profile staircases (*see* 38.3), as do houses* (*see* 82.4), ballcourts*, tombs* and numerous other aspects of the built environment. On the micro-level, however, stairs were also important within throne chambers and palatial residences. Thus, elevated thrones often contain profile steps to allow tribute-bearers to approach the king (ill. 1; *see* 38.4). With great gods like Itzamnaaj*, the sky* itself is bent into the shape of a throne and steps to allow the approach of mortal supplicants (*see* 100.3).

However, it is important to note that frontal views of staircases are far more common than profiles. These are usually indicated by the simple convention of stacked horizontal lines. For instance, one exquisite polychrome vessel privileges the viewer with a sideline view of the Maya ballgame (ill. 2; *see* 36.2–4). Doubling as benches, in which are seated not only musicians but also an apparent referee who drops the ball into play, the rising staircase of this ballcourt building cunningly places the viewer on the benches of the mirroring (unseen) structure, as if actually present at the game. Unlike the more conventional approach to illustrating ballgames, which feature a profile structure and at most two or three players, this frontal view allows whole teams of ballplayers to share the court. This may also explain why the frontal view of staircases was favored in the depictions of large ceremonial events, as in the famous captive presentation scene from the Bonampak murals (*see* 61.3).

While ladders and scaffolds are somewhat less common than staircases in Maya art, they were nevertheless important in accession scenes and depictions of scaffold sacrifice. On a series of accession stelae from Piedras Negras (*see* 17.2), the incumbent king has climbed into the niche of a high scaffold (as revealed by the footprints passing over the lashed-together poles of the **EHB** sign below him). The Late Preclassic murals of San Bartolo, in which an early king seated in a scaffold receives the Jester God headband of lords* from a subordinate who climbs a ladder to reach him, show that this ceremony had a long ancestry. Yet scaffolds were also the locus of elaborate hunting sacrifices (ill. 3), where captives dressed or posed as deer* were fastened to the scaffold to be burnt, shot with arrows or decapitated. At first glance, the connection between sacrifice and accession to the throne may not be apparent, but the two rituals were linked by a common concern for fertility, regeneration and rebirth.

EHB

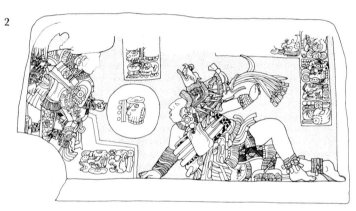

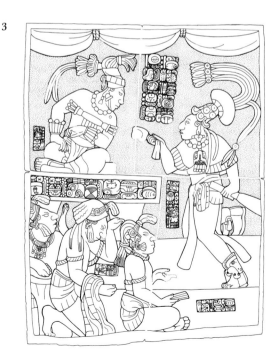

1 Fruit trees sprout from the tomb of a dead king. Incised vessel. Early Classic.

2 Chak Ak'aach Yuhk of La Corona plays ball at Calakmul. Unprovenanced panel. Late Classic.

3 Aj Chak Maax presents captives to Yaxchilan king Itzamnaaj Bahlam IV. Unprovenanced panel. Late Classic.

Muhk is the Mayan word for "tomb" and "burial," and the **MUHK** sign depicts a profile skull* (a *pars pro toto* skeleton) within a field of deep black* shadow (indicated by cross-hatching) interred under the profile view of a vault or staircase. Just such a burial can be seen on Piedras Negras Stela 40 (see 99.3), where Ruler 4 scatters incense into the tomb of his mother. Although fully fleshed, her corpse doubles for the skull in the **MUHK** glyph, and the stepped vault above her for its characteristic enclosure. Similarly, on the famous Berlin Tripod (ill. 1), an interred skeleton is stretched out beneath the earth, while up above him rears a four-stepped mortuary pyramid*. From the skeleton spring three anthropomorphic fruit trees*, the central one of which partakes both of the identity of the deceased (whose name he wears in his headdress) and of the resurrected Maize* God, whose sprouting cacao* tree form he assumes. The women flanking him probably represent his mother and/or spouse(s).

Although highly representational, the **MUHK** logograph is nonetheless richly symbolic and bears striking formal and semantic relationships with the hieroglyphs for step*, cave* and death*. The connection to steps was particularly nuanced and has great significance for the interpretation of staircases throughout Maya art. On one vase (*see* 82.4) bats* and other nocturnal rodents lurk in the shadows beneath a staircase in a manner most suggestive of the **MUHK** glyph, particularly when the close connection between bats and caves is taken into account. Like caves, staircases were secluded locales redolent with themes of death and transformation, an ideology doubtless stemming in part from the elaborate staircases of mortuary structures. For example, Copan's Temple of the Hieroglyphic Stairway was specifically identified as the *yehbil umuhkil ?-ajaw* or "the stairs of the tomb of the Copan king" – in other words K'ahk' Uti' Witz' K'awiil (r. AD 628–695), whose burial was found immediately below. Elaborately decorated with the symbols of remote Teotihuacan, the steps, summit temple and tomb comprised a conjoined ancestral shrine to the dead king.

These connections help to explain the ballgame scene on a limestone panel (ill. 2) where Chak Ak'aach Yuhk of La Corona plays ball against an individual in pronounced Teotihuacan garb at the city of Calakmul. Like the sculptures of warrior ancestors set into Copan's hieroglyphic stairway, this militaristic figure seems to emerge from the steps themselves and may well represent a patron ancestor of Calakmul. On Yaxchilan Hieroglyphic Stairway 2 (*see* 19.2), the steps within another ballgame scene provide a list of beheaded ancestral deities in yet another reference to the link between tombs and stairways. Finally, given scenes of prisoner sacrifice associated with steps (*see* 61.3), the ultimate fate of the captives on another panel is clear (ill. 3). The steps and throne edge surrounding them form a cartouche not unlike that seen in the tomb glyph, and one need not guess at the reason for their mournful postures.

MUHK

* DEATH 7
SKULL 18
PYRAMID 38
STEP 39
BLACK 46
CAVE 52
TREE 71
BAT 74
CACAO 95
MAIZE 98

1 A woman holds folded pieces of paper. Jaina-style figurine. Late Classic.

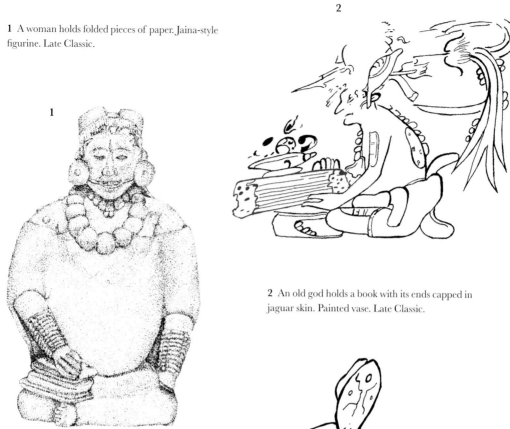

2 An old god holds a book with its ends capped in jaguar skin. Painted vase. Late Classic.

3 A rabbit scribe paints in a book depicted on the Princeton Vase. Late Classic.

4 A book and a shell paint pot draped in jade beads. Painted plate. Late Classic.

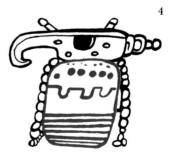

Mesoamerican books are classified as screenfolds, that is, the pages are glued together in a long chain and then folded like an accordion; both front and back sides were easily read by flipping through the leaves. The stack of folded pages could be quite high – one Maya book has 112 leaves and measures nearly 7 meters long when spread out. In Classic Ch'olt'ian the words for "book" and "bark paper" are identical, since books were commonly made from the bark of the fig tree (*Ficus cotinifolia*). The production of bark paper may have been the job of women. A Jaina figurine shows a woman holding a folded stack of paper (ill. 1). After gluing, the pages were coated with lime stucco, polished and then painted by scribal specialists, an endless process since the books were fragile and in continual need of recopying. The three surviving books of unequivocal prehispanic Maya origin (the Paris, Dresden and Madrid Codices) were produced in northern Yucatan, where Maya culture flourished during the Late Postclassic period. They date close to the time of Spanish contact; hence their miraculous survival.

Tragically, native books still in use in sixteenth-century Yucatan were systematically destroyed by Spanish priests, most infamously by the Bishop of Yucatan, Diego de Landa. Nor has a single book of the thousands penned by Classic scribes been found intact, although hope springs eternal that one will turn up in a burial or cave. The sad fact is no one today has ever seen a Classic period book. However, dozens of pictures of them have survived from this era and show that they were stored between wooden covers decorated with jaguar* pelt. The hieroglyphic sign for book shows off the jaguar pelt with its roseate spots and crenellated edges. The book glyph is stylized in a squarish, sometimes tall, cartouche, the height perhaps indicative of a hefty, important tome. Typically, just a few leaves, rendered as a stack of narrow rectangles, are visible between the covers.

Book imagery is largely restricted to pictorial ceramics, the medium of choice for virtuoso painting, and therefore the best place to advertise the painter's profession, especially its divine inspiration. Painted ceramics preserve many depictions of scribes, books and writing paraphernalia. Both supernatural and human scribes are shown sitting in front of books. When the book is open, they are usually engaged in painting or interpretation, both hallmark skills of sagacious scribes. The rendering of books favors clear viewing over perceptual logic. Some closed books have jaguar skin covers capping the ends rather than the top and bottom (ill. 2). For books shown in an open position the page opens in front of the scribe, rather than to the left or right, as it really would have (ill. 3). The book cover typically dangles from or props up the first page. Closed books are often shown with shell paint containers emblematic of scribal craft. A book supporting a paint pot was a conventional iconographic motif. The one in ill. 4 is decked out in jade beads, revealing the Maya's regard for their hieroglyphic books, which were as precious to them as jewels.

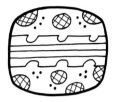

HUUN

* JAGUAR 83

1

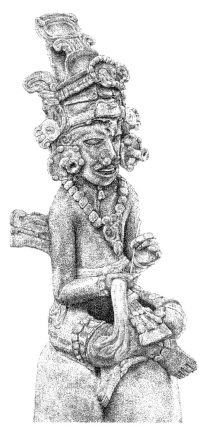

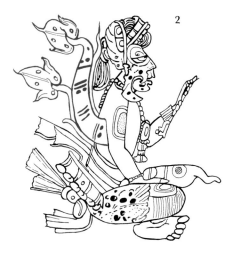

2

4

3

1 A scribe holds an elaborated leaf sign. Lid of ceramic vessel, Cleveland Museum of Art. Early Classic.

2 A supernatural scribe has a "number tree" banner under his arm. Painted vase. Late Classic.

3 A banner merges with tree signs. Painted vase. Late Classic.

4 Tendrils sprout from the body of a supernatural scribe. Painted vase. Late Classic.

5 An offering trio includes a piece of bark paper. Stucco relief House A, Palenque. Late Classic.

5

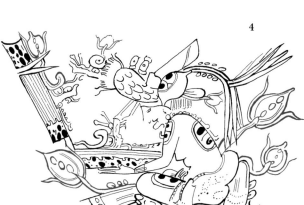

An attribute of scribes, nicknamed the "number tree" or "computer printout," is a flowing panel inscribed with bar and dot numerals, typically bordered by a leaf-tipped tendril cueing its botanical nature. In a strict sense the sign reads **AAN** "leaf"; however, this idea extended to a writing surface, much as we speak of a "leaf" of paper. These connections are well illustrated in an Early Classic ceramic sculpture, originally forming the lid of a large vessel, in which the **AAN** logograph literally serves as a writing surface (ill. 1). A further reminder of the sign's association with writing is the numerical inscription (ill. 2), which additionally connotes scribal intellect couched as a mastery of computation; number-marked panels sometimes stream out of a scribe's mouth like sage pronouncements (*see* 53.4). Emblematic of scribal craft, the numbers do not represent real calculations.

Writing paraphernalia is often incorporated into the costumes of scribes. This is equally true of the number tree which flows banner-like from under the arms of supernatural scribes (ill. 2). In more complex treatments, this "banner" merges with other scribal gear, such as the so-called "deer* ear." That the number tree sometimes bears tree* signs (ill. 3) reminds us of its arboreal source. Indeed, pictorially the number tree sometimes behaves like a tree, assuming an upright position.

The tendril with its bulbous tip bearing tiny circles, diagnostic of fruit-bearing trees, serves as a botanical qualifier for the number tree. This tendril occurs as an independent motif in Maya art, often seen dangling from headbands to indicate that they are made of paper. Indeed, paper scarves were quintessential signs of lordly status (*see* 4.1; 70.3). On the Oval Palace Tablet the tendril clarifies the meaning of a lonely strip of bark paper standing in lieu of a complete headband (*see* 28.4). The tendril also adorns scribal headgear. On one vase it blossoms from around an old supernatural scribe (ill. 4). These pictorial contexts, involving headbands, scribes and trees, confirm that the tendril references the *amate* or fig tree (*Ficus cotinifolia*), the source of bark paper used for writing surfaces, and the leaf, with its seed-like dots, perhaps suggests the fruitiness of a fig. In one iconographic vignette, a detail of a stucco relief from House A, Palenque, the presence of a number tree next to a turkey* head suggests that it here represents a bark paper offering, as this type of triadic composition (usually placed over an offering bowl), as well as delectable turkeys, are associated with sacrificial offerings (ill. 5).

In ill. 4 a personified form of the leaf-tipped tendril rests on the upper page of an open book*. The zoomorphic head with shark's* tooth recalls the personification of the bark paper headband, known as *huun* (*see* 4). This creature, also known as the Jester God, sprouts tendrils – however, with jeweled tips – and refers to a bark paper object, reminiscent of the number tree. The blurred semantic and visual boundaries of the two zoomorphic heads, confusing from our perspective, allowed from a Maya perspective a complex layering of function and meaning.

AAN

2

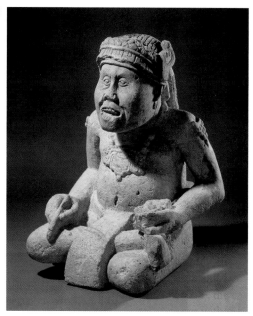

1

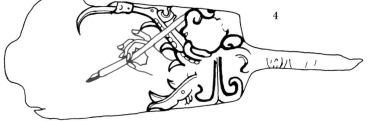

1 Paint container in the form of a hand.
Carved shell. Late Classic.

2 A supernatural scribe holds a brush and a
shell paint pot. Structure 82, Copan. Late
Classic.

3

3 The Maize God as a scribe.
Painted plate. Late Classic.

4 A scribe's hand and brush emerge
from a centipede maw. Incised bone,
Miscellaneous Text 53, Burial 116,
Tikal. Late Classic.

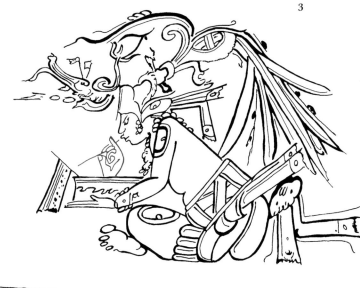

4

A logograph for "writing" is a delicately poised hand with two fingers grasping a slender writing tool. The affected elegance of the gesture is in keeping with the social milieu of the writing arts in ancient Maya society, in which scribes were leading intellectuals and prominent courtiers. So heavily did a city's prestige rest on their battery of scribes that they were targeted for capture in warfare. Normally, the words for the related concepts of "writing" and "painting" are spelled with a sequence of syllables (i.e., **tz'i-bi**, yielding *tz'ihb* "writing" and **tz'i-ba-li**, yielding the derived form *tzi'ihbaal* "color, decoration"). These rare logographic substitutions reflect the shared root **TZ'IHB**, though the former appears in reference to a "colorist, decorator" (*ajtz'ihbaal*), the latter to the act of writing itself. The choice of a painter's hand to distill the idea of writing, seen here, reveals just how deeply the Maya respected technical expertise.

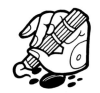

TZ'IHB

Two components of the scribe's toolkit, a brush – or more commonly a stylus-like painting implement – and shell paint container, served as scribal insignia. One paint container is carved to look like a scribe's elegant hand (ill. 1); holding a brush, it would resemble the logograph. Most depicted scribes are supernaturals, a fact reflecting the pervasive mystification of writing in Maya culture. The old supernatural scribe in ill. 2 has stone* markings on his arms and holds a brush and paint pot. Although not under the patronage of a particular god, writing was believed to have been a divine invention and was associated especially with gods of creation, ancestry and fertility. A painted plate shows the Maize* God cradling a book* in his left hand and proffering a stylus in his right (ill. 3). The hand holding the stylus practically duplicates the logograph for writing down to the curled fingers. This stylization reveals the conventional nature of the scribe's gesture as well as how the writing system readily imported imagery into the inventory of logographs.

In scribal portraits the painting hand in action is often severed from the rest of the body, allowing it to be read as an autonomous sign. In ill. 3 the scribe's hand, popping right out of the book in an impossible position, is treated in an almost glyph-like fashion. In another case, an incised bone from the tomb of Jasaw Chan K'awiil I of Tikal, the hand emerges out of a zoomorphic maw (ill. 4). Here, the hand and brush stand for the scribe and do so more effectively than a portrait, the manner in which figures are usually depicted emerging from monsters' maws. As a *pars pro toto* reference to scribe, the hand and brush impart a sense of technical virtuosity that could not be expressed by a facial portrait. They also satisfy formal requirements in that the brush gives the creature an ersatz tongue, brilliantly integrating the hand into the composition. The hand further locates the scribe's creative genius. In ill. 4 the zoomorphic head is that of the mysterious centipede*. The carved bone is a remarkable study in symbolic imagery in Maya art, as it combines a metonymic allusion to scribes and a metaphoric allusion to the Underworld, an elegantly simple, yet powerful, statement about the divine nature of writing.

* BOOK 41
STONE 70
CENTIPEDE 75
MAIZE 98

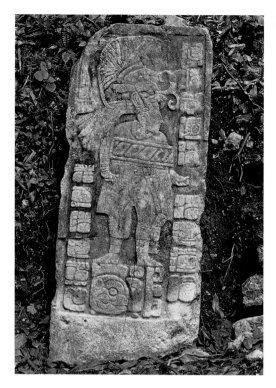

1 A ruler as ballplayer stands on a toponym with the number six. Stela 7, Seibal. Late Classic.

2 "Six cloud" title worn in Chahk's headdress. Stela D, Copan. Late Classic.

3 A personified version of number six qualifies a toponymic basal register. Stucco relief, Pier F, House D, Palenque. Late Classic.

4 A full-figure version of the glyph for "sixteen days." Lintel 48, Yaxchilan. Late Classic.

4

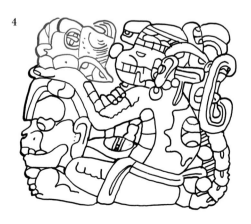

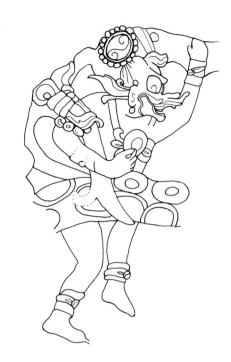

Numbers were generally written using bar and dot notation, the bar representing five and the dot one. Numbers from zero to twelve had alternate head variant forms. These head variants are mostly portraits of recognizable deities, such as gods of the sun* (4), wind* (3) and death* (10). Head variants for the numbers thirteen through nineteen combine traits of the head variant for ten with those of a lower number. This elaborate treatment of numbers reflects the Maya's fascination with numerology, also evident in the fact that both bar and dot and, more rarely, head variant numerals were incorporated into pictorial imagery. Typically, numbers serve as glyphic labels forming part of a figure's name, qualifying a location or quantifying some depicted items, such as tribute offerings.

The number six was incorporated fairly often into imagery. For reasons that are still unclear, the Maya favored the number six when naming locations. On a stela from Seibal, a ruler dressed as a ballplayer stands over a glyphic compound, **6-EHB-NAL**, *ehb* referring to step*. "Six step" may identify a six-stepped structure which, given the ruler's costume, may be a ballcourt* (ill. 1).

More commonly, places labeled by six are cosmic realms, as the identity of many supernatural locations was in some measure defined numerically. This arose from the fact that the Maya imposed a grid on the cosmos, parsing it into horizontal and vertical divisions. An example of this is the thirteen layers of heaven and nine layers of the Underworld mentioned in Colonial sources, while some Maya groups still preserve a belief in numbered cosmic layers. A position in a vertical layer was indicated by a number prefacing one of several terms for a cosmic realm, such as sky*, flower*, mountain* or cloud*. Six plays this role on Stela D, Copan (ill. 2). Here Chahk* bears the glyphic tag "six cloud," likely referencing the god's celestial abode. Since a god's essence was intimately associated with his cosmic realm – in a manner of speaking, space defined the god – these spatial tags served as titles, this one worn like a headdress.

Head variant forms of six also occur in depictions of cosmic realms. The God of Number Six exhibits the peculiar trait of an axe forming the center of his eye. His aquiline nose, creased cheeks and jutting tooth resemble the Sun God, but the identity of this god and meaning of his axe eye remain enigmatic. A spectacular example of the God of Number Six occurs on a stucco relief on Pier F, House D, Palenque (ill. 3). The head rises from a water lily flower standing for water*, part of an ensemble of aquatic symbols clinging to a swirling water lily plant. The placement of this imagery in the basal register of the scene confirms its locative function, situating the protagonists in a watery realm, qualified by the number six. The axe-eyed god appears in an iconographically elaborated Long Count date on Yaxchilan Lintel 48 (ill. 4). It, along with the skull below, equivalent to ten, represent the number sixteen, a count of days expressed by a monkey* full-figure variant of **K'IN**, or day, who holds the head of the God of Number Six.

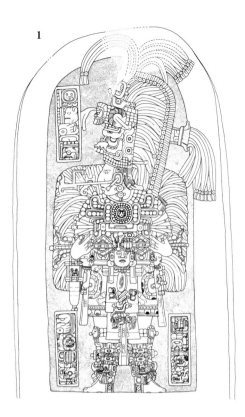

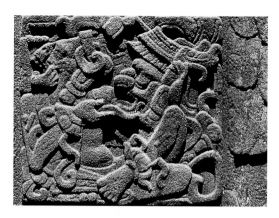

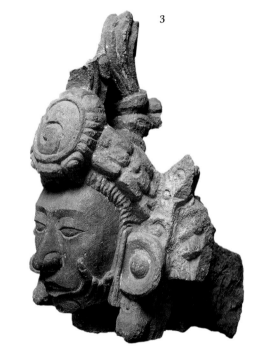

1 Jasaw Chan K'awiil I gestures like the hand of the God of Zero. Stela 16, Tikal. Late Classic.

2 A full-figure form of zero in an expression for "zero days." Stela D, Quirigua. Late Classic.

3 Architectural sculpture in the form of the God of Zero. Copan. Late Classic.

4 The crowning figure is the God of Zero. Stela E, Quirigua. Late Classic.

5 An Underworld goddess displays the hand on lower jaw and black face mask. Painted vase. Late Classic.

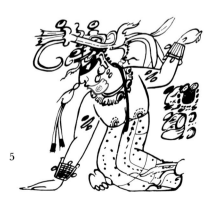

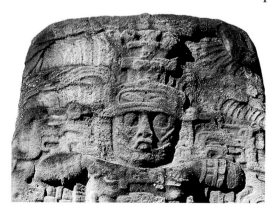

The Maya calendar records historical dates via the Long Count, a tally of days from a specific date in the past. Since the starting point was August 13, 3114 BC, large numbers needed to be written. This was made practicable by means of a base twenty place-notation system requiring the use of zero, the concept of which was known in Mesoamerica by at least 200 BC. The Maya had a number of ways to represent the word *mih* "zero": it could be spelled phonetically as **mi-hi** (the latter often suppressed, and involving several allographs), or with at least three different logographs for **MIH**, one of them a personified head. The head depicts a young Death* God distinguished by a hand over the lower jaw. The hand often makes a gesture with the middle two fingers retracted, an elegant gesture seen on some elite figures (ill. 1). The hand occupies the same position as the skeletal lower jaw characteristic of Death Gods, including the God of Number Ten. Thus, one function of the hand was to distinguish the head variant of zero from ten, both of which center around death symbolism. Iconographically, the hand-on-lower jaw marked a state of death without resorting to skeletalization. For instance, on Stela 31, Tikal, the ruler's father, shown as a down-peering head, is understood to be deceased by the hand serving as his lower jaw (*see* Introduction, ill. 8).

Full-figure versions of the God of Zero are replete with death attributes. These include a death collar, eyeballs, percentage signs and a centipede* headdress. The example in ill. 2 has a skull* head. Why such pervasive death symbolism for zero? Apparently, zero connoted transition, the ultimate model of which is between life and death; this liminal aspect of zero was expressed through death, flower and water* symbolism.

The God of Zero occurs infrequently in pictorial contexts. A uniquely striking example is a sculpted head from Copan, originally part of a life-size architectural sculpture (ill. 3). A single hand seems to grip the jaw, and the partitive disk sits squarely over the chin. Thus, the hand is not to be thought of as severed but rather as a symbolic hand gesture. The god's headdress is a conventional one found on Death Gods, featuring the spiral version of zero framed by an eyeball-studded death collar. The same design decorates the kilt of Jasaw Chan K'awiil I in ill. 1. Clearly, this stela shares iconography with the God of Zero, and the glyphic hand marking the katun-ending in the text even makes the retracted finger gesture.

The God of Zero's visage crowns a stela from Quirigua (ill. 4). Separate hands frame both sides of his jaw and meet at the partitive disk on his chin. Death symbols include the percentage signs on his cheeks. The presence of this god on the stela may relate to the stela's name, mentioned in the text, which includes one of the common **mi** syllables in a probable spelling of zero.

What may be a female counterpart to the God of Zero is painted on a Late Classic vase. She has the hand-on-lower jaw, displays death symbols and is youthful (ill. 5). The black eye mask, however, links her with the god Akan*, whose iconographic persona is closely related to the God of Zero.

45

ZERO

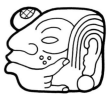

MIH

* AKAN 5
DEATH 7
SKULL 18
WATER 72
CENTIPEDE 75

1 a b

2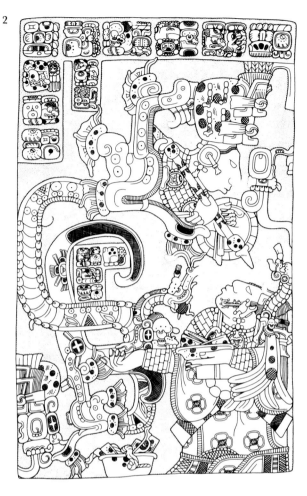

3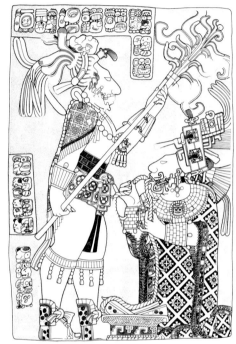

4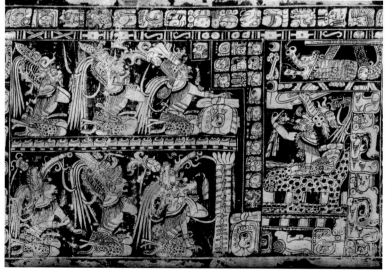

1 Glyphs incorporating the element **IHK'** "black." Late Classic. 1a Lintel 2 of Temple IV (H3), Tikal. 1b Panel 3 (O1), Piedras Negras.

2 Lady K'abal Xook transforms into a warrior-goddess. Lintel 25, Yaxchilan. Late Classic.

3 Lady K'abal Xook lets blood as the king holds a fiery spear. Lintel 24, Yaxchilan. Late Classic.

4 Creation scene. Painted vase. Late Classic.

The **IHK'** sign provides one of the best illustrations of the symbolic representation of color in Maya art. While the basic shape of the sign is constant regardless of medium, the central diagnostic varies from a field of cross-hatched incisions (in carved examples) to a field of black ink (in painted ones).

In writing, the diagnostic attributes of the **IHK'** sign are regularly infixed into other glyphs. Occasionally, these are read as straightforward conflations, as in the compound for the ninth month, Ihk'sihoom (Ch'en in Colonial Yucatan), written **[IHK']-SIHOOM-ma** (ill. 1a), or *ihk'in* "night," written **[IHK']K'IN-ni** (ill. 1b). Here, the infix denotes little more than "black." More often, however – as can be seen in the glyphs for cave*, darkness*, moon*, rubber ball* and tomb* – the incorporation of the **IHK'** sign carries important extralinguistic connotations and makes a semantic contribution to our understanding of the objects and entities so qualified.

In art, the supple uses of the **IHK'** sign can be illustrated on two lintels from Yaxchilan Structure 23, the funerary monument of Lady K'abal Xook, principal wife of Itzamnaaj Bahlam III (r. AD 681–742) (ills. 2, 3). These fine carvings were probably commissioned by Lady K'abal Xook herself; the texts give her an uncommon prominence, and she is the only individual to feature in all of the associated carvings. On Lintel 25 (ill. 2), the queen is actually depicted twice. First, we see her kneeling in celebration of her husband's accession by conjuring a supernatural two-headed centipede*. As the text informs us, she herself emerges from the upper head of this creature, transformed into the warrior-goddess Ixik Yohl, a deity with prominent Teotihuacan affiliations. Note the diverse uses of **IHK'**: it marks not only the great swirl of black smoke behind the centipede, but also the feather in the lady's headdress and the obsidian bloodletters* in their bowls. The lintel also reveals a plethora of uses for jaguar* skins, including the headdresses of the centipede and goddess, the spear-wrappings, the covers of the books* in their bowls, and the bowls themselves. While the black spots on the paper and the sides of the bowls were once thought to refer to blood*, a glance at Lintel 24 shows otherwise (ill. 3). Here, Lady K'abal Xook pulls a thorn-laden rope* through her tongue as swirls of blood form on her lips and cheeks. This iconography is quite distinct from that of the jaguar pelts implicated in Itzamnaaj Bahlam III's sandal-backs and the nearby book covers.

As an example of the more general use of black paint in Maya art, consider the delineation of shrouded nighttime imagery in painted scenes. On the Vase of the Seven Gods (ill. 4), a dark black wash, crossed bones and stacked mountain* monsters indicate that the scene takes place in God L's underworld cave (*see* 92.2). As the text informs us, this is the "gathering together" of a number of baleful Underworld deities alongside their lord, God L.

46

BLACK

IHK'

1 Yax Ehb Xook. Stucco terrace mask, Uaxactun Group H. Late Preclassic.

2 Benediction scene. Stela 7, Yaxchilan. Late Classic.

3 Temple offerings for Itzamnaaj. Dresden Codex, page 27. Late Postclassic.

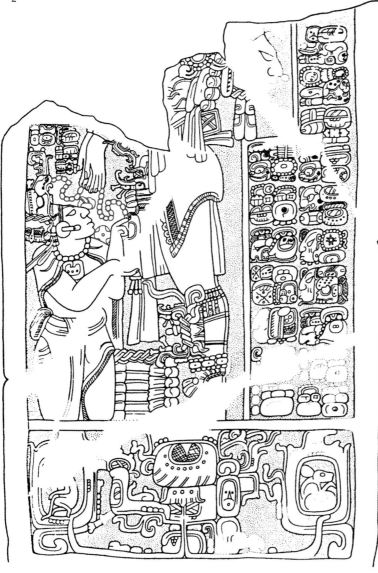

1

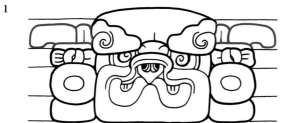

3

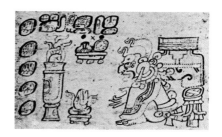

In Mayan languages, *yax* refers to the visible spectrum between green and blue, a pairing of color that occurs frequently in nature – as in the iridescent plumage of the quetzal*, for instance, or the foamy spray of sea water. Mayan, like other languages, simply does not distinguish between these colors with separate terms. In Maya writing, the **YAX** sign signals this composite blue-green color. Some forms of the **YAX** sign have crenellated edges, probably representing a large cut shell, and since *Spondylus shells** and other bivalves have pregnant links with marine symbolism in Mesoamerican art, this may explain the association of the shell motif with the blue-green colors of water.

Like the color terms black* and yellow*, the **YAX** sign occasionally appears in art to label the color of an associated object, as in a stucco relief from Palenque, where it apparently qualifies the associated sky* band as blue-green in hue (*see* 60.3). But more often the **YAX** sign operates linguistically, providing elements of the name or identity of associated objects. A particularly clear example of this sort comes from a Late Preclassic mask at Uaxactun (ill. 1), where the large shark* head (**XOOK**), its step*-shaped eyebrows (**EHB**) and the scalloped cut-shell elements (**YAX**) above the earspools all conspire to provide a monumental spelling of the name of Tikal's founder, Yax Ehb Xook (*see* Introduction, ill. 7 for another iconographic spelling of this name). The Early Classic Copan founder K'inich Yax K'uk' Mo' (r. AD 426–435?) also had recourse to monumental iconographic spellings of his name, as can be seen on the Margarita façade (*see* 91.3). An intertwined quetzal (**K'UK'**) and macaw (**MO'**) provide the final portion of the name, while Sun* Gods (**K'INICH**) emerging from their beaks and two of the early, scalloped **YAX** signs provide the title and color term. Gods, too, are named in this manner. Both the Hero Twin* Yax Baluun (*see* 89.3) and the Yax Naah Itzamnaaj aspect of the Creator God (*see* 9.3; 93.2) also wear the cut-shell **YAX** diadem.

Yet not all of the occurrences of the **YAX** sign are so straightforwardly related to color, and there is some indication that the sign could be used for the homophonous term *yax* "unripe, new." Thus, **YAX** and **K'AN** are frequently paired in contexts where the complementary opposition unripe/ripe seems more likely than blue-green/yellow. One such is the frequent benediction theme from Yaxchilan, where rulers pour virgin water labeled with the symbols **YAX** and **K'AN** over bound altars. Occasionally, subordinates reach out to touch the falling droplets (*see* 20.4), or are themselves favored with the benediction (ill. 2). Similarly, in scenes of temple offerings (ill. 3 and *see* 64.2), plates containing the unripe/ripe pair sit alongside offerings of tamales* and censers* full of burning incense. In all of these scenes, the paired signs probably serve to suggest the state of purity necessary for the successful conduct of ritual.

YAX

1

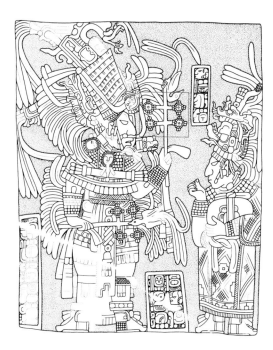

1 A dance with floral bird staffs and *ihkaatz* bundle. Lintel 5, Yaxchilan. Late Classic.

2 Woodpecker brings gifts to the White Hawk. Incised vessel. Late Classic.

3 Sacrifice of the Jaguar God of the Underworld. Codex-style vessel. Late Classic.

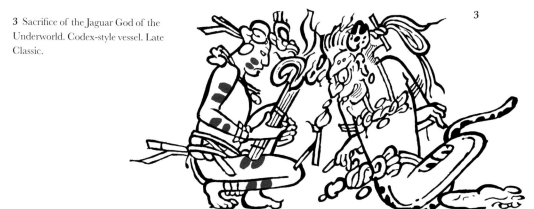

3

2

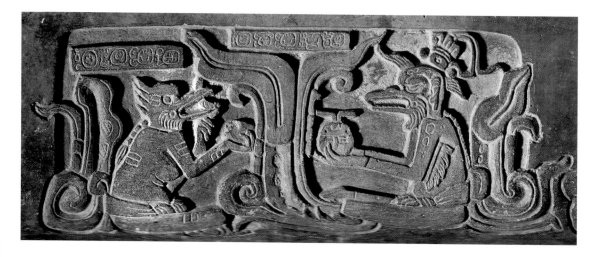

Chak is a versatile color term in Mayan languages. While its primary referent is to "red" or "ruddy" colors, it can also encompass colors we would label "brown" and "purple." The origin of the **CHAK** sign is not precisely known, though there can be little doubt that early versions are affiliated with bone* iconography, and that occasional iconographic examples highlight this relationship. Perhaps the sign is meant to invoke flesh adhering to bone. In any event, the central diagnostic is a pair of dark strokes. Such marks cue the presence of the **CHAK** sign, serving to symbolically mark red-, brown- or purple-colored objects in both writing and art.

A number of glyphs are marked with these diagnostic parallel strokes, including those for fish*, flower* and penis*, among others. Unlike some other instances of conflation, such as those involving the signs for black* or yellow*, these incorporated elements of the **CHAK** sign are not meant to be read. Rather, such markings are extralinguistic, and are solely intended to convey the colors of these objects to the viewer. Thus, fish and flowers are canonically labeled as "red" or "purple" (*see* 30.1; 56.3; 90.3), and penises are qualified as "ruddy," "purple," or "brown." This extralinguistic usage of signs is perhaps best illustrated where the flower sign invades iconography. Hummingbirds*, for instance, are regularly depicted stabbing such flowers with their long beaks, and an intricate dance scene from Yaxchilan depicts the same flowers on dance props alongside elaborately-plumed birds (ill. 1). These flowers are certainly qualified as "red" or "purple" by their diagnostic markings, but this is again a symbolic, nonlinguistic usage.

In sculpture, such symbolism achieves an even more developed form. As the iconographic equivalent of red paint, **CHAK** markings serve to delineate the colors of objects and entities in an otherwise colorless medium. On one incised vessel, for instance, an anthropomorphic woodpecker (at left) presents gifts to an aged, lordly hawk (at right) (ill. 2). While associated hieroglyphs provide some evidence for their identification, both birds are also marked with symbolic attributes of color. Thus, while the woodpecker is frequently painted a deep red in polychromatic scenes, here it takes the parallel slashes that presumably mark it as having red plumage. Similarly, the hawk wears the **SAK** "white" sign on its head, clearly echoing the nearby hieroglyphic caption **SAK-'i**, for *sak 'i* or "white hawk."

One group of humanoid supernaturals, the Chan Te' Xib or "Four Males," invariably sport red body markings in painted scenes from codex-style ceramics (ill. 3; *see* 32.1). In these scenes, the Chan Te' Xib immolate the Jaguar* God of the Underworld with a large torch. While its exact significance remains unknown, this event may have served as a mythic rationale for the sacrifice of prisoners, as suggested by the ritual recreation of this event on Naranjo Stela 35, and by a Tonina captive trussed up as this ill-fated deity (*see* 98.5).

48

RED

CHAK

* BONE 13
PENIS 16
BLACK 46
YELLOW 49
FISH 81
JAGUAR 83
HUMMINGBIRD 90
FLOWER 97

1

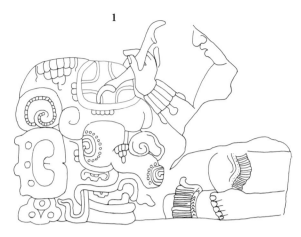

2

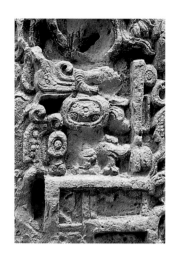

3

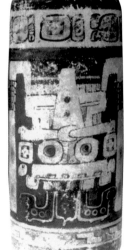

1 **K'AN** sign in the forehead of a personified stone. Emiliano Zapata Panel. Late Classic.

2 Seven-black-**K'AN** toponym. Stela D, Copan. Late Classic.

3 **K'AN** signs in a frame and deity forehead. Painted vase. Late Classic.

4 Tlaloc head adorned with earplugs in the form of a **K'AN** sign. Painted vase. Late Classic.

5 Cruciform pit dug under an E-plan structure. Water jars rest in each arm of the cross. The jar in the center is surrounded by erect jade celts. Cival. Late Preclassic.

4

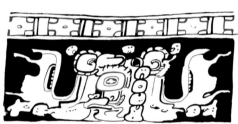

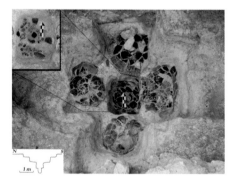

5

An abstraction of the four directions, the equal-armed cross may be the most widely shared symbol in the ancient Americas. As an implicit cosmogram, the cross was commonly associated with the sun* and heat in the Americas. It stood for a turquoise jewel in Postclassic Central Mexico, a mineral linked to fire; it may have had solar associations in the Mississippian Eastern Woodlands; and it is prolific in Chavin art of the Andes. In ancient Maya thought, this symbol, called a **K'AN** cross, had a primary meaning of "yellow" (*k'an* in Mayan). We know this with certainty because the Maya used hieroglyphs to record color-directional symbolism (*see* 6.4), and a **K'AN** sign is paired with "south," a direction explicitly linked to yellow in Colonial sources. Beyond color coding, the **K'AN** sign was broadly deployed to invoke cosmic locations, derived from the four-part shape of the sign, and also jewelry, derived from associations of "yellow" with precious things like ripe maize*.

In Maya art, the **K'AN** sign often marks things of a yellowish hue, such as the gopher* and turtle*. This is equally true of the yellowish limestone favored as a building material, the Classic Mayan expression for which is *k'an tuun*, "yellow stone." A limestone panel depicts a sculptor carving an altar visualized as a personified stone* marked by a **K'AN** sign, a pictorial iteration of *k'an tuun* (ill. 1). More esoterically, the **K'AN** sign is juxtaposed with the glyph for black* and the number seven. The example in ill. 2 merges the signs for "black" (cross-hatching) and "yellow" in the same cartouche. This compound names an otherworld location, not well understood but apparently associated with maize. The **K'AN** sign is often incorporated into zoomorphic heads, for instance, a personified tree that marks the cosmic center, as well as frames that define supernatural locales (ill. 3), usually fecund environments linked with maize and water lilies. Like the sign for wind*, the **K'AN** cross is painted on cave walls; large versions of both symbols are present at the Yucatecan cave Tixkuytun.

The **K'AN** sign alludes to sacrificial offerings, an outgrowth of its meanings related to ripe maize and precious jewels. The sign marks a scroll representing a sacred fluid (*see* 20.4) and is sometimes shown burning in braziers as though itself an offering (*see* 64.2). In the Dresden Codex plates are filled with offerings, including the hieroglyphs for a rubber ball*, blue-green* and the **K'AN** sign. As a token of something precious, the sign is incorporated into jewelry. In ill. 4 it represents a jewel earplug adorning a Tlaloc head in Teotihuacan style.

Likely inherited from the Olmec, the cosmological **K'AN** cross is a compositional underpinning of Maya art and architecture. Cruciform wall niches occur in the Palenque Palace, and cruciform sub-stela chambers have long been known from Copan. A remarkable cruciform cache pit was discovered at the base of an E-group Complex at Cival, Guatemala, dating before 350 BC (ill. 5). As seen in the diagram, water jars marked the four corners, and around the jar in the deeper central pit were erect jadeite celts* and pebbles.

K'AN

* JADE CELT 21

BLACK 46

BLUE-GREEN 47

SUN 62

RUBBER BALL 68

STONE 70

WIND 73

GOPHER 82

TURTLE 89

MAIZE 98

1 Warriors arrive by dugout canoe. Murals, Temple of the Warriors, Chichen Itza. Terminal Classic.

2 Death of the Maize God on an incised "canoe bone" (*jukuub baak*). Burial 116 (MT 38-A), Tikal. Late Classic.

3 Two gods hunt shark by canoe. Incised vase. Late Classic.

4 The Maize God's rebirth. Painted vase. Late Classic.

1

2

3

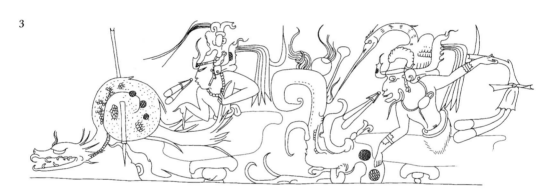

4

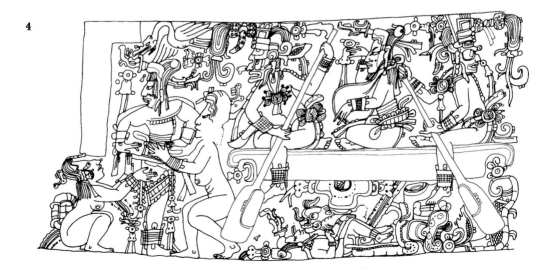

Until recently, scholars knew frustratingly little about Maya maritime and riverine technology. The reason is obvious: canoes, paddles and nets were constructed of highly perishable materials like wood* and rope*. Thankfully, the recent discovery of a Sapodilla wood paddle (preserved in anaerobic mangrove peat) and a large fragment of a canoe (interred in a dry cave), both dating to Classic times, have begun to remedy this lack. Coupled with the rich depictions of canoes in art and writing, these data allow a fresh assessment of the role of canoes in Maya culture.

The Maya word *jukuub* means "dugout," and this is clearly what the **JUKUUB** sign depicts. By convention, the dugout canoe is shown in profile, tipped up at one end, and equipped with either a miniaturized paddle or fishing net. As in art, both the canoe and its paddle are marked with wood signs (ills. 2, 4), and the **JUKUUB** glyph thus conforms in most respects to the dugouts known from the ethnographic record.

The canoe played a crucial role in connecting the tribute-driven economies of Classic times, as many city-states were located along rivers, their portages or the coast. For this reason, some Classic art stresses the economic and practical nature of the canoe. Thus, a group of rain gods is shown fishing from their canoe on a carved bone (*see* 71.1), and a group of warriors arrives by canoe on a mural from Chichen Itza (ill. 1). While most canoes in art (and the sole archaeological specimen) appear to have been small vessels, rarely containing more than two or three individuals, there is some evidence of larger craft (ill. 2). Christopher Columbus encountered a dugout "as long as a galley and eight feet wide" off the coast of Honduras in 1502. It had space for some thirty crew and passengers, a cabin and ample trade goods, including salt, pottery, textiles and cacao*. The size of Maya dugouts would seem to have been limited only by the size of available trees, and there is every reason to believe that exceptionally large canoes would have been needed to move the massive stones used in construction.

Canoes also held a prominent position in Maya religious thought. Thus, the Sun* God paddles a canoe in one scene (*see* 81.4), perhaps emerging from the Underworld in the east. Canoes also served as vehicles for the soul's journey to paradise. A series of carved bones from Tikal depict the dying Maize* God (ill. 2), accompanied by mourning animal companions, ferried into the afterlife by the Paddler Gods*. Other scenes show canoe voyages as a great hunt, where a shark* is pursued by spearmen, either in canoes (ill. 3) or wading in the ocean*. In one complex scene (ill. 4), the Maize God is reborn from a shark, dressed in jade finery and ferried by the Paddlers (though the order of these events remains uncertain). The association of canoes with the afterlife may explain the canoe recently recovered from a cave burial in Belize.

JUKUUB

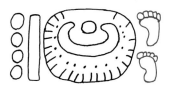

1

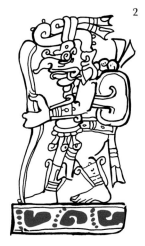

2

1 9-shell-footprint glyphic compound. Stucco relief, Margarita Structure, Copan. Early Classic.

2 Chahk strides upon a road. Dresden Codex, page 65. Late Postclassic.

3 Portrait of God L smoking a cigar. Carved limestone panel, Temple of the Cross, Palenque. Late Classic.

4 Two merchant gods drill fire on a road. Madrid Codex, page 51. Late Postclassic.

5 Pecked footprints in a cave entrance at Actun Uayazba Kab, Belize. Classic period.

4

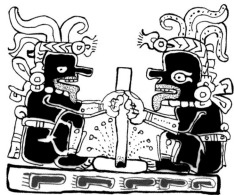

3

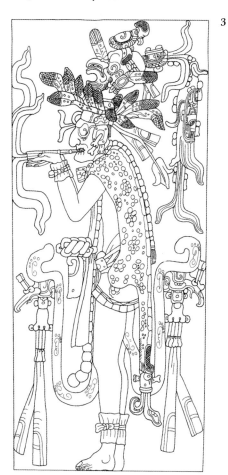

5

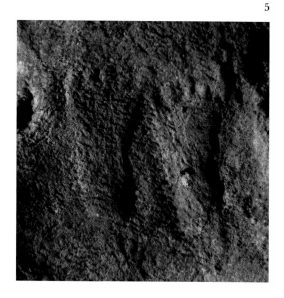

In the absence of beasts of burden, land travel in ancient Mesoamerica was solely on foot. Thus, footprints were a logical choice to signal a journey as well as bodily movement, such as ascending stairs, dancing or processing. The footprint would not have been construed as a foot since signs for body parts are marked by a partitive disk, never present on the footprint. A band lined with footprints represented a path taken, iconography seen as early as 150 BC in the San Bartolo murals. In the writing system, the footprint stood for the syllable **bi**, derived from the Ch'olan term for "road," *bih*. While not employed as a logograph for "road," footprints aligned in a linear fashion represented this concept.

Footprints were shown in pairs to indicate "arrival." Paired footprints occur with the number nine and a shell to form a standard glyph compound specifying a mythic location. The example in ill. 1 is part of a stucco relief associated with Copan's dynastic founder, K'inich Yax K'uk' Mo', who was foreign to the Copan Valley. It is tempting to interpret the footprints as an allusion to his historic "arrival" at Copan. In this rendition of the glyph compound from AD 450, the footprints are fairly realistic; however, in later examples they are stylized nearly beyond recognition. The stylized version, which became standard, is paired with a set of steps* to form a complex logograph expressing the verb *t'ab*, "to ascend."

Since the Maya metaphorically conceived of time as a journey, footprints expressed abstract concepts of temporal flow. For instance, a depiction of Chahk* in the Dresden Codex shows him in the guise of a traveler with walking staff and backpack, striding on a footprint-studded road (ill. 2). One scholar has suggested that the road symbolizes half a year.

The footprint's link to travel made it emblematic of merchant gods. The Classic Maya merchant god, known as God L, is an elderly gent sporting an avian headdress and jaguar* skin clothing. In a limestone relief from Palenque, God L's role as traveling merchant is suggested by his oddly sinuous loincloth, reminiscent of a winding road studded with footprints (ill. 3). During the Postclassic period the role of merchant god devolved to a deity known in Colonial Yucatan as Ek Chuah. Apart from his black* color, Ek Chuah's distinguishing trait is a Pinocchio-like nose, something he shares with the Aztec merchant god Yacateuctli. In the Madrid Codex a pair of Ek Chuahs squat upon a footprint-studded road (ill. 4). While identifying traveling merchants, the footprints may also allude to a mythic peregrination, suggested by the act of fire-drilling.

Footprints are present in Maya cave art. Pecked into calcitic formations, over a dozen footprints are found in the Belizean cave Actun Uayazba Kab (ill. 5). Both positive and negative foot imprints are present in Yucatecan caves, as are handprints. Generally, handprints left at a shrine are viewed as personal testimonials to a pious act. A foot imprint may also have been regarded as a personal signature. For commemorating a journey to a cave, a footprint would have been an appropriate "signature" given its association with travel.

bi

* CHAHK 6
 STEP 39
 BLACK 46
 JAGUAR 83

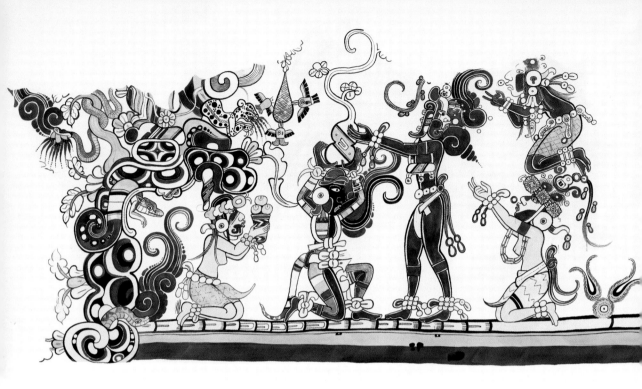

1

1 The Maize God and the first family emerge from a mountain cave. North Wall Mural, San Bartolo. Late Preclassic.

2 A Jaguar God lectures his subordinates from within a mountain cave. Incised vase, Mundo Perdido, Tikal. Late Classic.

2

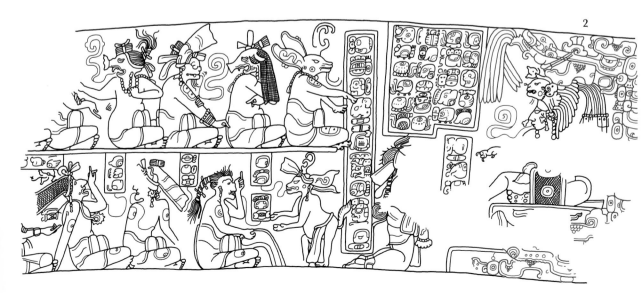

Much of the Maya area is underlain by a karstic limestone landscape. This includes not only the ubiquitous hill caves of southeastern Mexico and the Maya Mountains of Belize, but also the enormous underground caverns and great sinkholes or cenotes* of northern Yucatan. These multifarious caves play vital roles in modern Maya ritual life, and archaeological evidence indicates that the use of caves for pilgrimage centers, shrines and even tombs* dates back to at least the Middle Preclassic period.

In Mayan languages, the word for "cave," "well" and even "grave" was *ch'een*. Central to its meaning is the concept of a moist opening in the earth and, like the signs for earth*, mountain* and stone*, the **CH'EEN** glyph features a profile enclosure which highlights its significance as a shadowy Underworld environment. Indeed, its most consistent feature apart from the overhanging enclosure is a bisecting field of deep shadow, which it shares with the glyph for tomb. By convention, this shadow is indicated by black* ink in painted texts, but cross-hatched in incised ones. Various items of undoubted Underworld affiliation are infixed into this field of darkness, including an impinged bone*, a mandible, crossed bones and even a disembodied eye. In Maya art, such devices are frequently found on the wings of bats* (*see* 74.4), or on the skirt of an aged Underworld goddess (*see* 86.5) and likely mark these beings as inhabiting caves. On the Vase of the Seven Gods (*see* 46.4), two disembodied eyes and a pair of crossed bones are set against the deep black background of the vase. Coupled with the stacked zoomorphic mountains behind and beneath God L, this iconographic usage of the **CH'EEN** glyph indicates that the scene takes place in a great mountainous cave in the Underworld (*see* 80.3).

But despite these occasional appearances of the **CH'EEN** glyph in art, most caves were in fact shown as either stacked mountain monsters or as the profile maws of zoomorphic mountains (*see* 9.1–2). Thus, in the Late Preclassic murals of San Bartolo (ill. 1), the Maize* God emerges from a mountain cave into a wild landscape of jaguars* and devouring serpents*. His wife and three other ancestral couples help him bring sustenance out of the cave in the form of tamales* and a great water gourd. For the Maya, as for most Mesoamericans, caves were regarded as a place of emergence and a crucial locale in the story of the origins of maize. Yet caves are also the present-day abode of gods and spirits, all of whom needed to be placated and appeased in ritual. On one incised vessel (ill. 2), an anthropomorphic Jaguar God sits within a hill cave and holds forth to an audience of gods and animals, including anthropomorphic deer*, peccaries and a monkey*. Although the poetic language is unclear in places, the Jaguar God clearly refers to captives and tribute in a lengthy speech, and calls his abode "my earth (and) my cave."

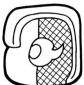

CH'EEN

* BONE 13

 TOMB 40

 BLACK 46

 CENOTE 53

 EARTH 54

 MOUNTAIN 55

 STONE 70

 BAT 74

 DEER 78

 JAGUAR 83

 MONKEY 84

 SERPENT 86

 MAIZE 98

 TAMALE 100

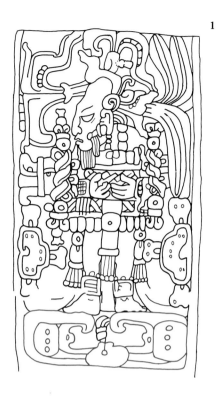

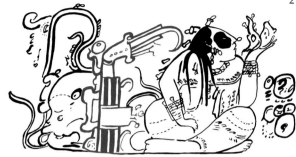

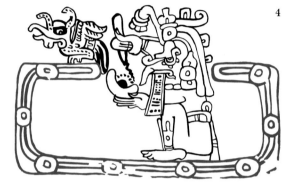

1 The Maize God dances over his cave of emergence. Stela 11, Copan. Late Classic.

2 An Underworld goddess sits in a water-filled cave. Painted vase. Late Classic.

3 A baby jaguar falls into a cave inside a mountain. Painted vase. Late Classic.

4 Chahk as a scribe inside a cenote. Madrid Codex, page 73. Late Postclassic.

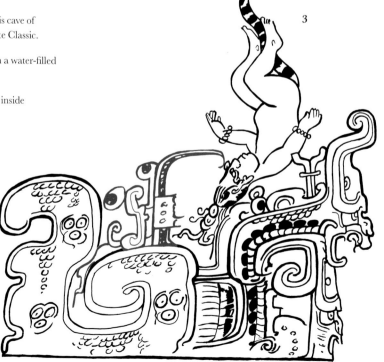

Symbols for cosmic locations form the backbone of Maya art, not just by defining spatial context for a scene but also in structuring its formal composition. Among the most prevalent are those dealing with water* and the Underworld. These concepts intersected via the phenomena of caves* and cenotes (sinkholes), both viewed as entrances to the Underworld, sources of life-giving water and mythic places of origin. Caves and cenotes also served as ritual theaters for petitioning fertility gods of maize* and rain*, ancestors and other spirits. These water-filled cavities were pictured conceptually as a fleshless jaw forming a U-shaped enclosure. The U sometimes surrounds three circles symbolic of the water found in caves and cenotes, a motif also present in the related glyph for the moon*. The bone fabric of the enclosure is made evident by black* bands, this representing the marrow within the bone*, as well as the ubiquitous cartouches with tiny circles representing bony plates, details also found on the bone and bone throne* glyphs. The ends of the U terminate in pointed fangs that create a portal-like opening. Thus the sign implies both enclosure and portal. The fangs actually derive from the poison claws of the centipede*, a skeletal creature associated with death and liminal states. In Maya writing the jaw is often compounded with the glyph for black to form a toponym for a dark, wet Underworld location.

Befitting a water-filled cavity, aquatic imagery frequently accompanies the skeletal jaw. On Copan Stela 11, a ruler reenacting the birth of the Maize God stands above the jaw meant to denote his place of emergence. Dotted water scrolls cue the cave's fertile wetness (ill. 1). The figure's placement above the U is significant as it indicates that the Maize God has fully emerged into the world from his cave womb, and he dances to celebrate this.

To adapt to different compositions, the jaw's U-shape was often modified. One modification is the half jaw, angled to create a shelter, thus allowing a figure to be shown sitting in a cave or cenote. In many half views an eye is added to convert the jaw into a profile face (ill. 2). The jaw in ill. 2 shelters a woman, possibly a death avatar of the Moon Goddess, whom the Maya believed retreated to a wet cave when she disappeared during invisibility. Sometimes reduced to a mere black hook, the half jaw is often juxtaposed to a symbolic mountain*. On one vase a baby* jaguar* slides into the hook-like jaw, here emphasizing its function as a mountain portal (ill. 3). This imagery recalls the practice of sacrificing children in wet caves or tossing them into cenotes, both attested archaeologically.

In northern Yucatan the jaw was further modified by giving it rounded tips and jewel-like disks rather than bony plates. By the Late Postclassic the standard form of the logograph was this simplified black-banded, jeweled crescent (ill. 4). The jewels point to a new identity for the symbol, now linked to an aquatic serpent whose body bears the same markings. At this time the logograph referred primarily to cenotes, common features of the Yucatecan landscape.

CENOTE /
WATERY CAVE

WAAY?

1 Bean plants and flowers sprout from the earth. Madrid Codex, page 25b. Late Postclassic.

2 Ancestors sprout from the earth as fruit trees. Palenque Sarcophagus. Late Classic.

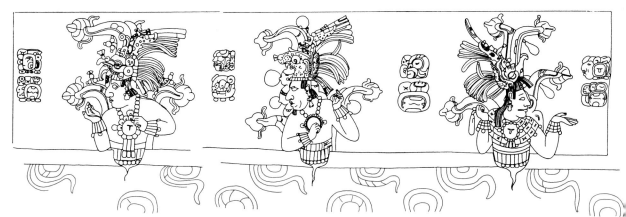

3 Chahk sits in a *saskab* mine. Dresden Codex, page 67b. Late Postclassic.

4 Itzamnaaj K'awiil stands on the earth. Stela 14, Dos Pilas. Late Classic.

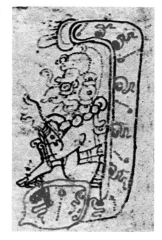

Although it shares many features with the hieroglyph for stone*, the **KAB** sign is distinguished by the presence of two partial circles (black in painted texts, cross-hatched in carved ones) which are usually set apart by one or more descending curved lines, not unlike question marks. These markings are themselves suspended from or attached to a profile enclosure which evokes the enclosed environment of caves*, mountains* and the cold stone interior of the earth, and which the **KAB** sign shares with these and a few other glyphs.

Other aspects of the iconic origin of the **KAB** sign remain obscure, but the sign clearly represents the widespread word *kab*, meaning "earth," and its behavior in art demonstrates that it was first and foremost a symbol of the natural earth. Thus, in the Madrid Codex (ill. 1), a number of scenes show bean plants and young, flowering Ceiba trees growing from **KAB** signs, which evidently represent the soil from which they sprout. Similarly, on the sides of the sarcophagus of the Palenque king K'inich Janaab Pakal I (ill. 2), a number of cherished ancestors sprout as fruiting trees* from cracks in a groundline marked by repeated iterations of the **KAB** glyph (*see* 71.4). The convention of the repeated **KAB** elements is obviously meant to signal the composition of this ground line as a solid and unbroken band of earth.

This convention also appears in an important scene from the Postclassic Dresden Codex (ill. 3). Here, the rain god Chahk* sits atop a large **KAB** glyph and within a profile enclosure formed of a field of repeating **KAB** elements terminating in the hieroglyphic sign **SAK** "white." As the associated text indicates, Chahk is situated within a *sak kab* or limestone powder mine. Literally *sak kab* means "white earth," but *sak kab* (and the worn-down form *saskab*) were also terms for the natural limestone powder much sought after by Maya builders for making cement. The elegant incorporation of hieroglyphic signs in this image informs us that Chahk is not only seated atop the earth, as indicated by the large **KAB** sign below him, but is also within a *sak kab* mine, indicated by the conjoined earth band and **SAK** sign. A similar convention appears on Piedras Negras Stela 40 (*see* 99.3). Here, Ruler 4 scatters incense on his mother in her tomb*, which is marked by the **KAB** signs on the vault above her as being located within and beneath the earth.

The earth sign also appears as a simple groundline in numerous scenes (*see* 94.1). Thus, on a stela from Dos Pilas (ill. 4), the king Itzamnaaj K'awiil (r. AD 698–726) stands on an earth band interspersed with hieroglyphs describing a "star war." Below this band, and, by this convention, on the ground but in front of the king, sprawls a captive taken in the war.

KAB

* CHAHK 6

TOMB 40

CAVE 52

MOUNTAIN 55

STONE 70

TREE/WOOD 71

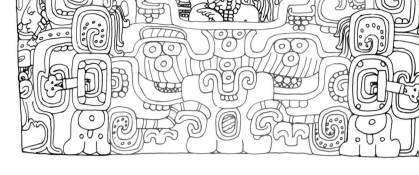

1 The Maize God emerges from a mountain. Stela 1, Bonampak. Late Classic.

2 Stacked Witz Monsters form the corners of a building. Structure 22, Copan. Late Classic.

3 Chahk's seat is a mountain throne. Dresden Codex, page 41. Late Postclassic.

4 Stepped format of text resembles a mountain sign. Zoomorph P, south, Quirigua. Late Classic.

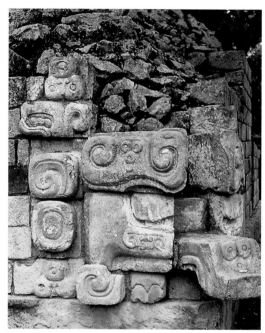

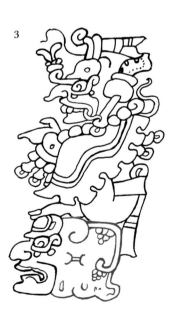

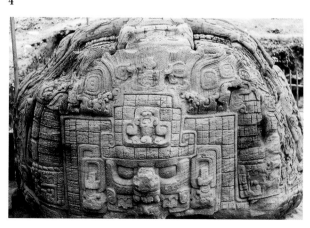

Although the Lowland Maya were basically flatlanders, the concept of the sacred mountain was a fundamental tenet of their religion since it was rooted in pan-Mesoamerican traditions that transcended local topography. Mountains were conceived as residences of gods and ancestors, making them important pilgrimage destinations on a par with caves* and other sacred landforms. Both real and mythical mountains are mentioned in inscriptions, this accounting for most occurrences of mountain hieroglyphs. The texts of Copan, for instance, mention Macaw* Mountain (Mo' Witz), perhaps a real mountain in the Copan Valley. To enhance their divine status, kings linked themselves with such venerated mountains.

The internal markings of the **WITZ** logograph are identical to those for stone*, **TUUN**; however, the former has irregular contours, usually split and curled at the top and indented on the sides, a convention for wild terrain. Pictorially, the sign is personified as the Witz Monster, a zoomorphic head with long upper lip and no lower jaw, elaborated with the same **TUUN** markings and flowing contours of the logograph (ill. 1). Incarnating the living, sacred earth as mountain, the Witz Monster is itself a cosmogram. The stepped mouth and forehead allude to cosmic portals, providing points of access into the earth. These cave-like openings often shelter gods and ancestors, as in ill. 1, where the Maize* God emerges from the forehead. This particular Witz Monster occupies the basal register of a stela. Although not pictured here, the ruler, Yajaw Chan Muwaan II of Bonampak, is positioned above, a compositional strategy for associating kings with sacred mountains.

The stepped cranium of the Witz Monster is suggestively architectonic. This is no accident as the Maya viewed pyramids* as mountains. Buildings are commonly labeled as mountains by the addition of Witz Monster heads on the façade (ill. 2). Buildings designated as mountains replicated the sacred landscape, thereby sanctifying ritual spaces within cities. Particular mountains were specified by additional imagery; often this refers to maize, alluding to the Maize God's birth from a cave in a sacred mountain, a pivotal episode in Maya creation mythology. Cosmic mountains depicted in Maya art represent various otherworld realms, for instance of wind* (*see* 73.3) and flowers* (*see* 62.1).

Conceptually, mountains overlapped with thrones, and images of them often merge. For instance, the Dresden Codex pictures Chahk* sitting on a personified mountain that also bears the symbol for the cushion throne* (ill. 3), labeling the mountain as Chahk's seat, personified by a deity head. One remarkable mountain throne is Zoomorph P, Quirigua. This enormous ball of intricately carved sandstone is inscribed with Witz Monster imagery. Zoomorph P is both cosmic mountain and seat, its puffy shape recalling the cushion throne, and, like the bone throne*, it is one of the three stones of the cosmic hearth. The text on the south face is configured as a stepped mountain that frames a personified water scroll, marking the monument as a "water mountain throne" (ill. 4).

1 A water-band. Mural, Tomb 1, Río Azul. Early Classic.

2 The Sun God and the Wind God in the ocean. Stucco vessel, Burial 160, Tikal. Early Classic.

3 Water Lily Serpent on the Merrin Bowl. Early Classic.

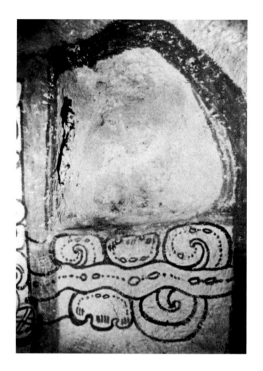

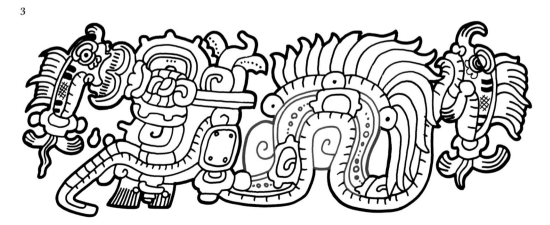

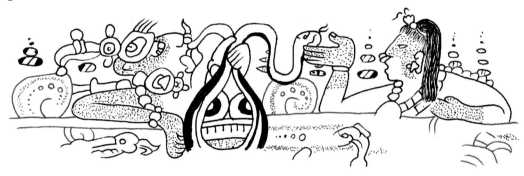

Although it is not always recognized, because of the understandable archaeological focus on the agricultural and riverine aspects of their civilization, the Maya also had a profound respect for and intimate understanding of the sea. Thus, they were well aware of the origins of shark* teeth, *Spondylus* shells*, stingray spines* and conch shell trumpets*, and there is both ethnographic and iconographic evidence that their skill with the canoe* allowed them to venture far along their coasts.

The **POLAW** sign is clearly a portion of the water-band long recognized as a symbol of watery environments in Maya art, yet it is only recently that a reading of this sign as **POLAW** "ocean, sea" has emerged. The decipherment makes possible a fresh engagement with aqueous imagery in Maya art and writing. Thus, in the murals of Río Azul Tomb 1 (ill. 1), elaborate water-bands display the same waves, droplets and scrolls of foam as the **POLAW** sign. The replication of an oceanic environment on the walls of this tomb suggests that the frequent inclusion of *Spondylus* shells, stingray spines, corals and sponges in Maya burials may have been an intentional strategy to equate mortuary space with the sea.

For the Maya, the ocean was the source of seasonal winds* and rain*, and the daily birthplace of the sun*. One particularly widespread term for "sea" in Mayan languages – *k'ahk'nahb*, literally "fiery pool" – probably references this association between sun and sea. That the Maya had a sophisticated understanding of evaporation and precipitation is revealed on an Early Classic vessel from Tikal (ill. 2). Waist-deep in the sea, the diurnal Sun God dips a serpent into the ocean, drawing forth a makeshift bag of rainwater, so marked by the enclosed sign for darkness*. Inverted rain symbols show the evaporation of water into the sky*, while the Wind God gestures and sings, blowing the moisture-laden air towards land. On the Dumbarton Oaks panel, a Chahk* impersonator dances with a rainwater container, suggesting that the Sun God's bag was delivered to the Rain God for precipitation onto the land (*see* 6.2).

In light of these insights, it may be necessary to rethink the significance of the Water Lily Serpent so prevalent in Maya art (ill. 3; *see* 19.2; 72.2, 3). Although often referred to as the God of the Number Thirteen, because it functions as the head variant sign for that number, or the Water Lily Monster, thanks to its tied water lily pad and flower headdress, frequently nibbled upon by fish*, this creature is clearly the zoomorphic form of the water-band. Its body is marked by the same waves, droplets and foam scrolls as the **POLAW** sign, and this suggests that it functioned as the embodiment of the sea. Where one might have been tempted to take water lilies as evidence of a freshwater association, they probably operated as more general symbols for water*. The Water Lily Serpent was evidently an important entity in its own right, with servants in the form of (poorly understood) duck-billed Wind and Water Gods (*see* 73.5).

POLAW

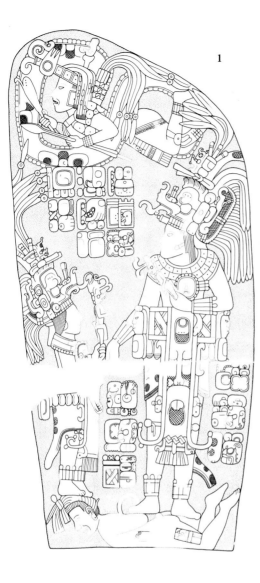

1

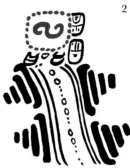

2

1 A figure hovers in an ophidian cloud scroll over a scene of ritual scattering. Stela 4, Ucanal. Terminal Classic.

2 Rain symbols fall from a cloud logograph. Painted vase. Late Classic.

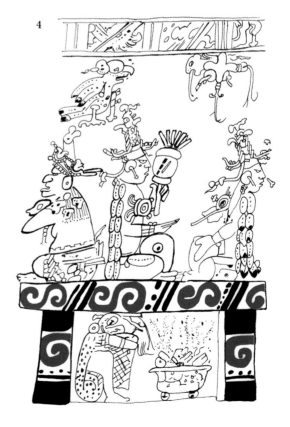

4

3 Cloud symbols rest over two Chahks. Dresden Codex, page 68. Late Postclassic.

4 A cloud sign marks a bench. Painted vase. Late Classic.

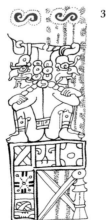

3

Maya writing employs several logographs for "cloud." The one discussed here, a reverse S surrounded by dots, is read *muyal*. While not a very direct representation of a cloud, the scrolls echo its convolutions and the dots its precious cargo of water. Though our mental picture of a cloud is a white, fluffy thing, for the Maya it was the black cloud that was the harbinger of rain*, and the **MUYAL** logograph is often prefixed by the glyph for black*. An evocative concept in Maya thought, black, rain-bearing clouds fit into a paradigm of the natural order, perhaps best thought of as a reciprocal exchange between humans and gods: life-sustaining rain, a gift from the gods, falls from the sky; in return, humans burn offerings, the smoke nourishing their divine benefactors. Black clouds not only alluded to rain but also were heavenly counterparts to the smoke from burnt offerings, thus encapsulating all phases of the cycle. In one scene of a scattering ritual, an invoked spirit rides a cloud with serpent* markings, the serpent being the cloud's zoomorphic counterpart (ill. 1). This scene illustrates one function of clouds in Maya art: to transport gods seen in visions, much as clouds cued visionary experiences in the Christian tradition of Western art. While lacking perceptual realism, the stylization of clouds as scrolls triggered mental associations with serpents and billowing smoke. Some serpents bear S-shaped cloud symbols, recalling the Aztec god Mixcoatl "cloud-serpent."

Elsewhere the "cloud" sign was employed in such straightforward contexts as indicating rain falling from the sky. On a painted vase, a stream of water, marked by the water stacks rain symbol, was positioned so that it falls from a **MUYAL** logograph which is actually part of a horizontal rim text (ill. 2). The idea of rain is conveyed here by the pointing device much-used in Maya art: where imagery and the glyph that names it come in contact. The rain-producing nature of clouds is linked with the Rain God Chahk* in the Dresden Codex. There, two Chahks sit back to back on a sky-band platform (ill. 3). Above each is a cloud, one dry and one pouring rain.

In Maya writing the cloud logograph is sometimes prefixed with the number six* to form the compound "six cloud" or *wak muyal*. In one case (*see* 44.2), Chahk wears these glyphs in his headdress. "Six cloud" probably refers to a heavenly realm inhabited by Chahk. The Maya envisioned the heavens as a great dome divided into vertical layers, each the residence of different gods and celestial bodies. Ethnographic accounts from Yucatan suggest that these layers could be referred to by the term *muyal* or "cloud," and that Chahk was believed to live in the sixth layer. Thus, the **MUYAL** sign also served as a toponym specifying a heavenly stratum associated with water, fertility and ancestors. The cloud symbol sometimes marks thrones to show the sitter's location in such a heavenly realm (ill. 4) and also appears as a design brocaded on women's garments, likewise linking them with the heavens.

57

CLOUD

MUYAL

* CHAHK 6
SIX 44
BLACK 46
RAIN 67
SERPENT 86

1 Directional glyphs with astronomical symbols. Mural, Tomb 12, Río Azul. Early Classic.

2 Fireflies with darkness markings. Painted vase. Late Classic.

3 A monkey variant of the **K'IN** glyph, in a full-figure expression for "zero days," wears the deer ear with the sign for darkness. Palace Tablet, Palenque. Late Classic.

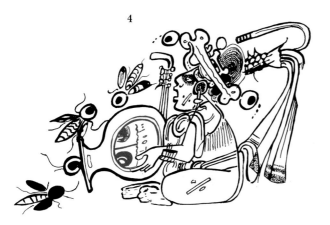

4 Mok Chih holds a vat of honey wine swarmed by bees. Painted vase. Late Classic.

5 The nocturnal sun next to a centipede head. Zoomorph P, Quirigua. Late Classic.

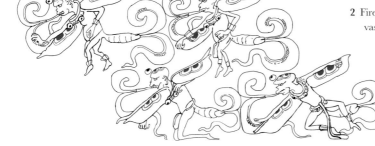

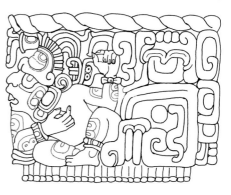

The hieroglyph for "darkness/night" derives from conventional details of a serpent* body: black* patches represent skin patterns set above scalloped belly plates. The former are a critical diagnostic, while the belly plates are often omitted. This ancient logograph stood for one of the twenty days of the calendar, called Ak'bal in Late Postclassic Yucatan. Hence, the sign is commonly called the *ak'bal* glyph: nevertheless, the sign's pronunciation was *ak'ab* "darkness/night." In the writing system, this sign qualified things of dark hue, pertaining to the night or dark places, such as caves* and the Underworld. For instance, the **AK'AB** sign stood for the night sun when placed in opposition to the **K'IN** glyph, the blazing daytime sun*. This role in nocturnal specification is evident in a suite of directional and astronomical hieroglyphs painted on the walls of Tomb 12 at Río Azul. The **K'IN** sign aligns with east and, on the opposite wall, the **AK'AB** sign with west (ill. 1). The fact that black is the color for west makes the use of the **AK'AB** sign for the night sun even more fitting. Another binarism based on **K'IN** and **AK'AB** occurs in connection with the Paddler Gods*, who embody bright and dark solar aspects, a function of their canoes* journeying between heaven and Underworld, much like the sun. The **AK'AB** glyph stands for the Jaguar* Paddler and **K'IN** for the Stingray Spine Paddler. As it represents the westerly or nocturnal sun, the **AK'AB** sign also appears on many sky*-bands.

Iconographically, the **AK'AB** glyph is one of several signs denoting a physical or associative property by marking the surface of the thing it qualifies. Functioning in Maya art much like an adjective, this sign conveys the notion of dark color or something linked to darkness, for instance, caves, bats*, jaguars, death* figures and various ghoulish Underworld denizens: **AK'AB** glyphs mark a swarm of bizarre-looking fireflies* on a pictorial vase (ill. 2). The sign also had a more benign color labeling function for various dark-hued items (*see* 23.2–5). Similarly, vessels containing dark substances bear this sign. One is an elongated wavy device tucked in the headdress of supernatural scribes, alluding to a shell paint container (ill. 3). The **AK'AB** infix is suggestive of the vessel's cargo of sooty paint. Chahk* frequently sports an *olla* (a ceramic water storage vessel) with an **AK'AB** infix thought to contain dark rains poured from his magic vessel (*see* 6.1–2 and 56.2). Depicted on a painted vase, a malevolent *wahy* linked to pulque sickness, Mok Chih, lifts an **AK'AB**-marked *olla* swarmed by bees likely containing a dark fermented honey drink (ill. 4).

The **AK'AB** glyph is a dark counterpart to the glyph for a bright jade celt*. Both of these signs mark the bodies of supernaturals, imputing attributes of their physical makeup or cosmic personality. Zoomorph P, Quirigua portrays an **AK'AB**-marked Sun God next to a curled version of the centipede* jaw (ill. 5). This skeletal creature symbolizes the Underworld passageway of the night sun after it disappears at sunset. Accordingly, the **AK'AB** glyph marks the sun in its westerly, nocturnal aspect.

AK'AB

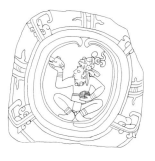

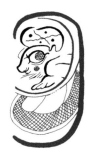

1

3

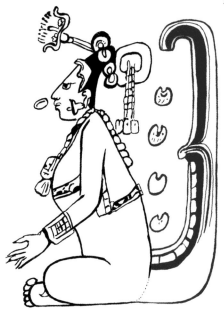

5

1 Full lunar glyph. Unprovenanced relief sculpture. Late Classic.

2 A half lunar glyph identifies the Moon Goddess. Painted vase. Late Classic.

3 A rabbit sits in a moon sign. Tablet of the 96 Glyphs, Palenque. Late Classic.

4 A skull with flanking moon signs on its jaw. Stela D, Quirigua. Late Classic.

5 A white lunar glyph indicative of bone attached to the Moon Goddess. Painted vase. Late Classic.

4

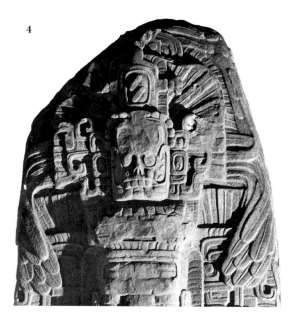

The sign for the moon is a pastiche of familiar graphic elements relating to maize*, caves* and death*, uniquely assembled in the lunar glyph. Hence, most details of the glyph are conceptual apart from the crescent, representing the moon in many world cultures. The lunar glyph occurs as full and half crescents, each having different compositional roles. The half crescent is usually attached to other features, whereas the full crescent generally stands independently, often enclosing a figure (ill. 1). The lunar glyph's conceptual details derive from a tradition of beliefs about the moon and Moon Goddess. The curved enclosure is the goddess's portable dwelling which arches over her back (ill. 2). She shared her cosmic home with a rabbit* (ills. 3, 5).

The Moon Goddess's domain was conceived as a cool, wet cave which stood in contrast to the hot, celestial realm of the masculine Sun* God. Indeed, the sun and moon formed an ancestral couple that stood in symbolic opposition. The Maya believed that when the moon disappeared at conjunction, the Moon Goddess had retreated into the water of her cave inside the earth. In this death phase, the moon is conceived as skeletal, seen in a skull with moon signs for jaws at the summit of Stela D, Quirigua (ill. 4). Given her subterranean persona, the Moon Goddess was patron of the month Ch'en, a term for a water-filled opening in the earth. Connections between the moon and caves explain why the lunar glyph resembles the symbol for a cenote*/watery cave in that both are crescent enclosures made of bone*, and as such both have black* bone marrow markings; that of the moon appears as a curved black patch. When hue is indicated, the lunar crescent is typically white, not just the color of bone but also the color of the moon (ill. 5). This color coding classified the moon as feminine and cool, forming an opposition to the sun, associated with red, heat and masculinity.

Ironically, the death-related black patch in the lunar glyph contains circles representing maize seeds, referencing the moon's contribution to agricultural fertility, a role it shared with the Maize God. The Moon Goddess and Maize God are in many respects parallel beings. Young and often wearing the same netted costume, they both have womb-like homes in caves. Conceived as a water container, the moon aided farmers by dumping its contents during the rainy season. The three circles in the crescent represent the moon's aqueous bounty filling her cave. In ill. 2 this is shown as tiny **HA'** or water* signs.

As mentioned, the Moon Goddess was the primordial female ancestor; many contemporary Maya still address the moon as "our grandmother." The Moon Goddess's standard pose – seated in her cave – also reflects a feminine stereotype, as women sat to weave, cook and care for infants. Whereas the Maize God, analogous to a corn plant growing in a field, is usually shown standing, the Moon Goddess, an embodiment of the interior, domestic woman, in touch with the earth, is shown seated, a creature of her Underworld domicile, the lunar crescent.

59

MOON

UH

1
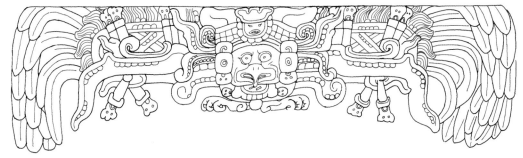

2
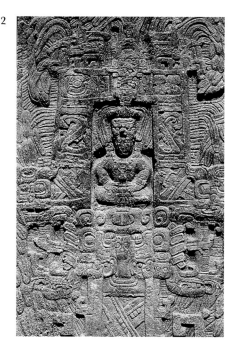

3
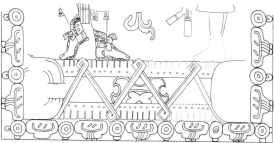

1 The wing of a supernatural bird resembles the sky logograph. Lintel 1, Temple IV, Tikal. Late Classic.

2 A sky-band frames a seated figure. Stela I, Quirigua. Late Classic.

3 An abstract form of a sky-band in a basal register. Stucco relief. Pier D, House D, Palenque. Late Classic.

4 Chahk's throne is a sky logograph. Dresden Codex, page 34. Late Postclassic.

5 A split sky emblem glyph in a basal register. Stela 4, Yaxchilan. Late Classic.

5
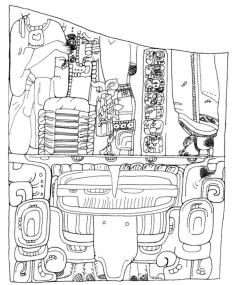

4

The diagnostics of the sky logograph are a pair of straight, curved or crossed bands resting above a wing-like element infixed with tiny "seeds" all of which are framed by a cartouche. While the rationale for these details is uncertain, the sign resembles the wing of a supernatural bird, called the Principal Bird Deity, with Preclassic origins, perhaps dating to Olmec times. In Classic Maya art this bird's wing often repeats the **CHAN** logograph's crossed bands and seed-like circles framed by feathers (ill. 1). The Maya symbol system drew an equivalence between the upper atmosphere and birds, this accounting for the wing form of the sky glyph and the fact that the sky, in the sense of its uppermost stratum, was personified by a bird. Birds took sky titles, such as God L's owl* companion called Thirteen Sky, *uhxlahuun chan*. Numerologically, thirteen is at the sky's apex.

Most pictorial occurrences of the **CHAN** logograph are in so-called "sky-bands." This band is divided into compartments each containing a symbol related to celestial phenomena, such as the sun*, moon*, night* or stars*, celestial qualities or symbols for divine attributes (ill. 2). The segmented, linear form of the sky-band recalls the body of serpents*, which were themselves deeply implicated in astronomical symbolism. The straight, clearly organized structure of the sky-band visually translates a view of the sky as orderly, a progression of celestial bodies predictably marching across the heavens. The **CHAN** logograph occurs in the sky-band in several forms. Both the crossed bands and wing may be compressed within the compartment; just the wing may appear; just crossed bands may appear; or, conflating two traits, two wing elements may form crossed bands. The latter is illustrated in a sky-band on Quirigua Stela I where the celestial frame conveys the ruler's heavenly status (ill. 2). In lieu of the usual sky-band frame, a stucco relief from Palenque presents two stretched out wing-elements from the **CHAN** logograph joined by a twisted band which marks the bodies of celestial serpents (ill. 3). This highly conceptual rendering of the sky, with both bird and serpent allusions, encases a sun symbol in a solar cartouche. Sky-bands are typically placed on rectilinear objects and borders that accommodate their shape, such as the edges of thrones, ceremonial bars, architectural frames, and headdresses. Sky-bands also trim edges of clothing, such as women's dresses and men's loincloths. Occasionally, the sky glyph stands in lieu of a sky-band. For instance, Chahk* is often shown "in the sky" in the Dresden Codex by his seated position on a sky-band, but in one case this idea is communicated by a sky glyph looking much like a cushion throne* (ill. 4).

The **CHAN** logograph sometimes occurs with a split top as in the Tikal regnal name, Sihyaj Chan K'awiil, or "heavenly K'awiil is born." The glyph depicts K'awiil* bursting out of a V-shaped crack in the sky in allusion to his birth (*see* Introduction, ill. 8). A split sky logograph is the emblem glyph of the Classic Maya city of Yaxchilan. Stela 4 features the presiding ruler, Itzamnaaj Bahlam IV, accompanied by his wife and a subordinate, positioned over the site's emblem glyph, the split sky set in the head of a sky bird (ill. 5).

CHAN

1 Turtle constellation. Incised shell, Mundo Perdido burial, Tikal. Late Classic.

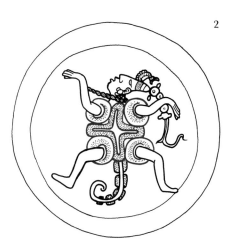

4

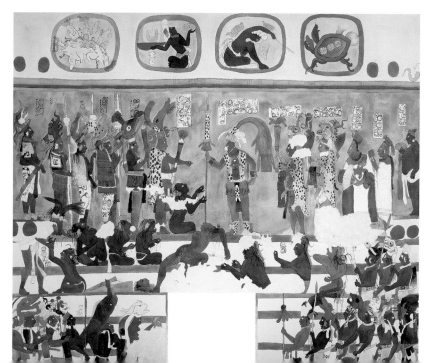

2 Scorpion star or constellation. Polychrome plate. Late Classic.

3 Yajaw Chan Muwaan II is presented with tortured and bleeding captives. Bonampak murals, Room 2, Front Wall. Late Classic.

4 "Striking Spark Star Jaguar". Codex-style vessel. Late Classic.

3

Although it is frequently referred to as the "Venus" glyph, the testimony of modern languages and ancient writing assure us that **EK'** was actually a more general term, encompassing stars, planets and even constellations. When required, specificity as to the precise class of heavenly body under discussion was achieved through the use of preposed adjectives or nouns. Thus, the planet Venus is always referred to as *chak ek'*, literally "great/red planet," no doubt a reference to its singular brightness, as well as to its central role as patron and harbinger of warfare. Similarly, the constellation of Orion was apparently known as *ahk ek'* or "turtle* constellation" (ill. 1; *see* 70.2).

Like other glyphs, **EK'** has both full and abbreviated forms. While each is subject to varying degrees of simplification or elaboration, their equivalence is indicated by free substitution in numerous contexts. Thus, on one Late Classic polychrome plate, the legs and arms of an anthropomorphic scorpion emerge from the full form of the **EK'** glyph (ill. 2) in a probable reference to the constellation of Scorpio (*sinan ek'*). A similar scorpion constellation emerges from an abbreviated **EK'** sign on the famous Sky-band Bench from Copan. Such images underscore the tendency to personify heavenly bodies in Maya art. This is well illustrated in the Late Classic murals of Bonampak (ill. 3). Here, king Yajaw Chan Muwaan II stands before his courtiers, wives and Yaxchilan allies, who present to him a group of tortured and bleeding captives taken in battle. The scene takes place at night, as indicated by the presence of flaring torches* and by the painted cartouches inset with lively characters and **EK'** glyphs hovering above. These stellar cartouches are surely meant to reproduce the sky* as it appeared that night, with zoomorphic Gemini (the peccaries, at far left) and Orion (the turtle, at far right) framing anthropomorphic stars, planets or constellations. Similarly, a rodent star descends from a sky-band on a painted vase (*see* 57.4), and the large **EK'** signs flanking a monumental portrait of the Jaguar God of the Underworld at Copan suggest the representation of still another asterism (*see* 83.5).

Central to any understanding of the **EK'** sign is its role in the demarcation of the starry heavens. This explains its pride of place in the ubiquitous sky-bands associated with celestial events in iconography (*see* 60). To cite one prominent example, **EK'** appears alongside the signs for sun*, moon* and darkness*, among others, on the sky-band encircling the sarcophagus lid of the Palenque king K'inich Janaab Pakal I (*see* 21.3). Also enclosed in this sky-band are several prominent courtiers and priests of the dead king, presumably deceased as well. Now incarnated as various lesser lights of the predawn sky, they herald their king's apotheosis as a solar deity.

Other appearances of the **EK'** glyph are more playful and have little obvious relevance to Maya astronomy. Thus, "Striking Spark Star Jaguar" (ill. 4), a sorcery-sent *wahy* being (*see* 7), is regularly associated with **EK'** glyphs. That this was a particularly baleful demon is suggested by the volutes of fire* emitted by the lightning serpent* (*see* 65.1, 3), and by the jaguar's* combative pose with uplifted stone* prepared to strike*.

EK'

* STRIKE 19
DARKNESS 58
MOON 59
SKY 60
SUN 62
FIRE 64
TORCH 66
STONE 70
JAGUAR 83
SERPENT 86
TURTLE 89

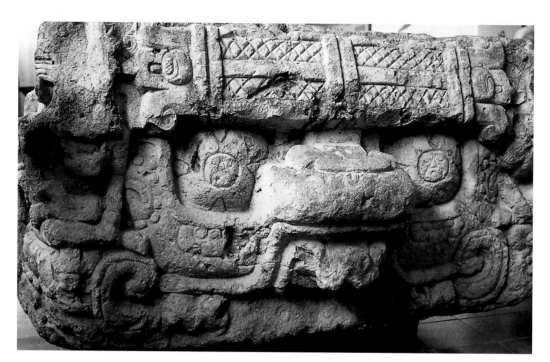

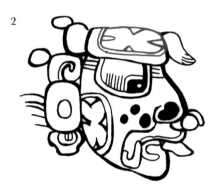

2

1 A stone seat configured as an otherworld location. Altar U, Copan. Late Classic.

2 Head of the Sun God. Mural, Tomb 1, Río Azul. Early Classic.

3 The **K'IN** glyph in a solar cartouche with centipede heads at the corners. Stela 1, Tikal. Early Classic.

4 The sun with floral rays. Dresden Codex, page 52. Late Postclassic.

3

4

The Maya symbol of the sun is a flower* with four petals, a number intrinsic to solar cosmology. Indeed, the head of the Sun God personified the number four, invoking both the four world directions, established by the sun's east–west path, and the tzolkin date of world creation on 4 Ajaw. The petals of the **K'IN** glyph are defined by notches and marked by single or paired lines, sometimes dotted. The double lines mark the flower as red*, the color assigned to the daytime sun in its easterly aspect. A solar symbol of Preclassic origin, the four-petaled flower stood for the bright heavens of the diurnal sun, conceived as a flower- and bird-filled paradise. A highly compact version of this cosmic realm is a stone seat from Copan showing a personified mountain* with **K'IN** glyph eyes infixed with an *ajaw* "flower" (ill. 1).

The color red evokes the sun's fiery heat and vitality, a trait consonant with the sun's masculine persona. Solar heat is manifested on censers/offering bowls*, used for ritual burning, by the insertion of a **K'IN** glyph on the bowl. The sun's fiery aspect is also linked to the jaguar*, a creature associated with fire*, the night sun and war, epitomized by the martial Jaguar God of the Underworld whose face sometimes bears a **K'IN** glyph.

The Sun God usually appears as a looming anthropomorphic head with squarish squint eyes and protruding T-shaped front teeth or a projecting shark's* tooth (ill. 2). His prominent nose and cheek creases indicate maturity but not the decrepitude of some elderly gods. The fact that the maturation of all living things depended on the sun's radiant heat may account for his aged appearance. Black spots, especially common in the Early Classic, perhaps representing sun spots, mark his face, while mouth scrolls visualize his vital heat. **K'IN** symbols often mark the Sun God's head. Classic inscriptions refer to the Sun God as K'inich Ajaw, "great sun lord," or Ajaw K'in, "lord of the sun," names for the Sun God that survived in Colonial Yucatan. As these epithets imply, the Sun God was a celestial counterpart to the king. The king's solar persona is evinced by the regnal title *k'inich*, "great sun." Monarchical-solar virtues included masculine heat and territorial dominance: as the blazing sun ruled the sky, so the king ruled the earth. Rulers impersonated the Sun God, who was a kind of supreme paternal ancestor. One wall of House A, Palenque was decorated with ancestor portraits projecting out from a **K'IN** sign so that they appear to be the pistols of a solar flower.

Denoting the bright heavens, the **K'IN** glyph occurs regularly on sky*-bands. When shown by itself, however, it is often framed by a cartouche, a notched circular enclosure made of a hard material, usually carved shell but sometimes flint* (ill. 3). Profile centipede* heads projecting from the corners do double duty as solar beams and floral embellishments. The convergence of the sun, flint and centipedes in the shield*-like solar cartouche evinces the sun's association with warfare. In sections of the Dresden Codex dealing with eclipses the sun projects flower-tipped rays, a manifestation of its benign aspect (ill. 4).

K'IN

1

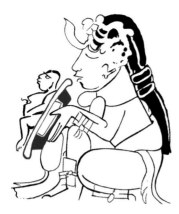

2

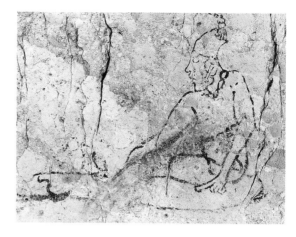

1 A sacrificed infant in an offering dish. Popol Vuh Bowl. Late Classic.

2 A cave painting of a figure seated before a bowl of burning incense. Drawing 63, Naj Tunich. Late Classic.

3

3 An offering bowl on the forehead of a zoomorphic brazier holds a burning rubber ball. Painted vase. Late Classic.

4 Carved jade depicting the Quadripartite Monster. Early Classic.

5 Quadripartite Badge on the headdress of Sihyaj Chan K'awiil II. Stela 2, Tikal. Early Classic.

4

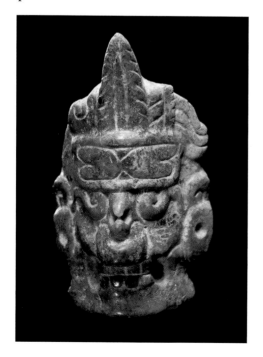

5

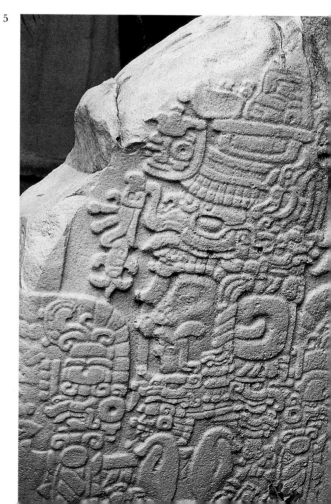

A glyphic verb, probably read *el* "to burn," depicts a ceramic dish compacted so that the rim looks like a bar, and the bowl resembles a tub marked by the **K'IN** glyph, symbol of the sun*. Because they were so basic, serving in the humblest of ceremonial proceedings, shallow dishes of this type were prototypical offering vessels. They can be seen holding an array of, sometimes grisly, offerings: infants (ill. 1; *see* 70.3), severed body parts (*see* 71.2), foodstuffs (*see* 81.2) and other prized items (*see* 23.5). Yet this dish was equally connected to burning, since offerings were typically destined for a fiery destruction. A cave painting from Naj Tunich, for instance, shows smoke billowing from the same type of vessel (ill. 2), and ceramic dishes have been found in caves associated with charcoal and incense. The bowl, then, referenced offering and burning practices, the latter understood as ritual burning that produced smoke for the gods' delectation. The sun's relationship to fire* – the transformational agent of burning – and the flow of natural cycles perpetuated by sacrifice, may account for the **K'IN** glyph displayed on the bowl.

In Maya art the offering/burning bowl was the foundation for more complex images which ultimately return to the theme of sacrifice. For instance, the **K'IN**-marked bowl adorned the crown of a zoomorphic head, this representing a ceramic stand supporting the vessel, like censer stands found at Palenque. One painted vase shows a combination bowl and stand holding a burning rubber ball (ill. 3). This functional item was the basis of a yet more elaborate image in which offerings are arrayed along the bowl's rim, a compositional ploy to make visible the vessel's contents. The bowl holds a conventional offering trio consisting of a *Spondylus* shell*, stingray spine* and device with cloth and floral traits. This enigmatic symbol cluster is known as the Quadripartite Badge, and when crowning the personified stand, typically a skeletal zoomorphic head, the Quadripartite Monster (*see* 21.3). A tiny jade carving depicts the Quadripartite Monster and even shows the stingray spine as a functional perforator (ill. 4). The Quadripartite Monster regularly appears on the tail* of the so-called Cosmic Monster, a zoomorphic model of the universe in the form of a crocodile*, perhaps suggesting that sacrifice is the engine that drives the universe's natural cycles.

In the Early Classic, the Quadripartite Badge formed the headdress of a god known as GI. On the fifth-century Stela 2, Tikal, Sihyaj Chan K'awiil II impersonates GI and wears the Quadripartite Badge above a jeweled Jester God headband (ill. 5). Both badge and monster are central to Maya iconography, yet are so evocative and layered in meaning that neither can be precisely defined. Fundamentally, the Quadripartite motif invokes the sacrificial complex and its role in sustaining the universe's vital forces. These ideas are most evident in the presence of the stingray spine, the quintessential bloodletter, and the square-nosed serpent*, emblematic of the life force, which appears in the Quadripartite Badge, especially when worn by women.

EL

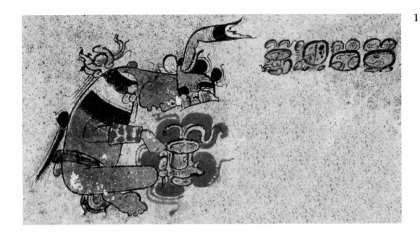

1

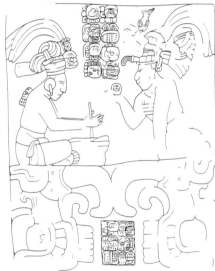

3

1 The personified spirit of "fire" or "fever." Painted vase. Late Classic.

2 A baby sacrifice in a brazier. Incised vessel. Late Classic.

3 Fire-drilling scene. Unprovenanced panel. Late Classic.

2

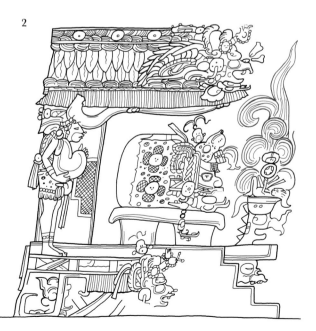

The **K'AHK'** sign was one of the first logographs to be confidently deciphered. This depended largely on the iconic transparency of its abbreviated form, which clearly represents a tongue of flame and a swirl of smoke. Yet even more important were frequent contexts of phonetic substitution and complementation and a rich usage of essentially the same symbol in art.

The characteristic tongue-and-swirl of the **K'AHK'** glyph regularly labels burning objects in Maya art, in particular cigars (*see* 5.3–4, 51.3 and 80.1–2), torches* (*see* 32.1) and spears (*see* 46.3). Fiery supernaturals also partake of **K'AHK'**-markings, including the Lightning God, K'awiil* (*see* 10.1–2 and 95.3) and his companion the lightning serpent* (*see* 61.4 and 65.1, 3) among many others (*see* 74.4 and 76.2–3). While the abbreviated form of the **K'AHK'** sign is most common, there are occasional contexts where the full form predominates, as in the name of a certain type of demon or personified disease (*wahy*) simply named *k'ahk'* "fire" or, perhaps, "fever" (ill. 1). The visual origin of this full form remains somewhat elusive, though there are growing indications that it may descend from an earlier script horizon, or perhaps even a precursor script of Late Preclassic Highland Guatemala or the Isthmus of Tehuantepec.

Fire was a powerful transformative agent in Mesoamerican thought: a vehicle for the transmutation of sacred offerings like blood*, rubber* and tamales* into the ascending plumes of smoke and luxurious scents which were the food of the gods. Such burnt offerings were usually made on an altar* or in a censer*. On one Late Classic vessel (ill. 2), we receive a rare glimpse of a temple as the setting for such a ritual. Here, a large censer is placed on a stairway outset before a throne, its contents billowing large tongues of flame and scrolls of smoke (*see* 63.2). In the censer are a sacrificed baby* and the **YAX/K'AN** "ripe/unripe" pairing that signifies ritual purity and transmutation (*see* 47.2–3 and 20.4).

Because of the transformative and cleansing aspects of fire, the act of fire-drilling came to be seen as a divine one, akin to the creation of the sun* and the world. On one Late Classic panel from the vicinity of Yaxchilan (ill. 3), the Yaxchilan king Itzamnaaj Bahlam IV and his prominent vassal, the *sajal* Aj Chak Maax, are depicted in the guises of Wind* and Water* Gods drilling fire at a mythological cenote*/watery cave marked by the profile heads of two massive centipedes*. The associated text reads in part "fire is drilled" (*johch'aj k'ahk'*). Among the later Aztecs, fire-drilling played an important role in the New Fire ceremony performed at the ends of calendrical cycles. In this rite, fire was drilled in the chest of a captive and distributed throughout the city, guaranteeing the arrival of the morning sun and the initiation of a new cycle.

K'AHK'

* BABY 1
K'AWIIL 10
BLOOD 12
ALTAR 32
CENOTE 53
SUN 62
CENSER 63
TORCH 66
RUBBER BALL 68
WATER 72
WIND 73
CENTIPEDE 75
SERPENT 86
TAMALE 100

1

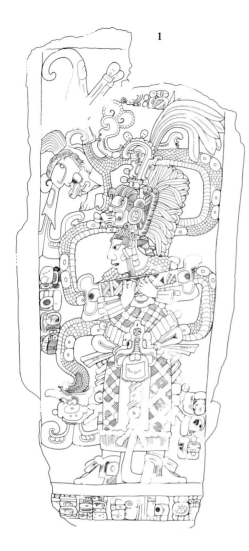

2

1 A queen conjures K'awiil and a lightning serpent. Unprovenanced Stela. Late Classic.

2 **TOK-ko** glyph in storm. Paris Codex, page 21. Late Postclassic.

4

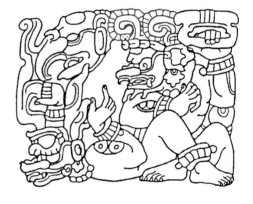

3 K'awiil, Itzam and the lightning serpent. Codex-style vessel. Late Classic.

4 Full-figure **YOPAAT** glyph. Zoomorph B, Quirigua. Late Classic.

3

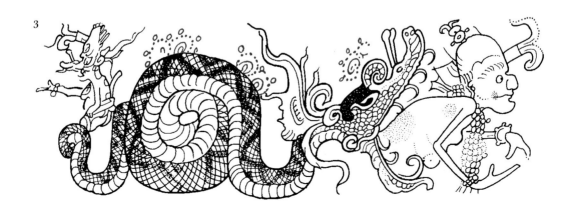

Like many glyphs, the dotted curl sign **TOK** (also syllabic **to**) has both full and visually-abbreviated forms. While both forms are prevalent in writing, the latter was preferred in art (ills. 1–4). The glyph betrays a number of iconographic similarities to that for fire*, and this provides the first clue to its fiery nature. Another clue comes from the Late Postclassic Paris Codex (ill. 2), where the sign is depicted falling from the sky* alongside a torrent of water* in a pattern most evocative of lightning. Finally, although linguistic support for a narrow translation of "spark" is still wanting, the Yucatec verb *tóok* "burn" may open the door to an interpretation of this sign as a type of flashing or sparking fire associated with lightning.

The best iconographic evidence for a meteorological significance comes from the frequent use of the sign as a qualifier for lightning serpents* in Maya art. Thus, on a remarkable stela now on display in San Francisco (ill. 1), an unknown queen conjures a fantastic ophidian being, which undulates across the monument and courses through the large, hollow bone* she clasps to her chest. That the serpent represents lightning is clearly indicated by its flaming tail, by the **TOK** element on its forehead, and by the Lightning God K'awiil* emerging from the serpent's gaping maw. On a series of codex-style vessels, other flame-tailed and **TOK**-marked serpents wrap their lightning coils around stone-wielding jaguars, though here the snakes belch forth flames in lieu of the Lightning God (*see* 61.4). Yet the close association of these serpents with K'awiil is reflected in numerous vessel scenes where we find that the lightning serpent frequently comprises one of K'awiil's legs (ill. 3; *see* 10.1). In one of these images (ill. 3), the belching serpent emits Itzam (God N), the aged Creator God and directional deity of thunder. Such scenes are frequent in Maya art and their intent may well have been to generate a coherent image of a thunderbolt: the startling phenomenon of a simultaneous thunderclap and brilliant lightning flash.

Another important context for the **TOK** element is the iconography of the meteorological deity Yopaat, a specific aspect of the Storm God, Chahk*. Befitting his role as deified lightning, Yopaat regularly wields boxing weapons (*see* 19.3–5) and sports the **TOK** sign on his forehead. Although this cranial element has often been misinterpreted as the syllabic sign **to**, it is evident from more elaborate examples that this actually represents the sparking or flaming hair of the god itself (ill. 4). Despite his distinct name, Yopaat is clearly an aspect of Chahk, commonly wearing the crossed-band shell diadem and *Spondylus* shell* earpieces otherwise characteristic of that god. As with the other meteorological deities venerated as warriors, such as Chahk, K'awiil and K'inich Ajaw, Classic kings occasionally took the name Yopaat upon their accession. Indeed, the example illustrated here (ill. 4) comes from the regnal name of K'ahk' Tiliw Chan Yopaat of Quirigua (r. AD 724–785).

65

SPARK

TOK

* CHAHK 6

K'AWIIL 10

BONE 13

SKY 60

FIRE 64

SPONDYLUS SHELL 69

WATER 72

SERPENT 86

2

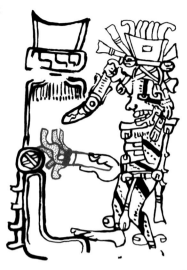

3

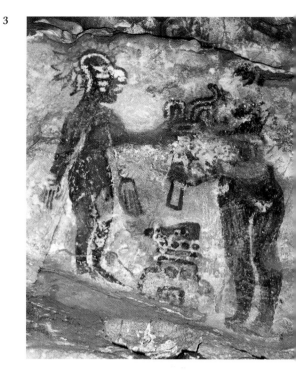

1 A courtier holds two torches. Painted vase. Late Classic.

1

2 A Death God marked with flint signs attacks a building with spear and torch. Madrid Codex, page 86. Late Postclassic.

3 A figure holds a torch in ritual scene. Painting in Jolja Cave. Early Classic.

4 Huk Sip burns forest and calls game animals. Carved vase. Late Classic.

4

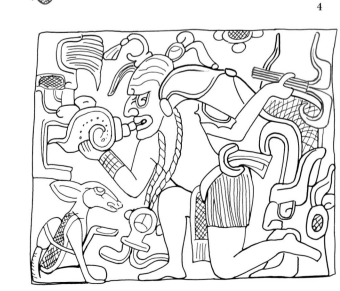

The sign for torch is a tied, flaming bundle of sticks. Torches found in caves resemble the hieroglyph, being composed of sticks bundled by strips of dried vegetable fiber; however, these bindings are usually absent in pictorial art. The best torches were made from resinous pine (*Pinus oocarpa*), a product that was not widely available in the Lowlands and therefore had to be obtained by trade. Thus, pine had measurable economic value and figured in the list of tribute demands. In ill. 1, a detail of a tribute scene, a courtier presents pine sticks and a burning torch to an enthroned lord*. In many respects torches were indispensable to the Maya, who lacked wax candles, oil lamps and other artificial illumination apart from torches and open fires. Torches were critical to the slash-and-burn agriculture practiced by most Maya farmers, who had to annually torch the fields. They could also serve as weapons for attacks targeting highly flammable thatched roofs of houses*. A scene in the Madrid Codex shows a god threatening a building with spear and torch (ill. 2). Such militaristic conflagrations are described in Classic texts as *puluyi* "it burns." Torches also appear in several mythological scenes of fiery sacrifice (*see* 32.1; 48.3).

In Maya art, torches appear in scenes where illumination actually would have been required (*see* 46.3); for instance, some cave paintings depict individuals holding torches. An early cave painting from Chiapas shows two figures standing over an altar rendered as a hieroglyphic date, 9 Ajaw (AD 297). One holds a torch as would be expected in a cave ritual (ill. 3). The Maya had various methods for handling torches, sometimes carrying them in ceramic tubes or attaching them to poles to keep the fire at bay. We may be seeing these kinds of handle-like torch holders in ills. 2–3.

The torching of agricultural fields is the subject of a carved ceramic vessel featuring the god of the hunt, Huk Sip (Seven Sip), blasting his conch trumpet* to beckon forest animals (ill. 4). The torch overlaps with a personified tree*, the so-called Patron of Pax, a head combining tree and fire* symbols. The burning head is a metonym for the conflagration of the entire forest. Huk Sip's torching is much like his trumpet call, in that clearing forest attracted game animals; indeed, a deer* makes an appearance at left.

Given that fire played a pivotal role in Maya thought, the torch had complex symbolic dimensions. A torch could stand for solar heat and drought (*see* 91.1) or the light of a firefly*. Torches alluded to lightning, represented by the forehead torch of K'awiil* (*see* 10.2). Mini-torches were worn in headdresses often with feathers mimicking flames (*see* 4.4). Fagots used for fuel in burning rituals resemble torches and were essentially their symbolic equivalent. Burning pine, a smoke-producing combustible, even added to the desired smoky atmosphere of Maya ritual. Pine was so indispensable in this regard that it also served as an offering, and Maya art shows torches and bundled sticks among the offerings in ritual vessels (*see* 27.5).

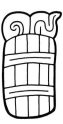

TAAJ

* LORD 4
K'AWIIL 10
TRUMPET 31
HOUSE 37
FIRE 64
TREE 71
DEER 78
FIREFLY 80

1

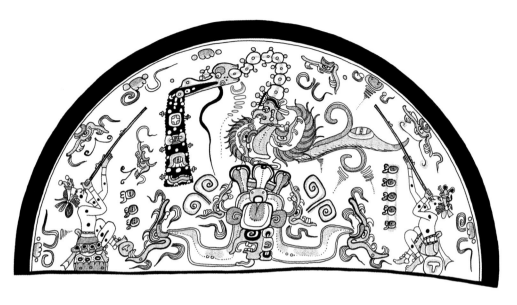

2

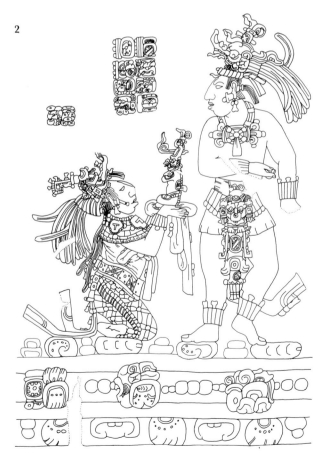

1 Blowgunning scene on the Blom Plate. Late Classic.

2 Ritual taking place in a wet cave. Tablet of Temple XIV, Palenque. Late Classic.

Ha'al is the word for "rain" in a number of Mayan languages and was clearly derived from the pan-Mayan word *ha'* "water." As with other such derivations, it refers to a specific example of the previously general noun. Thus, rain was considered a specific category of water*. Only recently deciphered and apparently restricted to late inscriptions, the **HA'AL** sign appears as three inverted triangles marked with horizontal lines, suspended below an ovoid cartouche. Often the sign was abbreviated to just the inverted triangles.

In Maya iconography, flowing or standing water is typically marked by a series of small pyramids of horizontal strokes that attenuate from bottom to top. Conventionally referred to as water stacks, these icons undoubtedly provided the origin of the **HA'AL** sign and are perhaps best known for their delineation of watery surfaces, as in scenes involving canoes* (*see* 50.2, 3, 81.3 and 71.1). In these contexts, the elements probably represent ocean spray, the stacks diminishing in size as they recede from the watery surface. In another scene, water stacks far removed from the surface of the water may signal evaporation in the presence of gods of Sun* and Wind* (*see* 56.2).

Yet water stacks have even stronger associations with rain and falling water. Perhaps the clearest example hails from the famous Blom Plate, allegedly uncovered near Chetumal Bay in Quintana Roo, Mexico, almost six decades ago (ill. 1). In this impressive scene, the avian avatar of Itzamnaaj* perches high in the sky, a great torrent of water issuing from his elaborate headdress, and inverted water stacks cascading from his wings, tail* and various other elements in the sky. The symbols clearly represent falling water, perhaps precipitated by the blowguns of the Hero Twins* (*see* 71.3), who take aim at the monster bird while seated on cushion thrones*. On one vessel, glyphs spelling the word for "cloud"* (*muyal*) release a shower of rain also labeled with the water stacks elements (*see* 57.2). On Quirigua Stela H, a similar downpour showers the Maize God as he emerges from a mountain* (*see* 98.2), and the moist breath of the Maize* God is qualified with water stacks in the Late Preclassic murals of San Bartolo (*see* 52.1). Finally, water pouring from the hands of rulers in benediction scenes is also marked with these elements (*see* 47.2, 60.5 and 20.4), as are the rims of water jars (*see* 58.4), particularly those carried by Chahk* impersonators (*see* 6.2).

In addition to specific associations with rain, the **HA'AL** sign could combine with other symbolism to qualify watery cave* environments. Thus, on the Tablet of Temple XIV of Palenque (ill. 2), the young K'inich Kan Bahlam II reenacts an ancient mythical event in a cave alongside his mother. Below him are signs for water, wind and rain, as well as glyphs spelling the word *k'ahk'nahb* "fiery pool."

HA'AL

1

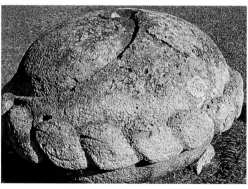

3

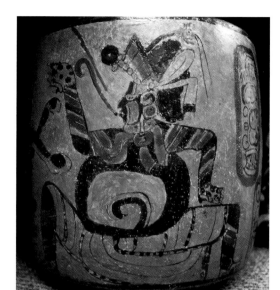

1 A rubber ball burns in a brazier. Madrid Codex, page 39. Late Postclassic.

2 An offering bowl holds four rubber balls. Madrid Codex, page 96. Late Postclassic.

4

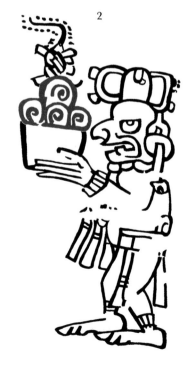

3 A *wahy* character has a rubber ball body. Painted vase. Late Classic.

4 An effigy rubber ball encircled by a rope. Altar of Stela 4, Copan. Late Classic.

2

By 1500 BC Mesoamericans knew the art of turning latex from *Castilla elastica*, a tree native to topical regions of Mexico and Central America, into rubber. Affiliated with the Olmec, the oldest rubber objects to survive are balls made from wound strips of rubber, constructed somewhat like the inside of a golf ball. This technique for making rubber balls likely accounts for their codification, which took the form of a thick, black* spiral. Spiral-shaped glyphs are fairly common in the Maya symbol system and have such diverse meanings as a curled tail*, a shell, emitted sound, several maize*-related items and even curls of smoke. Refining the meaning of a spiral was made possible by context and subtle formal differences. For instance, the rubber ball spiral tends to be black, recalling processed rubber, is fairly circular and has especially tight windings.

As is well known, rubber balls served as sporting balls, and fairly realistic ones can be seen in conjunction with ballcourts*. However, an equally important role of the rubber ball was as a ritual offering that was burned along with other sacrificial materials, such as incense and blood*-soaked paper. The resultant smoke provided a kind of olfactory nourishment for the gods, as did burnt blood, incense and any other combustible placed in the censer*. Rubber was conceptually linked with blood; indeed, the logograph may actually read **CH'ICH'** "blood." In Mayan languages latex is called the "blood of trees," and rubber balls were conceived as ersatz blood offerings. A story from the *Popol Vuh* tells of a maiden whose angry father wanted her killed and demanded her heart as proof. The executioners spared her life by offering her father a substitute heart made from a rubber ball. Indeed, Mesoamericans likened the quivering of a bouncing rubber ball to a beating heart.

While uncommon, spiral-shaped rubber balls do occur in Maya art. Most are found in the Postclassic codices, priestly manuals especially concerned with prescribing ritual offerings for specific ceremonial occasions. Here rubber balls are pictured burning in tall braziers (ill. 1) or piled in bowls with other sacrificial objects (ill. 2). Among codical depictions, only one scene shows the spiral as a sporting ball (*see* 36.2). During the Classic period, rubber balls generally appear as dark, round solid objects, while the spiral form is rare. However, one occurs on a Late Classic painted vase in the guise of a strange *wahy* creature whose bulging torso is composed of a spiral-shaped ball (ill. 3). Copan is home to an unusual sculpted version, a gigantic three-dimensional rubber ball encircled by a rope* (ill. 4). Rubber balls are commonly shown bound in this fashion. The rope made handling sticky, heavy balls easier and added fuel for their combustion. Binding was itself a sign of the object's offertory status, as rubber balls were standard sacrificial offerings. The Copan ball is identified as rubber by the spiral channel, comparable to the hieroglyphic sign, which also directed real blood offerings poured into a depression at the top. The spiral's dual role on this unique monument perfectly illustrates the abiding connection the Maya made between rubber balls and blood sacrifice.

CH'ICH'?

* BLOOD 12
ROPE 24
BALLCOURT 36
BLACK 46
CENSER 63
TAIL 88
MAIZE 98

Natural Elements and Materials 165

1

5

4

1 A ruler impersonates the deity GI. Stela I, Copan. Late Classic.

2 A noblewoman wears typical female costume. Unprovenanced stela. Late Classic.

3 Courtiers decked out in white capes and *Spondylus* shell necklaces. Room 1 mural, Bonampak. Late Classic.

4 A kneeling woman wears a *Spondylus* shell pendant seen in profile. North Wall Mural, San Bartolo. Late Preclassic.

5 A basket filled with tribute offerings includes quetzal feathers and *Spondylus* shells. Painted vase. Late Classic.

2

3

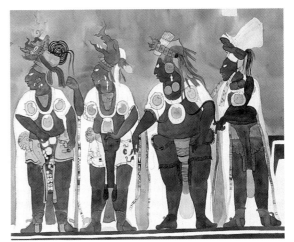

Spondylus shell (*Spondylus spp.*), also called thorny or spiny oyster, was among the most coveted luxury items in ancient Mesoamerica. The Maya exploited several species harvested off the Caribbean and Pacific coasts which were distributed through long-distance trade. A bivalve shell, *Spondylus* had various uses. Whole, unmodified valves were placed in caches and burials. More commonly, the spines and white outer layer were scraped away to expose a layer of red shell used for manufacturing jewelry and tiny figurines. Partially modified whole valves worn in costumes implied high status. At Tikal, even the debris from worked *Spondylus* was placed in ritual deposits.

?

The *Spondylus* shell is not employed as an independent logograph in Maya writing but as a component of several complex signs; perhaps owing to this supportive function, its linguistic reading remains unknown. The hieroglyph presents the inside of a modified valve. Bumps on the perimeter represent the nubs of broken spines; an inner ring marks where a thick layer of white shell meets a red* layer rimming the edge; curls indicate the hinge; and tiny circles either mark perforations for suspension when paired or supply aquatic associations when strung out in long chains.

The aquatic *Spondylus* valve served as the earflares of the Rain God Chahk*, as well as a related god called GI; a ruler dressed as GI on Copan Stela I wears a particularly large pair (ill. 1). Topping his headdress is the Quadripartite Badge, an offering bowl/censer* holding three sacrificial items; that at right is a *Spondylus* valve. Here, the shell epitomizes an offering that only a king could afford, suggesting both pious sacrifice and conspicuous wealth. A qualifier on "sacred fluid" scrolls related to the hieroglyph for "holy," the *Spondylus* shell functions like an adjective marking the precious nature of other things.

A conventional symbol positioned in the pelvic region, always accompanying a netted costume of tubular jade beads and worn specifically by women and the Maize* God (or his impersonators), features a shark* head with a *Spondylus* shell in place of the lower jaw (ill. 2). The location of the shell over the groin recalls a statement by Bishop Landa that in sixteenth-century Yucatan a shell served to cover the genital region of young girls. On the Late Preclassic San Bartolo murals a female wears a red *Spondylus* shell in precisely this fashion (*see* 93.3). The U-element marking the hinge is typical of early versions of the shell.

Spondylus valves were worn as necklace pendants by courtiers, usually displaying the smooth red inner surface (ill. 3). That this motif occurs in the San Bartolo murals by 150 BC, where a shell hangs on a woman's necklace, shows the antiquity of this practice (ill. 4). Like gold or diamonds, *Spondylus* had intrinsic value, and many royals chose to take their prized mollusks – commonly found in elite graves – to the afterlife. Painted vases portray lords* receiving baskets of tribute overflowing with valuable commodities. Standard among them are *Spondylus* valves, quetzal* feathers, jade and cloth, signifiers of enormous wealth (ill. 5). There was scarcely a bolder statement of material privilege than a *Spondylus* valve next to a few quetzal feathers.

* LORD 4
CHAHK 6
RED 48
CENSER 63
SHARK 87
QUETZAL 93
MAIZE 98

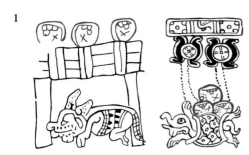

1

2

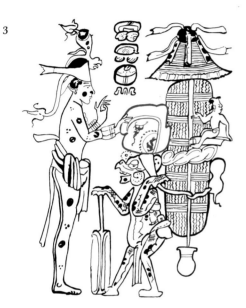

3

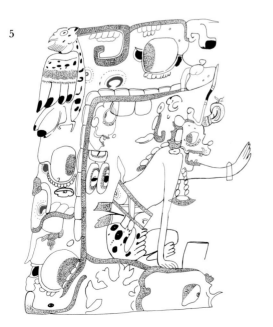

5

1 Stone weights on a trap. Madrid Codex, page 91. Late Postclassic.

2 Three hearthstones, part of a turtle constellation. Madrid Codex, page 71. Late Postclassic.

3 A toad carries a stone altar for child sacrifice. Painted vase. Late Classic.

4 A personified stone in the hieroglyphic expression for *lakam tuun*. Stela D, Copan. Late Classic.

5 Chahk's house is a cave in a mountain marked by stone signs. Painted vase. Late Classic.

6 The sturdy body of an aged world bearer is conveyed by stone signs. Carved stone bench, Structure 82, Copan. Late Classic.

4

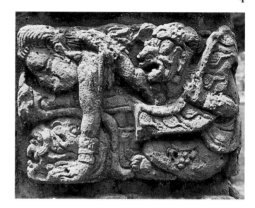

6

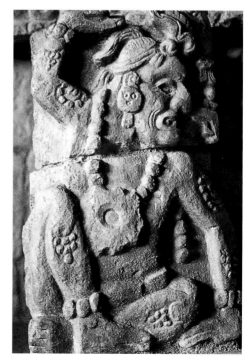

The hieroglyph for common stone (but never referring to semi-precious stones, such as jade), **TUUN**, has a set of specific markings, usually framed within a cartouche or, when personified, placed inside a zoomorphic head. They include a cluster of circles resembling a bunch of grapes – as this motif is nicknamed – and a dotted semicircle typically framing a scroll, a black* semicircle or black arc. In sculpted media the black areas appear as cross-hatching. Since these elements specify the day called Kawak in Colonial Yucatan, they are often called *kawak* markings. Nevertheless, **TUUN** or "stone" markings better convey their literal meaning. How these dotted and globular elements came to represent stone remains obscure. However, the dotted semicircles may be curved versions of the flint* sign's dotted bands. Indeed, it seems that flint markings were the generic designator of "stone" during the Preclassic and that **TUUN** markings later assumed this general role as flint became more specialized. The two signs are in any case conceptually related and sometimes mingle their details, particularly on objects made of flint.

The basic role of the **TUUN** sign is to identify objects made of stone. Often this is quite straightforward. For instance, three **TUUN** signs represent three rocks weighing down an armadillo trap in the Madrid Codex (ill. 1). Notice the X, an addition to the sign common in Postclassic Northern Yucatan. Another Madrid Codex scene shows the celestial hearth as a pile of three rocks, carried by a turtle* constellation located in Orion (ill. 2). On a Late Classic pictorial vase a toad carries a **TUUN** sign, here representing a sacrificial altar* (ill. 3), while the infant to be sacrificed rests in an offering bowl* balanced on his pack.

The erection, piling and other manipulations of stone was an entrenched mode of ritual behavior in Maya culture. During the Classic period, calendrical ceremonies typically involved actions directed toward a stone monument. One was the erection of a stela, glyphically described as *utz'apaw tuun*, "he drives the stone into the ground." In an example of this phrase on Stela D, Copan, the stela, called a "banner stone," employs a full-figure personified **TUUN** sign (ill. 4). Another ceremony is referred to by a verb featuring a hand holding a stone, read *uk'alaw tuun*, "he wraps the stone," alluding to the binding of stone monuments in rope* or cloth.

Perhaps more than any other symbol in Maya art and writing, the graphic elements of the **TUUN** sign were employed freely and independently to specify that something is either made of or has qualities of stone. For instance, the mountain* glyph is essentially a zoomorphic head bearing the constituent elements of the **TUUN** sign. In ill. 5 the mouth of this creature, called the Witz Monster, forms a cave-like opening, here the domain of Chahk*. A carved bench in Copan's Structure 82 depicts an old atlantean god (**ITZAM**) with **TUUN** markings on his body. These signs may suggest that his body is as sturdy as a rocky mountain, as he acts in this scene as world bearer (ill. 6).

TUUN

* CHAHK 6
ROPE 24
FLINT 27
ALTAR 32
BLACK 46
MOUNTAIN 55
OFFERING BOWL 63
TURTLE 89

1

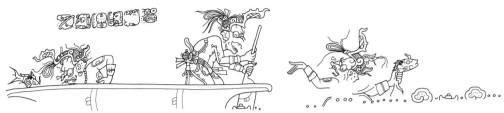

2

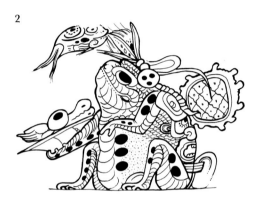

4

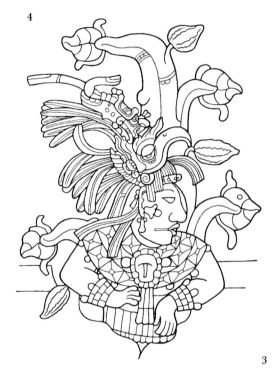

1 Three Rain Gods fishing from a canoe. Incised bone (MT-51), Tikal. Late Classic.

2 A fat toad holds a wooden bowl. Codex-style vessel. Late Classic.

3 Blowgunning scene. Codex-style vessel. Late Classic.

4 Lady Sak K'uk' erupts from the ground as a cacao tree. Palenque Sarcophagus. Late Classic.

3

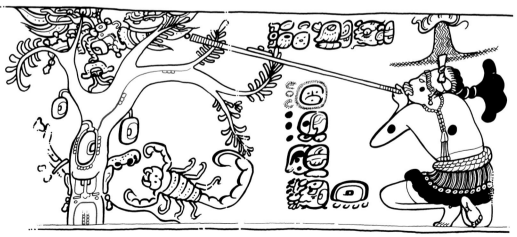

As might be expected given the lush rain forests of Central America, trees figure prominently in Maya art. Probably derived from the globules of resin that form at natural splits and crevices in living wood, the **TE'** glyph refers to both trees (*te'*) and forests (*te'el*), though it could also be employed for its sound value alone in the writing of other words. The sign's roots in forest symbolism are deep, however, and central to any understanding of its significance in art, where it unambiguously serves to denote trees and wooden objects. Thus, in a series of lively scenes from carved bones excavated at Tikal (ill. 1; *see* 50.2; 81.3), both canoes and paddles are frequently marked with the **TE'** sign. Similarly, the composition of certain sacrificial bowls was also indicated in this manner (ill. 2; *see* 94.3), probably to avoid confusion with a plethora of vessels made from different materials, such as clay and stone. In this way, the **TE'** sign marks wooden objects throughout Maya art, including axe-handles (*see* 14.1), digging sticks (*see* 21.2), architectural platforms (*see* 39.3), animal traps (*see* 94.1) and, of course, trees themselves (ills. 3, 4; *see* 95.1; 21.2–3). This feature is of enormous assistance to students of Maya art, since almost all wooden objects from Maya civilization have long since disappeared.

The **TE'** sign is more than a convenient label for wooden objects, however. Trees are key symbols whose primary function is the contrast of natural and cultural space. Wilderness scenes involving hunting or fowling, for instance, typically include at least one tree to set them apart from activities taking place in cities and other artificial landscapes, as on the famous Blowgunner Pot, where Juun Ajaw shoots the descending avian form of Itzamnaaj in a forested landscape (ill. 3; *see* 66.4, 67.1). Such scenes are clear cases of *synecdoche*, one tree referencing the presence of an entire forest.

The Yucatec Maya recognize the presence of a *yá'axche'* or "first tree," which they equate with the ceiba (*Bombacaceae spp.*). Indeed, the tree in ill. 3 is labeled with the **YAX** sign, indicating that it was just such a tree. Among the tallest trees in Mesoamerica, ceibas dominate the rain forest skyline and embody the *axis mundi* – a central pillar of the cosmos uniting the sky*, earth*, and Underworld. As home to a diverse biological community, these trees symbolized the riches of the entire rain forest ecosystem. Further, Maya mythology made a profound connection between fruit trees and the creation story, wherein the rebirth and resurrection of maize* presaged the arrival of fruits and other tasty comestibles, especially cacao/chocolate*. Thus, divine ancestors were occasionally depicted as fruit-laden trees, underscoring their role as providers and nurturers (ill. 4; *see* 54.2; 21.3; 40.1). In Yucatan, many modern Maya villages are centered around ceiba trees, the multivocal symbols of rain forest abundance and ancestral protection.

TE'

* EARTH 54
SKY 60
CACAO 95
MAIZE 98

1

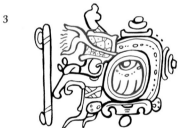

2

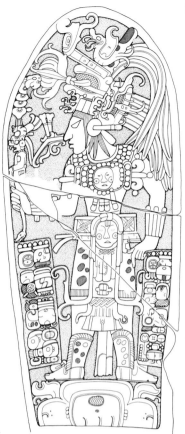

3

4 Water Lily Jaguar. Painted vase. Late Classic.

5 The Maize God emerges from a pool of water indicated by a panel with markings of a water lily pad. Painted vase. Late Classic.

1 "Fish-nibbling-upon-water-lily-flower" motif. Stela N, Copan. Late Classic.

2 A water lily in a headdress and in a basal register. Stela 4, Machaquila. Terminal Classic.

3 A symbol compound with the *imix* form of water lily joining a serpent with a flower and pad headband. Number seven identifies this as a toponym. Painted vase. Late Classic.

4

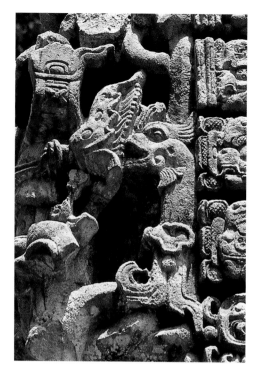

5

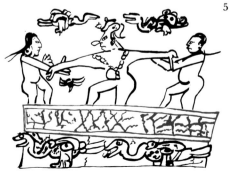

The water lily (*Nymphaea ampla*) may trump even maize* as the most prevalent plant species in Maya art. Its importance arises from the fact that it was a symbol of something utterly fundamental: water. While there were other aqueous symbols, the water lily was the one standardized in the writing system. Two water-related logographs derive from the water lily. The flower spawned the sign for water, *ha'*. The flower's shape defers to the cartouche, while curved lines represent feathery petals. Opposite them is a cross-hatched or black* circle rimmed with dots representing the center of the flower. This sign stands for the first day of the twenty-day cycle, called Imix. The water lily leaf is the basis of a logograph for pool, *nahb*, a term for the water lily itself. The leaf has crenellated edges and bears a dotted diamond pattern formed by wavy lines. This pattern not only identifies water lily pads and turtles* in Maya art but also crocodiles* in central Mexican art, linking it generally with aquatic flora and fauna. The pattern may ultimately derive from the pattern of cracks on a turtle carapace. The "pool" logograph depicts the lily pad itself (occasionally associated with scrolls, stem or other parts of the plant) floating in a pool of water indicated by the conjoined water-band sign (*see* 56).

In Maya art, the water lily evokes lacustrine environments, and the ubiquitous motif, "fish-nibbling-upon-water-lily-flowers," suggests the prodigious animal and plant life found in wetland eco-niches (ill. 1). On Machaquila Stela 4 the king wears this motif as a headdress (ill. 2). Covering his brow, the leaf is tied by the flower stem, and the flower, nibbled by a fish*, opens at left. The king also stands on the glyphic **HA'** form of the flower, which serves in this instance as a toponym. Water lily pedestals, bands and frames situated figures in aquatic locations, both real and mythic (*see* 44.3). On a painted vase a Water Lily Serpent* wearing a leaf-flower headband is juxtaposed to a **HA'** sign framed by a dotted water-band supporting two rain* symbols (ill. 3). The number seven, in bar-dot form, identifies this water-laden imagery as a numbered mythic location. Because water was a path to the Underworld, water lilies are often associated with death* imagery, especially skulls*, as well as *wahy* demons. One such is a fat toad bearing a humorous headdress comprised of a water lily pad and flower, the latter nibbled by a fish (*see* 71.2). Another is the Water Lily Jaguar*, who wears water lily costuming or, as in ill. 4, is entangled in a luxuriant water lily plant. An able swimmer, the jaguar doubtless got tangled up in water lilies, and so the imagery is not at all far-fetched.

The details of a water lily plant were used in abstract ways. An example of this is seen in ill. 5, a composition familiar in the corpus of vase painting, in which the Maize God arises from water, sometimes flanked by nubile, naked maidens. The watery Underworld from which he emerges is shown very conceptually as a rectangular panel bearing the rather crudely drawn markings of a water lily pad, standing for "pool." There can be no doubt this is water, as a bird is shown head-down diving into it.

HA'

.POOL

NAHB

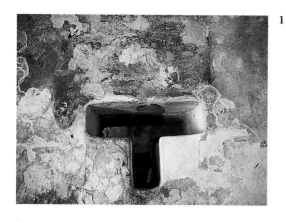

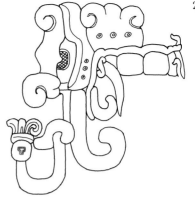

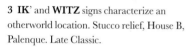

1 An **IK'** logograph forms a wall penetration. Palace, Palenque. Late Classic.

2 An **IK'** logograph marks a breath scroll on a zoomorphic monster. Altar U, Copan. Late Classic.

3 **IK**' and **WITZ** signs characterize an otherworld location. Stucco relief, House B, Palenque. Late Classic.

4 The patron of the month Mahk. Stone panel, Bonampak. Late Classic.

5 Two duck-billed gods bear **IK'** and **POLAW** body markings. Painted vase. Late Classic.

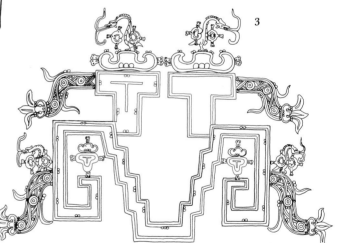

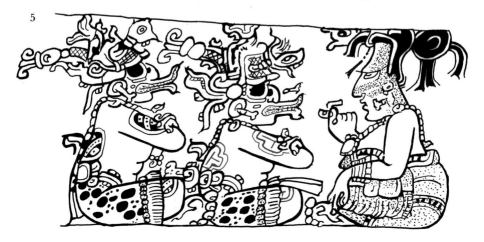

Mesoamericans saw themselves as part of a seamless universe, likening their own bodies to the earth with its cycle of growth and decay. The body's animating breath had a counterpart in the earth's winds, and the Maya used the same term for both. This term, *ik'* "wind" and "breath," is also the name of the second day of the twenty-day cycle. Oddly, the symbol for these ethereal, atmospheric phenomena is a rigid T-shaped sign, vaguely resembling a profile view of a stylized jade earflare. Even though wind had a destructive aspect as a purveyor of drought and disease, which the Maya greatly feared, wind's life-affirming qualities are emphasized in Maya art. The symbol for wind intermingles with such pleasurable things as jade jewelry, flowers*, maize* and music. **IK'** signs fashioned from jade were worn as pectorals (*see* 20.3 and 28.4), covering the area of the body where breath is generated.

Apart from maize foliation, wind and breath symbolism account for a substantial portion of Maya art's characteristic scroll work. Voluminous scrolls were attached to clouds*, mouths, flowers, basically anything emitting wind, aroma or sound. However, the **IK'** sign offered a more coded, compact and precise way of expressing these effusive phenomena. It served specific compositional purposes, one being to stand alone, almost emblem-like, and remain semantically unambiguous, something which a scroll is incapable of without strong contextual cues. For instance, **IK'** is the main sign of an emblem glyph of a site near Tikal, Motul de San José. Large **IK'** signs are painted on cave walls, caves being conduits of wind. Objects with acoustical properties, such as rattles, drums* and jingling ornaments were marked by **IK'** signs (*see* 2.4). And this symbol frames wall openings and niches in the Palenque Palace (ill. 1).

The convergence of wind and breath is apparent in the substitution of **IK'** signs for breath scrolls. More than a biomechanical process, breath was a life force akin to a soul. This breath soul was pictured in various guises: as scrolls, jewel-like flowers and floral tendrils related to the square-nosed serpent*, expelled from the nose or mouth. Sometimes the **IK'** sign attaches to these other visual metaphors for breath (ill. 2).

A unique combination of wind, flowers and jewels is the subject of a painted stucco relief from House B, Palenque (ill. 3). An open **IK'** symbol penetrating the wall sits next to a closed one. Both touch a stepped cleft representing the forehead of a personified mountain*. **IK'** signs appear on composite jewel-flowers within the forehead scrolls. This symbolic assemblage likely represents a mythic location conceived as a wind mountain.

The Classic Maya Wind God was a handsome youth sporting a woven headband with floral medallion and occasionally an **IK'** sign on his earplug (ill. 4). The Wind God personifies the number three, and presides over the month Mahk. The codical Wind God (God H) sometimes bears an **IK'** sign on his cheek. Variant duck-billed Wind and Water Gods, recalling the Aztec Wind God, Ehecatl, are also known among the Maya, occasionally portrayed with **IK'** and **POLAW** (*see* 56) signs labeling their bodies (ill. 5).

IK'

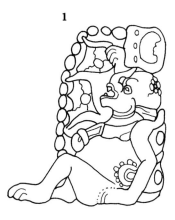

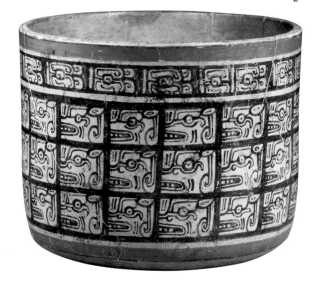

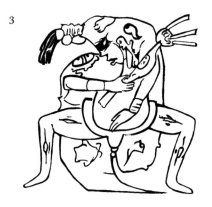

1 A full-figure variant of the Copan emblem glyph. Stela D, Copan. Late Classic.

2 Repeating bat heads. Painted vase. Late Classic.

3 An anthropomorphic bat *wahy* creature. Painted vase. Late Classic.

4 A bat with fiery breath. Chama-style painted vase. Late Classic.

5 A bat with extruded eyeball. Painted vase. Late Classic.

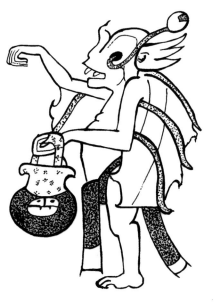

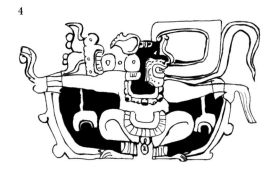

Ally of Underworld ghouls and purveyor of violent death, the bat was the most demonic animal in the Maya bestiary. This gruesome persona was probably not modeled after the blood lust of the vampire bat, but from bats' frenzied foraging behavior, darting about and letting out shrill squeals, something that can be unnerving to behold. A key aspect of this behavior is the way fruit bats (*Artibeus jamaicensis*) snip off fruit as they swoop through the air, a feat the Maya likened to decapitation. Though this interpretation of bat behavior may seem idiosyncratic, it was also held by the headhunting Asmat of Irian Jaya. To the Maya the bat was a decapitator. In the *Popol Vuh*, one of the Hero Twins* merely peers out of his hiding place only to have his head snipped off by the Death Bat.

A fanged animal head with ears, the hieroglyph for bat can be recognized by its erect leaf-like nose, seen as an instrument of decapitation, and in the *Popol Vuh*, a bat nose is described as a stone dagger. Indeed, the nose sometimes bears a reflection sign as though made of a hard, polished substance. As the bat is a denizen of caves, its head and body are sometimes marked with the glyph for darkness*, and in chromatic media bats are often painted black. Frequently sporting the dark cheek spot of mammals, the bat head is used widely in Maya writing. In addition to serving as a logograph for "bat," it is also a syllabograph for **tz'i** and the symbol of the month Suutz' or "bat." A distinct use of the bat sign in Maya writing is in the Copan emblem glyph, which features spectacular full-figure versions integrated with other glyphic elements, including stone* (ill. 1).

Occasionally, the bat head alone appears in pictorial compositions. A profusion of bat heads painted on a vase recalls bats' frenetic swarming behavior (ill. 2). However, in Maya art bats generally appear as full-length figures, usually with a bloated belly and exposed, always male, genitalia. Bats strike a characteristic frontal, squatting pose with their heads in profile and arms extended. This pose is occasionally assumed by human male figures apparently in a bat guise (*see* 59.1). One such figure, in ill. 3, is a *wahy* demon shrouded in cape-like bat wings. Bat wings were analogous to the capes and skirts of Underworld figures which bear the same array of death* symbols: crossed bones*, a human mandible, a shell-like device, the percentage sign, seen on the figure's legs in ill. 3, and the ever-present extruded eyeball with trailing optic nerve. Bats also wear eyeball-studded death collars or have their own eyeballs extruded (ills. 4, 5). As in ill. 4, they frequently emit mouth scrolls which merge their shrill squeal with a kind of fiery breath. One style of Classic Maya vase painting from the Chama region of Alta Verapaz, Guatemala, a land abundant in large caves, specialized in full-length bat portraits (ill. 4). The Maya even produced sculptures of bats, ranging from ceramic figurines to large versions in stone at Copan. Bat sculptures originally decorated the façade of the now-destroyed Structure 20, which has been compared to the House of Bats, a cave-like Underworld setting in the *Popol Vuh*.

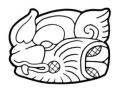

SUUTZ'

* DEATH 7
HERO TWINS 8
BONE 13
DARKNESS 58
STONE 70

4

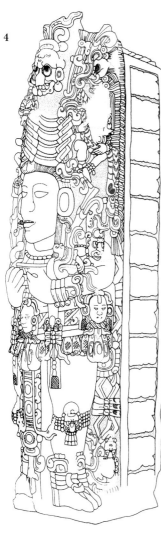

1

1 Tropical American giant centipede (*Scolopendra gigantea*).

2 A supernatural centipede. Painted vase. Late Classic.

3 Two lords dance in the guise of supernatural solar centipedes. Painted vase. Late Classic.

4 Waxaklajuun Ubaah K'awiil of Copan brandishes a double-headed centipede bar from which solar gods emerge. Copan Stela A. Late Classic.

2

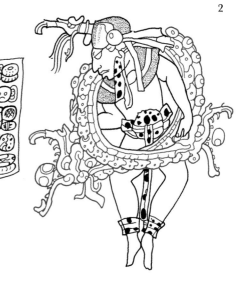

3

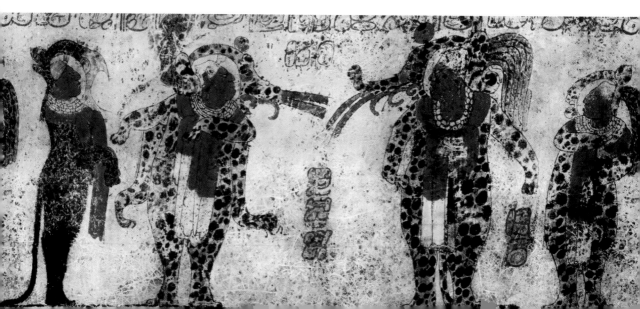

Chapaht is the Ch'orti' word for "centipede," and the **CHAPAHT** glyph is almost certainly a depiction of the tropical American giant centipede (*Scolopendra gigantea*) (ill. 1). Aggressive and carnivorous, this nocturnal arthropod can grow to some 30 centimeters in length and has been known to attack and consume animals much larger than itself, including rats, frogs, birds and even small snakes. It is in fact the largest and most poisonous centipede on earth, and before the advent of modern antitoxins was quite capable of killing even human beings.

While somewhat fanciful in outline, depictions of the centipede are motivated by a realistic assessment of the creature's truly strange appearance (ill. 2). The prominent fangs of glyphic and iconographic examples are surely suggested by the centipede's formidable maxillipeds (poison claws), which contain poison glands and strongly resemble fangs, while the animalistic eyes are perhaps somewhat stylized reflections of its ocelli (light sensing organs). In art, ethnozoological and artistic reinterpretation may play a role in the adoption of pitted contours typical of bone*. These are probably an attempt to capture the peculiar qualities of the creature's exoskeleton. Finally, seemingly outlandish depictions of two-headed centipedes (ills. 2, 4) are probably a reflection of its large final pair of legs. These strongly resemble a second set of antennae, thereby creating the effective illusion of a second head (ill. 1).

Like other aggressive and/or nocturnal animals, the centipede could assume the role of a *wahy*, an animate spell or curse sent by a sorcerer. The supernatural centipede depicted in ill. 2 was associated with the ruling house of Palenque. Its glyphic label terms it a Sak Baak Naah Chapaht, or "white bone carapace centipede," an evocative description of the creature's exoskeleton. In one scene from an unprovenanced vessel (ill. 3), Yajawte' K'inich of Motul de San José dances in the guise of another supernatural centipede: Huk Chapaht Tz'ikiin K'inich Ajaw (literally "seven centipede eagle sun god"). The centipede's popularity as an aggressive military symbol may in part explain why no fewer than five kings of Tonina were named after the centipede.

Notwithstanding its aggressive aspect, the centipede was also a symbol of transformation and rebirth. On the Palenque sarcophagus lid, K'inich Janaab Pakal I emerges as a juvenile deity from the very maw of the centipede (*see* 21.3). On Copan Stela A, king Waxaklajuun Ubaah K'awiil (r. AD 695–738) brandishes a double-headed centipede bar from which he conjures images of the Sun God, K'inich Ajaw (ill. 4). Elsewhere, on Yaxchilan Lintel 25, Lady K'abal Xook summons a great two-headed centipede and is herself transformed into a warrior-goddess by the creature (*see* 46.2). Such powerful symbolism no doubt owed much to the creature's underground habitat and associations with the ancestral dead and perhaps explains how the centipede's maw became the inspiration for the cenote* glyph. Similarly, the frequent solar associations of centipedes may perhaps be explained by the concept of the sun sinking into the Underworld (*see* 58.5 and 62.3).

CHAPAHT

* BONE 13

CENOTE 53

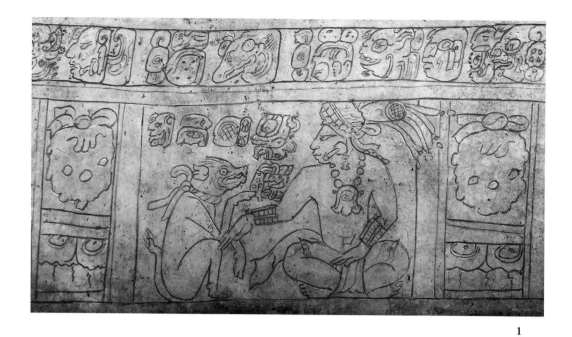

1

1 A young god receives a coati in his palace. Incised vessel. Late Classic.

2 A supernatural coati holds an offering plate. Codex-style vessel. Late Classic.

3 A supernatural coati sports death symbolism. Painted vase. Late Classic.

3

2

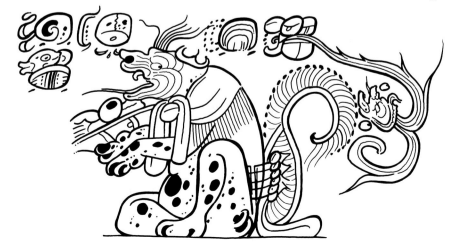

The white-nosed coati (*Nasua narica*) is an omnivorous mammal indigenous to Central America. Curious and playful, the coati somewhat resembles the raccoon, to which it is related, but has a longer snout and tail. The **TZ'UTZ'IH** glyph is clearly a portrait of the coati, whose characteristic trilobate ear helps to distinguish it from portraits of dogs* and jaguars*. Glyphs associated with the coati in such scenes often spell its name out phonetically, usually as **tz'u-tz'i-(hi)**.

Although the Maya domesticated only the dog and the turkey*, they seem to have reared a number of wild animals as pets: including macaws*, monkeys*, gophers* and coatis. Foremost among these was the coati, which seems to have attained a prominence in Maya homes perhaps unequaled by any other animal. As Diego de Landa reported in the sixteenth century:

"There is an animal which they call coati, wonderfully active, as large as a small dog, with a snout like a sucking pig. The Indian women raise them and they leave nothing which they do not root over and turn upside down and it is an incredible thing how wonderfully fond they are of playing...there are many of them and they always go in herds in a row, one after the other, with their snouts thrust in each other's tails, and they destroy to a great extent the field of maize into which they enter."

In art, however, little of this playful and mischievous side of the coati is visible. Rather, the animal's role seems to have been moral in nature. In one mythological scene from an incised vessel, for instance, a coati appears before a youthful god in an indoor setting (ill. 1). The walls are decorated with *Spondylus* shell* and darkness* signs, marking the scene as one of tribute. Sporting a twisted cloth scarf usually symbolic of sacrifice, the coati sits up on his haunches and gestures towards the deity, who pats him reassuringly as one might a dog. Inscribed glyphs above and between the two figures record their conversation: "there isn't much tribute, said the coati" (*mih oon patan, yaljiiy tz'utz'ih*). While the scene is difficult to fathom, it is a recurrent one, and the coati brings the disappointing news to other masters elsewhere, including even the great god Itzamnaaj*. Could it be that the poor coati is nothing but a scapegoat sent in the place of its master to break the damning news to his overlord? If so, it is possible that such scenes represent the merest fragments of a myth whose purpose was to inform nobles in Classic society about their proper duties and obligations.

Other, more clearly supernatural coatis appear as animate spells or curses (*wahy*) in scenes from codex-style ceramics (ills. 2, 3; *see* 7). Little of naturalism characterizes these depictions, and the creatures sport sacrificial scarves or death*-eye collars. Some are marked with jaguar spots (ill. 2), and their tails* emit the large flames referenced by the associated glyphs reading "fire-tailed coati" (*k'ahk' neh tz'utz'ih*).

TZ'UTZ'IH

1

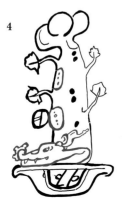

2

3

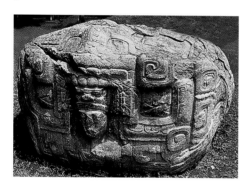

1 Winged crocodile. Side of Altar T, Copan. Late Classic.

2 Ceramic crocodiles found in a cache at Santa Rita, 16.5 cm long. Late Postclassic.

3 K'ahk' Tiliw Chan Yopaat emerges from the mouth of a crocodilian Cosmic Monster. Zoomorph B, Quirigua. Late Classic.

4 A crocodile tree in a sacrificial bowl. Painted vase. Late Classic.

5 The loincloth of Waxaklajuun Ubaah K'awiil in the form of a crocodile's head and feet. Stela C, Copan. Late Classic.

4

5

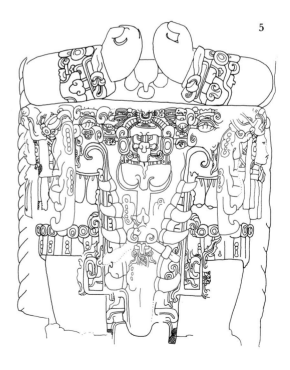

The hieroglyph for crocodile (*Crocodylus acutus*) is a zoomorphic head with toothy snout, usually curled snugly in the glyph block, and eye marked by crossed bands. The head displays ovals with dots, a common marker of rough texture (ills. 1, 4; *see* 84.2, 3; 94.3); here they refer to the tough scutes covering the animal's body. An anthropomorphic crocodile on the side of Altar T, Copan shows this basic array of crocodilian diagnostics (ill. 1). Royalty identified themselves with the crocodile, and one of the most famous names in Classic Maya history is the fourth-century Tikal ruler Yax Nuun Ahiin I (Blue-Green Knot Crocodile), imagined as a world axis since both *yax* – the color term for blue-green* – and the crocodile allude to the cosmic center.

In Mesoamerican creation myths the earth is said to have arisen out of a dark primordial sea. The crocodile made an ideal analog of the primordial earth since it floats dramatically to the surface reminiscent of a nascent landmass bobbing up from the murky depths. Even the creature's ridged back was thought by the Aztecs to resemble the earth's peaks and valleys. The Maya also envisioned the earth* as a crocodile, and the name of a god called Itzam Kab Ahiin, or Itzam Earth Crocodile, was recorded in early Colonial Yucatan. In the Late Postclassic period, four ceramic crocodiles, recalling this entity, were placed in a cache at Santa Rita, Belize (ill. 2).

The crocodile figured in a number of cosmological paradigms. The most enigmatic and complex is the so-called Cosmic Monster, a composite being modeled on a crocodile's body but fused with other animals, like the deer* and serpent*, and a host of symbols. A massive sandstone Cosmic Monster, Zoomorph B, Quirigua, displays many crocodilian features: belly scales, scutes, clawed feet, crossed eye bands and ovals with circles rimming the eyes (ill. 3). Framed within the beast's arching jaw, as though commanding center stage, is the Quirigua king K'ahk' Tiliw Chan Yopaat.

The crocodile was a potent symbol of cosmic order because it stood for both the earth's surface when in a horizontal position and, in a vertical position, the axis of the universe, much like a World Tree. Indeed, Maya art sometimes merged the crocodile with a tree*. In ill. 4 a serrated shell, corresponding to the **YAX** sign associated with crocodiles, rests on the snout of a crocodile-tree; all of these details reinforce the notion of the world center. On the east face of Copan Stela C, the ruler, Waxaklajuun Ubaah K'awiil, wears a unique loincloth transmogrified into the flattened head and dangling feet of a crocodile; present are the telltale oval body markings and rows of curved teeth (ill. 5). This vertically positioned reptile is a variant of the crocodile-tree, seen in ill. 4, and makes the ruler himself appear to be a stalwart axis of the earth. Maya kings used these kinds of pictorial allusions to make their own bodies seem part of cosmic order, thus claiming divine justification for their political legitimacy. The crocodile played a prominent role in the cosmic models exploited in royal art.

AHIIN

* BLUE-GREEN 47

 EARTH 54

 TREE 71

 DEER 78

 SERPENT 86

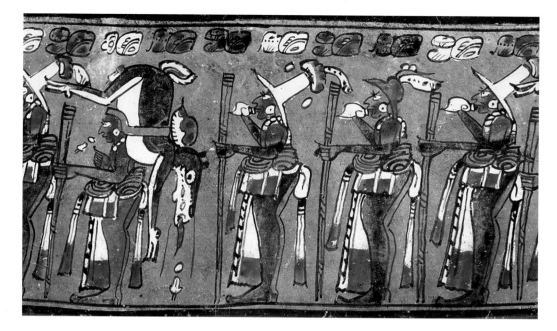

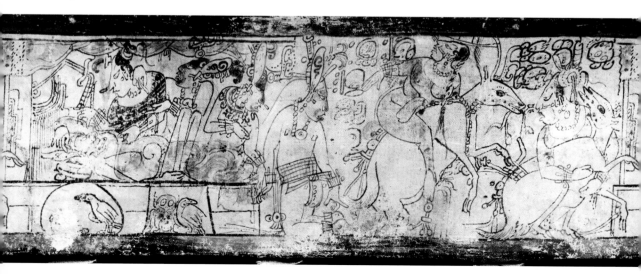

1 Hunting scene. Painted vase. Late Classic.

2 The Deer God, Huk Sip. Codex-style vessel. Late Classic.

3 Huk Sip and one of his charges. Dresden Codex, page 13d. Late Postclassic.

4 Mythological scene. Codex-style vessel. Late Classic.

Although several distinct species of deer are native to the Maya Lowlands, it is the white-tailed deer (*Odocoileus virginianus*) that is most frequently depicted in art. Easily recognized by its characteristic white tail (ills. 1, 4), which it lifts when alarmed, and also by the large branching antlers sported by stags late in the year (ill. 4; *see* 100.3), the white-tailed deer was a favorite subject of Maya artists. In the hieroglyphic script, the **CHIJ** sign is clearly a portrait of this animal and typically sports the vestigial antlers of early spring, as well as long ears with a spiral motif representing the animal's musky odor, common to depictions of deer and peccaries in Maya art (ills. 2, 4; *see* 8.2; 30.2; 52.2; 81.4; 82.1; 100.3). The dark cheek spot and dotted muzzle, both characteristic of mammals, are equally frequent traits.

The white-tailed deer was the game animal *par excellence*, and numerous scenes show huntsmen burdened with deer (ill. 1). That hunters may not have had far to roam for deer is suggested by numerous depictions of this creature ruminating on maize* foliage (ill. 4; *see* 82.1). Modern farmers know to watch for deer nibbling the tender young shoots at the edges of their fields, and we can probably assume that ancient agriculturalists were equally aware of this. Deer were economically important animals, and venison tamales*, bound deer haunches (*see* 94.4), and even deer antlers figure frequently as tribute and sacrificial offerings in Maya art. Indeed, the hoof of a deer (*may*) was in fact the default glyphic label for tobacco snuff (likewise *may*) and other sacred offerings (*mayij*) described in hieroglyphic texts.

Yet it is in the realm of mythology that deer receive their most compelling treatment. Thus, the Deer God, Huk Sip, is himself depicted as an old man with the characteristics of deer, including large antlers and deer ears (ills. 2–4). It was this supernatural game warden that humans had to appease in order to hunt deer or convert forest into farmland. Frequently depicted blowing a conch shell trumpet* to summon his charges (ill. 2), he also appears to take responsibility for the burning of forest to make agricultural land (*see* 66.4). One particularly complex series of codex-style vessels provides snapshots of a poorly-understood myth related to this god (ill. 4). In these scenes, both deer and the anthropomorphic deer spirits known as *sips* (all marked with the same deer ears and antlers as Huk Sip himself) congregate around the bed of their lord, who appears to be ill or dying. The central event, at least according to associated hieroglyphs, seems to be the "carrying of the wife of Huk Sip" by one of the deer, which wears a large conch shell trumpet around its neck. Intriguingly, this woman sports none of the deer-like trappings of the other figures, and one is left to suppose that she represents a goddess of a different order who has perhaps married into the Deer God's clan. Is she riding off to seek assistance for her husband? Such scenes provide tantalizing fragments of mythologies that would otherwise be entirely lost to us.

CHIJ

* TRUMPET 31
 MAIZE 98
 TAMALE 100

 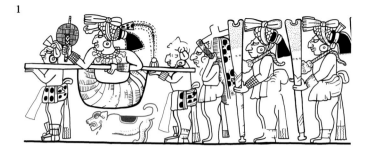

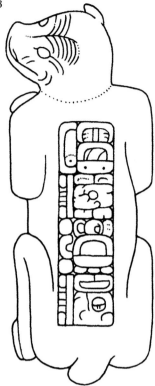

1 Processional scene on the Ratinlixul Vase. Late Classic.

2 An anthropomorphic dog examines tribute offerings. Painted vase. Late Classic.

3 Sculpture of a dog as tomb-guardian. Monument 89, Tonina. Late Classic.

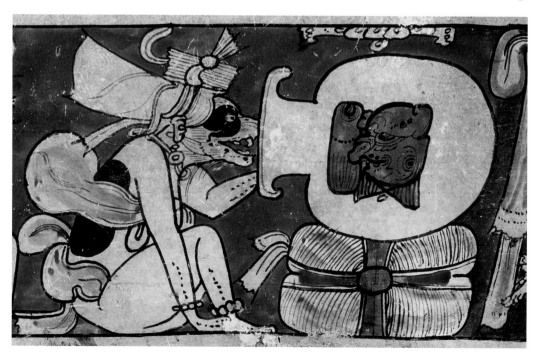

While *tz'i* is the more widespread word for "dog" in Mayan languages, there is some evidence that the Classic Maya had recourse to the synonymous term *ook*. In fact, the latter was the word of choice for the tenth day of the Maya calendar, a day named "dog" throughout Mesoamerica. Even more importantly, phonetic complements and substitutions show that both readings of the dog sign were viable in Classic times. Whether read **TZ'I'** or **OOK**, however, the sign clearly depicts a dog, and its conical teeth, dark eye patch, and mammalian cheek spot are reflected in numerous depictions of the dog in art.

The native Mesoamerican dog was one of only two domesticated animals kept by the Maya, the other being the turkey*, and this accounts to some extent for the prominence of the dog in art. There were actually several breeds of dogs and to judge from ethnographic accounts, each was put to slightly different use. One strain was both hairless and barkless, and its lot in life was to be fattened on corn and then either eaten or sacrificed. Such a dog is probably depicted in a mythological scene from a codex-style vessel, where it looks on as the baby* jaguar* is sacrificed, little realizing that it is probably next on the menu (*see* 1.3). In the *Popol Vuh*, the Hero Twins* sacrificed just such a dog before bringing it back to life to demonstrate their powers to the Underworld gods.

Another breed of dog was larger and stronger, and was both a trusted friend and a companion in cross-country travel. On the Ratinlixul Vase (ill. 1), at the head of a retinue including trumpeters and a throne-bearer, a lord is borne in a litter* as his canine companion stretches himself realistically below (*see* 31.3–4; 34.2). That dogs may also have guarded storehouses and households is suggested by one scene from a Late Classic polychrome vase (ill. 2). Dressed in court fineries, including jade jewelry and the cylindrical headdress of scribes, this anthropomorphic dog inspects a tribute offering comprised of a large urn and cloth bundle.

So close was the connection between men and dogs that it seems to have survived even death. A prevalent belief in ancient Mesoamerica was that a faithful dog would continue to serve his master in the afterlife, guiding him past obstacles in his path to Flower Mountain, the Maya equivalent of the paradisiacal Elysian Fields. That this belief has a long history in Mesoamerica is indicated by mixed burials of dogs and humans as early as the Late Preclassic period (*c.* 400 BC) and extending, in the Maya area at least, until Postconquest times. One Late Classic sandstone sculpture from Tonina probably depicts a watchful dog as guardian of his master's tomb (ill. 3). Originally set on top of Burial 1 of Structure F4-6, the sculpture bears four glyph blocks which relate the tomb guardian to its owner, identifying it simply as *u tz'i'* or "his dog."

* BABY 1
HERO TWINS 8
LITTER 35
JAGUAR 83
TURKEY 94

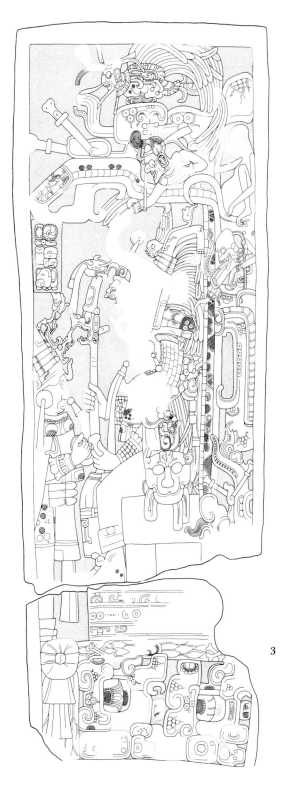

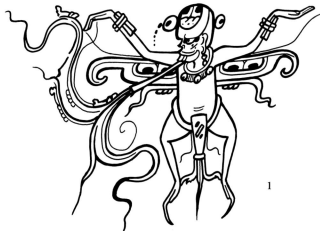

1 A firefly with a large burning cigar. Codex-style vessel. Late Classic.

2 A firefly impersonator. Painted vase. Late Classic.

3 K'inich Yo'nal Ahk II's palanquin. Stela 5, Piedras Negras. Late Classic.

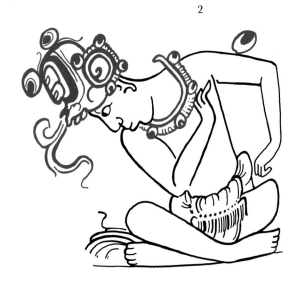

Although rare and still of somewhat uncertain reading, the **KUHKAY** glyph is undoubtedly a depiction of the firefly or lightning bug (family *Lampyridae*) so well-known from Maya iconography. Thus, an **AK'AB** "darkness"* sign appears prominently on its cranial plate, labeling the firefly as a nocturnal or subterranean creature, like numerous other insects, as well as some mammals like the jaguar*, bat* and gopher*. In addition to providing an interesting zoological classification, the darkness label helps to set the **KUHKAY** sign apart from the somewhat similar signs for death* and skull*. Nevertheless, the firefly shares other characteristics with these signs, such as disembodied eyes, present in practically all examples, and the percentage sign frequently appearing with Death Gods (ill. 1). These associations are present in the depictions of other insects in Maya art (such as the ant, grasshopper and mosquito), and suggest that the Maya saw a kinship between certain hard, shiny insect carapaces and bones*.

The firefly makes its best-known appearance on the Metropolitan Vase (*see* 1.3), where it flies above a grim scene of infant sacrifice. The bulbous lower portion of the firefly is actually a fair depiction of the bioluminescent abdominal lanterns of many firefly species, and a swarm of fireflies with flaming lanterns are depicted in one vase scene (*see* 58.2). As with the firefly in ill. 1, these also sport **AK'AB** markings on wings and head. Where the Metropolitan Vase firefly holds out a burning torch* to shed light on the scene below, the other lightning bugs smoke tubular cigars instead (ill. 1; *see* 58.2). These scenes have long been viewed as allusions to the incident in the *Popol Vuh* in which the Hero Twins* attach fireflies to the unlit ends of their cigars in the House of Darkness, in order to outwit the Underworld lords. While a straightforward association between fireflies and the Hero Twins has yet to be found in Maya art, there nevertheless seems every reason to associate fireflies with the nocturnal Underworld. There is even some indication from Maya writing that firefly deities were worshipped at sites like Tikal and Dos Pilas, and a firefly impersonator appears on one Late Classic polychrome vessel (ill. 2). Note the clear darkness sign on the headdress, the disembodied eyes, and the swirling fire* sign emanating from the skeletal nose: all traits clearly present on the **KUHKAY** sign.

Piedras Negras Stela 5 provides one of the few appearances of an insect on a sculpted monument (ill. 3). Erected in AD 716 by K'inich Yo'nal Ahk II (r. AD 687–729), this monument shows the king and his loyal courtier, K'an Mo' Te'. The king grasps a K'awiil* scepter and sits on a massive war litter* carved to resemble a mountain* cave*. A firefly with lit cigar emerges from one of the cave openings behind him, as do a monkey* and the Jaguar God of the Underworld (*see* 32). As on the ceramic vessels, the presence of the firefly signals the dark, subterranean environment of the scene.

80

FIREFLY

KUHKAY?

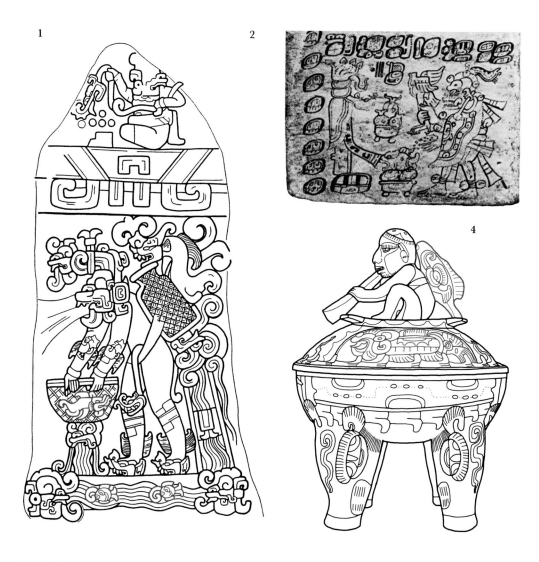

1 Chahk fishing. Stela1, Izapa. Late Preclassic.

2 Fish sacrifice. Dresden Codex, page 27. Late Postclassic.

3 Three Rain Gods fishing from a canoe. MT 51-B, Tikal. Late Classic.

4 The Dallas Tetrapod. Early Classic.

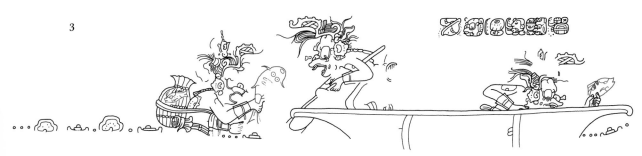

The Maya had a deep knowledge of riverine and coastal marine fishes, so it should come as little surprise that the **KAY** glyph was based on an edible, freshwater fish species with which they were familiar. Thus, the creature sports the distinctive indented tail and ray-shaped lateral fins of the Cichlids, a large family of fish inhabiting the lakes and lower river valleys of Central America, particularly the Usumacinta River drainage. One member of this family, the redhead cichlid (*Vieja synspila*), even shares the dark body spots characteristic of the **KAY** glyph.

Fish are a recurrent symbol in Maya art, though it must be said that their presence in a scene often does little more than qualify the aquatic location of action. Thus, in one Late Classic scene of the spearing of a great shark, a fish swimming through the legs of one of the protagonists probably indicates that the action takes place underwater (*see* 87.3), just as the fish swimming below Chahk's* feet on Izapa Stela 1 likely sets the scene at sea (ill. 1).

One pervasive motif is that of the "fish-nibbling-upon-water-lily-flowers." While this occasionally identifies impersonators of the Water Lily Serpent (compare 56.3 with 72.2–3), most occurrences are more general in nature, probably reflecting little more than an aquatic association (*see* 72.4, 69.5 and 71.2). The same is probably true of the widespread "water-bird-swallowing-fish" motif (*see* 54.4), albeit with the same caveat: as a headdress, this motif usually represents the deity GI (*see* 4.1).

In the Dresden Codex (ill. 2), a fish is offered up for sacrifice, reminding us that fish comprised an important component of the Classic Maya diet. Yet fishing also served as an important religious metaphor. On the aforementioned Izapa Stela 1 (ill. 1), fishing is likened to an act of rainmaking as clouds and water cascade from Chahk's fishing net and creel. On two related scenes from the incised bones of Tikal Burial 116 (ill. 3; *see* 71.1), several directional Rain* Gods fish from their canoes*. While one of the deities paddles the canoe, two wade waist-deep in the spray and surf (*see* 56 and 67), plucking fish from the waters and storing them in a creel fastened to their backs (ill. 3). Although superficially a straightforward fishing scene, these activities may represent folk explanations for Chahk's role in rainmaking activities.

On the Dallas Tetrapod (ill. 4), the Sun* God (so identified by a **K'IN** sign on his head) paddles westward across the sea, his watery location clearly indicated by the fish on his back, two larger fish paralleling his course, and the characteristic waves and swirls of ocean* below him. The vessel is supported by four peccaries rooting in the earth with their long snouts, their foreheads marked by spiral volutes indicating their strong musk. Their eyelids carry darkness* markings, suggesting that we glimpse a nocturnal (and perhaps even subaquatic) scene prior to the Sun God's cresting of the eastern horizon.

KAY

* CHAHK 6
CANOE 50
OCEAN 56
DARKNESS 58
SUN 62
RAIN 67

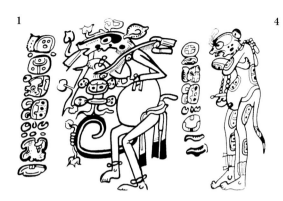

1 A supernatural deer and gopher. Painted vase. Late Classic.

2 A gopher marked as a nocturnal being. Stucco façade, Tonina. Late Classic.

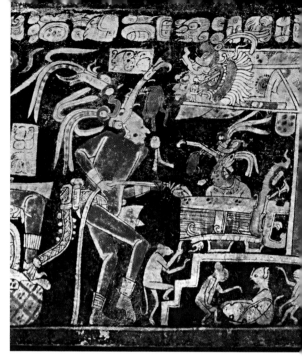

3 Three gophers feast on maize foliation. Hieroglyphic Stairway, Copan. Late Classic.

4 Rodents and other mischievous animals beneath the floorboards of a temple. Painted vase. Late Classic.

5 A gopher held by bare-breasted women. Painted vase. Late Classic.

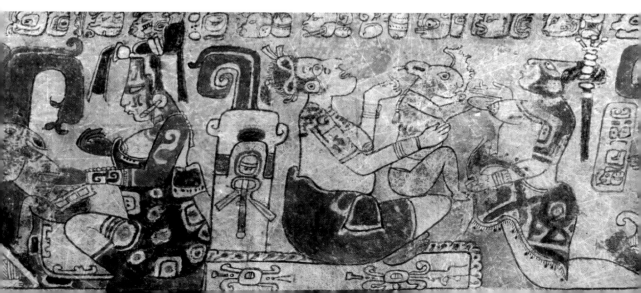

Baah is the word for "pocket gopher" (*Orthogeomys spp.*) in many Mayan languages, and the **BAAH** glyph is a relatively straightforward depiction of this nocturnal short-tailed, burrowing mammal. While early forms of the glyph tend to emphasize the creature's long front teeth, a trait still seen in some later iconography (ills. 1, 2), these are effectively hidden in later forms by long fronds of leafy vegetation upon which the gopher nibbles, a trait also referenced in art (ills. 3, 5). An important Late Classic innovation is the **K'AN** (yellow*) infix on the creature's cheek, no doubt employed to reference the color of the pocket gopher's hide: invariably tan to light yellow-brown. Finally, in Late Postclassic times, the creature was recategorized alongside various nocturnal and/or subterranean animals such as the jaguar*, bat* and firefly*, and therefore came to be labeled with **AK'AB** (darkness*) markings in the codices.

The pocket gopher was probably regarded as the quintessential pest of gardens and grain stores, a role it retains to this day. The hybrid Yellow Gopher Rat (*K'an Baah Ch'o'*) – an animate spell or curse (*wahy*) sent by a sorcerer – is occasionally depicted in scenes which suggest some kinship to the mischievous, maize-thieving rat of the *Popol Vuh*. On one vessel, the same creature dances alongside a vegetation-munching deer* (ill. 1). In a large stucco frieze from Tonina (ill. 2), the creature carries an object which has been likened to the ballgame ball retrieved for the Hero Twins* by a rat in the *Popol Vuh*. Note that both "gopher rats" partake of the **AK'AB** markings characteristic of nocturnal creatures. The conception of the gopher as a pest may also be reflected on Copan's Hieroglyphic Stairway, where a number of pocket gophers are depicted consuming large amounts of maize* vegetation (ill. 3). More generally, rodents and other pesky animals are depicted prowling about beneath the floorboards of houses and temples (ill. 4), where they were no doubt seen as being up to all sorts of mischief.

Other scenes suggest that pocket gophers may have been kept as pets – like coatis* and dogs*. Thus, on polychrome ceramics, the gopher is frequently cradled, occasionally even suckled, by bare-breasted women (ill. 5), a correlate of tameness discussed by Bishop Landa in the sixteenth century. In another vessel scene, the sky god Itzamnaaj* converses with a gopher familiar in his palace.

In writing, the prevalence and importance of the **BAAH** glyph is due primarily to homophony. In addition to "gopher," *baah* also means "head" and "top." Thus, the name of Waxaklajuun Ubaah K'awiil, an important eighth-century king of Copan, meant "Eighteen are the Heads of K'awiil*" and *not* "18 Gopher" (much less "18 Rabbit"). While these and other terms in the script were regularly written with the **BAAH** glyph, it is important to realize that it was here used for its sound value alone and carried none of its semantic associations.

BAAH

1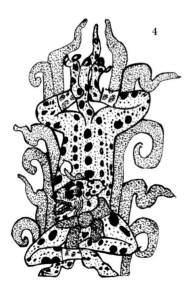

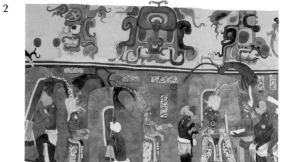

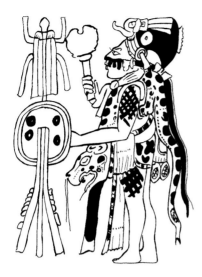

1 A jaguar skin draped over a warrior in a ritual procession. Painted vase. Late Classic.

2 Jaguar pelts in a ceremonial scene. Room 1 mural, Bonampak. Late Classic.

3 A double-headed jaguar throne. Uxmal. Terminal Classic.

4 The Fire Jaguar *wahy* character, K'ahk' Hix. Painted vase. Late Classic.

5 The Jaguar God of the Underworld flanked by star signs. Jaguar Stairway, Copan. Late Classic.

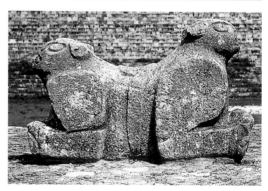

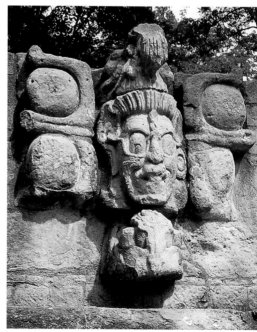

No creature roaming the Central American tropical forest was more respected than the jaguar (*Panthera onca*), a hefty beast often exceeding 200 pounds (90 kg). That the word for jaguar, *bahlam*, occurs in the names of more Maya kings than any other animal is not surprising given that the jaguar was a paragon of cunning and brute force, metaphorically equated with military valor. The jaguar logograph is a feline head with spotted pelage (including the mammalian cheek spot), large incisors and lobed ear. In full-length jaguar depictions, the roseate pattern of the pelage is sometimes carefully rendered but more typically is reduced to three blackened circles. The ear was a distinctive trait; effigy jaguar ears were fashioned from pottery, and the ear functioned as an independent sign. Anthropomorphic gods who wear jaguar ears include the Hero Twin* Yax Baluun, the Jaguar God of the Underworld and the Jaguar Paddler God*.

The jaguar's ferocity made it an ideal insignia of warriors who wore jaguar parts, whether head, skin, tail* or paws, like a badge of honor (ill. 1). "To spread out jaguar skin" was an expression for war, and implements of war, such as shields* and spears, were festooned with strips of pelt. A staple presence at royal courts, jaguar skin was a conspicuous sign of wealth, likely obtained as tribute. A detail of the Bonampak murals illustrates this: jaguar skin adorns the kilts and sandals of dancers and covers a box, while several pelts are proffered by servants at left (ill. 2). In addition to the jaguar skin cushion throne*, kings sat on jaguar effigy thrones. Single- and double-headed stone jaguar thrones are found at such Northern Lowland Maya sites as Uxmal and Chichen Itza (ill. 3; *see* 28.4). Ritual performers donned jaguar body parts, such as tails, ears and paws, as well as full-length jaguar skin suits (*see* 75.3). Jaguar skin embellished prized objects such as books* and offering bowls*.

The jaguar hunts at dusk, and its eyes, golden orbs adapted for low light, glow eerily in the dark. Because of this and the fact that jaguars seek refuge in cave entrances, Mesoamericans linked the jaguar with sorcery and nocturnal phenomena. The jaguar's association with night* is manifested in the **AK'AB** sign often infixed in the jaguar logograph. Strange jaguar beings are among the most common *wahy* ogres, such as K'ahk' Hix, a jaguar emitting flames (ill. 4).

The jaguar was associated with both water* and fire*. Jaguars often hunt near water and are adept swimmers. The Water Lily Jaguar embodied this aqueous aspect (*see* 72.4). The jaguar's fire aspect is manifested in the Jaguar God of the Underworld, who combines the face of the Sun* God, jaguar ears, a twisted device, or cruller, above the nose, and a shell beard. The visage of this being decorated ceramic braziers used in burning rituals. Platform terraces display sculpted versions of the Jaguar God of the Underworld which are thought to mark stations for fire rituals. The example in ill. 5, from Copan's Jaguar Stairway, has jaguar ears and star* signs flanking his head. The fire aspect of the jaguar was linked to warfare, and the face of the Jaguar God of the Underworld is a common motif on small round shields (*see* 29.5).

83

JAGUAR

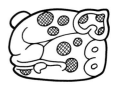

BAHLAM

1

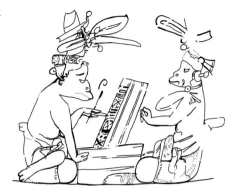

3

1 Howler monkey scribes. Painted vase. Late Classic.

2 Scratching spider monkey. Painted vase. Late Classic.

2

3 A spider monkey with a chocolate pod. Painted vase. Late Classic.

4 A spider monkey copulates with a woman on a painted vase from Uaxactun, Guatemala. Late Classic.

4

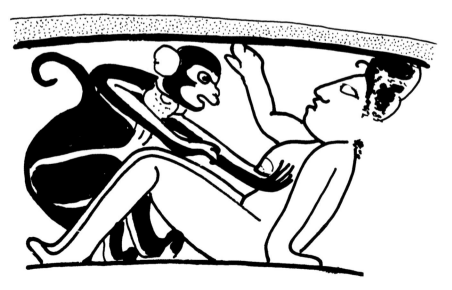

Two important genera of monkeys still make their home in the tropical lowland forests of the Maya area: howler monkeys (*Allouatta palliata*) and spider monkeys (*Ateles geoffroyi*). The Maya employed various terms for these monkeys (syllabic **ba-tz'u** or *baatz'* for howlers, and **ma-xi** or *maax* for spiders), but a logographic form is known only for the latter. The **MAAX** sign clearly shows the 3-shaped pattern of intersecting light and dark facial fur often seen in portraits of monkeys (ills. 2, 4), a dark cheek spot characteristic of mammals (ill. 2; *see* 74; 78–79; 83), and a common dotted-oval marker of rough, wrinkly skin (ills. 2, 3; *see* 77.4; 94.3). Interestingly, while both monkeys were equipped with powerful prehensile tails*, Maya artists seem to have associated these organs mostly with the spider monkey (ills. 2–4; *see* 94.3).

Howler monkeys are somewhat lethargic, sleeping some fifteen hours per day, and rarely ranging more than a quarter of a mile daily (400 meters). Their deafening roar, produced by vibration of the hyoid bone in their larynx, is largely directed to warning other groups of their movements so that direct confrontation might be avoided. Maya artists associated the powerful howlers with scribes and artisans, in which guise they most commonly appear in art (ill. 1).

Spider monkeys on the other hand are active and agile and have a well-deserved reputation as mischief-makers. They have been known to hurl sticks and stones (and more unmentionable substances) at passersby and occasionally harass and attack even the somewhat larger howlers. This playful mischievousness of the spider monkey was a favorite theme of Maya painters, and monkeys are occasionally depicted scratching themselves (ill. 2), dancing (*see* 22.2) and enjoying fruits and cacao* pods stolen from kitchen gardens (ill. 3).

It is perhaps for these reasons that monkeys were so frequently associated with clowns* in Maya art, and the reputation of the monkey as a humorous entertainer is widespread in Mesoamerica. But such abrogation of social norms had a serious side as well, and monkeys were widely associated with drunkenness, licentiousness and sexual transgression and are frequently depicted exposing their genitalia (ill. 3), and even participating in interspecies copulation (ill. 4). Such scenes reflect Maya concerns with explaining the obvious similarities between monkeys and humans: observations which apparently centered on the role of the monkey as a failed human, with concomitant lessons to share with humanity. Such a role is evident in the *Popol Vuh*, where the gods are said to have punished the inattentive inhabitants of a previous creation by turning them into monkeys. Similarly, the theme of the modern Chamula Tzotzil *Carnaval* is also world destruction, where actors dressed as monkeys enact the violent *Pasión* (the killing of the solar-identified Christ). As with clowns, the ritual buffoonery and libidinous excesses of monkeys evoked laughter, but also served to highlight inappropriate behavior by linking it to the world of animals and to the punishments of the gods.

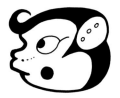

MAAX

* CLOWN 2
 TAIL 88
 CACAO 95

1

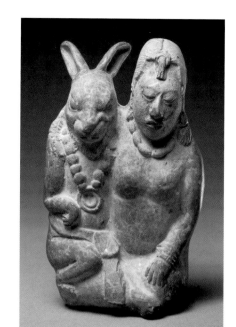

2

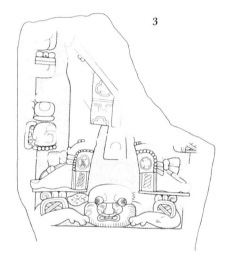

3

1 Water lily ear markings of a rabbit seen in frontal view. Painted vase. Late Classic.

2 Moon Goddess and rabbit. Jaina-style figurine. Late Classic.

3 A rabbit toponym trodden underfoot by a ruler. Stela 40, Naranjo. Late Classic.

4 A rabbit with the Sun God and God L. Painted vase. Late Classic.

4

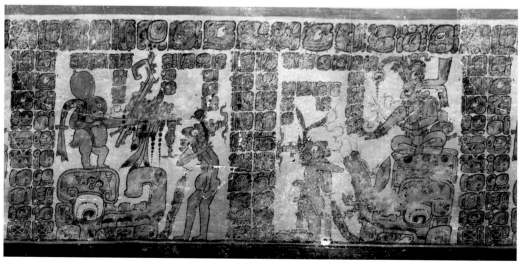

Although occasionally confused with the logograph for gopher*, the rabbit (*Sylvilagus spp.*) has a distinct whisker-like ruff, dotted fore-muzzle, droopy eye and long ear bearing an X draped atop the head as required by the shape of the cartouche. The X is actually part of a net pattern that appears on water lily pads and turtle* carapaces and refers to a pool* of water. The full pattern is seen on frontal views of rabbit ears (ill. 1). Why a rabbit ear would allude to water lies in the rabbit's relationship with the moon*. Like the ancient Chinese, Mesoamericans visualized dark areas on the full moon as a profile rabbit. We know from Aztec lore that the lunar rabbit was thought of as a rascal, prone to drunkenness and lewdness, brash behavior also associated with lunar deities. The rabbit's penchant for bacchanalian revelry is less blatant in Maya culture, although a rabbit is sometimes depicted hugging, or even groping, the Moon Goddess, his lovely companion (ill. 2). The home of the Moon Goddess and the rabbit was the moon, conceived as an Underworld, wet environment, much like a cave* or cenote*. Mythically inspired, this aquatic habitat accounts for the water lily pattern in the rabbit's ear. In Maya art, symbols placed on animal ears comment on their assigned domains, and the rabbit's was the wet lunar cave. Drawing a distinction between the rabbit ear and deer* ear was also necessary because their ears were used as independent symbols and were quite similar in appearance. On a practical level then, ear markings helped distinguish the two types of long ears while providing clues about each creature's personality. The ear markings also drew certain parallels between the rabbit and deer, which, besides being long-eared game animals, were linked in Maya lore.

Maya kings generally did not adopt rabbits as alter egos, perhaps because they, too, viewed them with some degree of circumspection. Nor are rabbits found among the frightening animal *wahy* creatures depicted on vases. Moreover, only rarely are figures garbed in rabbit costume (*see* 22.3). However, places were named after rabbits. One such location is Rabbit Stone, *t'uhl tuun*, associated with the site of La Mar in the Western Lowlands. A rabbit cradling the Naranjo emblem glyph in each arm appears in the basal register of Naranjo Stela 40 (ill. 3). Trampled underfoot by the king, the disconsolate rabbit stands for some unidentified place conquered by Naranjo.

More than just the Moon Goddess's playmate, the rabbit was the archetypal companion and assistant of the gods. On the Princeton Vase, for instance, a rabbit appears in the unique guise of scribe of God L (*see* 41.3 and 92.2). On yet another vase, acting at the behest of the Sun* God, a rabbit, also pictured behind the Sun God's leg, grasps the insignia of a stripped and humiliated God L (ill. 4), one episode in a mythic narrative involving God L's downfall. While serving the gods, the rabbit's loyalties are fickle and reveal his unpredictable nature. Most likely, the rabbit was a trickster among the Maya, a not uncommon role for this wily little creature.

T'UHL

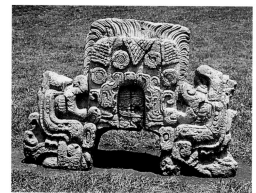

1

2

3

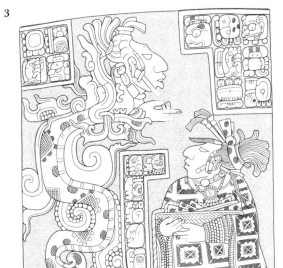

4

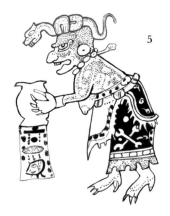

5

1 An arching two-headed feathered serpent. Altar G3, Copan. Late Classic.

2 Serpent column. Upper Temple of the Jaguar, Chichen Itza. Terminal Classic.

3 A serpent serves as a conduit of an invoked spirit. Lintel 15, Yaxchilan. Late Classic.

4 A serpent emphasizes the demonic character of a *wahy*. Painted vase. Late Classic.

5 Creator goddess and midwife Chak Chel wears a serpent head tie. Madrid Codex, page 30. Late Postclassic.

.

The hieroglyph for serpent is a zoomorphic head with blunt muzzle, rounded supraorbital plate, scales on the lower jaw and fangs. Some of these traits can be omitted, except the diagnostic fangs. The species of serpent is non-specific; yet most full-length serpents are either boa constrictors or a venomous snake, such as the rattlesnake or fer de lance. For a variety of reasons – linguistic, morphological and biological – the serpent was a treasure trove of metaphorical allusion in Maya thought, starting with the fact that the word for serpent is similar to that for sky*. The serpent's sinuous form evoked all manner of things: ropes*, penises*, lightning, clouds* and cosmic paths. Its dangerous behavior related serpents to the awesome but potentially deadly forces of nature. Conversely, regenerative behaviors, such as molting, made the serpent a fertility symbol.

Throughout ancient Mesoamerica serpents had sky associations and were employed in models of celestial structure and mechanics. Arched like a sky-band frame (ill. 1), the creature's living body was proof of the celestial dome's vital durability. Other celestial phenomena were conceived as a serpent: the ecliptic, a constellation and lightning, Chahk's* ophidian axe (*see* 6.2).

The serpent was identified with various sky-dwelling creatures, such as the Ch'orti' celestial rain beast *chijchan* "deer*-serpent," an anomalous creature echoed in depictions of serpents with antlers from the Classic period. While the Maya had an indigenous version of the celestial feathered serpent (ill. 1), one type, with roots in a war complex, was borrowed from Teotihuacan. Surging into prominence during the Terminal Classic period, the feathered serpent is a hallmark of the Mesoamerican Postclassic. Massive examples form columns and balustrades at Chichen Itza (ill. 2).

The serpent's body was a conduit permitting supernaturals to pass from divine to mortal worlds and emerge through the gullet. Works of art portray the culmination of this journey, usually triggered by a burnt offering (ill. 3; *see* 65.1). As an open-ended path, the serpent is often two-headed (ill. 1), seen, for instance, in the ceremonial bar, proof of the king's ability to manifest spirits. Spiritual stuff was also channeled through a twisted snake-like rope seen weaving through the heavens. Like the sky and ecliptic serpents, the snake-rope gave tangible form to the heavens' structural integrity.

On the darker side, serpents, sometimes merged with the centipede*, evoked the Underworld. The zoomorphic analog of a cave* was a serpent (*see* 80.3). A hissing fer de lance wrapped around the neck of a *wahy* magnified its frightening demeanor (ill. 4; *see* 61.4).

In this potent, ominous aspect, serpents were also associated with women. The archetypal domestically skilled woman wore an emblematic cloth head tie which, for the old creator goddess, Chak Chel, was transfigured into a serpent, its body knotted like pliable cloth (ill. 5). This Medusa-like headdress linked elderly women with elemental forces of nature and the earth's generative powers via the serpent.

KAAN

* CHAHK 6
PENIS 16
ROPE 24
CAVE 52
CLOUD 57
SKY 60
CENTIPEDE 75
DEER 78

1

a

 c

 b

4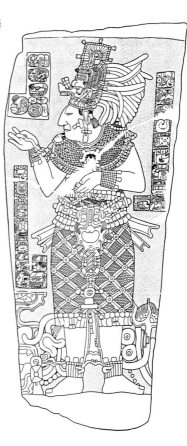

1 Full-figure 'shark' signs. Late Classic.
1a Hieroglyphic Stairway 5 (102), Yaxchilan.
1b Structure 82 bench (Fa), Copan.
1c Copan, Corte Altar.

2 Two gods spear a supernatural shark. Painted vase. Late Classic.

3 The Wind God emerges from the wounded shark. Painted vase. Late Classic.

4 Lady Ook Ahiin of Mopoy (or Pomoy) dressed as a Maize Deity. Unprovenanced stela. Late Classic.

2

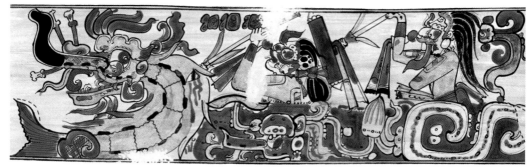

3

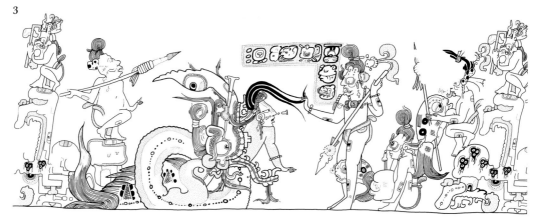

On the face of it, the importance of sharks in a predominantly riverine civilization would seem negligible. Then again, the bull shark (*Carcharhinus leucas*) is no ordinary shark. It is unique in its ability to penetrate freshwater and has been found hundreds of kilometers upriver throughout the Maya area, especially in the mighty Usumacinta. The typical bull shark can reach 2 to 3.5 meters (7 to 11 ½ ft) in length. Because it frequents the shallow waters where humans like to swim, it is an extremely dangerous predator, responsible for dozens of human deaths per year.

Xook means "shark" in a number of Mayan languages, and the **XOOK** sign was clearly a portrait of the creature. Not only does the blunt snout and serrated row of triangular teeth strongly resemble those of the bull shark, but also the characteristic hooked eye and plethora of facial and body fins serve to separate the **XOOK** sign from otherwise similar depictions of fish* and serpents*. Close comparison of the logograph with full-figure variants (ill. 1) and depictions in art (ills. 2, 3) reveals two other important traits. First, the shark regularly sports an oval infix characteristic of jade* (*see* 21), a common iconographic convention for marking the bright, shiny or wet skin of supernatural and/or aqueous entities. Second, the shark's tail is often marked with a *Spondylus shell**, presumably labeling it as a creature of the water.

While the shark makes varied appearances in art, many can be seen as finite episodes from a longer mythological narrative concerning the origins of maize*, wind* and rain*. Three scenes in particular, despite being from Late Classic vessels of widely varying traditions, demonstrate an extraordinary continuity of action. First, GI and other Rain Gods pursue a fleeing shark, stabbing it with long flint*-tipped spears (ill. 2; *see* 50.3). Next, they approach the wounded creature with weapons held ready, seizing the young Wind God as he emerges from its mouth (ill. 3). Associated hieroglyphs provide a date deep in mythological time and read in part "the shark is speared." In another scene of uncertain association, the Maize God emerges from a shark in the pose of a baby* (*see* 50.4). While still poorly understood, such scenes no doubt comprise fugitive episodes of the maize and creation cycles. The underwater birth of the Maize God is surely referenced by the shark's head and *Spondylus* shell worn by Maize God impersonators in Maya art (ill. 4). Similarly, the shark bone throne* set up by gods of creation at the beginning of our present era may well have been fashioned from the carcass of the beast from which the Wind God was liberated.

The shark was considered a powerful semi-divine creature, so it comes as little surprise that it figured prominently in ancient onomastics. The first-century founder of Tikal's dynasty was named Yax Ehb Xook "First Step* Shark" (*see* 47.1), and Ix K'abal Xook "Lady Shark Fin" was a prominent queen of eighth-century Yaxchilan (*see* 46.2–3).

XOOK

1

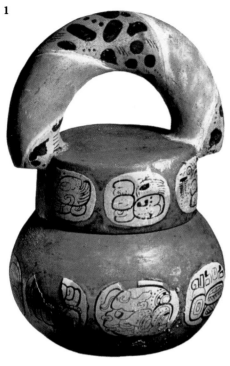

1 Faux jaguar tail handle. Painted and stuccoed vase, Tomb 19, Rio Azul. Early Classic.

2 Sacrificial Baby Jaguar in offering plate. Painted vase. Late Classic.

3 *Lab Te' Hix* "Sorcery Stick Jaguar". The Popol Vuh Bowl. Late Classic.

2

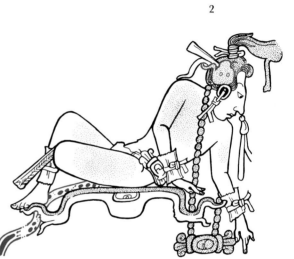

3

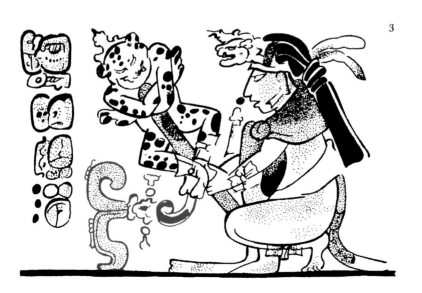

The Maya hieroglyph for "tail," also serving as phonetic **ne**, obviously depicts a jaguar* tail proper, including the signature spotted rosettes, parallel lines and striped foretail (ills. 1, 2; *see* 2.1, 2; 61.4; 72.4). For this reason, the **NEH** glyph provides one of the clearest examples of sign conventionalization known from Maya writing. That is, while the **NEH** sign is a perfectly natural depiction of a jaguar tail, it is at best a highly conventionalized term for tails in general, particularly when employed as a descriptor for the tails of coatis*, deer* and monkeys*, for instance. As with all hieroglyphic scripts, this decoupling of specific characteristics is unavoidable whenever one seeks to pictorially represent a general category, for categories do not actually exist in nature, and one must therefore choose a specific member of the category to represent: hence the problem of the jaguar tail representing all tails (or the signs for bone*, house* and skull* representing all types of bone, houses and skulls). In art, of course, there is no such decoupling of specific characteristics, and each of these animals appears with their respective tails (*see* 76.1, 78.1, 4 and 84.2–4).

Jaguars were significant and powerful creatures in Maya art, so their pelts were particularly prized as costume elements and clothing. Most depictions of such costumery include the jaguar tail as a particularly revealing characteristic of the animal from which the pelt was harvested (*see* 51.3, 75.3 and 83.1, 4). Jaguar tails could also appear in headdresses (*see* 25.4) and as the handle of incense bags (*see* 24.3). Indeed, one impressive Early Classic polychrome vessel (ill. 1), excavated from Tomb 19 at Río Azul, contains a faux jaguar tail handle, its artful painting clearly meant to replicate the real jaguar tail handles of incense bags.

Because of its condensed form but unmistakable associations, the jaguar tail became a useful diagnostic in art. Thus, while numerous scenes of the sacrifice of the Baby Jaguar merge the icons of baby* and jaguar to a pronounced extent, producing hybrid babies with jaguar paws, facial features and tail (*see* 1.3), there is at least one illustration that downplays these characteristics to a significant extent (ill. 2). Nevertheless, the jaguar tail and jaguar ear on this young Maize* God provide minimal but unmistakable evidence that this is essentially the same Baby Jaguar encountered in other scenes. And note also that this character sports the same elaborate rope pectoral and topknot as the equally sacrificial Jaguar God of the Underworld (*see* 32.1 and 48.3).

A remaining mystery is the significance of burning tails, such as that sported by *Lab Te' Hix* (Sorcery Stick Jaguar), a rather forbidding *wahy* spirit (ill. 3). The puzzling device is frequently found on jaguars (*see* 32.2) but is not exclusive to the big cats, appearing also on other mammals (*see* 30.2, 76.2–3, 89.2) and even on reptiles (*see* 12.3, 65.1). Such associations may mark particularly powerful (ritually "hot") entities, but some of the iconography remains unexplained.

* BABY 1
BONE 13
SKULL 18
HOUSE 37
COATI 76
DEER 78
JAGUAR 83
MONKEY 84
MAIZE 98

1 Turtle-shell drums and deer antler drumsticks. Bonampak Murals, Room 1. Late Classic.

2 Resurrection scene. Painted vase. Late Classic.

1

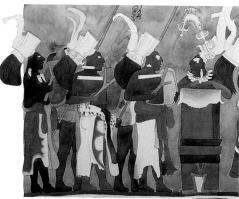

3

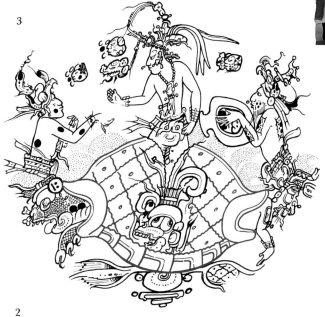

3 Resurrection scene. Codex-style plate. Late Classic.

2

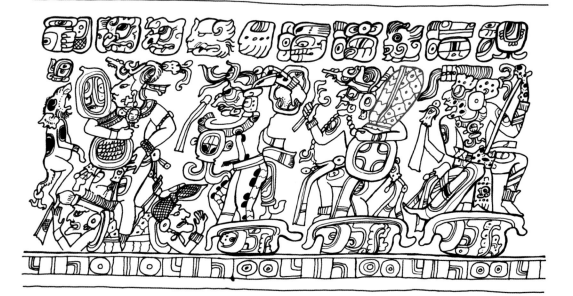

There are several different signs representing the word *ahk* "turtle," but the most common represents a profile view of a turtle carapace. Like its depictions in art (ills. 2, 3), the carapace is marked with the so-called "water* lily motif," a wavy reticulated pattern infixed with circles. Although this element does indeed mark water lily pads (*see* 72 and 71.2), it seems to derive from the mosaic pattern of the vertebral and pleural shields of the turtle carapace itself. Beneath the carapace is a somewhat stylized cross-section of the turtle's ventral shell, or plastron, characterized as from five to seven individual segments. As with a real turtle shell, the hieroglyph has openings at both ends for the turtle's head, limbs and tail (*see* 70.2).

There are several reasons why the turtle shell was favored as the subject of the **AHK** sign. For one thing, and unlike the turtle's somewhat more equivocal reptilian head, which shared certain characteristics with frogs, toads and even serpents*, a turtle shell is a particularly clear referent. (Although it might be said that some confusion results from the simultaneous usage of a similar sign for **MAHK** "turtle shell.")

Turtle shells appear to have been particularly common fixtures at Classic Maya celebrations, where they were evidently employed as drums*. In the late eighth-century murals of Bonampak, for instance, a group of musicians are depicted drumming on turtle shells with deer* antlers (ill. 1). It is worth noting that these turtle shells are painted yellow*, a probable reference to the **K'AN** sign that frequently marks turtles in art. In still other mural scenes, marine turtles are occasionally depicted swimming in shallow coastal waters (*see* 37.2), their outlines essentially limited to a clearly demarcated shell with the sketchiest of emergent limbs and head.

But by far the most common context for the turtle shell in Maya art is the so-called "resurrection scene" of the Maize* God, Juun Ixim (ills. 2, 3). Numerous examples are known, though all have as their central message the emergence of the Maize God from the earth, almost always represented by a split turtle shell. On one Late Classic polychrome vessel (ill. 2), the Maize God, carrying a gourd of water and a bag of maize seed, is released from the turtle shell by a blow from the lightning axe of Chahk*, while the Stingray Paddler God* beats accompaniment with a deer antler on a yellow turtle shell drum. On the codex-style Resurrection Plate (ill. 3), the Maize God is accompanied by his sons, the Hero Twins*, one of whom pours water onto his father's sprouting form from a vessel labeled with the darkness* sign. It is still uncertain whether the split turtle shell in these scenes is solely a reference to the earth* (which some Mesoamerican cultures evidently saw as resting on the back of a turtle) or whether it was instead seen as a reference to the constellation of Orion (*see* 61.1, 3 and 70.2).

89

TURTLE

AHK

* CHAHK 6
 HERO TWINS 8
 PADDLER GOD 11
 DRUM 30
 YELLOW 49
 EARTH 54
 DARKNESS 58
 WATER/POOL 72
 DEER 78
 SERPENT 86
 MAIZE 98

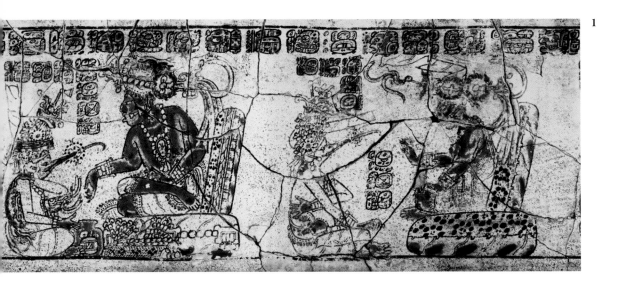

1 Itzamnaaj receives the hummingbird in his palace. Hummingbird Vase, Burial 196, Tikal. Late Classic.

2 Itzamnaaj and Yax Baluun with hummingbirds. Dresden Codex, page 7b. Late Postclassic.

3 A hummingbird in flowery paradise. Deletaille Tripod. Early Classic.

2

3

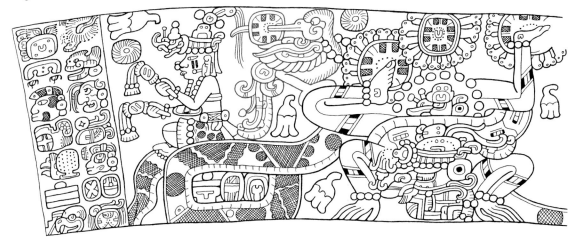

The hummingbird (family *Trochilidae*) is among the smallest birds in nature, averaging only some 7–12 centimeters (2¾–4¾ inches) in length. Yet it is also among the most exotic, with a colorful, iridescent plumage and a rapid, darting flight, punctuated every now and again by periods of hovering, as it draws forth nectar from the flowers which are its primary sustenance. The **TZ'UNUN** sign is clearly a portrait of the hummingbird (ills. 1–3). Its characteristically long and slender bill, complete with a perforated flower* located midway along its length, serves to distinguish it from depictions of other birds (*see* 30.4). Associated hieroglyphs are an additional aid to identification, often providing a phonetic **tz'u-nu** spelling of the bird's name (ills. 1, 2). Such spellings are predictably haplographic, omitting what would have been a duplicate final **nu** sign.

In art, the hummingbird is often depicted in the company of Itzamnaaj*, king of the gods. In two delightful scenes from the famous Hummingbird Vase of Tikal (ill. 1), Itzamnaaj sits on a throne facing an anthropomorphic hummingbird. Associated glyphs provide a portion of their dialogue: "'...it is in front of you, my lord,' says the hummingbird to Itzamnaaj" (*awichnal wajwaal yaljiiy Tz'unun ti Itzamnaaj*). This is probably a reference to the jar of maize* gruel (*sa'*) which the hummingbird has brought as a gift. Sadly, much of the rest of the dialogue is cast in a poetic language which resists interpretation, but the hummingbird apparently receives his wings as a result of this conversation, suggesting that Itzamnaaj dispenses them in exchange for the maize offering (*see* 100.3 for another "just so" story involving deer). In the Dresden Codex (ill. 2), Itzamnaaj wears a hummingbird bill in one scene, and an actual hummingbird appears with Yax Baluun*. In both cases, the hummingbird is said to be the "prophecy" (*chich*) of the associated god. Like the owl*, the hummingbird may well have been thought of as a heavenly messenger, though probably a benevolent one, and this may explain his privileged contact with Itzamnaaj and other gods in such scenes.

That the hummingbird was generally seen as a denizen of the heavens can be appreciated from its appearance on the Early Classic Deletaille Tripod (ill. 3). Perching amidst an Elysian scene of paradise, the hummingbird is surrounded by flowers, birds, acrobats and musicians (*see* 30.1).

Yet there is another side to hummingbirds. During their reproductive season, hummingbirds can become quite aggressive and fearless, attacking animals many times their size, and this seems to have given rise to militaristic associations. Thus, the great war palanquin of Yax Mayuy Chan Chahk, eighth-century king of Naranjo, was actually called a "hummingbird litter" (*tz'unun piit*) and featured a tall idol wearing a prominent hummingbird bill (*see* 35.2–3). These militaristic associations of hummingbirds are doubtless reflected in the name of the Aztec war god Huitzilopochtli, "Hummingbird on the left," as well as in hummingbird symbolism on Mississippian warclubs.

TZ'UNUN

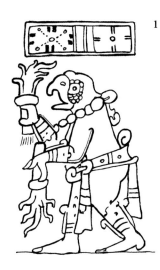

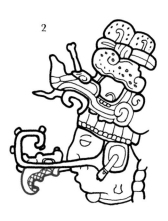

1 A fire macaw like K'inich K'ahk' Mo'. Dresden Codex, page 40b. Late Postclassic.

2 A macaw beak links this ruler to a macaw character. Stela 3, Tamarindito. Late Classic.

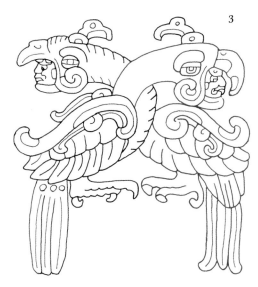

3 A macaw and quetzal form the name of K'inich Yax K'uk' Mo'. Stucco relief, Margarita Structure, Copan. Early Classic.

4 A pair of macaws name the sacred mountain framing Waxaklajuun Ubaah K'awiil. Stela B, Copan. Late Classic.

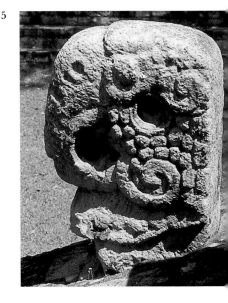

5 Macaw head. Ballcourt A-III, Copan. Late Classic.

In ancient Mesoamerica, the long red feathers used to fashion headdresses and other ceremonial regalia came from a large parrot, the colorful scarlet macaw (*Ara macao*). Because of their stunning red plumage, scarlet macaws were raised in captivity and traded as far from the tropics as the American Southwest. The macaw hieroglyph highlights details of the bird's head, notably a patch of bare, bumpy skin near the eye and the distinct upper beak – double-arced with black* markings on the inner edge and tip, represented by cross-hatching in sculpted media. The bare skin is shown as clustered circles or, in a more stylized fashion, a ring of circles surrounding the eye. A hallmark of the macaw, this eye ring was employed in Maya writing for the syllabograph **mo** abbreviated from *mo'* "macaw."

The macaw's brilliant red plumage was likened to fire* and by extension the blazing sun*, both associated with the color red*. In one incidence of trickery recounted in the *Popol Vuh*, macaw tail feathers are stuck on the end of a torch* to simulate flames. The *Popol Vuh* also speaks of a character, Seven Macaw, who pretends to be the blazing sun, but the avian imposter is defeated by the Hero Twins*. Another solar manifestation of the macaw is known from Colonial Yucatan, K'inich K'ahk' Mo', Great Sun Fire Macaw; his cult, dedicated to curing disease, was headquartered at Izamal. Ironically, many diseases – termed "seizures" or "winds" – were attributed to the macaw. In the Dresden Codex, the macaw's sun and fire aspects converge in a depiction of another numbered macaw deity, Four Macaw (4-**MO'-NAL**), brandishing a torch in an augury for drought while a sky*-band labeled with **K'IN** glyphs floats above (ill. 1).

The macaw was adopted in regnal names that could easily be referenced pictorially by the bird's distinctive eye or beak. For instance, on Tamarindito Stela 3 a figure is identified by a macaw beak affixed to a breath scroll in the form of a square-nosed serpent* (ill. 2). Macaw references are especially abundant at Copan. The dynastic founder's name, K'inich Yax K'uk' Mo', Blue-green* Quetzal* Macaw, invokes the most exquisite birds in the Maya realm. An Early Classic stucco relief from the Margarita Structure depicts the name as an intertwined macaw and quetzal; the macaw, with characteristic beak markings, sits to the right (ill. 3). The Sun God head in the birds' beaks and the scalloped projection on their crowns supply, respectively, the *k'inich* and *yax* components of the name.

Copan's inscriptions refer to a sacred place called Macaw Mountain, Mo' Witz, pictured on Stela B as two macaw heads framing a personified mountain*. Some have misconstrued the long beaks as elephant trunks, even claiming this as evidence of trans-Pacific contact; however, the beak markings and bumpy skin patch are definitive macaw traits (ill. 4). The king who commissioned Stela B, Waxaklajuun Ubaah K'awiil, transformed Ballcourt A-III into a sacred arena of the macaw. Stone mosaic sculptures of macaws graced the ballcourt* temples and macaw heads were tenoned into the court's side walls (ill. 5). These macaws may honor a god ancestral to the *Popol Vuh*'s braggart Seven Macaw.

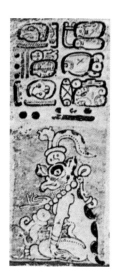

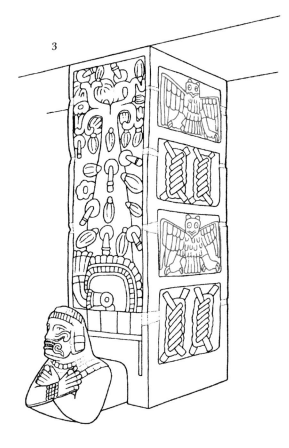

1 The "Thirteen Sky-Place Owl." Dresden Codex, page 10a. Late Postclassic.

2 God L's Underworld Palace. The Princeton Vase. Late Classic.

3 West Pier of the Temple of the Owls, Chichen Itza. Terminal Classic.

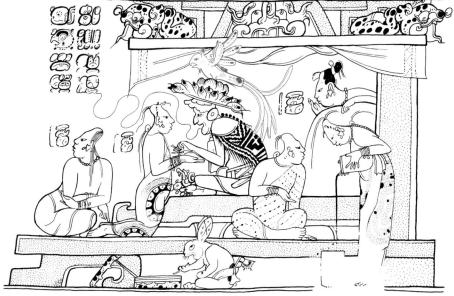

The great horned owl (*Bubo virginianus*) is perhaps the most widespread owl in the Americas and its distinctive feathered tufts, characteristic white throat patch and relatively large size made it a favorite subject of Mesoamerican artists. In the *Dresden Codex* (ill. 1), an anthropomorphic great horned owl (named Uhxlajuun Chan Nal Kuy or "Thirteen Sky-Place Owl") is shown with one hand outstretched in an offering pose, its two great tufts of feathers clearly visible to either side of its head.

Numerous depictions of this majestic bird are known from Late Postclassic Aztec and Mixtec art, and its portraits evidently graced the shields and armor of warriors from Classic Teotihuacan. Yet for all of the owl's numerous depictions in Highland Mexico, it is among the Maya that the great horned owl received its most sensitive and enduring portrayals.

In the *Popol Vuh*, owls appear as the special messengers and servitors of Underworld gods. For instance: owls carried the summons of the Underworld gods to the Hero Twins*; owls brought the first incense to the gods; and it was owls who were commanded by the Underworld gods to sacrifice the Hero Twins' mother; luckily she proved as wily as her offspring and managed to thwart their plans. That owls played a similar role during the Classic period is illustrated by numerous depictions of God L, the conspicuously wealthy merchant lord of the Underworld. In one famous scene (ill. 2) God L sits in his ostentatious Underworld palace with the owl in its customary perch on God L's hat (*see* 51.3 and 95.3). Although God L seems pleasantly absorbed in the task of fastening a jeweled bracelet onto one of his many young concubines, as others pour him a frothy chocolate beverage to his right, the owl is evidently startled or surprised by a grisly decapitation sacrifice happening just offstage (*see* 14.1) and rustles his feathers in warning. This is the beginning of God L's comeuppance at the hands of the Hero Twins and their father, the Maize* God, which will eventually see him stripped of his finery and deposed from power.

This tale carried a powerful message and was clearly meant to warn kings and other noblemen of the danger inherent in the abuse of power and wealth. In Colonial Yucatan and Highland Guatemala, dance dramas reenacting the defeat of the Underworld gods by culture heroes were performed during festival days and served as a periodic release for social pressures. These public performances may perhaps explain the decoration of the Temple of the Owls at Chichen Itza (ill. 3), which sports depictions of owls, weaving* and the body of the dead Maize God, from which grows a "money tree" laden with cacao* pods and jade earspools (*see* 95.1–3). A spirited recreation of God L's sumptuous palace, the Temple of the Owls was probably used as the setting for elaborate recreations of the myth of God L, the Hero Twins and the rebirth of the Maize God.

O' / KUY

1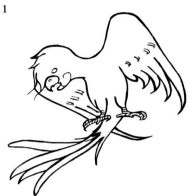

2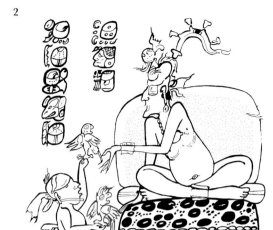

5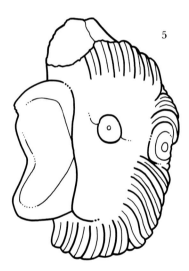

3

1 A lifelike rendition of a quetzal. Painted vase. Late Classic.

2 A dwarf presents a quetzal and parrot to Itzamnaaj. Painted vase. Late Classic.

3 A woman's headdress incorporates a quetzal head with crest and tail feathers. North Wall Mural, San Bartolo. Late Preclassic.

4 An intertwined quetzal and macaw. Painted lid of a ceramic bowl. Early Classic.

5 A sculpture of a quetzal head in volcanic tuff originally set into a building façade. Copan. Late Classic.

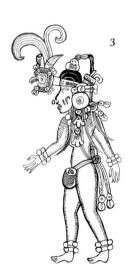

4

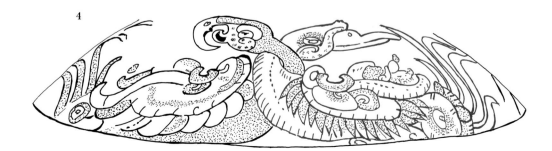

The resplendent quetzal (*Pharomachrus mocinno*, genus Trogon, named from Nahuatl *quetzalli*) had exceptional importance among bird species to the ancient Maya. Its habitat is humid, mountainous cloud forest, which, before modern deforestation, surrounded the southern margins of the Maya Lowlands, making the bird accessible to lowland traders. What they sought was the exquisitely plumed male. Except for a scarlet breast, the male is covered in iridescent, delicately pointed green feathers. It has an unremarkable black and white tail hidden by green tail coverts, three to four per bird, reaching 30 cm in length. Fluttering like emerald ribbons, these extraordinary tail feathers were luxury items of the first order desired by the rich and powerful throughout Mesoamerica.

Commonly adopted in royal names, the hieroglyph for the quetzal is a bird head with two diagnostic traits: a short, wavy crest and small bill. Full-length renditions reveal the elegant tail feathers and pointed, widely-spaced wing feathers (ill. 1). Gracing scenes of Elysian paradises, the magnificent quetzal epitomized the good life. Thus, the bird's pleasing image adorns pictorial vases, as in ill.1. The quetzal also made a gift fitting for the gods. A painted vase portrays a dwarf presenting a quetzal and parrot to the god Itzamnaaj* (ill. 2). The feathers had their own power of signification and adorned sacrificial offerings, affirmation of their preciousness. In some Mesoamerican languages the concept of fine plumage, the most sumptuous of materials, was conveyed by the term for the quetzal.

Owing to their restricted habitat and incessant demand for their plumage, quetzal feathers were major trade and tribute items. Tribute scenes in Maya art usually include a bundle of quetzal feathers (*see 69.5*), which was tucked into headgear or held as a sign of status (*see 3.2*). Spectacular headdresses and backracks were fashioned from quetzal feathers. However, the incorporation of the quetzal in costume appears at the dawn of Maya art, as one female figure in the San Bartolo murals wears a quetzal headdress. A tiny crest marks the brow, and the tail feathers and wing stand erect (ill. 3); a comparable headdress is worn by women in the Late Classic (*see 97.4*).

Although not a major god, the quetzal had supernatural associations. Occasionally, Chahk* wears the bird's crest as does the Principal Bird Deity. Anthropomorphic versions of the quetzal suggest it played some role in myth. Indigenous names for the feathered serpent across Mesoamerica, such as Quetzalcoatl and K'uk'ulkan, include the term for quetzal, although the reference seems to be to quetzal feathers rather than the bird itself.

Maya rulers incorporated the quetzal into their names. The name of Copan's dynastic founder, K'inich Yax K'uk' Mo', is elaborated iconographically by an entwined macaw* and quetzal (*see 91.3*). A lidded bowl from the Peten shows a similar pairing of birds (ill. 4); the quetzal, to the right, is painted blue and has diagnostic pointed feathers. Perhaps the imagery bears some relationship to the Copan king, who may have been a Peten native. Copan boasts a rare three-dimensional sculpture of a chirping quetzal originally set into the façade of a building (ill. 5).

K'UK'

* CHAHK 6
ITZAMNAAJ 9
MACAW 91

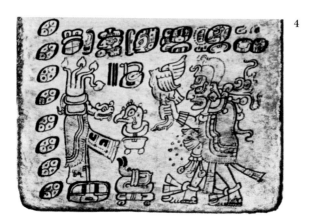

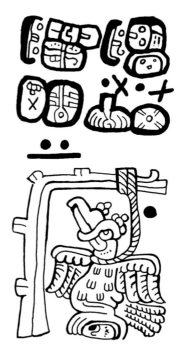

1 Turkey in a noose. Madrid Codex, page 91a.
Late Postclassic.

2 Tribute scene. Bichrome vessel. Late Classic.

3 Processional scene. Codex-style vessel. Late
Classic.

4 Itzamnaaj sacrifices a turkey to idol of the New
Year. Dresden Codex, page 28c. Late Postclassic.

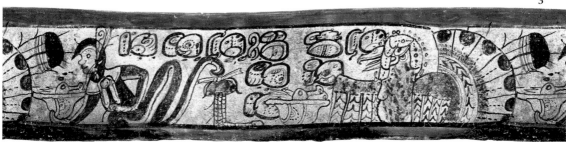

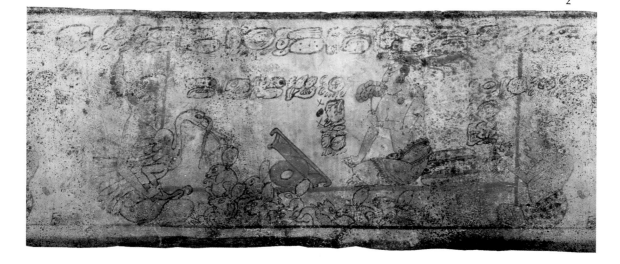

The **AK'AACH** sign is easily identified by its long, slender beak and bare, wattled head and neck. It also exhibits one or more dotted ovals, a common marker of rough or wrinkly texture (ill. 3; *see* 77.1, 4; 84.2, 3). These are the quintessential features of the ocellated turkey (*Agriocaris ocellata*), largest of the game fowls of Central America.

As one of only two animals domesticated by the Maya (the other being the dog*), the ocellated turkey had an undeniable prominence in ancient diet. Indeed, as several scholars have suggested, long low walls surrounding households at various sites may well have been the pens where the Maya raised flocks of turkey for food. Other turkeys seem to have been snared in the wild, and by all accounts much industry and ingenuity seems to have been spent on traps for these creatures. Thus, in a series of almanacs related to hunting and fowling, the Madrid Codex depicts a wild turkey caught in a noose (ill. 1). Associated glyphs refer to "the turkey's noose" (*u le' kutz*), here using a different word for turkey from the one most commonly seen in Classic inscriptions. Elsewhere, in painted scenes from polychrome vases, huntsmen seize wild turkeys.

Whether reared or caught in the wild, turkeys were economically important animals, and it is as tribute offerings and sacrifices that they are most frequently depicted in art. In one humorous scene from an unprovenanced vessel, Juun Ajaw, one of the Hero Twins*, is seated before his overlord, Itzamnaaj* (ill. 2). As the king of the gods smells a handful of flowers* and gazes into a mirror*, Juun Ajaw presents him with a large, tame turkey and eight fattened rabbits*, which tumble in a riotous heap before him. Juun Ajaw's tribute to Itzamnaaj is clearly analogous to that paid mortal kings by their sublords, and such mythic scenes no doubt served as exemplars and reminders of proper courtly etiquette.

Elsewhere, in numerous processional scenes from codex-style ceramics, a supernatural sorcery-sent turkey *wahy* is depicted alongside other demonic animals (ill. 3; *see* 76; 82; 83). Although enigmatic in the extreme, the scenes are replete with sacrificial symbolism. Most of the animals carry large bowls laden with grisly offerings, including human hands, eyeballs and bones*, and all of the mammals wear knotted scarves, a motif closely associated with decapitation sacrifice. That beheading was a common fate of turkeys is confirmed by a scene from the Dresden Codex (ill. 4). Here, Itzamnaaj scatters incense before the idol of the incoming year and offers it the headless body of a turkey. Before him, on the ground, lay other typical offerings: thirty-five lumps of resin, a turkey head tamale* in an offering bowl, and a haunch of venison. The degree to which these depictions match Landa's sixteenth-century descriptions of Yucatec New Year ceremonies is astounding and well illustrates the economic and ritual importance of turkeys.

One Late Classic lord of La Corona was actually named after the turkey. On a limestone panel now in the Art Institute of Chicago (*see* 40.2), Chak Ak'aach Yuhk, or "Lord Great Turkey," is depicted playing ball at Calakmul against a figure garbed in the trappings of a Teotihuacan ancestor. In his headdress can be seen the ocellated turkey which is his namesake.

1 The Maize God as the *Iximte'* "Maize Tree". Incised vessel. Early Classic.

2 The Maize God's head sprouting from a cacao tree. Painted vase. Late Classic.

2

1

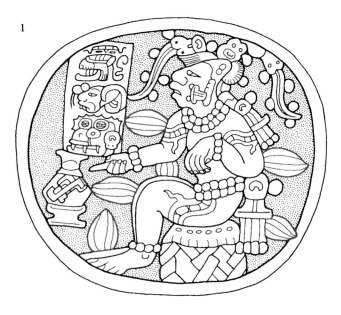

3 God L's Underworld palace. Painted vase. Late Classic.

3

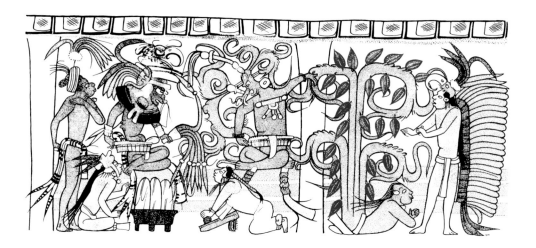

The fruit of the tropical cacao tree (*Theobroma cacao*) was widely regarded as a delicacy in Mesoamerica. Roasted and ground, the caffeine-rich beans yielded by this pulpy fruit were mixed with water, vanilla, chilies and other seasonings and rendered into frothy drinks favored by elites and commoners alike. Indeed, most of the decorated ceramics known to us from Classic times were in fact service vessels for these zesty drinks, and cacao was so valued that, at least among the Late Postclassic Aztec, dried cacao beans became a form of currency. Given its important role as both social and economic capital, it is little wonder that cacao was so widely featured in art.

Depictions of the cacao tree and its characteristic reddish seedpods partake of a vivid naturalism, but they are never completely divorced from the underlying mythology of cacao, which was seamlessly interwoven with the story of the Maize* God. Apparently, the decapitation and death of the Maize God at the hands of Underworld gods saw the end of only one phase of his existence, for he was reconstituted as the *iximte'* or "maize tree," in which form he gave forth all sorts of fabulous fruits, including cacao. One vessel in the collections of Dumbarton Oaks shows the recently sacrificed Maize God in this form (ill. 1), clearly marked with tree* signs and sprouting cacao pods from his limbs. Elsewhere, depictions of the fruiting "maize tree" are somewhat more realistic but nevertheless sprout directly from the body of the slain Maize God (ill. 3; *see* 92.3) or sport seedpods in the form of his decapitated head (ill. 2).

Other scenes clearly show what happened next. God L, the well-known merchant prince of the Underworld, seizes this magical "money tree" and parks it outside his sumptuous palace (ill. 3). Here he has his many daughters and/or consorts busy day and night grinding cacao beans into powder, or pouring him foaming cups of chocolate (*see* 92.2). While the ultimate source of his wealth and power, this unfair hoarding of cacao also proves to be his undoing. Eventually, as the *Popol Vuh* informs us, the Maize God is able to use his close proximity to the Underworld palace to impregnate one of the Underworld lord's daughters, who flees to the surface world to give birth to the Hero Twins*. A series of complex and still not completely understood adventures follows, but with the assistance of K'awiil* (ill. 3), a conniving rabbit* (*see* 92.2) and the Moon* Goddess, the Hero Twins eventually defeat God L, strip him of his rank and wealth, and free their father from the palace of the Underworld gods.

Because of these complex mythical events, cacao itself was conceived of as a sacred fruit, and the act of drinking it akin to partaking of the flesh and blood of the Maize God. Cacao was therefore much more than a valued commodity and pleasant drink: it was a cornerstone of Classic Maya religion.

95

CACAO / CHOCOLATE

KAKAW

1

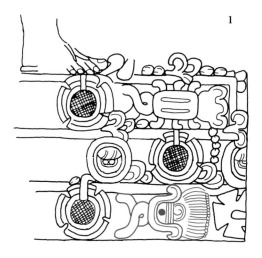

2

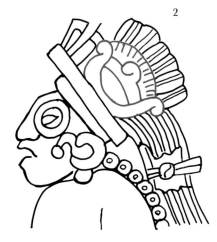

3

1 Floral elements in Teotihuacan style, including a cattail reed, adorn the palanquin of Jasaw Chan K'awiil I. Lintel 2, Temple I, Tikal. Late Classic.

2 A goggled figure wears the cattail reed sign in his headdress. Temple 26 inscription, Copan. Late Classic.

3 Cattail reed signs and other motifs influenced by Teotihuacan art. Stucco frieze, Acanceh. Early Classic.

Scholars continue to debate the relationship between the Classic Maya and the Central Mexican city of Teotihuacan. Beyond doubt, however, is Teotihuacan's dominance in Mesoamerica from roughly AD 300 to 550 and its profound impact on the Maya. This is evidenced at many Classic Maya cities by the presence of artistic influence and artifacts from Teotihuacan. Signs of Teotihuacan influence on the Maya are especially prodigious during the fifth century, particularly at Tikal and Copan, where key historical figures displayed themselves in Teotihuacan-style trappings. One lingering question is: Did Maya kings emulate Teotihuacan from afar to further their political ambitions or did Teotihuacanos directly interfere in the affairs of Maya royal courts, and if so, to what extent? The discovery of a logograph for "cattail reed" (*Typha spp.*), or *puh* in Classic Ch'olt'ian, has enlivened this debate, if not resolved it.

As a representation of a reed, the **PUH** logograph is highly conceptual. The lower half resembles an inverted sky* glyph with the "wing" usually reduced to a curl. The upper half has a dotted fringe presumably representing the projecting cattail but flattened into the cartouche. These elements often rest on a U-shaped base which represents the plant's surrounding leaves. This logograph may refer to the city of Teotihuacan, a significant fact given that the Nahuatl term for "place of reeds" is *tōllān* (hereafter Tollan). In the Protohistoric period, "Tollan," a name assigned to different places by different peoples, came to signify a city of mythical stature claimed as the foreign homeland of political factions attempting to justify their right to rule; for the Aztecs, Tollan was identified with Tula, Hidalgo. That the Classic Maya thought of Teotihuacan as a "place of reeds" suggests that Teotihuacan was the prototype of the legendary Postclassic city of Tollan.

In Maya art the reed logograph occurs in constellation with other Teotihuacan traits, often of a militaristic nature, as seen on Lintel 2, Temple I, Tikal. Outfitted with Teotihuacan costume and weaponry and protected by Teotihuacan-style mosaic War Serpents, Jasaw Chan K'awiil I rests his feet on a dais that bears Teotihuacan-style flora, including a cattail reed (ill. 1). The **PUH** logograph is also worn in headdresses, often by individuals wearing goggle-like eye-rings, to imply a Teotihuacan connection (ill. 2). On Piedras Negras Panel 2, a king's youthful heir wears the Teotihuacan eye goggle device and a tall headdress adorned with a bird whose wing resembles the reed glyph. Indeed, for reasons that are unclear, the **PUH** logograph mirrors a type of Teotihuacan-style bird wing, perhaps explaining its incorporation of sky glyph elements. The **PUH** sign, sprouting a reed, appears on a stucco frieze at Acanceh, Yucatan (ill. 3). Shells and scrolls at the top and stepped frames surrounding the figures have parallels in Teotihuacan murals. The discovery of the **PUH** glyph and realization that it is a toponym for Teotihuacan supports the proposition that these foreigners from Central Mexico really did meddle in the political affairs of the Maya, at least during the period of Teotihuacan ascendancy. This discovery has helped to dismantle an isolationist view of Classic Maya history.

PUH

* SKY 60

1

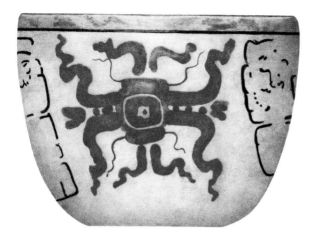

2

3

4

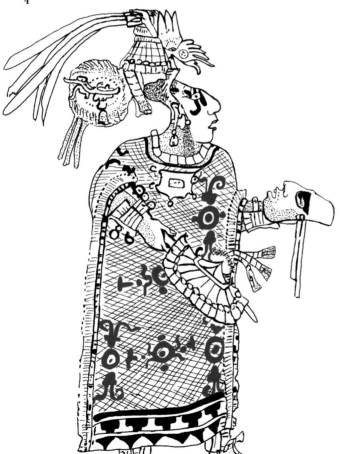

1 A flower painted on a ceramic vessel. Buenavista del Cayo. Late Classic.

2 Solar frame with double bars found on **NIK** logograph. Stela 10, Piedras Negras. Late Classic.

3 Jade earflares in form of a flower. Late Classic.

4 Flower designs woven into woman's dress. Late Classic.

5 A painted flower from a mural of flowers on the exterior of House E, Palenque. Late Classic.

5

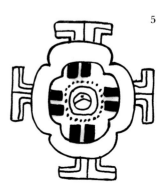

From a design perspective, Maya artists looked at flowers as intricate assemblages composed not just of their visible parts – petals, pollen, stamen – but also of invisible characteristics, such as nectar and aroma. Transcribed as dots, balls and curlicues, these floral building blocks were treated with great artistic license – every dot and squiggle was not required to match a botanical feature (ill. 1). As a result, flowers were quite imaginative, sometimes incorporating little figures into the center, most spectacularly in Jaina figurines with fully-modeled human figures emerging from the flower. The **NIK** logograph is equally conceptual. It depicts a flower frontally as a circle either in a solid or dotted outline. Paired short bars divide the circle into four petal-like sections, recalling the **K'IN** glyph, a symbol of the sun* also based on a four-part flower. The double bars are a sign for the color red* (*see* 48.1), suggesting an important association between red and flowers among the Maya. Indeed, the **K'IN** flower is usually painted red when hue is indicated, and solar frames even include the double bars for red found on the **NIK** logograph (ill. 2). Additionally, pairs of wavy lines radiate from either the top or all four sides of the logograph. These lines represent centrally projecting structures, perhaps fragrance emanations or pistils. In either case, they are flattened and symmetrically arranged to balance the frontal composition. The logograph for flower thus incorporates information about color and odor through conventional graphic elements.

In the Maya symbol system, flowers had one of the richest ranges of metaphorical significance, which factored in their beauty and fragrance. Flowers were equated with precious jewels. Jewelry design drew heavily from flowers – in many depictions it is almost impossible to distinguish the two. The balls and bars of jade earflares and pectorals convey the sensibility of flowers if not mimicking them outright (ill. 3). Floral accoutrements were extremely popular as a sensual enhancement. Stylized versions of the **NIK** logograph were brocaded into clothing, especially women's apparel (ill. 4), and real flowers were tucked into headdresses. Certain buildings designated as "flower houses" seem to have capitalized on this same pleasure principle. One such "flower house" is House E in the Palenque Palace, whose west façade is covered by paintings of colorful flowers set against a white background (ill. 5).

Apart from sensual pleasure, the delicate flower had more onerous roles as the embodiment of a vital force, or soul, and a marker of ontological states. The wafting scent of flowers was a manifestation of vitality also contained in breath and wind*, pictured as curly mouth emanations comparable to the flower's fragrance scrolls. This flower-breath life force could alternately be shown as flower-jewel ornaments or naturalistic flowers placed by the nose and was personified by a god of flowers and wind, called God H in the Schellhas deity classification system. God H's youth, beauty and floral trappings recall the Aztec flower god Xochipilli. An attribute of God H is a flower worn on a woven headband (*see* 73.4).

97

FLOWER

NIK

* RED 48

SUN 62

WIND 73

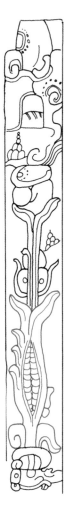

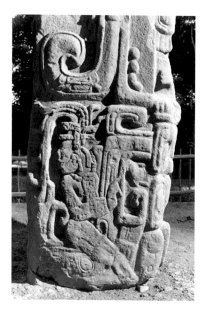

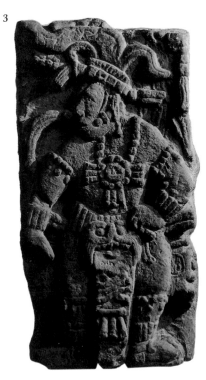

1 A maize cob in the husk. Jamb relief, Temple of the Sun, Palenque. Late Classic.

2 The Maize God on the base of Stela H, Quirigua. Late Classic.

3 Dancing Maize God with the **NAL** sign sprouting from his head. Copan. Late Classic.

4 Portrait of K'inich Janaab Pakal I. Carved stucco, Temple of the Inscriptions, Palenque. Late Classic.

5 A stylized maize motif dangles from the collar of a captive dressed as the Jaguar God of the Underworld. Relief sculpture, Tonina. Late Classic.

The ancient Maya were well aware that a flourishing community hinged, as it did for their forebears, on an abundant maize crop. That maize made their civilization possible is acknowledged in creation myths featuring the birth of the Maize God, and maize generally came to symbolize all things good and beautiful. Quite literally, the Maya, as other Mesoamericans, worshipped the foodstuff that sustained and ordered existence.

A stylization of corn growing on the stalk, the **NAL** logograph exploits the familiar suite of botanical graphic elements, in this case tiny circles and scrolls representing corn kernels and flowing leaves. As with flowers*, they were combined in fanciful and especially graceful ways – often kernels line the edges of elegantly swirling leaves. A thickened form at the center is the cob with its seed cargo; in fact *nal* specifically refers to corn on the cob. The tight curl to one side is highly diagnostic of maize, being infixed into the Maize God's portrait glyph, and was also used to represent steamed dough balls made from ground maize (*see* 100). The **NAL** sign proper was used wholesale in art, often set above a figure's earplug (*see* 6.2). In Maya writing this logograph could stand for *nal* in its original "maize" sense but more often served as a rebus for an identical-sounding locative suffix similar to "ville" in English. Thus, the **NAL** logograph often marks toponyms.

In pictorial contexts, maize exhibits tremendous formal versatility. The maize plant could be represented in somewhat realistic guise. For instance, the stalk and cob are well defined on jamb reliefs from the Temple of the Sun at Palenque (ill. 1). The Maya always represented a naturalistic cob shrouded in leaves, as it actually grows. However, maize could be suggested in more conceptual ways by combining scrolls and circles, basically dismembering the plant and rearranging its parts. This stylization gave freedom to swirls and arabesques that could be worked into any composition.

Of all plants, maize was one with which the Maya personally identified. Since ancestral gods fashioned the first humans from maize dough, their own bodies were believed to be made of maize. The likening of maize to the human body explains the persona of the Maize God: a beautiful, fully human male figure with plant symbolism restricted to his head, which is elongated and often blossoms into what is essentially the **NAL** logograph. On Quirigua Stela H, the **NAL** sign erupting from the Maize God's crown mingles with his long flowing hair, an allusion to silky maize tassel (ill. 2). More characteristically the **NAL** sign rises abruptly from the crown of the Maize God (ill. 3). This look had such appeal that it was imitated in elite hairstyles as seen in the stucco head of the Palenque ruler K'inich Janaab Pakal I, whose upswept coiffure resembles the curled foliage of maize (ill. 4). The Maya also utilized a more rigid, symmetrical stylization of the **NAL** sign, a seed-filled cartouche flanked by leaves that better served frontal representations of maize and was placed on headdresses and necklaces (ill. 5).

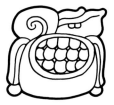

NAL

* FLOWER 97

1

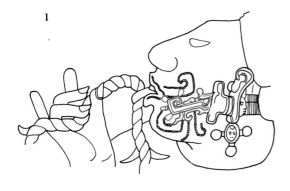

2

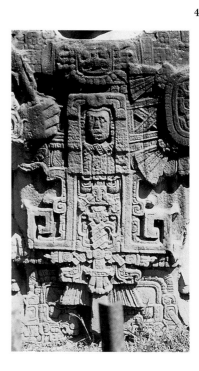

3

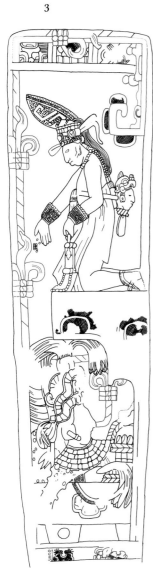

4

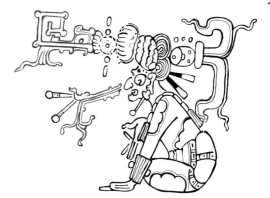

1 Bloodletting scene shows a serpent mingling with a woman's blood. Lintel 24, Yaxchilan. Late Classic.

2 A square-nosed serpent in the floral headdress and breath emanation of Itzamnaaj. Painted vase. Late Classic.

3 The vital essence of an ancestor rises from a tomb as Ruler 4 scatters incense. Stela 40, Piedras Negras. Late Classic.

5

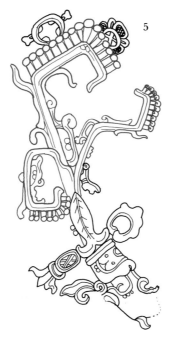

4 A typical royal loincloth framed by square-nosed serpents. Stela K, Quirigua. Late Classic.

5 A square-nosed serpent grows from a stingray spine in a Quadripartite Badge. Stucco relief. Pier C, House D, Palenque. Late Classic.

This logograph combines ophidian and floral elements in the form of a slender band that makes several 90-degree turns, suggesting the upturned snout of a sinuous serpent. Eye and nose rest atop the band and beneath are several curly fangs and no lower jaw. The bent snout is lined with widely spaced round beads or a series of tubular ones, jewels that reveal the creature's refined essence. This "square-" or "fret-nosed serpent" is a prominent, albeit esoteric, feature of Maya art. It seems to embody a radiant life force, expelled through the mouth, nose, or center of a flower, and dispersed throughout the universe, much like mana in Polynesia.

The square-nosed serpent often simulates a projecting botanical structure, such as a pistol or stamen. For example, it springs out of a jade earflare configured like a flower worn by Lady K'abal Xook on Yaxchilan Lintel 24 (ill. 1; see 46.2). By strategic overlapping, the serpent mingles with her sacrificed blood*, shown as lines of dots, suggesting a coalescence of vital energies. A square-nosed serpent pops out of a flower* worn in the headdress of Itzamnaaj* (ill. 2), and an abstract version floats in front of his nose, visualizing the god's vital essence.

The square-nosed serpent is a radiant energy on Stela 40 from Piedras Negras. Ruler 4 (r. AD 729–757) kneels over the tomb* of a female ancestor pictured as an enthroned bust-length figure (ill. 3). At the behest of the king who throws* incense toward his honored ancestor, she expels her breath-like soul. Configured as a rope* marked by flaming sacrificial knots, the ascendant soul's head, at upper right, is a square-nosed serpent. Bearing a black-petaled flower on its snout, the serpent confers the ancestor's essence on the king. Similar ideas underlie the imagery on a standard type of loincloth donned by rulers in formal portraiture. The loincloth presents an elongated deity head which marks the World Tree, flanked by square-nosed serpents (ill. 4). As scholars have shown, this is a folded version of full-blown cosmic trees. Here, the serpents reference the cosmic center and, by their placement near the groin, the ruler's life force sacrificed in genital bloodletting.

The square-nosed serpent marshals these same ideas when it occurs in a trio of symbols set in a personified censer/offering bowl*. In cases where women are associated with this motif, known as the Quadripartite Badge, the square-nosed serpent generally occupies the position of the stingray spine*, suggesting that the serpent has some association with women. Occasionally the serpent emerges directly from the stingray spine, imagery resembling a growing plant (ill. 5). These iconographic convergences and substitutions situate the square-nosed serpent in the complex of blood sacrifice. In ill. 5, the square-nosed serpent is marked by the symbols for yellow* and the same black-petaled flower seen in ill. 3. This suite of symbols marks a fluid-like scroll (see 20.4) that bears striking similarities to the square-nosed serpent in that it, too, carries the forces animating the human body and wider universe.

?

* ITZAMNAAJ 9
 BLOOD 12
 THROW 20
 ROPE 24
 STINGRAY SPINE 25
 TOMB 40
 YELLOW 49
 CENSER 63
 FLOWER 97

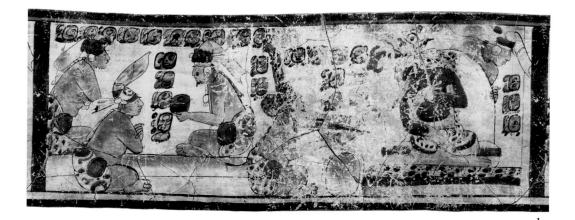

1

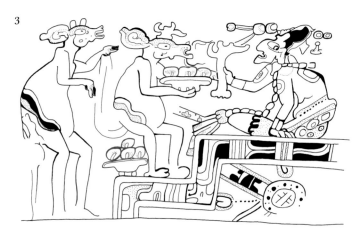

3

1 Lords receive courtiers bearing gifts of tamales. Painted vase. Late Classic.

2 Court scene with tamales and other tribute items. Painted vase. Late Classic.

3 Itzamnaaj receives a delegation of deer on his celestial throne. Painted vase. Late Classic.

2

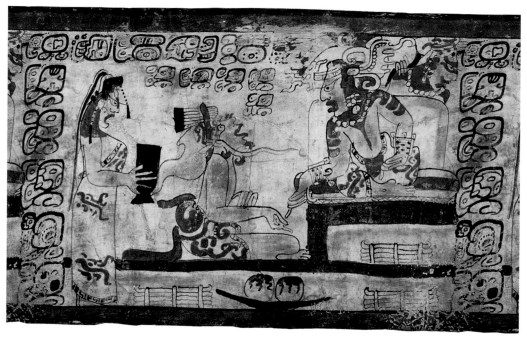

Although often referred to as the K'an glyph because of its typical usage for the fourth day sign (*k'an* in Yucatec Mayan of the Colonial period), phonetic substitutions and complementation demonstrate that this sign carried only the values **WAAJ** and **OHL** during Classic times. *Waaj* was a widespread term for "tamale" (though it now means "tortilla" in some languages and is a more general term for "bread" in others), and *ohl* more specifically meant "maize* dough." However, the **OHL** sign was more frequently used in the script to represent the homophonous term *ohl* "heart." With respect to its iconic derivations, the sign clearly represents a ball of maize dough wrapped in a large green leaf, a motif with clear cognates in art.

That tamales were the premier breadstuff of Classic Maya times is revealed in numerous courtly scenes on ceramics. On one Late Classic polychrome vessel (ill. 1), a seated lord* is offered a plate full of tamales by one of his underlings. Also on offer is a large tribute bundle, probably filled with jade or cacao* beans. The importance of the tribute items is highlighted by the bodyguard who rather surreptitiously watches for interlopers from behind the lord's throne. In a related scene from another vessel (ill. 2), we see a woman holding a tall cacao vessel and a series of offerings arranged before a throne, including several bundles of textiles and a wide shallow plate with two large tamales dripping with sauces. As in modern Maya festivals, tamales seem to have been frequently combined with other ingredients and seasonings, especially meats. Thus, in the Late Postclassic Dresden Codex, one deep bowl contains *ak'aach waaj* or "turkey tamales" (*see* 94.4) while another contains *huh waaj* or "iguana tamales." Similarly, several plates from the Uaxactun region are epigraphically labeled as *we'ib ta sak chijil waaj* or "plates for deer* tamales." Intriguingly, archaeological evidence from palace groups in this region show high concentrations of deer bones alongside service dishes just like those depicted in art, a strong indication that elaborate feasts of deer tamales did indeed take place in these courtly settings.

The mythological dimensions of tamales are more profound than they might appear at first glance. According to the *Popol Vuh*, humans were fashioned from ground maize and blood*. Thus, offerings of maize tamales were just as sacred as blood offerings, and they largely remain sacred offerings among the modern Maya. It is probably for this reason that celestial court scenes frequently illustrate tamale offerings in addition to other valuable tributary items. In a somewhat humorous adaptation of such scenes, a mythological tableau from one Late Classic vessel shows several deer approaching the heavenly abode of the great god Itzamnaaj* (ill. 3), who sits on an effulgent throne apparently fashioned from the sky* itself. They offer him plates heaped high with tamales, and he reciprocates by giving them antlers! Similar "just so" stories are known for the coati*, hummingbird* and turkey*.

100

TAMALE

WAAJ / OHL

* LORD 4
 ITZAMNAAJ 9
 BLOOD 12
 SKY 60
 COATI 76
 DEER 78
 HUMMINGBIRD 90
 TURKEY 94
 CACAO 95
 MAIZE 98

allograph A technical term referring to the relationship between two formally different signs that are nevertheless equivalent in either sound or meaning. The simple **pa** sign and its comical head variant (*see* Introduction, ill. 1) are allographs.

baktun An invented term (the Classic word was *pihk*) for a unit of time in the Long Count consisting of 20 katuns (144,000 days). For Long Count dates within an historical timeframe, the baktun is the largest temporal unit. Much of the Classic period transpired during the ninth baktun.

capstone A flat stone spanning the top of a corbel vault. Painted capstones are common in Yucatan and Campeche.

caption A short text adjacent to (or occasionally on the surface of) an illustrated figure or object, which it names or describes.

cartouche An enclosing circle (with or without pedestal) which serves to identify day signs in the Maya calendar (*see* 12.1). It is consciously modeled after the French term *cartouche* for similar encircling signs in Egyptian hieroglyphic writing.

cenote A Spanish term (from Yucatec *tz'onó'ot*) referring to a collapsed sinkhole exposing ground water, often steep-sided, such as the Sacred Cenote of Chichen Itza.

Ch'olt'ian The ancestor of two Eastern Ch'olan languages, Ch'olti' (now extinct) and Ch'orti' (still spoken in Guatemala and Honduras). Another descendant of Ch'olti'an, sometimes called Classic Ch'olti'an, is the prestige language of the Maya script. Along with the closely related Western Ch'olan languages (Ch'ol and Chontal), Ch'olti'an is a descendant of Proto-Ch'olan.

codex-style ceramics A style of painted pottery produced in the El Mirador Basin of Northern Guatemala and nearby Southern Campeche (particularly Calakmul), during the Late Classic period. The decoration features a crisp black line for figures and text set against a cream background, with scenes framed by thin red bands. This treatment recalls the appearance of Maya codices, accounting for the name codex-style.

corbel vault The method by which stone roofs were constructed in Maya architecture. From the springing of the vault, stone courses were laid such that they gradually came closer together until they met at the ceiling apex. A small gap at the top was spanned by a tabular capstone.

Cosmic Monster Also called the Starry Deer Crocodilian, this composite zoomorphic supernatural is based on the crocodile but also exhibits details of deer (78), serpents (86), stars/planets/constellations (61) and the personified censer/offering bowl (63) or Quadripartite Monster, which appears on its tail. The Cosmic Monster is a complex embodiment of the heavens and may have fluctuated in form and meaning.

cosmogram A schematic representation of the structure of the cosmos. Among the simplest are geometric forms, such as a cross or a circle, which express fundamental spatial concepts about the perceived universe. Cosmograms can also consist of more complex arrangements of elements and, correspondingly, convey greater detail about the nature of the cosmos.

dedicatory text *See* Primary Standard Sequence.

deer ear A wavy, lozenge-shaped device tucked behind the ear of supernatural scribes, so-named because of their resemblance to deer ears in art. The device often bears jade celt (21) markings, indicating a hard, shiny surface, or the sign for darkness (58). Some examples resemble cut-shell paint pots, but the form of the deer ear is quite variable.

ecliptic An implied band in the sky delimited by the annual path of the sun seen against the background of stars. The ecliptic demarcates the area in which the sun, moon, planets, and zodiacal constellations move across the sky. The Maya envisioned this band as a great two-headed serpent that carried along these heavenly bodies.

emblem glyph Strong associations between Maya cities and so-called emblem glyphs have been known since the 1950s. Yet we now realize they are more than labels for cities, city-states or even kingdoms and seem to identify the highest-ranking lords within specific bloodlines. Some kingdoms (such as Tikal and Dos Pilas) shared the same emblem, others (such as Yaxchilan) reckoned descent through two separate emblems, and still others (such as Dzibanche and Calakmul) were the seats of authority for Snake emblem holders at different periods. The emblem glyph was compounded with standard affixes reading *k'uhul ajaw*, "holy lord." In this form the emblem glyph is a high-ranking title that incorporates the name of a dynastic lineage, such as *k'uhul kaan ajaw* "holy Snake[-dynasty] lord."

full-figure glyph Personified or head variant signs which have become fully animate through the addition of arms, legs, etc., embracing or even enveloping other signs in the glyph block and frequently subverting the norms of reading order.

glyph A catch-all term for signs in the Maya writing system (including syllabographs, logographs, numerical signs and space fillers). Consciously modeled after *hieroglyph*, derived from a Greek word for "sacred sign."

haab The Classic Maya term for the 365-day "vague year" made up of 18 months of 20 days, plus a 5-day transitional "month." *Haab* was also a term for the 360-day unit of time in the Long Count, designed to approximate a year but still be divisible by 20.

haplography A common abbreviational convention of Maya writing whereby repeating syllables are omitted in writing, as in **ka-wa** for *kakaw* "chocolate" and **u-ne** for *unen* "baby." From Greek *haplos* "single" + *-graphia* "writing."

head variant An allograph of a basic sign which has become personified as either anthropomorphic or zoomorphic, such as the deity heads used to represent the more common signs for numbers. Not distinct in kind from full-figure glyphs.

Itzaj *See* Proto-Yucatecan.

Jester God So-named because of the peaks sprouting from its head reminiscent of a jester's cap, the Jester God was called *huun* in the Classic period, a word for the fig tree and its derivatives, including bark cloth and paper. Usually appearing as a head, the Jester God is a personification of the bark paper headband that was the traditional crown of Maya kings. Examples have also been found fashioned in jade (*see* 4.4).

katun-ending The unit of time consisting of twenty *haab* (a period of 7,200 days or almost 20 years) was called a *k'atun* in Colonial Yucatan (katun in conventional Colonial orthography). In Classic times, this period was referred to as *winikhaab*, literally "twenty years." The completion of a katun in the Long Count, or katun-ending, was celebrated by Maya kings, often with the casting of incense and the commemorative erection of stelae.

logograph Literally a "word sign" (from Greek *logos* "word"), this class of glyph conveys both sound and meaning and is indivisibly linked to a particular morpheme or word. Logographs were shared with the pictorial symbol system and frequently derived from it.

Long Count Although technically a cycle (repeating every five thousand years), the Long Count was an eminently serviceable record of historical dates during the Classic period. It was reckoned from a beginning point on August 13, 3114 BC. The number of accumulated days was recorded by five base-twenty temporal units. They registered single days (*k'in*), 20-day months (*winik* or *winal*), 360-day "years" (*haab*, deviating from base twenty to approximate a year), 20 years (*winikhaab*, nicknamed katun), and 400 years (*pihk*, nicknamed baktun). Mythological Long Count dates sometimes register temporal units higher than the baktun and from the previous Long Count cycle.

Manikin Scepter A nickname for a scepter representing the Lightning God K'awiil. Maya kings are shown holding this scepter by a handle formed from K'awiil's serpent foot.

Maya, Mayan Maya is the adjective used for the people and their art, culture and civilization. Mayan is a specific adjective referring to their languages and things, such as writing, related to language. Thus one says "Maya temple" and "Mayan language" but can say either "Mayan glyphs" or "Maya glyphs" depending on whether

the intent is the glyphs as a vehicle of Mayan language or as an example of Maya art.

metonymy The substitution of the name of an attribute or an adjunct for that of the thing meant, e.g., flint for "warrior" or skirt for "woman."

morpheme The smallest part of a word retaining meaning. Some Mayan logographs, such as **CHAN** "sky," encode a single morpheme only. Others encode two or more morphemes, such as **JUKUUB** "dugout canoe," which is composed of *juk* "to hollow out" plus an *-uub* instrumental suffix, yielding *jukuub* "thing which is hollowed out."

Nahuatl The language of the Aztecs and many of their neighbors in Late Postclassic Highland Mexico. In this book, several god names and technical terms are drawn from this important indigenous language.

onomastics The field of study concerning the origin, construction and meaning of names.

pars pro toto *See* synecdoche.

partitive disk In its common Late Classic form, this is a large circle with a tiny interior circle, looking something like a donut, placed at the corner of any sign derived from a body part in Maya writing, such as those for hand, head and penis (but not confined to logographs). The disk indicates that the labeled element is part of a living entity, and although shown independently, is not a severed body part. Given the role of dismemberment in warfare, sacrifice and funerary ritual, the distinction between a severed and living limb was important. The partitive disk also appears on other *pars pro toto* signs, such as steps (parts of buildings) and branches (parts of trees).

pelage The traditional term for the jaguar markings common in Maya art and writing. In origin the term refers to the fur of any mammal (cf. Old French *pel* "hair").

percentage sign A motif consisting of a diagonal line and two circles, resembling a percentage sign. The sign is associated with death and/or sleep, and is frequently seen on *wahy* creatures (*see* 7.3, 58.4), insects (*see* 5.1–3, 80.1), and Underworld beings (*see* 45.5). Its iconic origins are unknown.

period-ending The completion of a baktun, katun, or quarter division of a katun. These calendrical stations were traditionally celebrated by Maya rulers or high-ranking priests.

personification *See* head variant and full-figure glyph.

phonetic complement Syllabographs were frequently employed by Maya scribes as keys to the pronunciation of associated logographs. When prefixed, they reinforced the initial sound of a word (e.g., **ka-KAAN** for *kaan* "snake"). When suffixed, they complement the final consonant, but also provide clues to the complexity of the final vowel. When the vowel of the complement and that of the logograph agree (e.g., **K'AN-na** for *k'an* "yellow," **K'AHK'-k'a** for *k'ahk'* "fire") the result can be either a simple or complex vowel. When the vowel of the complement and logograph disagree (e.g., **TUUN-ni** for *tuun* "stone") the result is almost always a long or otherwise complex vowel.

phonetic sign *See* syllabograph.

Popol Vuh In the early eighteenth century, the Dominican friar Francisco Ximénez copied this sixteenth-century epic written in K'iche' from a now-lost manuscript formerly preserved in Chichicastenango, Guatemala. Ximénez' transcription is the oldest surviving copy. The *Popol Vuh*, loosely meaning "counsel book," is a compilation of stories treating world creation, the defeat of the Lords of the Underworld by the Hero Twins and the mytho-history of prominent K'iche' Maya lineages. Iconographic and epigraphic evidence demonstrates that the saga of the Hero Twins dates back to at least the Late Preclassic period and that it played a key role in the ideology of Maya kingship.

Primary Standard Sequence (PSS) Named by its discoverer, Michael Coe, this is a formulaic inscription usually found on Late Classic painted ceramics. Following a series of dedicatory verbs, the inscription usually goes on to mention the vessel's decoration, form and function, such as "painted drinking vessel for cacao" or "carved bowl for *atole*." Most vessels then name the owner or commissioner (the distinction is unclear) and a handful then go on to identify the artist. The length of these dedicatory inscriptions varies, though some provide unique historical information, such as the titles and parentage of vessel owners or the signatures of the artists who made them.

Principal Bird Deity An avian supernatural whose earliest manifestations date from the Late Preclassic. While the plumage is modeled on a quetzal, the bird has a long, downturned raptorial beak, a schematic serpent head embedded in the wing and other deity markers, such as large square eyes and a shiny celt emblazoned on his forehead or chest. During the Classic period, the bird was related to the god Itzamnaaj (9), and can be seen wearing the same blue-green (47) cut-shell diadem and jade celt (21) pectoral. A cosmic symbol, the bird is often seen perched on the World Tree or framing otherworldly scenes. The Principal Bird Deity seems to have some relationship with Vucub Caquix, or Seven Macaw, the pretender sun of the *Popol Vuh* who is humbled by the Hero Twins.

Proto-Yucatecan The ancestor of five closely related modern Mayan languages: Itzaj, Mopan, North Lacandon, South Lacandon and Yucatec (*q.v.*).

Quadripartite Badge/Monster A standard motif in Maya art is a bowl-shaped burning vessel bearing an infixed **K'IN** glyph and supporting three elements along the rim: a *Spondylus* shell, stingray spine and cloth or vegetal construction, all of which relate to sacrifice and ritual offering (*see* censer/offering bowl (63)). These four basic components have given rise to the quadripartite name. The monster variant occurs when the censer is set in the forehead of a skeletal zoomorph (itself the rear head of the Cosmic Monster), possibly a figurated brazier of a type well known in ceramic art.

quatrefoil A four-lobed element resembling a flower or four-leafed clover. In Maya art, quatrefoils signify openings in the humid earth, such as caves, wells and waterholes (*see* 26.4).

scepter *See* manikin scepter.

Schellhas deity classification system In a study published in English in 1904 (Schellhas 1904), the German scholar Paul Schellhas classified the gods in the Dresden Codex, labeling them alphabetically as Gods A, B, C, etc. Scholars still occasionally use these alphabetic labels for Maya deities, although most have been set aside as their identities and indigenous names have come to light. For instance, it is now known that Schellhas's God B is Chahk and God K is K'awiil. However, the names of God L and Goddess O remain uncertain, so scholars still use their Schellhas designations.

sky-band In iconography, the Maya represented the sky (60) as a band divided into a series of rectangular compartments, each containing a symbol for a heavenly body, such as the daytime and nighttime sun (62), the moon (59) and stars/planets/constellations (61). These boxes recall the serial pattern of serpent skin, and the sky-band has explicitly ophidian details. Sky-bands typically serve as scenic frames for celestial events, designate celestial architecture (e.g., the thrones of sky gods) or decorate ceremonial bars held by divine kings.

stela (pl. **stelae**) A standard format for carved monuments, the stela is a freestanding dressed stone slab erected in public space to commemorate important historical and calendrical events, such as period-endings. While some stelae are undecorated (perhaps having been painted), the majority bear inscriptions and images, the ruler portrait being the most common. The tallest Classic Maya stela is 35 feet high.

syllabograph This class of hieroglyphs conveys sound alone, taking the form of a consonant-vowel (CV) sequence or syllable. Many syllabographs seem to have been derived from pictorial logographs ending in a weak consonant or semi-vowel. Thus, although syllables are employed in writing to spell words or provide phonetic complements to logographs, their pictorial origins still make them useful lenses for the interpretation of iconography.

synecdoche A relationship expressed by using a part to stand for a whole, sometimes also called *pars pro toto*, literally "part for whole." Such relationships are common in Maya iconography, but are also present in glyphic abbreviations, such as a toad's ear standing for "toad," or a branch standing for "tree."

talud-tablero Literally "slope-table," this is an architectural profile characteristic of, and identified across Mesoamerica with, Teotihuacan in Central Mexico. It features a rectangular panel, or *tablero*, set above a sloping base, or *talud*. This type of construction occurs in the Maya area (*see* 38.3) and is considered evidence of Teotihuacan influence.

tamale A Mexican bread fashioned from cornmeal dough steamed or baked in cornhusks.

Teotihuacan Located in the Basin of Mexico, northeast of Mexico City, Teotihuacan was the dominant power of Classic Central Mexico, creating an art style and symbol system that became the foundation of all subsequent Central Mexican art. Teotihuacan was the largest city in Classic Mesoamerica and is said to have been the sixth-largest city in the world at around AD 500. Its impact on the economic and political affairs of Classic Mesoamerica was so enormous that it developed a mythical status as a holy city where political power could be legitimated. This mythic template endured the fall of Teotihuacan at about AD 550, and became the basis of the legendary Postclassic Tollan.

Tlaloc The Nahuatl name for this Central Mexican god of rain, lightning and agriculture is known from early Colonial Aztec sources; however, depictions of him with his characteristic goggle eyes and fanged lip bar are present much earlier at Teotihuacan. Early Classic Teotihuacan influence introduced Tlaloc into Maya iconography as a Storm God, where he is predominantly associated with militaristic themes.

Tollan Literally, "place of reeds" in Nahuatl, Tollan is invoked in many early Colonial native language sources, ranging from Central Mexico to the Maya area, as a great foreign city from which elites claimed their origin because of its singular status in legitimating political power. Closely allied with the cult of the Feathered Serpent, Tollan may have originally been Teotihuacan but later became attributed to different cities, such as Cholula, Tula and Chichen Itza, in the period after the fall of Teotihuacan.

toponym A hieroglyphic sign or compound naming a place, which might be a section of a city, a topographical feature or a mythical or cosmic location. While most toponyms consist of a few conjoined signs, in scenes they can be pictorially elaborated and often occur in the basal registers of reliefs.

tuun The Classic Ch'olti'an word for "stone" (cf. Yucatec *tùunich*). Some scholars use *tuun* as a reference to "year," but this is based on Colonial Yucatec usage, and is clearly misapplied to the Classic period. The Classic Maya word for "year" was *haab*.

tzolkin An ersatz modern term (the ancient term is unknown) for the 260-day count comprised of twenty days and thirteen numbers.

Tzotzil A Tzeltalan (Mayan) language related to Ch'olti'an (and Proto-Ch'olan) by virtue of their mutual descent from Proto-Greater-Tzeltalan. Along with Tzeltal and Colonial Tzendal, Tzotzil is thus an important resource language for the study of Maya hieroglyphic writing.

wahy Malevolent personifications of sorcerous spells, manifested as various diseases and misfortunes. Depictions of *wahy* are prolific on painted ceramics and usually appear in the form of monstrous, hybrid animals and skeletalized figures frequently laden with the symbolism of death (7) and darkness/night (58). Although some mysteries remain, *wahy* are clearly associated with horrific forms of illness, sacrifice and death.

water-band In iconography, the Maya represented bodies of water (56, 72) as a band decorated with aqueous symbolism, such as water lilies, water scrolls, cut shells, fish and the water stacks symbol of rain (67). Water-bands typically served as toponyms on stelae or wall panels. In one instance they appear below figures engaged in ritual within a moist cave or spring (*see* 67.2). In others, individuals wade chest-deep in the water-band to indicate the watery location of action (*see* 56.2, 71.1, 81.3, 87.2).

World Tree A mythical first or central tree supporting the heavens in Maya belief, frequently associated with the ceiba (*Bombacaceae spp.*). From Yucatec Mayan *yá'axche'il kàab* "first tree of the world."

Yucatec Mayan language spoken in Yucatan and Belize which has enjoyed a long and important history in Maya studies, providing technical terms for calendar periods, place names and gods, many of which can be found in this book. Although not directly represented in many inscriptions outside of Northern Yucatan, the language is nonetheless conservative of important features of ancestral Mayan languages, making it a valuable source for students of Maya writing.

NOTES

Reader's Guide

1 Wilkinson (1992). **2** Gardiner (1982:438-548). **3** Classic Mayan/Ch'olti'an: Coe & Van Stone (2005:8-9), Martin & Grube (2008:11); Nahuatl: Karttunen (1992); Yucatec Maya consonants and Proto-Mayan forms: Kaufman (2003); Yucatec Maya tone and vowel length: Bricker et al. (1998). Note that we differ from these sources in the representation of *h* in several Classic Mayan words where the historical evidence seems supportive (e.g., Chahk, *chapaht, ihk', muhk* and *wahy*). Although Mayan *b* is generally implosive, we do not follow Kaufman (2003) in marking this with an apostrophe because it is non-contrastive. **4** See especially Stuart (1987, 2005c), Coe & Van Stone (2005) and Martin & Grube (2008).

Introduction

1 Stephens (1841:158). **2** Stuart (2005b). **3** Saturno et al. (2005). **4** Martin & Grube (2000, 2008). **5** Houston et al. (2000b). **6** Drought: Curtis et al. 1996, Gill (2000); Exploitation: Rice et al. (1985), Abrams & Rue 1989, Diamond (2005); Warfare: Webster (2002). **7** Demarest et al. (2004). **8** See Coe (1999) and Coe & Van Stone (2005) for readable introductions to the decipherment and mechanics of Maya writing, respectively. **9** Gopher: S. Houston pers. comm. (2002); Loss of vowel-length: Houston et al. (2004); Collapse of j/h distinction: Grube (2004b). **10** Beyer (1928). **11** Priests: Zender et al. (2000),

Zender (2004a); Artisans: Coe and Kerr (1998). **12** Zender (2002b). **13** God markings: Coe (1978, 1982); Brightness: Houston et al. (2006). **14** Stone (2002). **15** Zender (2007a). **16** Sounds and Smells: Houston et al. (2006: 141–163); Musk: Houston (2010). **17** Houston & Mathews (1985), Martin & Grube (2008). **18** S. Guenter, pers. comm. (1998). **19** Martin (2002). **20** Grief: Houston (2001), Grube & Gaida (2006:117–131). **21** Lacadena (2004). **22** Partitive disk: Houston et al. (2006:13–14). **23** For further details see Schele & Miller (1986), Zender (1999) and Houston et al. (2006). **24** For the most recent translation of the *Popol Vuh* see Christenson (2003). **25** Stone (2002). **26** For further discussion of the Resurrection plate see Schele & Miller (1986), Taube (1992a) and Zender (2006b). **27** Stuart (1995). **28** Wearing names: Kelley (1982), Zender (2004c). **29** Stuart & Houston (1994); Tokovinine (2008). **30** Stuart (1999). **31** Stuart (2004). **32** Martin & Grube (2000, 2008), Tokovinine (2008), Zender (2001). **33** A. Tokovinine pers. comm. (2005). **34** Iconographic "3 Mountain" toponym at Caracol: Stuart (2007b). **35** Ihkaatz as "jade": Stuart (2007a). **36** Pointing: Bassie-Sweet (1991), Wald (1994). **37** For the excavation of the Altar Vase see Adams (1962, 1971); our readings differ from Adams (1977). **38** The appearance of *h* rather than *j* in the suffix conveniently dates this text after *c*. AD 735: Grube (2004b).

Catalog

1 See Martin (2002) for the **UNEN** reading and related concepts

of infant symbolism, including the Maize God's rebirth and an explanation of the enigmatic Chacmool. See Taube (1994) for the *k'ex* concept.

2 Although clearly syllabic in most of its contexts, there is some evidence that this sign could also carry the logographic value **PA'** (Taube 1989b:Fig. 24–10). Bricker (1973) and Acuña (1978) have summarized much important material on Maya ritual humor. It is to Taube's analysis (1989b) of clowning in Maya religion that we owe most of our specific examples, as well as the identification of the *pa'* character.

3 Proskouriakoff (1961) was the first to recognize the female head glyph as prefatory to female names in the inscriptions. Stuart (1998:387 n. 7) deciphered the **IX/IXIK** sign. Joyce (1996) observed that women's formal portraiture on stelae is less feminized and tends to blur gender differences. See Stone (1999) for a discussion of women in ancient Mesoamerica and Vail & Stone (2002) for feminine stereotypes.

4 See Inomata et al. (2002) for the exciting recent discovery of the Jester God diadem at Aguateca, Guatemala.

5 The **AKAN** glyph was deciphered by Grube & Nahm (1994), while further observations on the nature and role of Akan come from Grube (2001a) and Zender & Guenter (2003). Grube (2004c) has previously explored associations with insect iconography, but the connection to Ch'ol *akan* "wasp" is made here for the first time. We quote Diego de Landa from the Tozzer edition (1941). For large narrow-necked containers for alcohol see Houston et al. (2006:116).

6 Chahk's attributes and appearances through time are summarized in Taube (1992a). Also see Taube (1986) for the interpretation of Zoomorph O, Quirigua, and Taube (1995) for the origin of Chahk's spiral eyes and forehead in early cloud iconography. For a detailed discussion of the etymology of the god's name and two of his aspects, Yax Ha'al Chahk and Uk'uw Chan Chahk, see Lacadena (2004).

7 The phonetic value of the "death" logograph is somewhat uncertain, and **KAM** is a possibility. For the **WAY** glyph see Houston & Stuart (1989) and Grube & Nahm (1994); for the "sorcery" reinterpretation see Stuart (2005c:160–165) and Grube & Gaida (2006:55–57). The *wahy* transliteration was proposed by Zender (2007c) on the basis of cognates in Yucatec *(wáay)* and Itzaj *(waay)* that represent expected phonetic developments from the hypothesized form **wahy* "sorcery, spirit." See Roys (1965:xi) for personified illnesses in Maya ethnomedicine.

8 We follow Simon Martin (in Miller & Martin 2004:281 n. 13) in seeing *baluun* as the Classic form of the number nine, and therefore Yax Baluun as the name of the Classic era Xbalanque. See Coe (1989) and Taube (1993:56–66) for more background and detail on the Hero Twins in Classic Maya mythology and imagery.

9 Itzamnaaj is a label of convenience, not a decipherment. See Taube (1992a:31–41) for a foundational discussion of God D. Our discussion of God D and God N owes much to Bassie (2002) and Martin (2006a). Stuart (2006) recently pointed to the wealth of the Principal Bird Deity, and Zender (2005) to God D's mountain hall. Itzamnaaj's role in "just so" stories is first noted here: *see* 90, 100, and Finamore and Houston (2010:121) for an example apparently involving a nocturnal animal.

10 See Taube's discussion (1992a) of God K for an overview of K'awiil's primary characteristics.

11 Stuart (1988) first noted the Paddlers' association with the **K'IN** and **AK'AB** glyphs. See Freidel et al. (1993:92) for the Paddler Gods' role in transporting the Maize God in Maya creation myths. Speculation on the nature of the Paddlers' bathing ritual is offered by Wichmann (2004b) based on ethnographic work by Kerry Hull.

12 See Houston et al. (2006:93–95) for the "blood" glyph and its iconographic associations. The Becan vessel was discovered by Luz Evelia Campaña in Becan Structure IX (Campaña & Boucher 2002, Finamore & Houston 2010:250–253). See Stuart (2005b) for Palenque's Temple XIX bench and Taube (2004b) for Copan's Temple 16.

13 Stuart (1985a) demonstrated the **BAAK** reading and its twin meanings "bone" and "captive." See Miller (2005) for Maya crossed bones, skulls and pirate flags. The juxtaposition of crossed bones and skulls begins in the Terminal Classic period at Uxmal and Chichen Itza and continues into the Late Postclassic. The imagery alludes to death and the Underworld and is distinct from the decapitated heads of skull racks. The textile-like crossed-bone pattern on the Cementerio Group platform recalls Klein's analysis (2000) of crossed bones and skulls in association with women's skirts, platforms, and the grisly death and fertility goddesses, known as Tzitzimimeh in Aztec art.

14 See Martin (2006b) for the Princeton Vase and God L.

15 See Miller (1983) for the gesture of respect, and Ancona-Ha et al. (2000) for a useful catalog of Classic Maya gestures. The **ICHON** reading and the significance of the "presence pose" were proposed by Zender (2007b) on the basis of Tzotzil *ichon* "front, presence" (Laughlin 1988:143). Given the phonological history of Tzotzil (where earlier **a* is sometimes reflected as *o*), and the lack of wider cognates for this word, *ichan* is also a possibility.

16 Amrhein (2001) provides a comprehensive study of the phallic cult in Terminal Classic northern Yucatan. She interprets the phallus as a symbol of fertility, ancestry and the cosmic center. Stone (1995a) has discussed phallic imagery in the cave context at Naj Tunich. For texture markings on penises and the role of nudity and disgrace see Houston et al. (2006:16, 213–216).

17 See Schele & Miller (1986:119–120) for a fuller discussion of the Olmec pectoral incised with Late Preclassic Maya glyphs and imagery.

18 See Ramos (2004) and Taube (2004b) for the iconography of Copan's Temple 16. Nikolai Grube, Simon Martin, and Marc Zender have elsewhere discussed additional diagnostics for the visual separation of the **KAM/CHAM** death's head and the **JOL** skull (see Reese-Taylor et al. 2007:42–43).

19 The **JATZ'** reading is from Zender (2004a). For discussions of the role of boxing in Maya art see Taube & Zender (2009).

20 Grube (1990) deciphered the "scattering" hand as *chok* "to throw." The substitution of the God C glyph for the scattered material, interpreted as blood, in the illustrated vase scene was suggested by Stuart (1988:187–188).

21 Stuart (2007a) proposed the sign's association with jade, and Bernal (n.d.) demonstrated its derivation from fruit iconography. See Zender (1999:78 n. 48) for the *uk'ees* reading, and Zender (2004b:195–196) for further discussion of incised celts.

22 The decipherment of the **NEHN** sign is due to Simon Martin (personal communication, 1999), who first noted the substitutions with **ne-na** spellings in the name of the Copan ruler Bahlam Nehn. See also Fialko (2000:148) for the spelling **u-ne-na** (*u-nehn* "his mirror") on a stone mirror back from Topoxte. See Miller & Martin (2004:24–25) for the role of mirrors in the royal court and Miller & Taube (1993:114–115) for divinatory scrying and the military associations of the Aztec *tēzcacuitlapilli*.

23 Although Taube (1991) interprets the obsidian bloodletter logograph as a stylization of a core and blade, it more likely derives from the conventional guise of obsidian bloodletters which often have bulging shafts and needle-like tips. The hieroglyph essentially places the blade next to the shaft. See Christenson (2003:203 n. 502) for a discussion of *ch'ahb* as it relates to captive sacrifice.

24 Looper & Kappelman (2001) outline the distribution of the twisted rope motif in Maya art and discuss its Preclassic origins. See Stuart (1996) for the ritual complex of stone monument binding. Stuart (2000b) also discussed the figure-eight form of the rope logograph at Palenque associated with the verb *ch'am* "to take" and argues that the "taking of rope" was an act in which elites donned a twisted neck cloth. Zender (2002c) proposed the **CH'AJAN** reading on the basis of a **-na** phonetic complement.

25 The **KOHKAN** value for the stingray spine was independently suggested by Davletshin (2003) and Zender (2002a). See Stone (1988) for a discussion of autosacrificial bloodletting and sexuality, and Thompson (1961) for the initial connection between

ethnohistoric accounts and blood-drawing scenes in art. Houston et al. (2000a) report on the discovery of stingray spines and hafts from Piedras Negras. Haines et al. (2008) summarize information about the spine's venomous properties.

26 The Council House interpretation of Copan Temple 22A is due to Barbara Fash et al. (1992). Jeff Kowalski (personal communication, 1999) interprets the "mat" motifs at Uxmal as textiles. For a comparison of the motifs on ancient and modern Maya textiles see Morris (1985). Our discussion of the early stone-binding on the Copan Peccary Skull is due to Houston et al. (2006:81–83).

27 Houston (1983b) deciphered the flint-shield compound as *tok'* *[took'] pakal*. See Schele & Miller (1986:73) for further discussion of eccentric flints.

28 First recognized as a helmet by Thompson (1962:279), who profitably compared the sign with associated iconography on Piedras Negras Panel 2, the **KO'HAW** reading is more recent, stemming from Linda Schele's observation of phonetic substitutions on the same monument (Schele et al. 1990:3 n. 5). For more in-depth analysis of the Teotihuacan warrior costume see Stone (1989). Taube (1992b) identified the zoomorphic version of the helmet as the War Serpent linked to a warrior cult at Teotihuacan. For discussion of the warrior skeletons found underneath the Temple of the Feathered Serpent see Cabrera Castro (1993).

29 Kelley (1976:208) first deciphered the shield logograph as **PAKAL**. The cross-hatched pattern with bead trim framing shields is also a common border design on woven cloth, such as women's huipils. Freidel et al. (1993:Fig. 8.27) noted the flexible shields carved as monumental stone sculptures at Tonina.

30 See Miller & Taube (1993:121–122), Houston (2002), Houston et al. (2006:257–270) and Zender (2010) for more on Maya music and instruments. Taube (1989b:368–371) discusses the ribald dance on K1549, and Zender (2004d:86–88,193–194) the musical instruments in the Deletaille Tripod scene. Stephen Houston (personal communication, 2002) discovered the Classic *lajab* term for hand drums.

31 See Danien (1997) and Houston et al. (2006:259–261) for further details on trumpets and the vessels in the Ratinlixul canon. See Taube (2003a) and Zender (1999:77–81) for hunting symbolism and the deity Huk Sip. See Houston et al. (2006:264) for the deer-spearing event.

32 See Miller & Martin (2004:171, 182) for the immolation of the Jaguar God of the Underworld. Stanley Guenter (personal communication, 2001) and Nikolai Grube (2004a:127–131) have each associated Foliated Ajaw with El Mirador. The "agave altar" translation is proposed here for the first time. For additional scenes of explicit human sacrifice before stela and altar pairs see K718 and K928.

33 Freidel et al. (1993:59–75) offer an extensive discussion of the creation text on Quirigua Stela C.

34 The ovoid shape of the Oval Palace Tablet was suggested by Miller (1999:110) to imitate the shape of a cushion. The "jaguar's mat" is mentioned in the *Chilam Balam of Chumayel* and discussed by Roys (1967:66 and n. 11). Zender (2006a:441) proposes the reading **TZ'AM** for both the cushion throne (T609a) and the so-called "**po**" sign (T687a), which does not carry the value **po** until Postclassic times.

35 Dmitri Beliaev (personal communication, 2002) suggested the **PIIT** reading on the basis of occasional **-ta** complements and the term for "litter" in Ch'olan languages. See Martin (1996) and Zender (2005) for Tikal's "star war" against Naranjo and the capture of its royal palanquin.

36 Recognition of the ballcourt glyph, which still lacks a linguistic reading, is the work of Houston (1983a). Miller & Houston (1987) explore relationships between ballcourt architecture and broader themes and symbolism in Maya culture.

37 For further details on "house" rituals from Classic inscriptions see Stuart (1998). Although one school of thought proposes to read the "house" sign with the final -*ch* of Yucatecan (Macri & Looper 2003:253), phonetic evidence establishes an unequivocal final -*t* in all script settings (Zender 2006a:440).

38 Schele & Freidel (1990:236) propose that the depictions of Baby K'awiil on the Temple of the Inscriptions represent a young K'inich Kan Bahlam II, and that his heir apparency was the "pyramid event" mentioned in the texts. But it is more likely that these images represent the deceased K'inich Janaab Pakal I, depicted as Baby K'awiil on his sarcophagus lid (*see* 1 and 21.3).

39 See Taube (1988) for a thorough discussion of scaffold sacrifice and royal accession.

40 Although often read as *MUK or *MUKNAL, it should be recognized that *muk* is a verb meaning "to bury," while *muhk* is a derived noun meaning "burial." It is this second form that explains the **MUHK-NAL** compound, which probably means "burial place." See Stuart (2005a) for Copan's Hieroglyphic Stairway and Martin (2006b) for the mythology of the cacao tree. See Grube and Gaida (2006:117–131) for an ample discussion of the Berlin Tripod.

41 Further information on the form and manufacture of Prehispanic Maya books can be found in Coe & Kerr (1998). Tate (1999) has raised the possibility that the production of bark paper was under the purview of women in ancient Maya society.

42 Substitution patterns that confirm the decipherment of the number tree as logographic **AAN** were proposed by Stuart et al. (1999:II-54). Coe (2004) believes that, botanically, the number tree refers to the fig tree used to make bark paper and suggests that the "leaf" resembles a fig leaf. The number tree in upright tree position occurs in the Madrid Codex page 69a. A *nikte'* collocation sits at the base of the tree.

43 Stuart (1987b) deciphered the syllabic spelling of *tz'ihb* "writing" as well as the expression for "scribe," *ajtz'ihb*. Coe & Kerr (1998) offer an excellent overview of scribes and their writing paraphernalia. See Johnston (2001) for the capture of scribes in warfare and their political importance in Maya society. Reents-Budet (1994) has amassed copious information on scribes and illustrates a variety of their shell paint containers.

44 See Stuart & Houston (1994:58) for a transcription of the toponym on Seibal Stela 7 as **WAK-e-bu-NAL**, *wakehbnal*. They link the "stair" (*ehb*) reference to ballgame imagery.

45 Looper (1995:154) proposed that the God of Zero on Quirigua Stela E relates to the stela's name. Stuart et al. (1999:II-35) present evidence that the God of Zero is bivalent as **mi/MIH**. See Grube (2004c) for additional discussion of the Goddess of Zero.

46 Beyer (1925) made several key observations on the distinction between painted and carved **IHK'** signs. Although frequently read *ek'* on the basis of Yucatec *éek'* "black" and Itzaj *eek'* "black" (e.g., Macri & Looper 2003:186), these cognates actually reveal that *ehk'* was the Proto-Yucatecan form, and that *ihk'* (with infixed-*h*) would have been the Classic form (Kaufman 2003:231). See Houston et al. (2009:33–35) for additional discussion of the **IHK'** sign.

47 David Stuart (2005c:9) was the first to notice the monumental Yax Ehb Xook spelling at Uaxactun, as well as the epigraphic and iconographic references to the Copan founder.

48 The **CHAK** sign was long ago recognized as the color "red" (Seler 1887). Its origins in bone iconography were demonstrated by Stuart (1987a) and Houston et al. (2009:30). See Miller & Martin (2004:171, 182) for the immolation of the Jaguar God of the Underworld and its association with captive sacrifice.

49 Coggins (1980) pointed out similarities between certain four-part symbols and the ground plans of pyramidal architecture. Taube (2000a) linked the **K'AN** sign with fire and centrality. See Bauer (2006) for the excavation of Cival's Preclassic cruciform cache. See Stuart (1990b) for the Emiliano Zapata Panel, and Houston et al. (2009:39–40) for additional iconographic contexts for the **K'AN** sign.

50 See Hopkins et al. (1985) and Thompson (1949) on ancient and contemporary dugout canoes. See McKillop (2005) and Prufer (2006) for the recent finds of a canoe paddle and canoe burial.

51 For strontium isotope analysis of dental enamel thought to be from Yax K'uk' Mo' as evidence of his foreign origins see Buikstra et al. (2004:210). Stuart (1998) proposed that the step verb with footprint is an iconic depiction of ascent. See Wichmann (2004a) for further metaphorical extensions of roads among the Maya, and Bricker & Miram (2002:40–41) and Wald (2004:32–33) for discussions of roads in the codices. Taube (1992a) discusses God L and God M in association with footprint imagery. See Helmke & Awe (1998) for the Actun Uayazba Kab caves.

52 David Stuart deciphered the **CH'EEN** sign, and we draw much of our discussion of cave iconography from his and Vogt's observations (Vogt & Quadripartite 2005). See Saturno et al. (2005) for the San Bartolo murals, and Taube (1986) for the emergence theme. Zender (2008a) has discussed additional signs for caves, rockshelters and cenotes.

53 MacLeod (n.d.) proposed a reading of this logograph as **WAY** based on spellings of the month Uayeb and occasional **-ya** complements. Zender (2008a) suggests **WAAY** on the basis of Yucatec *wàay* "cistern" and the architectural associations made by Hull & Carrasco (2004), who discuss the sign's relationship with the verb *mak* "to close, cover" (see also Zender 2006b). Taube (2003b) demonstrates that the maw and fangs, often doubled, are a stylization of a centipede's stinging mouth. See Stone (2003) for other iconographic usages of this sign and its relationship to the symbol for moon.

54 Bassie-Sweet (1991:95–102) and Zender (2008a) discuss the origins and iconography of the **KAB** sign.

55 Stuart (1987b) deciphered the **WITZ** sign. Looper (2002) discussed Zoomorph P as a "water mountain throne" and one of the cosmic hearth stones. Taube (1998:438) identified the stones in the Witz Monster's mouth as a symbolic hearth.

56 Schele and Miller (1986:46–47) long ago proposed that the Water Lily Monster is the symbol of standing bodies of water, such as the ocean. More recently, Lopes (2004b) deciphered the related water-band glyph as **POLAW**. Many of our points about the Maya view of the sea come from Taube (2004a:74–77), Houston & Taube (2006), and Finamore & Houston (2010).

57 Houston & Stuart (1990) first circulated an argument for the reading of T632 as **MUYAL**. At the same time, Andrea Stone proposed this reading in a note to Barbara MacLeod, later expanding on this (Stone 1996).

58 It is possible that this sign should rather be transcribed **AHK'AB** (Kaufman 2003:448). Beyer (1928) suggested the visual origin of the **AK'AB** sign in snake iconography. Grube (2001a) identified *Mok Chih* as "pulque sickness." The so-called "deer ear" seems to be a shell paint container, and Kerr (n.d.) points out an instance where it strategically touches the glyphic compound for "ink." Stuart (1988) linked the **AK'AB** glyph to the Jaguar Paddler. Taube (2004a) postulated that the **AK'AB** vase is Chahk's vessel containing dark rain-laden clouds. Zender (2006a:439, 2007a) identified the **AK'AB** signs on animals and insects as references to their nocturnal habits (see also Houston et al. 2006:13–14).

59 Bassie-Sweet (1991) first identified the three dots in the lunar glyph as water filling the lunar "cave." Milbrath (1999) discusses at length the role of the Moon Goddess in Maya agricultural lore, and Rosenbaum (1993:70) echoes the feminine connotations of the Moon Goddess's seated posture, noting that the Tzotzil of Chamula take the fact that women typically sit on the cold ground and go barefoot as a sign of their being in touch with the earth.

60 Carlson & Landis (1985) detail variations in the sky glyph seen in sky-bands. See Chinchilla (2005, 2006) for the astronomical significance of sky-bands. Other examples of the twisted cord, bent precisely like the Palenque stucco relief and marking serpent bodies, are given by Taube (1994:661 and Fig. 6a). Looper (2009:215) identifies the Palenque relief as a Centipede Dance commemorating the sun's emergence at creation.

61 See Love (1994), Milbrath (1999) and Chinchilla (2005) for further discussion of constellations in Maya art. For the role of stars in warfare see Martin (2001a:178–179). Our discussion of the

courtiers on the Palenque sarcophagus owes much to Oswaldo Chinchilla (2006). Floyd Lounsbury (cited in Miller 1986) first proposed that the constellations in the Bonampak murals reflected the appearance of the night sky on August 6, AD 792.

62 The notion of a floral solar paradise in Maya religion, as well as the relationship between the sun and male ancestors, is presented by Taube (2004a). Taube (2003b) also explored connections between the sun and centipedes. Stuart (1986) originally proposed that the solar eyes of Copan Altar U conveyed the title *k'inich* "sun-eyed"; however, this translation has been called into question.

63 Robertson (1974) was the first to systematically describe the traits of the Quadripartite Badge and Monster and show its varying contexts. Houston (cited in Stuart 1998:389) first suggested that the censer logograph represents the verb root *el* "to burn." Stuart (1998:389–390) understands this as a "house censing" ritual given the verb's association with the **NAAH** "house" logograph, T4.

64 See Stuart & Houston (1994:75–77) for the Laxtunich panel and Miller & Taube (1993:86–88) for fire-drilling.

65 See Taube (1989b:Fig.24–17) and Miller & Martin (2004:102–103) for "spark" markings. Houston (1988:130) distinguished the full and visually-abbreviated forms of **to/TOK** and David Stuart (personal communication, 2000) deciphered the **YOPAAT** term.

66 See Morehart et al. (2005) for an overview of pine in ancient Maya economics and ritual. Taube (2003a) discussed the figure in ill. 2 as "Wuk Zip" and observed that the personified tree was a metonym for a forest. Earlier, Zender (1999) had also identified this figure as Huk Sip, which seems to be the Classic form of the god's name. The stick-bundle torch seen in Maya art is also present in Teotihuacan and Olmec art.

67 See Blom (1950) and Hellmuth (1987:202–203) for the Blom Plate and its connections with the *Popol Vuh*. Lacadena (2004) deciphered the **HA'AL** sign and its associated iconography.

68 Lounsbury (1973) first identified the spiral form of rubber balls and related it to their technique of manufacture. For more on the iconography of rubber balls see Stone (2002).

69 See Moholy-Nagy (1989) for information on the ritual use and archaeological distribution of *Spondylus* shells at Tikal and other Lowland sites. For Landa's statement on shells as female pubic coverings see Tozzer (1941:102).

70 Bassie-Sweet (1991) suggested that *kawak* markings derive from cave formations, and linked them to other stony enclosures. Fox & Justeson (1984) identified the Madrid trap as a deadfall trap in which rocks crash down on the prey. The concept of the three-stone hearth is fleshed out by Freidel et al. (1993). The pervasive allusions to the three-stone hearth in Maya art and its relationship to the cosmic center are detailed by Taube (1998). Stuart (1996) discusses the rites of stone binding and stela erection.

71 Thompson (1950:282–284) first deciphered the **TE'** sign and explained many of its uses in script. David Stuart (personal communication, 2007) recently pointed out the **YAX** sign tagging the tree on the Blowgunner Pot (K1226).

72 See Stuart & Houston (1994:33) for a discussion of the toponym in the basal register of Machaquila Stela 4, as well as other varied uses of the **HA'** and **NAHB** form of the water lily in toponyms. For recent discussion of water lilies and the Water Lily Serpent see Finamore and Houston (2010). The complex form of **NAHB** is a good example of a "composite hieroglyph" (Fischer 1978) or "relational unit" (Zender 1999:70–83) a fairly common feature of Egyptian and Mayan writing.

73 See Stuart et al. (1999) for the Maya counterpart to the Central Mexican deity Ehecatl, a duck-billed avatar of Quetzalcoatl. See Houston & Taube (2000) for the iconography of wind, breath, sound and aroma, and for **IK'** signs as labels of musical instruments. See Taube (1992a, 2004a) for the Maya Wind God, the related breath soul and the paradisiacal Flower Mountain encompassing flowers, jade jewelry, wind and breath. The Palenque House B stucco may represent a similar kind of paradise. Stone (1995b) has compared God H to Xochipilli, the Aztec god of pleasure, gaming and music.

74 Christenson (2003) notes that the Maya linked fruit bats with decapitation because of the manner in which they snip fruit from trees. See Fash & Fash (1994) for a discussion of Copan Structure 20. Zender (2006a:439, 2007a) discusses the role of the **AK'AB** sign as a "nocturnal" marking. A male figure impersonating a bat is also seen on the Popol Vuh Bowl (Robicsek & Hales 1981:Fig. 88, top right). See Houston et al. (2006:213) for the exposed, threatening genitalia of bats and other wild animals.

75 Our zoological notes on centipedes follow Barnes (1987). The **cha-pa-ta** spelling on K1256 was deciphered by Grube & Nahm (1994). Further observations on centipedes in Maya art and writing are from Boot (1998) and Taube (2003b). Simon Martin (2001b; Martin & Grube 2000, 2008) identified the *chapaht* names at Tonina.

76 Grube & Nahm (1994:699) first realized the significance of the **tz'u-tz'i** spellings, though we have modified their reading on the basis of a fuller example yielding **tz'u-tz'i-hi**. The Landa quotation comes from Tozzer (1941:204–205). Houston et al. (2001:3-5) explained the tribute scenes.

77 David Stuart (personal communication, 2004) noted an abbreviated **a-hi** spelling for "crocodile" on a vase in the Museo Popol Vuh, Guatemala, thereby establishing the *ahiin* reading. For the Cosmic Monster see Stone (1983, 1985), Stuart (2005b) and Martin (2006a). Newsome (2001:291) analyzes the crocodilian loincloth on Copan Stela C. Taube (2003c) describes the crocodile's shell snout ornaments as references to vaporous breath. See Houston et al. (2006:16) for the oval texture marker.

78 The Deer God Huk Sip has been discussed by Taube (2003a) and Zender (1999:77–81). Robicsek & Hales (1981) were the first to gather and discuss examples of the dying Deer God theme. The spiral motif as a symbol for musk or odor is a recent discovery by Stephen Houston (2010). For discussions of *may* "tobacco" in Maya art and writing see Houston et al. (2006:114–116) and Grube and Gaida (2006:72–73, 189–191).

79 The **TZ'I'** sign and **tz'i-i** substitutions were first recognized by Stephen Houston and discussed in Stuart (1987b). Becquelin & Baudez's reports (1979–82, III) of excavations at Tonina facilitated Stuart's interpretation (1987b:n. 3) of Monument 89. Our ethnographic notes on dogs come largely from Thompson (1970:300–301).

80 The iconography of fireflies and their connections to the *Popol Vuh* story were first set out by Coe (1973:99) and Robicsek & Hales (1981:40–41). See Lopes (2004a) for the **KUHKAY** glyph. Zender (2006a:439, 2007a) elucidated the role of the **AK'AB** sign in the iconography of insects and other nocturnal animals.

81 Although its normal role is the syllabograph **ka**, the same sign occasionally functioned as logographic **KAY** (perhaps later **CHAY**) "fish." Recently, Kaufman & Justeson (2007:202) have proposed that the spots on the **ka** fish be interpreted as a conflation with **BAHLAM** "jaguar," but their proposal does not account for the appearance of these spots on other fish-related signs (e.g., **tz'u**), and *bona fide* compounds like **KAAN[BAHLAM]** and **[YOPAAT]BAHLAM** reveal that spots alone are not sufficient to cue "jaguar" conflations. See Taube (2004a:76–77) for Chahk's role as a fisherman. Houston (2010) first noted the spiral musk motif on the Dallas Tetrapod peccaries.

82 See Grube & Nahm (1994:699–700) for the *K'an Baah Ch'o'* reading and Rätsch & Probst (1985) for gopher hunting in Yucatan. Zender (2006a:439, 2007a) established the connection between **AK'AB** markings and nocturnal animals.

83 Although syllabic writing made it impossible to indicate the *h* in *bahlam*, modern Mayan languages are explicit regarding its presence in this word (Kaufman 2003). Taube (1998) observes that the Jaguar God of the Underworld is frequently sculpted on temple façades, representing built-in braziers for burning ceremonies. See Grube & Nahm (1994) for identification of the K'ahk' Hix *wahy*.

84 The **ma-xi** reading is from Stuart (1987b), while the **ba-tz'u** reading is from Grube & Nahm (1994). Much of our discussion of

85 For identification of the Rabbit Stone toponym in Piedras Negras inscriptions see Stuart & Houston (1994). Zender (2002d) linked this toponym with the site of La Mar. Further examples of vase scenes that shed light on the role of the rabbit, the Moon Goddess and the Maize God in God L's downfall are provided by Miller & Martin (2004:58–61).

86 Although *chan* is the form in Ch'olan languages, "snake" is complemented by **ka-** and disharmonic **-nu** in the script, evidently hearkening back to the antique pronunciation *kaan* (Martin 2005:5 n. 2). Schele (1989) pointed out several *wahy* characters combining serpent and deer imagery named *chij chan*, or "deer serpent."

87 David Stuart (1990a) deciphered the "shark" glyph as syllabic **u** and Jones (1996) proposed the logographic value **XOOK**. Recently, Stuart (personal communication, 2002) has pointed out the Late Classic emblem glyph of Chinaja (**XOOK-mo-o-AJAW**), a probable cognate of the *Xocmo* toponym known from Colonial maps (Feldman 2000:Map 1). See Quenon & LeFort (1997) and Taube (2004a) for the association of the shark with the Maize and Wind Gods, respectively. Finamore and Houston (2010:246) discuss the shark-spearing scenes.

88 See Faulkner (1952) and Goldwasser (2002) for sign conventionalization in Egyptian hieroglyphic writing.

89 See Zender (2006b) for the distinction between *ahk* "turtle" and *mahk* "turtle shell" in Maya art and script. See Saturno et al. (2005) for the water gourd and maize sack and much recent synthesis regarding the emergence scenes of the Maize God.

90 David Stuart (personal communication, 1999) noted the *awichnal* collocation on the Hummingbird Vase. Karl Taube (personal communication, 2000) first made the link between hummingbird imagery on Tikal Temple 4, Lintel 2 and the accompanying text. See Miller & Taube (1993:98) for hummingbird symbolism and Zender (2004d) for the Deletaille Tripod.

91 See Houston (1993) for a discussion of the macaw character on Tamarindito Stela 3. Zender (2005:9) outlines the contexts of the Four Macaw character.

92 Simon Martin (2006b) recovered the mythology of the cacao tree and the relationships of the Princeton Vase, the Temple of the Owls, God L, the Hero Twins and the Maize God.

93 Given the phonological development of this term (Kaufman 2003:614), there is some possibility that the sign should rather be transcribed **K'UUK'**. Stuart (1995:Ch. 10) called initial attention to tribute scenes in Maya art; the theme was later expanded upon by Houston (2000:173–174), who observed the bundling of quetzal feathers in tribute offerings.

94 David Stuart (personal communication, 1999) proposed the **AK'AACH** reading based on a substitution with the spelling **a-k'a-chi** on Site Q Panel 4 (aka La Corona Panel 3b). Knorozov (1952:116) deciphered the *u le' kutz* passage in the *Madrid Codex*. Houston et al. (2006:16) contributed the oval marker of rough or wrinkly texture.

95 In hieroglyphs, *kakaw* is always written syllabically as **ka-ka-wa** (or abbreviated as **ka²-wa** or **ka-wa**) and no logographic form exists; nonetheless, the imagery of cacao pods is remarkably standardized, and we have indicated one such as a guide to the imagery. Our discussion of the mythology of cacao and its connections with the Maize God myth and the *Popol Vuh* draw heavily from the work of Simon Martin (2006b). For more on the social and economic importance of cacao see McNeill (2006).

96 Stuart (2000a) recognized the meaning of the "cattail reed" logograph and proposed a decipherment, ultimately suggesting that it referred to the city of Teotihuacan. V. Miller (1991) detailed the extensive Teotihuacan influence in the Acanceh murals. For more on the debate over the nature of Early Classic Maya interaction with Teotihuacan, see Braswell (2003), Stuart (2000a), and Zender (2007b, 2008b).

97 Houston & Taube (2000) fleshed out the relationship among flowers, aroma and breath. Discovery of the interconnection among flowers, animating soul forces and wind can be credited to Taube (2004a). Taube also proposed that the quatrefoil, often serving as a cave entrance, mimics a flower because of its four-lobed shape and also that it represents a mouth from which breath emerges.

98 Maize iconography and identification of the Maize God were first systematically summarized by Taube (1985). For discussion of codical depictions of the Maize God, or God E, see Taube (1992a).

99 Freidel et al. (1993) proposed a substitution of the square-nosed serpent for "flower" in a standard death phrase, linking it to the concept of "soul." The substitution proves erroneous, but the flower symbolism seems inescapable. Schele & Miller (1986:Fig. I.4) proposed that the standard "God C-square-nosed serpent" loincloth is a folded World Tree. Taube (2004a) provides a detailed discussion of the nature of the "flower-breath soul" and its expression in Maya art.

100 The **WAAJ** sign was deciphered by Taube (1989a) and Love (1989). See Zender (2000) for a discussion of Classic Maya tamale plates (*we'ib*).

BIBLIOGRAPHY

Titles highlighted with an asterisk () are particularly useful for the general reader.*

Abbreviations
AM Ancient Mesoamerica; CIW Carnegie Institution of Washington (Washington, D.C.); *CMHI Corpus of Maya Hieroglyphic Inscriptions*; DO Dumbarton Oaks Research Library & Collections, Washington, D.C.; FAMSI Foundation for the Advancement of Mesoamerican Studies, Inc.; IMS Insitute for Mesoamerican Studies, State University of New York at Albany; INAH Instituto Nacional de Antropología e Historia, Mexico; *LAA Latin American Antiquity*; LACMA Los Angeles County Museum of Art; MARI Middle American Research Institute, Tulane University, New Orleans; *MVB Maya Vase Book*, Kerr Associates, New York (see Kerr 1989–); PARI Pre-Columbian Art Research Institute. San Francisco; PM Peabody Museum of Archaeology & Ethnology, Harvard University; *PRT Palenque Round Table* or *Mesa Redonda de Palenque*, gen. ed. M. Greene Robertson; *RES RES: Anthropology and Aesthetics*; *RRAMW Research Reports on Ancient Maya Writing*; T&H Thames & Hudson, London and New York; UNAM Universidad Nacional Autónoma de México; UOP University of Oklahoma Press, Norman; UPM University of Pennsylvania Museum, Philadelphia; UT University of Texas Press, Austin.

Abrams, E., & D. Rue, 1989, "The Causes and Consequences of Deforestation among the Prehistoric Maya." *Human Ecology* 16: 377–395.

Acuña, R., 1978, *Farsas y representaciones escénicas de los Mayas antiguos*. UNAM, Mexico.

Adams, R.E.W., 1962, "A Polychrome Vessel from Altar de Sacrificios." *Archaeology* 16(2): 90–92.

— 1971, *The Ceramics of Altar de Sacrificios*. PM Papers 63. Cambridge, Mass.

— 1977, "Comments on the Glyphic Texts of the 'Altar Vase'." In *Social Process in Maya Prehistory*, ed. N. Hammond, 409–420. Academic Press, London and New York.

Amrhein, L., 2001, An Iconographic and Historic Analysis of Terminal Classic Maya Phallic Imagery, PhD dissertation, Virginia Commonwealth University.

*Ancona-Ha, P., J. Perez de Lara & M. Van Stone, 2000, "Some Observations on Hand Gestures in Maya Art." *MVB 6*, 1072–1089. New York.

Baquedano, E., 1993, *Aztec, Inca and Maya*. Alfred A. Knopf, New York.

Barnes, R.D.,1987, *Invertebrate Zoology*. 5th edn. Saunders College Publishing, Philadelphia.

Bassie, K., 2002, "Maya Creator Gods." Mesoweb: www.mesoweb. com/features/bassie/CreatorGods/CreatorGods.pdf.

Bassie-Sweet, K., 1991, *From the Mouth of the Dark Cave: Commemorative Sculpture of the Late Classic Maya*. UOP, Norman.

Baudez, C., 1994, *Maya Sculpture of Copán: The Iconography*. UOP, Norman.

Bauer, J., 2006, "Between Heaven and Earth: The Cival Cache and the Creation of the Mesoamerican Cosmos." In *Lords of Creation: The Origins of Sacred Maya Kingship*, eds. V. Fields & D. Reents-Budet, 28–29. LACMA, Los Angeles.

Becquelin, P., & C. Baudez, 1979–1982, *Tonina, Une Cité Maya du Chiapas*. 3 vols., Paris.

Berjonneau, G., & J.-L. Sonnery, 1985, *Rediscovered Masterpieces: Mexico-Guatemala-Honduras*. 1985. Edition Arts, Boulogne.

Bernal, G., n.d., "El Rostro del Cielo y la Espina del Sacrificio," manuscript.

Beyer, H., 1925, "Apuntes sobre el Jeroglífico Maya Ek, 'Negro'." *Anales del Museo Nacional de Arqueología, Historia y Etnografía* 4(1): 209–215.

— 1928, "El Origen del Jeroglífico Maya Akbal." *Revista Mexicana de Estudios Históricos* 1(2): 3–7.

Blom, F., 1950, "A Polychrome Plate from Quintana Roo." *Notes on Middle American Archaeology and Ethnology* 4(98): 81–84. CIW.

Boot, E., 1998, "Centipedes and Fire Serpents at Chichen Itza." Paper presented at the 3rd European Maya Conference, Hamburg.

Braswell, G. (ed.), 2003, *The Maya and Teotihuacan: Reinterpreting Early Classic Interaction*. UT, Austin.

Bricker, V., 1973, *Ritual Humor in Highland Chiapas*. UT, Austin.

Bricker, V., & H.M. Miram, 2002, *An Encounter of Two Worlds: The Book of Chilam Balam of Kaua*. MARI 68.

Bricker, V., E. Pó'ot & O. Dzul, 1998, *A Dictionary of the Maya Language as Spoken in Hocabá, Yucatán*. University of Utah Press, Salt Lake City.

Buikstra, J., T.D. Price, L. Wright & J. Burton, 2004, "Tombs from the Copan Acropolis: A Life-History Approach." In *Understanding Early Classic Copan*, eds. E. Bell, M. Canuto & R. Sharer, 191–212. UPM, Philadelphia.

Cabrera Castro, R., 1993, "Human Sacrifice at the Temple of the Feathered Serpent." In *Teotihuacan: Art from the City of the Gods*, eds. K. Berrin & E. Pasztory, 100–115. T&H.

Campaña, L.E., & S. Boucher, 2002, "Nuevas imágenes de Becán, Campeche." *Arqueología Mexicana* 10(56): 64–69.

Carlson, J., & L. Landis, 1985, "Bands, Bicephalic Dragons, and Other Beasts: The Skyband in Maya Art and Iconography." In *4th PRT*, ed. E. Benson, 115–140. PARI.

Chinchilla, O., 2005, "Cosmos and Warfare on a Classic Maya Vase." *RES* 47: 107–134.

— 2006, "The Stars of the Palenque Sarcophagus." *RES*, 49: 39–58.

*Christenson, A., 2003, *Popol Vuh: The Sacred Book of the Maya*. O Books, Winchester.

Coe, M.D., 1966, *An Early Stone Pectoral from Southeastern Mexico*. Studies in Pre-Columbian Art and Archaeology 1, DO.

*— 1973, *The Maya Scribe and His World*. Grolier Club, New York.

*— 1975, *Classic Maya Pottery at Dumbarton Oaks*. DO.

*— 1978, *Lords of the Underworld*. Princeton University Art Museum, Princeton.

*— 1982, *Old Gods and Young Heroes*. Jerusalem.

*— 1989, "The Hero Twins: Myth and Image." *MVB* 1, 161–184.

*— 1999, *Breaking the Maya Code*, 2nd edn. T&H.

— 2004, "Gods of the Scribes and Artists." In *Courtly Art of the Ancient Maya*, eds. M.E. Miller & S. Martin, 239–241. T&H.

*Coe, M.D., & J. Kerr, 1997, *The Art of the Maya Scribe*. Abrams, New York.

*Coe, M.D., & M. Van Stone, 2005, *Reading the Maya Glyphs*, 2nd edn. T&H.

Coe, W., 1967, *Tikal: A Handbook of the Ancient Maya Ruins*. UPM, Philadelphia.

Coe, W., E. Shook & L. Satterthwaite, 1961, *The Carved Wooden Lintels of Tikal*. Tikal Report no. 6. UPM, Philadelphia.

Coggins, C., 1980, "The Shape of Time: Political Implications of a Four-Part Figure." *American Antiquity* 45: 727–739.

Culbert, T.P., 1975, *The Ceramics of Tikal: Vessels from Problematical Deposits*. Tikal Report no. 25, part A. UPM, Philadelphia.

Curtis, J., D. Hodell & M. Brenner, 1996, "Climate Variability on the Yucatan Peninsula (Mexico) During the Last 3500 Years, and Implications for Maya Cultural Evolution." *Quaternary Research* 46: 37–47.

*Danien, E., 1997, "The Ritual on the Ratinlixul Vase." *Expedition* 39(3): 37–48.

Davletshin, A., 2003, "Glyph for Stingray Spine." Mesoweb: www.mesoweb.com/features/davletshin/Spine.pdf.

Demarest, A., P. Rice & D. Rice (eds.), 2004, *The Terminal Classic in the Maya Lowlands: Collapse, Transition, and Transformation*. University Press of Colorado, Boulder.

*Diamond, J., 2005, *Collapse: How Societies Choose to Fail or Succeed*. Penguin, New York.

*Fash, W.L., 1991, *Scribes, Warriors and Kings. The City of Copan and the Ancient Maya*. T&H.

Fash, B.W., & W.L. Fash, 1994, "Copán Temple 20 and the House of Bats." In *7th PRT*, ed. V. Fields, 61–68. PARI.

Fash, B.W., W. Fash, S. Lane, R. Larios, L. Schele, J. Stomper & D. Stuart, 1992, "Investigations of a Classic Maya Council House at Copán, Honduras." *Journal of Field Archaeology* 19(4): 419–442.

Faulkner, R.O., 1952, "ʒpd = 'duck'." *Journal of Egyptian Archaeology* 38:128.

Feldman, L., 2000, *Lost Shores, Forgotten Peoples*. Duke University Press, Durham.

*Fields, V., & D. Reents-Budet, 2005, *Lords of Creation: The Origins of Sacred Maya Kingship*. LACMA.

Fialko, V., 2000, "El Espejo del Entierro 49: Morfologia y Texto Jeroglifico." In *El Sitio Maya de Topoxté*, ed. W. Wurster, 144–149. Verlag Philipp von Zabern, Mainz.

Finamore, D., & S.D. Houston, 2010, *Fiery Pool: The Maya and the Mythic Sea*. Peabody Essex Museum, Salem, Mass.

Fischer, H.G., 1978, "The Evolution of Composite Hieroglyphs in Egyptian Art." *Metropolitan Museum Journal* 12:5–19.

Förstemann, E., 1880, *Die Maya-Handschrift der Königlichen Öffentlichen Bibliothek zu Dresden*, Leipzig.

Fox, J., & J. Justeson, 1984, "Polyvalence in Maya Hieroglyphic Writing." In *Phoneticism in Maya Hieroglyphic Writing*, eds. J. Justeson & L. Campbell, 17–76, IMS 9.

*Freidel, D., L. Schele & J. Parker, 1993, *Maya Cosmos: Three Thousand Years on the Shaman's Path*. William Morrow and Co., New York.

Gardiner, A., 1982, *Egyptian Grammar: Being an Introduction to the Study of Hieroglyphs*, 3rd edn. Oxford University Press.

Gill, R.B., 2000, *The Great Maya Droughts: Water, Life, and Death*. University of New Mexico Press, Albuquerque.

Goldwasser, O., 2002, *Prophets, Lovers and Giraffes: Wor(l)d Classification in Ancient Egypt*. Wiesbaden.

Graham, I., 1967, *Archaeological Explorations in El Peten, Guatemala*. MARI 33.

Graham, I., E. Von Euw, P. Mathews & D. Stuart, 1975–, *CMHI*, vols. 1–8. PM, Cambridge, Mass.

Grube, N., 1990, *Die Entwicklung der Mayaschrift: Grundlagen zur Erforschung der Mayaschrift von der Protoklassik bis zur Spanischen Eroberung*. Acta Mesoamericana 3, Verlag von Fleming, Berlin.

— 2001a, "Intoxication and Ecstasy." In *Maya: Divine Kings of the Rainforest*, ed. N. Grube, 294–295. Könemann, Cologne.

*— (ed.), 2001b, *Maya: Divine Kings of the Rainforest*. Könemann, Cologne.

— 2004a, "El Origen de la dinastía Kaan." In *Los Cautivos de Dzibanché*, ed. E. Nalda, 117–131. INAH.

— 2004b, "The Orthographic Distinction between Velar and Glottal Spirants in Maya Hieroglyphic Writing." In *The Linguistics of Maya Writing*, ed. S. Wichmann, 61–81. University of Utah Press, Salt Lake City.

— 2004c, "Akan: the God of Drinking, Disease and Death." In *Acta Mesoamericana* 14, ed. D. Graña Behrens et al., 59–76. Verlag Anton Saurwein, Markt Schwaben.

Grube, N. & M. Gaida, 2006, *Die Maya: Schrift und Kunst*. Berlin.

Grube, N., B. MacLeod & P. Wanyerka, 1999, "A Commentary on the Hieroglyphic Inscriptions of Nim Li Punit, Belize." *RRAMW* 41.

Grube, N., & W. Nahm, 1994, "A Census of Xibalba: A Complete Inventory of 'Way' Characters on Maya Ceramics." *MVB* 4, 686–715.

Haines, H., P. Willink & D. Maxwell, 2008, "Stingray Spine Use and Maya Bloodletting Rituals: A Cautionary Tale." *LAA* 19(1): 83–98.

Hellmuth, N., 1987, *Monster und Menschen in der Maya-Kunst*. Austria.

— 1988, "Early Maya Iconography on an Incised Cylindrical Tripod." In *Maya Iconography*, ed. E. Benson & G. Griffin, 152–174. Princeton University Press, Princeton.

Helmke, C., & J. Awe, 1998, "Preliminary Analysis of the Pictographs, Petroglyphs, and Sculptures of Actun Uayazba Kab, Cayo District, Belize." In *The Western Belize Regional Cave Project: A Report of the 1997 Field Season*, ed. J. Awe, 141–199. Occasional Paper no. 1, University of New Hampshire, Durham.

Hopkins, N., J.K. Josserand & A. Cruz, 1985, "Notes on the Chol Dugout Canoe." In *4th PRT*, ed. E. Benson, 325–329.

Houston, S., 1983a, "Ballgame Glyphs in Classic Maya Texts." In *Contributions to Maya Hieroglyphic Decipherment*, ed. S. Houston, 26–30. HRAFlex, New Haven.

— 1983b, "A Reading of the Flint-Shield Glyph." In *Contributions to Maya Hieroglyphic Decipherment*, ed. S. Houston, 13–25. HRAFlex, New Haven.

— 1998, "The Phonetic Decipherment of Mayan Glyphs." *Antiquity* 62: 126–135.

— 1993, *Hieroglyphs and History at Dos Pilas*. UT, Austin.

— 2000, "Into the Minds of Ancients: Advances in Maya Glyph Studies." *Journal of World Prehistory* 14(2): 121–199.

— 2001, "Decorous Bodies and Disordered Passions." *World Archaeology* 33(2): 206–219.

— 2002, "Cantantes y Danzantes de Bonampak." *Arqueología Mexicana* 55: 54–55.

— 2010, "Maya Musk." Maya Decipherment: http://decipherment.wordpress.com.

Houston, S., C. Brittenham, C. Mesick, A. Tokovinine & C. Warinner, 2009, *Veiled Brightness: A History of Ancient Maya Color*. UT, Austin.

Houston, S., & P. Mathews, 1985, *The Dynastic Sequence of Dos Pilas*, PARI Monograph 1.

Houston, S., & D. Stuart, 1989, "The Way Glyph: Evidence for Co-Essences among the Classic Maya." *RRAMW* 30. Washington, D.C.

— 1990, "T632 as Muyal, 'Cloud'." *Central Tennessean Notes in Maya Epigraphy* 1. Nashville.

Houston, S., & K. Taube, 2000, "An Archaeology of the Senses: Perception and Cultural Expression in Ancient Mesoamerica." *Cambridge Archaeological Journal* 10(2): 261–294.

— 2006, "The Fiery Pool: Fluid Concepts of Water and Sea among the Classic Maya." Paper presented at the 11th European Maya Conference, Malmö, Sweden.

Houston, S., H. Escobedo, M. Child, C. Golden, R. Terry & D. Webster, 2000a, "In the Land of the Turtle Lords." *Mexicon* 22(5): 97–110.

Houston, S., J. Robertson & D. Stuart, 2000b, "The Language of Classic Maya Inscriptions." *Current Anthropology* 41(3): 321–356.

Houston, S.D., J.R. Robertson & D. Stuart, 2001, "Quality and Quantity in Glyphic Nouns and Adjectives." *RRAMW* 47.

Houston, S., D. Stuart & J. Robertson, 2004, "Disharmony in Maya Hieroglyphic Writing: Linguistic Change and Continuity in Classic Society." In *The Linguistics of Maya Writing*, ed. S. Wichmann, 83–101. University of Utah Press, Salt Lake City.

Houston, S., D. Stuart & K. Taube, 2006, *The Memory of Bones: Body, Being, and Experience among the Classic Maya*. UT, Austin.

Hull, K., & M. Carrasco, 2004, "*Mak-*'Portal' Rituals Uncovered." In *Acta Mesoamericana* 14, ed. D. Graña Behrens et al., 131–142. Verlag Anton Sauerwein, Markt Schwaben.

Inomata, T., D. Triadan, E. Ponciano, E. Pinto, R.E. Terry & M. Eberl, 2002, "Domestic and Political Lives of Classic Maya Elites." *LAA* 13(3): 305–330.

Johnston, K., 2001, "Broken Fingers: Classic Maya Scribe Capture and Polity Consolidation." *Antiquity* 75: 371–81.

Jones, C., & L. Satterthwaite, 1982, *The Monuments and Inscriptions of Tikal: The Carved Monuments*. Tikal Report no. 33, part A. UPM, Philadelphia.

Jones, T., 1996, "Polyvalency in the 'Xok' Glyph: Phonetic *u* and a Morphemic Patronym." In *8th PRT*, eds. M. Macri & J. McHargue, 325–342. PARI, San Francisco.

Joyce, R., 1996, "The Construction of Gender in Classic Maya Monuments." In *Gender and Archaeology*, ed. R. Wright, 167–195. University of Pennsylvania Press, Philadelphia.

Karttunen, F., 1992, *An Analytical Dictionary of Nahuatl*. UOP, Norman.

Kaufman, T., 2003, *A Preliminary Mayan Etymological Dictionary. FAMSI*: www.famsi.org/reports/01051/pmed.pdf.

Kaufman, T., & J. Justeson, 2007, "The History of the Word for Cacao in Ancient Mesoamerica." *AM* 18: 193–237.

Kelley, D., 1976, *Deciphering the Maya Script*. UT, Austin.

— 1982, "Costume and Name in Mesoamerica." *Visible Language* 16(1): 39–48.

*Kerr, J., 1989–, *The Maya Vase Book: A Corpus of Rollout Photographs of Maya Vases*, vols. 1–6, eds. J. Kerr & B. Kerr.

— n.d., "Where Do You Keep Your Paint Pot?" FAMSI: www.famsi.org/research/kerr/articles/paint_pot/index.html.

Klein, C., 2000, "The Devil and the Skirt: An Iconographic Inquiry into the Pre-Hispanic Nature of the Tzitzimime." *Ancient Mesoamerica* 11:1–26.

Knorozov, Y.V., 1952, "Drevniaia Pis'mennost' Tsentral'noi Ameriki" [The ancient writing of Central America]. *Sovietskaya Etnografya* 3: 110–118.

Lacadena, A., 2004, "On the Reading of Two Glyphic Appellatives of the Rain God." In *Acta Mesoamericana* 14, ed. D. Graña Behrens et al., 87–98. Verlag Anton Sauerwein, Markt Schwaben.

Laughlin, R., 1988, *The Great Tzotzil Dictionary of Santo Domingo Zinacatán, Volume 1: Tzotzil-English*. Washington, D.C.

Looper, M., 1995, The Sculpture Programs of Butz'-Tiliw, an Eighth-Century Maya King of Quirigua, Guatemala. PhD dissertation, University of Texas at Austin.

— 2002, "Quirigua Zoomorph P: A Water Throne and Mountain of Creation." In *Heart of Creation: The Mesoamerican World and the Legacy of Linda Schele*, ed. A. Stone, 185–200. University of Alabama Press, Tuscaloosa.

— 2009, *To Be Like Gods: Dance in Ancient Maya Civilization*. UT, Austin.

Looper, M., & J. Kappelman, 2001, "The Cosmic Umbilicus in Mesoamerica: A Floral Metaphor for the Source of Life." *Journal of Latin American Lore* 21(1): 3–53.

Lopes, L., 2004a, "Some Notes on Fireflies." Mesoweb: www.mesoweb.com/features/lopes/Fireflies.pdf.

— 2004b, "The Water-Band Glyph." Mesoweb: www.mesoweb.com/features/lopes/Waterband.pdf.

Lounsbury, F., 1973, "On the Derivation and Reading of the Ben-Ich Prefix." In *Mesoamerican Writing Systems*, ed. E. Benson, 99–141. DO.

Love, B., 1989, "Yucatec Sacred Breads Through Time." In *Word and Image in Maya Culture*, eds. W. Hanks & D. Rice, 336–350. University of Utah Press, Salt Lake City.

— 1994, *The Paris Codex*. UT, Austin.

MacLeod, B., n.d., "Notes on the Dragon Maw as *Way*," manuscript.

Macri, M., & M. Looper, 2003, *The New Catalog of Maya Hieroglyphs*. UOP, Norman.

Marquina, I., 1964, *Arquitectura prehispánica*. INAH.

Martin, S., 1996, "Tikal's 'Star War' Against Naranjo." *8th PRT*, eds. M. Macri & J. McHargue, 223–236. UOP, Norman.

— 2001a, "Under a Deadly Star: Warfare among the Classic Maya." In *Maya: Divine Kings of the Rainforest*, ed. N. Grube, 175–185. Könemann, Cologne.

— 2001b, "Una ventana al pasado: cómo las inscripciones Mayas esclarecen la historia, la arqueología y el arte." *Arqueología Mexicana* 48: 38–41.

— 2002, "The Baby Jaguar: An Exploration of Its Identity and Origins in Maya Art and Writing." In *La organización social entre los mayas*, eds. V. Tiesler & R. Cobos, 49–78. INAH, Mexico.

— 2005, "Of Snakes and Bats: Shifting Identities at Calakmul." *The PARI Journal* 6(2):5–15.

— 2006a, "The Old Man of the Maya Universe: Towards an Understanding of God N." Paper presented at the 30th Annual Maya Meetings, Austin, Texas.

— 2006b, "Cacao in Ancient Maya Religion: First Fruit of the Maize Tree and Other Tales from the Underworld." In *Chocolate in the Americas: A Cultural History of Cacao*, ed. C. McNeil, 154–183. University of Florida Press, Gainesville.

*Martin, S., & N. Grube, 2000, *Chronicle of the Maya Kings and Queens*. T&H.

*— 2008, *Chronicle of the Maya Kings and Queens*, 2nd edn. T&H.

Mathews, P., 1980, Notes on the Dynastic Sequence at Bonampak, Part 1. In *3rd PRT, Part II*, ed. M. Robertson, 60–73. UT, Austin.

Maudslay, A., 1889–1902, *Biologia Centrali-Americana: Archaeology*, 5 vols., R.H. Porter & Dulau, London.

Mayer, K.H., 1980, *Maya Monuments: Sculptures of Unknown Provenance in the United States*. Acoma Books, Ramona, Calif.

McKillop, H., 2005, "Finds in Belize Document Late Classic Maya Salt Making and Canoe Transport." *Proceedings of the National Academy of Sciences* 102: 5630–5634.

McNeill, C.L., 2006, *Chocolate in Mesoamerica: A Cultural History of Cacao*. University Press of Florida.

*Milbrath, S.,1999, *Star Gods of the Maya: Astronomy in Art, Folklore, and Calendars*. UT, Austin.

Miller, M.E., 1986, *The Murals of Bonampak*. Princeton University Press, Princeton.

— 1999, *Maya Art and Architecture*. T&H.

— 2005, "Rethinking Jaina: Goddesses, Skirts, and the Jolly Roger." *Record of the Princeton University Art Museum* 64:63–70.

Miller, M.E., & S. Houston, 1987, "The Classic Maya Ballgame and Its Architectural Setting: A Study of Relations Between Text and Image." *RES* 14: 46–65.

*Miller, M.E., & S. Martin, 2004, *Courtly Art of the Ancient Maya*. T&H.

*Miller, M.E., & K. Taube, 1993, *An Illustrated Dictionary of the Gods and Symbols of Ancient Mexico and the Maya*. T&H.

Miller, V.E., 1983, "A Reexamination of Maya Gestures of Submission." *Journal of Latin American Lore* 9(1): 17–38.

— 1991, *The Frieze of the Palace of the Stuccoes, Acanceh, Yucatan, Mexico*. Studies in Pre-Columbian Art and Archaeology 31. DO.

Moholy-Nagy, H., 1989, "The Social and Ceremonial Uses of Marine Mollusks at Tikal." *Prehistoric Lowland Maya Environment and Subsistence Economy*, ed. M. Pohl, 149–158. PM.

Morehart, C., D. Lentz & K. Prufer, 2005, "Wood of the Gods: The Ritual Use of Pine (*Pinus spp.*) by the Ancient Lowland Maya." *LAA* 16(3): 255–274.

Morley, S.G., 1935, *Guide Book to the Ruins of Quirigua*. CIW, pub. 16, Washington, D.C.

Morris, E., J. Charlot & A. Morris, 1931, *The Temple of the Warriors at Chichen Itza, Yucatan*. CIW 406.

Morris, W.F., Jr., 1985, "Flowers, Saints, and Toads: Ancient and Modern Maya Textile Design Symbolism." *National Geographic Research*, Winter 1985, 63–79.

Newsome, E., 2001, *Trees of Paradise and Pillars of the World: The Serial Stela Cycle of '18 Rabbit-God K' King of Copan*. UT, Austin.

Proskouriakoff, T., 1961, "Portraits of Women in Maya Art." In *Essays in Pre-Columbian Art and Archaeology*, ed. S. Lothrop, 81–99. Harvard University Press, Cambridge, Mass.

— 1963, *An Album of Maya Architecture*. UOP, Norman.

Prufer, K., 2006, "The Uxbenká Archaeological Project (UAP), 2006 Field Season." FAMSI: www.famsi.org/reports/06066/index.html.

Quenon, M., & G. LeFort, 1997, "Rebirth and Resurrection in Maize God Iconography." *MVB* 5, 884–902.

Ramos, J., 2004, "Research on Temple 16: An Ongoing Imagery Reconstruction of Temple 16, Copán, Honduras." FAMSI: www.famsi.org/reports/02098.

Rätsch, C., & H. J. Probst, 1985, "*Le bàho*: Ethnozoologie bei den Maya en Yucatán am Beispiel der *Orthogeomys spp.*" *Indiana* 10: 237–267.

*Reents-Budet, D., 1994, *Painting the Maya Universe: Royal Ceramics of the Classic Period*. Duke University Press, Durham.

Reese-Taylor, K., M. Zender & P. Geller, 2007, "Fit to be Tied: Funerary Practices among the Prehispanic Maya." In *Sacred Bundles: Ritual Acts of Wrapping and Binding in Mesoamerica*, eds. J. Guernsey & F. Kent Reilly, 40–58. Barnardsville, NC.

Rice, D., P. Rice & E. Deevey, Jr., 1985, "Paradise Lost: Classic Maya Impact on a Lacustrine Environment." In *Prehistoric Lowland Maya Environment and Subsistence Economy*, ed. M. Pohl, PM Papers 77, 91–105.

Robertson, M.G., 1974, "The Quadripartite Badge: A Badge of Rulership." In *1st PRT, Part I*, ed. M. Robertson, 77–92. PARI.

— 1983–1991, *The Sculpture of Palenque*, vols. 1–4. Princeton University Press, Princeton.

Robertson, M.G., R.L. Rands & J.A. Graham, 1972, *Maya Sculpture from the Southern Lowlands, the Highlands and Pacific Piedmont: Guatemala, Mexico, Honduras*. Lederer, Street & Zeus, Berkeley.

Robicsek, F., 1978, *The Smoking Gods: Tobacco in Maya Art, History and Religion*. UOP, Norman.

Robicsek, F., & D. Hales, 1981, *The Maya Book of the Dead: The Ceramic Codex*. University of Virginia Art Museum, Charlottesville.

Rosenbaum, B., 1993, *With Our Heads Bowed: The Dynamics of Gender in a Maya Community*. IMS.

Roys, R., 1965, *Ritual of the Bacabs*. UOP, Norman.

— 1967, *The Book of Chilam Balam of Chumayel*. UOP, Norman.

Saturno, W., K. Taube & D. Stuart, 2005, "The Murals of San Bartolo, El Petén, Guatemala: Part 1: the North Wall." *Ancient America* 7. Barnardsville.

Schele, L., 1976, "Accession Iconography of Chan-Bahlum in the Group of the Cross at Palenque." In *2nd PRT*, ed. M. Robertson, 9–34. PARI.

— 1989, "A Brief Note on the Name of the Vision Serpent." *MVB 1*, 146–160.

*Schele, L., & D. Freidel, 1990, *A Forest of Kings: The Untold Story of the Ancient Maya*. William Morrow, New York.

Schele, L., P. Mathews & F. Lounsbury, 1990, "Untying the Headband." *Texas Notes on Precolumbian Art, Writing, and Culture* 4. Austin.

*Schele, L., & P. Mathews, 1998, *The Code of Kings: The Language of Seven Sacred Maya Temples and Tombs*. Scribner, New York.

Schele, L., & J. Miller, 1983, *The Mirror, the Rabbit, and the Bundle*. DO.

*Schele, L., & M.E. Miller, 1986, *The Blood of Kings: Dynasty and Ritual in Maya Art*. Kimbell Art Museum, Ft. Worth.

Schellhas, P., 1904, *Representations of Deities of the Maya Manuscripts*. PM Papers 4. Cambridge, Mass.

Seler, E., 1887, "Entzifferung der Maya Handschriften." *Zeitschrift für Ethnologie* 9: 231–237.

— 1902–1923, *Gesammelte Abhandlungen*. Berlin.

Smith, R.E., 1955, *Ceramic Sequence at Uaxactun, Guatemala*, vol. 2. MARI 20.

Stephens, J.L., 1841, *Incidents of Travel in Central America, Chiapas, and Yucatan*. vol. 1. John Murray, London.

Stone, A., 1983, The Zoomorphs of Quirigua, PhD dissertation, University of Texas at Austin.

— 1985, "Variety and Transformation in the Cosmic Monster Theme at Quirigua, Guatemala." In *5th PRT, 1983*, ed. V.M. Fields, 39–48.

— 1988, "Sacrifice and Sexuality: Some Structural Relationships in Classic Maya Art." In *The Role of Gender in Precolumbian Art and Architecture*, ed. V.E. Miller, 75–103. Lanham, Md.

— 1989, "Disconnection, Foreign Insignia, and Political Expansion: Teotihuacan and the Warrior Stelae of Piedras Negras." In *Mesoamerica after the Decline of Teotihuacan A.D. 700–900*, eds. R. Diehl & J. Berlo, 153–172. DO.

— 1995a, *Images from the Underworld: Naj Tunich and the Tradition of Maya Cave Painting*. UT, Austin.

— 1995b, "The *Nik* Name of the Codical God H," manuscript.

— 1996, "The Cleveland Plaque: Cloudy Places in the Maya Realm." In *8th PRT*, eds. M. Macri & J. McHargue, 403–412. PARI.

— 1999, "Women in Ancient Mesoamerica." In *Women's Roles in Ancient Civilizations: A Reference Guide*, ed. B. Vivante, 292–312. Greenwood Press, Westport, Conn. & London.

— 2002, "Spirals, Ropes, and Feathers: The Iconography of Rubber Balls in Mesoamerican Art." *AM* 13(1): 21–39.

— 2003, "El Hogar de la luna es una cueva: un estudio iconográfico del arte maya clásico." In *Los Investigadores de la Cultura Maya* 11, 32–45, Universidad Autónoma de Campeche, Campeche.

Stuart, D., 1985a, "The 'Count of Captives' Epithet in Classic Maya Writing." In *5th PRT*, ed. V. Fields, 97–101. PARI.

— 1985b, "The Paintings of Tomb 12, Rio Azul." In *Río Azul Reports No. 3, the 1985 Season*, ed. R.E.W. Adams, 161–167. University of Texas, San Antonio.

— 1986, "The Hieroglyphic Name of Altar U." *Copan Note* 4.

— 1987a, "A Variant of the *Chak* Sign." *RRAMW* 10.

— 1987b, "Ten Phonetic Syllables." *RRAMW* 14.

— 1988, "Blood Symbolism in Maya Iconography." In *Maya Iconography*, eds. E. Benson & G. Griffin, 173–221. Princeton University Press, Princeton.

— 1990a, "The Decipherment of 'Directional Count Glyphs' in Maya Inscriptions." *AM* 1(2): 213–224.

— 1990b, "A New Carved Panel from the Palenque Area." *RRAMW* 32.

— 1995, A Study of Maya Writing, PhD dissertation, Vanderbilt University.

— 1996, "Kings of Stone: A Consideration of Stelae in Ancient Maya Ritual and Representation." *RES* 29/30: 148–171.

— 1998, "'The Fire Enters His House': Architecture and Ritual in Classic Maya Texts." In *Function and Meaning in Classic Maya Architecture*, ed. S. Houston, 373–425. DO.

— 1999, "The Founder of Tikal," manuscript.

— 2000a, "'The Arrival of Strangers': Teotihuacan and Tollan in Classic Maya History." In *Mesoamerica's Classic Heritage*, eds. D. Carrasco, L. Jones & S. Sessions, 465–513. University Press of Colorado, Boulder.

*— 2000b, "Ritual and History in the Stucco Inscription from Temple XIX at Palenque." *The PARI Journal* 1(1): 13–19.

— 2004, "The Beginnings of the Copan Dynasty: A Review of the Hieroglyphic and Historical Evidence." In *Understanding Early Classic Copan*, eds. E. Bell, M. Canuto & R. Sharer, 215–247. UPM, Philadelphia.

*— 2005a, "A Foreign Past: The Writing and Representation of History on a Royal Ancestral Shrine at Copan." In *Copán: The History of an Ancient Maya Kingdom*, eds. E.W. Andrews & W. Fash, 373–394. School of American Research, Santa Fe.

— 2005b, *The Inscriptions from Temple XIX at Palenque: A Commentary*. PARI.

— 2005c, *Sourcebook for the 29th Maya Hieroglyphic Forum, March 11–16*. University of Texas, Austin.

— 2006, "The Great Bird's Descent: Tracing the Legacy and Meaning of a Foundational Myth in Mayan and Mesoamerican Religion." Paper presented at the 11th European Maya Conference, Malmö, Sweden.

— 2007a, "Jade and Chocolate: Bundles of Wealth in Classic Maya

Economics and Ritual." In *Sacred Bundles: Ritual Acts of Wrapping and Binding in Mesoamerica*, eds. J. Guernsey & F. Kent Reilly, 127–144. Barnardsville, N.C.

— 2007b, "The Origin of Copan's Founder." Maya Decipherment: decipherment.wordpress.com/2007/06/25/the-origin-of-copans-founder/.

*Stuart, D., & S. Houston, 1994, *Classic Maya Place Names*. Studies in Pre-Columbian Art and Archaeology 33. DO.

Stuart, D., S. Houston & J. Robertson, 1999, "Recovering the Past: Classic Mayan Language and Classic Maya Gods. Notebook for the XXIIIrd Maya Hieroglyphic Forum at Texas." Maya Workshop Foundation, Univ. Texas at Austin.

*Tate, C., 1992, *Yaxchilan: The Design of a Maya Ceremonial City*. UT, Austin.

— 1999, "Writing on the Face of the Moon: Women's Products, Archetypes and Power in Ancient Maya Civilization." In *Manifesting Power: Gender and the Interpretation of Power in Archaeology*, ed. T. Sweely, 81–102. Routledge, London.

Taube, K., 1985, "The Classic Maya Maize God: A Reappraisal." In *5th PRT*, ed. V. Fields, 171–181. PARI.

— 1986, "The Teotihuacan Cave of Origin: The Iconography and Architecture of Emergence Mythology in Mesoamerica and the American Southwest." *RES* 12: 51–82.

— 1988, "A Study of Classic Maya Scaffold Sacrifice." In *Maya Iconography*, eds. E. Benson & G. Griffin, 330–351. Princeton University Press, Princeton.

— 1989a, "The Maize Tamale in Classic Maya Diet, Epigraphy, and Art." *American Antiquity* 54(1): 31–51.

— 1989b, "Ritual Humor in Classic Maya Religion." In *Word and Image in Maya Culture*, eds. W. Hanks & D. Rice, 351–382. University of Utah Press, Salt Lake City.

— 1991, "Obsidian Polyhedral Cores and Prismatic Blades in the Writing and Art of Ancient Mexico." *AM* 2 (1): 61–70.

— 1992a, *The Major Gods of Ancient Yucatan*. Studies in Pre-Columbian Art and Archaeology 32. DO.

— 1992b, "The Temple of Quetzalcoatl and the Cult of Sacred Warfare at Teotihuacan." *RES* 21: 53–87.

*— 1993, *Aztec and Maya Myths*. UT, Austin.

— 1994, "The Birth Vase: Natal Imagery in Ancient Maya Myth and Ritual." *MVB* 4, 652–685.

— 1995, "The Rainmakers: The Olmec and Their Contribution to Mesoamerican Belief and Ritual." In *The Olmec World: Ritual and Rulership*, ed. J. Guthrie, 83–103. Princeton University Press, Princeton.

— 1998, "The Jade Hearth: Centrality, Rulership, and the Classic Maya Temple." In *Function and Meaning in Classic Maya Architecture*, ed. S. Houston, 427–478. DO.

— 2000a, "The Turquoise Hearth: Fire, Self Sacrifice, and the Central Mexican Cult of War." In *Mesoamerica's Classic Heritage: From Teotihuacan to the Aztecs*, eds. D. Carrasco, L. Jones & S. Sessions, 269–340. University Press of Colorado, Boulder.

— 2000b, "The Writing System of Ancient Teotihuacan." *Ancient America* 1. Barnardsville, N.C.

— 2003a, "Ancient and Contemporary Maya Conceptions of the Field and Forest." In *The Lowland Maya Area: Three Millennia of Human-Wildland Interface*, ed. A Gómez-Pompa, 461–492. Food Products Press, New York.

— 2003b, "Maws of Heaven and Hell: The Symbolism of the Serpent and the Centipede in Classic Maya Religion." In *Antropología de la eternidad*, ed. A. Ciudad Ruiz, 405–442. Sociedad Española de Estudios Mayas, Madrid.

— 2003c, "Tetitla and the Maya Presence at Teotihuacan." In *The Maya and Teotihuacan: Reinterpreting Early Classic Maya Interaction*, ed. G. Braswell, 273–335. UT, Austin.

*— 2004a, "Flower Mountain: Concepts of Life, Beauty, and Paradise among the Classic Maya." *RES* 45: 69–98.

— 2004b, "Structure 10L-16 and its Early Classic Antecedents: Fire and the Evocation and Resurrection of K'inich Yax K'uk' Mo'." In *Understanding Early Classic Copan*, eds. E. Bell, M. Canuto &

R. Sharer, 265–295. UPM, Philadelphia.

Taube, K., & M. Zender, 2009, "American Gladiators: Ritual Boxing in Ancient Mesoamerica." In *Blood and Beauty: Organized Violence in the Art and Archaeology of Mesoamerica and Central America*, eds. H. Orr & R. Koontz, 161–220. Cotsen Institute of Archaeology Press.

Thompson, J.E.S., 1949, "Canoes and Navigation of the Maya and Their Neighbors." *Journal of the Royal Anthropological Institute* 79(1): 69–78.

— 1950, *Maya Hieroglyphic Writing: An Introduction*. CIW.

— 1961, "A Blood-Drawing Ceremony Painted on a Maya Vase." *Estudios de Cultura Maya* 1: 13–20.

— 1962, *A Catalog of Maya Hieroglyphs*. UOP, Norman.

— 1970, *Maya History and Religion*. UOP, Norman.

Tokovinine, A., 2008, The Power of Place: Political Landscape and Identity in Classic Maya Inscriptions, Imagery, and Architecture, PhD dissertation, Harvard University.

Tozzer, A.M., 1941, *Landa's Relación de las Cosas de Yucatan: A Translation*. PM Memoirs 18, Cambridge, Mass.

Vail, G., & A. Stone, 2002, "Representations of Women in Landa's *Reclación* and the Postclassic Codices: Gender Roles and Paradigms in Maya Literature and Art." In *Ancient Maya Women*, ed. T. Ardren, 203–228. Altamira Press, Culver City.

VanKirk, J., & P. Basssett-VanKirk, 1996, *Remarkable Remains of the Ancient Peoples of Guatemala*. UOP, Norman.

Vogt, E.Z., & D. Stuart, 2005, "Some Notes on Ritual Caves among the Ancient and Modern Maya." In *In the Maw of the Earth Monster: Mesoamerican Ritual Cave Use*, eds. J. Brady & K.M. Prufer, 155–185. UT, Austin.

Wald, R., 1994, "The Politics of Art and History at Palenque: Interplay of Text and Iconography on the Tablet of the Slaves." *Texas Notes on Precolumbian Art, Writing, and Culture* 80. Austin.

— 2004, "The Languages of the Dresden Codex: The Legacy of the Maya." In *The Linguistics of Maya Writing*, ed. S. Wichmann, 27–58. University of Utah Press, Salt Lake City.

*Webster, D., 2002, *The Fall of the Ancient Maya*, T&H.

Wichmann, S., 2004a, "El concepto de camino entre los mayas a partir de las fuentes epigráficas, iconográficas y etnográficas." In *La Metáfora en Mesoamérica*, ed. M. Montes de Oca Vega, 13–32. UNAM, Mexico.

— 2004b, "The Names of Some Classic Maya Gods." In *Acta Mesoamericana* 14, ed. D. Graña Behrens, 77–86. Verlag Anton Sauerwein, Markt Schwaben.

Wilkinson, R.H., 1992, *Reading Egyptian Art: A Hieroglyphic Guide to Ancient Egyptian Painting and Sculpture*. T&H.

Yadeun, J., 1993, *Toniná*. Mexico.

Zender, M., 1999, Diacritical Marks and Underspelling in the Classic Maya Script: Implications for Decipherment, MA thesis, University of Calgary.

— 2000, "A Study of Two Uaxactun-Style Tamale-Serving Vessels." *MVB* 6, 1038–1055.

— 2001, "The Conquest of Comalcalco: Warfare and Political Expansion in the Northwestern Periphery of the Maya Area." Paper presented at the 19th Annual Maya Weekend, UPM, Philadelphia.

— 2002a, "Metaphorical Child of Father Expressions," manuscript.

— 2002b, "Portraiture on the Denver Art Museum Stela and Other Monuments from the Lost Kingdom of Waxaab." Paper presented at the 4th Annual New World Art Symposium, Denver Art Museum.

— 2002c, "Recent Decipherments and Contributions to Glyphic Grammar." Workshop presentation at the 26th Annual Maya Meetings, Austin.

— 2002d, "The Toponyms of El Cayo, Piedras Negras, and La Mar." In *Heart of Creation: The Mesoamerican World and the Legacy of Linda Schele*, ed. A. Stone, 166–184. University of Alabama Press, Tuscaloosa.

— 2004a, "Glyphs for 'Handspan' and 'Strike' in Classic Maya Ballgame Texts." *The PARI Journal* 4: 1–9.

— 2004b, "Incised Celt." In *Ancient Civilizations of the Americas*, 92–93,

195–196. Miho Museum, Japan.

— 2004c, A Study of Classic Maya Priesthood, PhD dissertation, University of Calgary.

— 2004d, "Tripod Vessel with Mythological Scene." In *Ancient Civilizations of the Americas*, 86–87, 193–194. Miho Museum, Japan.

— 2005, "The Raccoon Glyph in Classic Maya Writing." *The PARI Journal* 5(4): 6–16.

— 2006a, "Review of *New Catalog of Maya Hieroglyphs*, by M. Macri and M. Looper." *Ethnohistory* 53(2): 439–441.

— 2006b, "Teasing the Turtle from its Shell: AHK and MAHK in Maya Writing." *The PARI Journal* 6(3): 1–14.

— 2007a, "Creatures of the Night: *ak'ab*-marking in Classic Maya Art and Writing." Workshop presentation at the 31st Annual Maya Meetings, Austin.

— 2007b, "Mexican Associations of the Early Classic Dynasty of Turtle Tooth I of Piedras Negras." Paper presented at the 31st Annual Maya Meetings, Austin.

— 2007c, "*Wahy* Creatures, Sorcery, and Personified Illness in Classic Maya Art and Writing." Workshop presentation at the 31st Annual

— 2008a, "Caves, Cenotes and Rockshelters in Classic Maya Art and Writing." Paper presented at the 5th Annual Tulane Maya Symposium, New Orleans.

— 2008b, "Disconnection, Foreign Insignia and Political Expansion: The Dynastic Symbolism of Piedras Negras." Paper presented at the 73rd Annual Society for American Archaeology Meetings, Vancouver.

— 2010, "The Music of Shells." In *Fiery Pool: The Maya and the Mythic Sea*, ed. D. Finamore and S. Houston, 83–85. Peabody Essex Museum, Salem, Mass.

Zender, M., & S. Guenter, 2003, "The Names of the Lords of Xibalba in the Maya Hieroglyphic Script." In *Eduard y Caecilie Seler*, eds. R. von Hanffstengel & C. Tercero, 91–126. INAH.

Zender, M., R. Armijo & M. Gallegos-Gomora, 2000, "Vida y Obra de Aj Pakal Tahn, un sacerdote del siglo VIII en Comalcalco, Tabasco, México." In *Investigadores de la Cultura Maya*, no. 9, tomo II, ed. R. Encalada, 387–398. UNAM.

SOURCES OF ILLUSTRATIONS

Abbreviations

AS Andrea Stone; AT Alex Tokovinine; *CMHI Corpus of Maya Hieroglyphic Inscriptions*; DORLC Dumbarton Oaks Research Library and Collections; DS David Stuart; FAMSI Foundation for the Advancement of Mesoamerican Studies, Inc.; HH Heather Hurst; IG Ian Graham; JK Justin Kerr; KT Karl Taube; LS Linda Schele; *MVB Maya Vase Book*; MZ Marc Zender; NG Nikolai Grube; SH Stephen Houston; SM Simon Martin; UPM University of Pennsylvania Museum

Contents
All glyph drawings MZ.

Introduction
1a–f Drawing MZ; 2 Drawing AS; 3 K5453. Photo JK; 4a–c Drawing MZ; 5 Drawing AS; 6 K6547. Photo Staatliche Museen zu Berlin, Preussischer Kulturbesitz; 7a–c Drawing MZ; 8 Drawing John Montgomery; 9 Photo MZ; 10a Drawing AS after Martin & Grube (2000:98); 10b K1698. Drawing MZ after Reents-Budet (1994:361); 11 Photo IG (courtesy Corpus of Maya Hieroglyphic Inscriptions, Peabody Museum, Harvard University).

Catalog
1: 1 Drawing SM; 2 K2723. Drawing SM; 3 K521. Drawing Dianne Griffiths Peck (after Coe 1973:99); 4 Drawing SM. **2:** 1 Drawing KT; 2 K774. Drawing KT; 3 Drawing KT (after Robicsek & Hales 1981:Fig. 68); 4 Photo MZ. **3:** 1 Photo LS; 2 Photo courtesy UPM; 3 Photo © Dumbarton Oaks, Pre-Columbian Collection, Washington, D.C.; 4 K2573. Drawing AS after *MVB* 2:245; 5 Photo courtesy Cleveland Museum of Art. **4:** 1 Drawing DS (2005b); 2 Drawing Mark Van Stone; 3 Drawing AT (DORLC); 4 Drawing MZ after Inomata et al. (2002:Fig. 12). **5:** 1 K927. Drawing AT; 2 K1230. Drawing AT; 3 Drawing AT (after Berjonneau & Sonnery 1985:Plate 354); 4 K1092. Photo JK. Boston Museum of Fine Arts. **6:** 1 K4013. Drawing AS after *MVB* 3:451; 2 Courtesy of the Stuart Collection, Barnardsville, N.C.; 3 Photo from Morley (1935:Fig. 23a); 4 Drawing AS. **7:** 1 K1652. Drawing NG; 2 K2286. Drawing NG; 3 K1197. Photo JK (after Robicsek & Hales 1981:Vessel 30); 4 Drawing AT (after Yadeun 1993:Frontispiece). **8:** 1 Drawing KT; 2 Drawing AT; 3 Photo Chip and Jennifer Clark; 4 K732. Photo JK. **9:** 1 K7821. Drawing MZ; 2 Drawing MZ; 3 K3863. Photo JK. **10:** 1 Kerr 702. Drawing AS after Robicsek (1978:187); 2 K6036. Drawing AS *MVB* 6:953; 3 Photo Martin Diedrich; 4 Photo courtesy UPM; 5 Drawing AS. **11:** 1 Drawing AS after Freidel et al. (1993:Fig. 5:6); 2 Photo AS; 3 Photo AS. **12:** 1 Drawing MZ; 2 K555. Drawing AT; 3 Photo Jorge

Perez de Lara. **13:** 1 Drawing AS; 2 Photo Virginia Miller; 3 Drawing AS after Jones & Satterthwaite (1982:Fig. 23); 4 Drawing AS after Robertson (1983–1991, IV:153). **14:** 1 Drawing MZ; 2 K1250. Photo JK. Kimbell Art Museum. **15:** 1 K1599. Photo JK; 2 Drawing AT. DORLC; 3 Drawing LS. **16:** 1 Drawing AS after Coe (1975:No. 15); 2 Photo Chip and Jennifer Clark; 3 K1082. Drawing AS *MVB* 1:57; 4 Photo Milwaukee Public Museum; 5 Drawing AS after Marquina (1964:Foto 440, p. 867). **17:** 1 Drawing AS after Coe (1966). DORLC; 2 Drawing AS after Martin & Grube (2000:143); 3 Photo AS; 4 Photo AS. **18:** 1 Drawing LS (after Schele & Miller 1986:Fig.VI.3, p. 244); 2 K3328. Drawing KT; 3 Photo MZ. **19:** 1 Drawing MZ; 2 Drawing IG (CMHI 3:160); 3 Photo New Orleans Museum of Art; 4 Drawing SH; 5 K791. Drawing MZ. **20:** 1 Drawing AS; 2 Drawing AS after Stuart (1988:Fig. 5.16); 3 Drawing AS after Grube et al. (1999:Fig. 1); 4 Photo AS. **21:** 1 K199b. Photo JK; 2 K1247. Drawing AT; 3 Drawing Merle Greene Robertson. **22:** 1 Drawing John Montgomery; 2 K505. Drawing MZ; 3 K1453. Photo JK; 4 K5764, 1728 and 5418. Drawings MZ. **23:** 1 Photo courtesy Denver Art Museum; 2 Drawing AS after Robicsek & Hales (1981:108); 3 Drawing AS after Schele (1976:Fig. 10); 4 Drawing AS after Stuart (2005b); 5 K2849. Photo JK. **24:** 1 K2859. Photo JK; 2 Photo AS; 3 Drawing AS after Grube (2001b:9); 4 Drawing AS after Jones & Satterthwaite (1982:Fig. 30); 5 Drawing AS. **25:** 1 Drawing SH; 2 Drawing AS. UPM; 3 Painting HH; 4 Drawing IG (CMHI 3:37). **26:** 1a–b Drawing MZ; 2 K2096. Photo JK; 3 K5179. Photo JK; 4 Drawing Barbara Fash; 5 Drawing Barbara Fash, courtesy Copan Mosaics Project and Copan Acropolis Project. **27:** 1 Photo AS; 2 Drawing AS; 3 K791. Drawing AS after Reents-Budet (1994:Fig. 5.10); 4 Photo AS; 5 Drawing AS after Jones & Satterthwaite (1982:Fig. 40a). **28:** 1 Drawing AS after Robertson et al. (1972:Plate 97); 2 Drawing AS after Coe (1967:102); 3 Photo Teobert Maler, Peabody Museum, Harvard University; 4 Drawing AS after Schele & Miller (1986:Fig. II.5); 5 Photo AS. **29:** 1 K4651. Drawing AS after *MVB* 4:577; 2 K1229. Drawing AS after *MVB* 1:69; 3 Photo LS; 4 Drawing AS after Martin (2001a:Fig. 265); 5 Photo courtesy British Museum. **30:** 1 Drawing AT after a drawing by Lin Crocker; 2 K1208. Drawing AT; 3 K3040. Photo JK; 4 K1549. Drawing KT. **31:** 1 K6984. Drawing AT; 2 K592. Photo JK (from Coe 1982:121); 3 K6317. Photo JK; 4 K7613. Photo JK. Heye Collection, Museum of the American Indian. **32:** 1 K4598. Photo JK; 2 K8351. Drawing AT; 3 K1882. Photo JK. **33:** 1 Drawing AS; 2 Drawing AS after Robicsek & Hales (1981:Fig. 88); 3 K5847. Drawing AS after *MVB* 6:943; 4 Drawing AS after Schele & Miller (1986:Fig. II.7); 5 Photo AS. **34:** 1 Drawing AS after Robertson (1983–1991, IV:Fig. 229); 2 K5013. Drawing AS after *MVB* 6:933; 3 Photo AS; 4 Drawing AS after drawing by LS; 5 Drawing AS after Mayer (1980:Pl. 51). **35:** 1 K767. Photo JK; 2 Drawing John Montgomery; 3 Drawing MZ (after H. Trik). **36:** 1 Photo AS; 2

Drawing AS; 3 K7694. Drawing AS after *MVB* 6:1002; 4 Photo Chip and Jennifer Clark. **37:** 1 Drawing AS; 2 Painting by A. Morris from Morris et al. (1931:Vol. 2, Pl. 159); 3 Drawing AS after Freidel et al. (1993:Fig. 4.4); 4 Photo AS; 5 Photo AS. **38:** 1 Photo AS; 2 Proskouriakoff (1963:53); 3 Drawing AS after Schele & Freidel (1990:Fig. 4:26); 4 K4549. Drawing AS after *MVB* 4:550. **39:** 1 K8089. Photo JK; 2 K5435. Photo JK; 3 Drawing AT, DORLC. **40:** 1 K6547. Drawing SM. Museum für Völkerkunde, Berlin; 2 Drawing LS. Art Institute of Chicago; 3 Drawing MZ. Kimbell Art Museum. **41:** 1 Drawing Anne Chojnacki after Baquedano (1993:40); 2 Drawing AS after Reents-Budet (1994:Fig. 2.15); 3 Drawing AS after Coe & Kerr (1998:Fig. 84); 4 Drawing AS after Robiscek & Hales (1981:Fig. 27a). **42:** 1 Drawing Anne Chojnacki after Berjonneau & Sonnery (1985:No. 364); 2 Drawing AS after Coe (1978:No. 16); 3 K5365. Drawing AS after *MVB* 5:787; 4 Drawing AS after Robiscek & Hales (1981:Vessel 64, p. 56); 5 Drawing AS after Robertson (1983–1991, III:Fig. 128). **43:** 1 K5766. Photo JK; 2 K2780b. Photo JK; 3 Drawing AS after Coe & Kerr (1998: 88); 4 Drawing AS after Coe & Kerr (1998:Fig. 65). **44:** 1 Photo Milwaukee Public Museum; 2 Drawing AS after Baudez (1994:Fig. 12); 3 Photo AS; 4 Drawing AS after Graham (*CMHI* 3:105). **45:** 1 Drawing William R. Coe after Jones & Satterthwaite (1982: Fig. 22); 2 Photo Martin Diedrich; 3 Courtesy Cleveland Museum of Art. 1953.154; 4 Photo AS; 5 K2286. Drawing AS after *MVB* 2:229.**46:** 1a–b Drawing MZ; 2 Drawing IG (CMHI 9:55); 3 Drawing IG (CMHI 3:54); 4 K2796. Photo JK (after Coe 1973:109). **47:** 1 Drawing MZ (after Stuart 2005c:9); 2 Drawing IG (after Tate 1992:194); 3 Dresden 27b (after Förstemann 1880). **48:** 1 Drawing IG (CMHI 3:21); 2 K4931. Photo JK; 3 K1299. Drawing SM. **49:** 1 Drawing AS after Stuart (1988:Fig. 1); 2 K2773. Drawing AS after *MVB* 2:286; 4 Photo Karl Herbert Mayer; 5 Drawing Joel Zovar. Photo courtesy Francisco Estrada-Belli. **50:** 1 Drawing MZ (after Thompson 1949:Fig. 1); 2 Drawing AS; 3 K1391. Drawing AT; 4 K3033. Drawing LS. **51:** 1 Drawing AS after Taube (2000b:Fig. 22f); 2 Drawing AS; 3 Drawing AS after LS; 4 Drawing AS; 5 Photo Christophe Helmke, courtesy Western Belize Regional Cave Project and Jaime Awe. **52:** 1 Painting HH; 2 Drawing AT (after Stuart et al. 1999:20). **53:** 1 Drawing AS after Baudez (1994:Fig. 98); 2 Drawing AS after Robiscek & Hales (1981:Vessel 186); 3 K4013. Drawing AS after *MVB* 3:451; 4 Drawing AS. **54:** 1 Drawing AS; 2 Drawing Tracy Wellman; 3 Dresden 67b (after Förstemann 1880); 4 Drawing SH. **55:** 1 Drawing AS after Mathews (1980:Fig. 3); 2 Photo AS; 3 Drawing AS; 4 Photo AS. **56:** 1 Photo Jacques VanKirk (after VanKirk & Bassett-VanKirk 1996:100); 2 Drawing KT (after Hellmuth 1987:Fig. 383); 3 Drawing MZ (after Hellmuth 1987:Fig. 321). **57:** 1 After Graham et al. (*CMHI* 2:159); 2 K2085. Drawing AS after *MVB* 2:214; 3 Drawing AS; 4 K3007. Drawing AS after *MVB* 3:378. **58:** 1 Drawing AS after Stuart (1985b:Fig. 41); 2 K8007. Drawing AS after *MVB* 6:1012; 3 Photo LS; 4 K2284. Drawing AS after *MVB* 2:228; 5 Drawing AS after Maudslay (1889–1902, II: Pl. 64). **59:** 1 Drawing AS after Mayer (1980:Pl. 69); 2 Drawing AS after Coe (1978:No. 7); 3 Drawing AS after Schele & Miller (1983:Fig. 18a); 4 Photo Thomas Tolles; 5 Photo MZ. **60:** 1 Drawing AS after Jones & Satterthwaite (1982:Fig. 74); 2 Photo AS; 3 Drawing AS after Robertson (1983–1991, V:Fig. 182); 4 Drawing AS; 5 Drawing AS after Tate (1992:Fig. 86). **61:** 1 K4880. Drawing MZ; 2 K4565. Drawing MZ; 3 Painting HH; 4 K2284. Drawing MZ. **62:** 1 Photo AS; 2 Drawing AS after Hellmuth (1987:594h); 3 Drawing AS after Jones and Satterthwaite (1982:Fig. 1); 4 Drawing AS. **63:** 1 Drawing AS after Hellmuth (1987:Pl. 12, No. 63); 2 Photo Chip and Jennifer Clark; 3 K7716. Drawing AS after *MVB* 7:1003; 4 K3168. Photo JK; 5 Photo AS. **64:** 1 K791. Photo JK; 2 K3844. Drawing AT; 3 Drawing SH. **65:** 1 Drawing Mark Van Stone; 2 Drawing AT; 3 K1006. Drawing SM; 4 Drawing KT. **66:** 1 K4336. Drawing AS after Kerr *MVB* 2:307; 2 Drawing AS; 3 Photo Jorge Perez de Lara courtesy Karen Bassie; 4 Drawing AS after Coe (1975: No. 6). **67:** 1 Drawing AT; 2 Drawing AS after Schele & Miller (1986:272). **68:** 1 Drawing AS; 2 Drawing AS; 3 K5010. Photo MZ; 4 Photo AS. **69:** 1 Drawing AS after Baudez (1994:Fig. 26); 2 Photo Dorie Reents-Budet. Art Institute of Chicago; 3 Painting HH; 4

Drawing AS after Saturno et al. (2005); 5 K1392. Drawing AS after Reents-Budet (1994:Fig. 6.27). **70:** 1 Drawing AS; 2 Drawing AS; 3 K7727. Drawing AS after *MVB* 6:1005; 4 Photo MZ; 5 Drawing AS after Coe (1978); 6 Photo MZ. **71:** 1 Drawing AT after Andy Seuffert, UPM; 2 K531. Drawing MZ; 3 K1226. Drawing MZ; 4 Drawing SM. **72:** 1 Photo AS; 2 After Graham (1967:Fig. 51); 3 Drawing AS after Hellmuth (1987:161); 4 Drawing AS after Robicsek & Hales (1981:Vessel 30); 5 K6298. Drawing AS after *MVB* 6:958. **73:** 1 Photo AS; 2 Drawing AS after Baudez (1994: Fig. 47); 3 Drawing AS after Robertson (1983–1991, II:Fig. 177); 4 Drawing AS after Taube (1992a:Fig. 28e); 5 K1485. Drawing AS after *MVB* 1:90. **74:** 1 Drawing AS after Baudez (1994: Fig. 11); 2 K5036. Photo JK. Los Angeles County Museum of Art; 3 K1379. Drawing AS after *MVB* 1:76; 4 K6996. Drawing AS after *MVB* 5:835; 5 K1440. Drawing AS after *MVB* 1:83. **75:** 1 Drawing MZ after Barnes (1987:Fig. 15–1); 2 K1256. Drawing SM; 3 K533. Photo JK; 4 Drawing A. Dowd. **76:** 1 K8076. Photo JK; 2 K1181. Drawing MZ; 3 Drawing MZ after Coe (1982:Vessel 60). **77:** 1 Drawing AS after Baudez (1994:Fig. 44); 2 Photo Diane Chase; 3 Photo AS; 4 Drawing AS after Hellmuth (1987:No. 596); 5 Drawing AS after Baudez (1994:Fig. 7b). **78:** 1 K808. Photo JK; 2 K2572. Drawing AT; 3 Dresden 13d after Förstemann (1880); 4 K1182. Photo JK. **79:** 1 K594. Drawing AT, UPM; 2 K505. Photo JK; 3 Drawing DS after Stuart (1987b:Fig.13a). **80:** 1 K8608. Drawing MZ; 2 K793. Drawing AT; 3 Drawing IG (*CMHI* 9:33). **81:** 1 Drawing Ayax Moreno; 2 Dresden 27c after Förstemann (1880); 3 Drawing AT after Andy Seuffert, UPM; 4 Drawing AT after Hellmuth (1987:Fig. 167). **82:** 1 K2023. Drawing NG; 2 Drawing AS after Yadeun (1993:3); 3 Drawing AT; 4 K1377. Photo JK; 5 K559. Drawing SM. **83:** 1 Drawing AS after Schele & Miller (1986:Pl. 84); 2 Painting HH; 3 Photo AS; 4 K2942. Drawing AS after *MVB* 3:371; 5 Photo AS. **84:** 1 K3413. Drawing AT after Coe & Kerr (1997:106); 2 K7525. Photo MZ; 3 K5070. Photo MZ; 4 Drawing SH after Smith (1955:Fig. 2g). **85:** 1 Drawing AS after Robicsek & Hales (1981:69); 2 Princeton University Art Museum; 3 Drawing IG (*CMHI* 2:10); 4 K1398. Photo JK. **86:** 1 Photo AS; 2 Photo AS; 3 After Graham (*CMHI* 3:39); 4 K791. Drawing AS after Grube & Nahm (1994:Fig. 36); 5 Drawing AS. **87:** 1a–c Drawing MZ; 2 Drawing Dianne Griffiths Peck (Coe 1975:Vessel 11). DORLC; 3 Drawing AT; 4 Drawing NG. **88:** 1 Photo George F. Mobley; 2 K688. Drawing SM; 3 K3395. Drawing DS. Museo Popol Vuh, Guatemala. **89:** 1 Painting HH; 2 K731. Drawing LS, courtesy FAMSI; 3 K1892. Drawing MZ. **90:** 1 K8008. Photo JK; 2 Dresden 7b after Förstemann (1880); 3 Drawing Lin Crocker after Hellmuth (1988:Fig. 4.2). **91:** 1 Drawing AS; 2 Drawing AS after Houston (1993:Fig. 4-5c); 3 Drawing AS after Taube (2000b:Fig. 22f); 4 Photo AS; 5 Photo AS. **92:** 1 Dresden 10a after Förstemann (1880); 2 K511. Drawing MZ; 3 Drawing SM. **93:** 1 K1383. Drawing AS after *MVB* 1:78; 2 K7727. Drawing AS after *MVB* 6:1005; 3 Drawing AS after Saturno et al. (2005); 4 Drawing AS after Hellmuth (1987:18, Tafel IV, no. 31); 5 Drawing MZ. **94:** 1 Drawing AT; 2 K2026. Photo JK; 3 K2010. Photo JK; 4 Dresden 28c after Förstemann (1880). **95:** 1 K4331. Drawing SM. DORLC; 2 K5615. Drawing SM. Popol Vuh Museum, Guatemala; 3 K631. Drawing SM. Photo AS after Coe et al. (1961:Fig. 12d); 2 Drawing AS after Schele & Mathews (1998:Fig. 2.12c); 3 Drawing AS after Seler (1902–1923, V:Fig. 11). **97:** 1 Drawing courtesy Joe Ball and Jennifer Taschek; 2 Drawing AS after D. Stuart (*CMHI* 9:54); 3 K4579a. Photo JK. Princeton University Art Museum; 4 K2695. Drawing AS after *MVB* 2:255; 5 Drawing AS after Robertson (1983–1991, IV:Fig. 29). **98:** 1 Drawing AS after Robertson (1983–91, V:Fig. 112); 2 Photo Thomas Tolles; 3 Photo Milwaukee Public Museum; 4 From Thames & Hudson archive; 5 Drawing AS after Miller & Martin (2004:Fig. 54). **99:** 1 Drawing AS after Graham (*CMHI* 3:53); 2 Drawing AS after *MVB* 3:43; 3 Drawing AS after Martin & Grube (2000:149); 4 Photo AS; 5 Drawing AS after Robertson (1983–1991, III:Fig. 162). **100:** 1 K5450. Photo JK; 2 K6059. Photo JK; 3 K3049. Drawing AT.